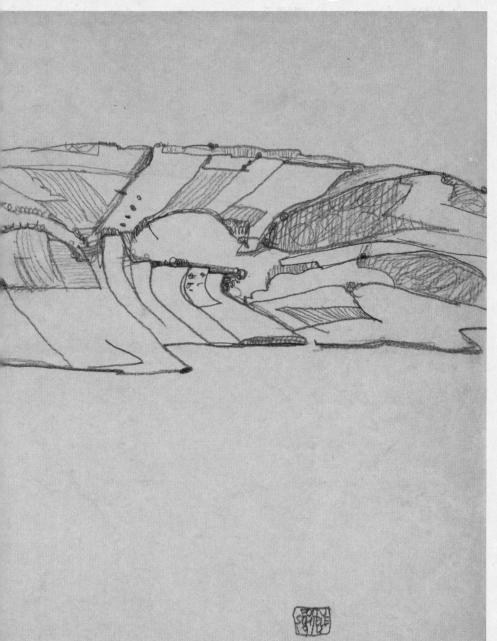

EGON SCHIELE

EGON SCHIELE
Drawings and Watercolors

JANE KALLIR

Edited by IVAN VARTANIAN

With over 300 color illustrations

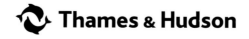
Thames & Hudson

First published in the United Kingdom in 2003 by
Thames & Hudson Ltd, 181A High Holborn, London WC1V 7QX.

First published in hardback in the United States of America in 2003 by
Thames & Hudson Inc., 500 Fifth Avenue, New York, New York 10010.

Reprinted in 2003, 2004, 2005, 2006, 2009

All artworks are reproduced with permission.

The foreword by Richard Avedon is an excerpt from the essay *Borrowed Dogs*, which is an adaptation of a talk given at The Museum of Modern Art, New York, on 27 September 1986. The essay was published in the catalogue *Richard Avedon Portraits* (Abrams, 2002). The excerpt is reproduced with the permission of the artist.

The typeface used throughout this publication is Mrs Eaves, designed by Zuzana Licko (Emigre), ca. 1996. The embellishment was designed by Ms. Licko and Miles Newlyn, and is from the illustration set Hypnopaedia, 1997.

Endpapers: *Landscape with Fields*, 1914.
Pencil. Signed and dated, lower right. 32 x 48.5 cm. Leopold Museum, Vienna.

British Library Cataloguing-in-Publication Data
A catalogue record for this book is available from the British Library

Library of Congress Catalogue Card No. 2002094856

ISBN: 978-0-500-51116-9

Printed and bound in China.

Table of Contents

꧁꧂

Foreword by Richard Avedon
Page 5

Introduction by Ivan Vartanian
Page 8

A Biographical and
Stylistic Study
by Jane Kallir

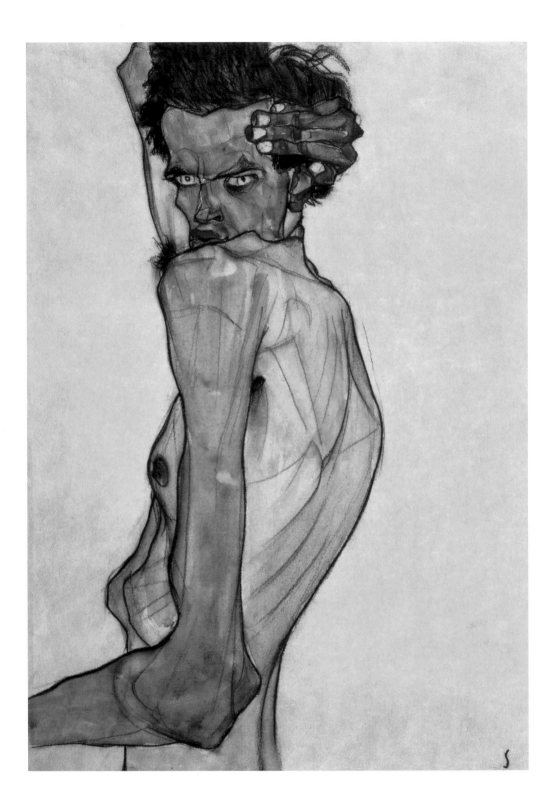

You can't get at the thing itself, the real nature of the sitter, by stripping away the surface. The surface is all you've got. You can only get beyond the surface by working with the surface. All that you can do is to manipulate that surface—gesture, costume, expression—radically and correctly. And I think Schiele understood this in a unique, profound, and original way. Rather than attempting to abandon the tradition of the performing portrait (which is probably impossible anyway), it seems to me that Schiele pushed it to extremes. He shattered the form by turning the volume up to a scream. And so what we see in Schiele is a kind of recurring push and pull: first toward pure "performance," gesture and stylized behavior pursued for its own sake, studied for its own sake; then these extreme stylizations are preserved in form, but disoriented, taken out of their familiar place, and used to change the nature of what a portrait is.

— Richard Avedon

Self-Portrait with Arm Twisting Above Head. 1910.
Watercolor and charcoal. Initialed, lower right. 45.1 × 31.7 cm. Kallir D. 688.
Private collection, New York.

Introduction

Egon Schiele's life and work comprise the quintessential coming-of-age story, that of a young man striving inexorably toward what was outside his grasp. Schiele's youthful solipsism and artistic ambition often brought him face-to-face with practical difficulties—among them financial straits and societal disapproval. But it was also his ambition that propelled his technical and stylistic development at such an astonishing pace; indeed, one of the most remarkable aspects of Schiele's short life is the ground that he covered in his career before his death in 1918, at the age of twenty-eight.

Even from a purely technical standpoint, the flowering of Schiele's genius was as rapid as it was dramatic. His rate of progression is mind-boggling. How does a child who likes to draw trains attain so quickly this mastery of line, color, human form, human expression? How does a young art student, producing impressive (though rather lackluster) academic studies, move on to achieve such emotive charge in his figures? How does early, cumbersome experimentation with oil paint turn in a matter of months into such uncanny skill with gouache and watercolor? The energy, speed, and confidence with which Schiele advanced stylistically and technically are like those of a young boy bounding up a flight of stairs. And it is this rate of development that warrants the simple organization of Schiele's oeuvre into discrete chronological segments—as in this book.

The focus of this volume is on Schiele's drawings and watercolors; unless otherwise indicated, all plates represent works on paper—by far the largest portion of his oeuvre. The book opens with Schiele's juvenilia, drawings he made at age fifteen, and from there progresses year by year over the twelve-year span of his artistic career. The plates generally follow the order in which the artworks were created—a natural sequence in Schiele's case, as he methodically worked through

distinct problems of line and color, advancing to the next assay only when he was satisfied that his current artistic challenge was resolved. It would, in fact, be possible to break down each year of Schiele's creative output into sets of months, or even weeks, and thus to trace the artist's stages in closer detail.

As Schiele's stylistic development catapulted forward, it was guided largely by his own vision, but also by the milieu in which he lived and worked—turn-of-the-century Austria and its prevalent social mores. Jane Kallir, author of Schiele's catalogue raisonné and preeminent authority on his life and work, here explores this creative development within its context. She examines the artist's relationships to society, to his family, to the art world, to women, and to his own art, and demonstrates through incisive stylistic analysis that the course and maturation of these relationships are reflected in his work.

The selection of images in this volume is as comprehensive as possible, both in terms of Schiele's output, and also in representing the broadest range of private and public collections. In several instances here, we have had the happy opportunity to reproduce work that has not been published before in color. The selection has been made with a view to deepening an understanding of Schiele's art, through an intensive exploration of his works on paper. Along with the well known, the technically flawless, and the masterpieces, readers will discover some images that might be construed as graphically or thematically repetitive, and others that may be deemed less than brilliant—all works have been included because, in themselves or by contrast, they reveal something valuable about Schiele or his process. And of course, many personal favorites have crept into the selection; it would be impossible to compile such a collection without a degree of attachment to certain images.

In Schiele's brief lifetime, he generated a copious volume of work. Along with his more than two thousand drawings and watercolors—our focus here—he produced more than three hundred oils, many of which were extremely ambitious productions. By the time he was in his mid twenties, his work had been seen in numerous exhibitions. So, although Schiele's drawings were his main bread and butter, he clearly possessed the ability to produce a full body of work, the energy and relevance of which remain apparent to this day. What was the source of such power and ability?

Schiele was endowed from the start with a truly extraordinary technical skill, which was honed and refined throughout his life. With that as his solid foundation,

he was able to dispense with given conventions of pictorial representation, narrative, and space, and devote himself to what he saw as *truth*. The results were often shocking in their way—as seen for example in his nudes of 1910, where the figures are removed from any recognizable pictorial field, the bodies warped, strangely colored, and disoriented. The perennial convention of the innocuous odalisque, positioned in a stable and nonthreatening plane, plays no part in Schiele's work. His candor was uncompromising; his courage to represent things—among them female sexuality—*as they are* is unsettling even now, nearly a century after his death.

Artistic theory and concept held little interest for Schiele. Rather, his aim was higher—the attainment of truth. With this lofty goal in view, he naturally considered his work sacred, and indeed his entire artistic mission is suffused with spiritual rhetoric. The artist often envisioned himself as a prophet or seer, and his work as a vessel for enlightenment. He had the arrogance and ambition of youth—these may well have allowed him the presumption to engage with the sacred—but he channeled his energies toward the creation of art that is far from ego-driven or self-engrossed.

The dichotomy in style, theme, quantity, and manner of production between Schiele's canvases and his works on paper make them seem almost like two distinct bodies of work. The oils, which often addressed spiritual themes overtly, were extremely labor intensive and frequently required more financial resources than he could afford. The drawings, by contrast, were produced at lightning speed, with minimal cost, and were rarely spiritual in subject. Schiele's overarching sacred mission, so apparent in his oils, is often overlooked as his great volume of drawings receive so much more attention. His groundbreaking vision of sexuality is interpreted as the product of a "sex-obsessed" mind, and thus is his spiritual striving further obscured and confounded. Certainly in Schiele's own time this was the case—as evidenced by his imprisonment in 1912 for 'public immorality'—but even today his name is popularly associated more with explicit sexuality than with spirituality.

In examining his artistic output, however, it becomes clear that the works on paper, in their stunning honesty and humanity, convey their own profound sacred message. Schiele's utter mastery of the medium allowed him to forgo received convention and to progress unimpeded toward purity of vision, toward essential truth. The achievement of these goals was for Schiele the central, sacred role of art, and of his own art in particular. It is also the basis of his power as an artist.

—I.V.

Early Years Through

1907

According to Egon Schiele's mother Marie, the artist began drawing at the age of eighteen months. While this may be an exaggeration, there is no doubt that Egon, whose entire brief career was defined by precocity, became enamored of art at a very young age. He was a prodigy alternately coddled and berated by a family that wanted desperately for him to succeed—but on their terms.

Born on 12 June 1890, Egon was the only son to survive a series of stillbirths and miscarriages. He was the middle child, flanked by an older sister, Melanie (born in 1886), and a younger one, Gertrude or 'Gerti' (born in 1894). A third sister, Elvira (born in 1883), died when Egon was three. The family was thus tragically marked by illness, a circumstance not uncommon at the time. All the more did Adolf and Marie Schiele hope that their one son would flourish.

The Schiele children spent the earliest years of their lives in an apartment above the train station in the provincial Austrian village of Tulln, where their father was stationmaster. During this period, the family was comfortably middle class. A civil service job such as Adolf's was considered a significant attainment in the old Austro-Hungarian Empire, which was dominated by an entrenched bureaucratic hierarchy. For two generations, the family's economic livelihood had revolved around the Imperial railway service. Egon's paternal grandfather, Karl Ludwig Wilhelm Schiele, had been a railway engineer, as was his uncle, Leopold Czihaczek. Egon's maternal grandfather, Johann Franz Soukup, had helped build the Northern and Western Bohemian line, and the family's modest fortune was invested in railway stocks.

So it was not surprising that Egon developed a childhood fascination with the railroad. He filled the entire apartment with toy railway lines, collected trains and imitated them, scuffling along in specially reinforced shoes while making puffing and whistling sounds. He also drew trains—long, long chains of them (pages 24–25). When

one of Adolf Schiele's colleagues told him that Egon's drawings were of professional quality, the proud father foresaw an engineering career. That the boy's true future should lie in art was something no one in the Schiele family anticipated.

Soon, however, it became apparent that the family's ambitions for their son were in conflict with his artistic inclinations. When Egon insisted on drawing instead of doing his Latin homework, his father threw the offending sketchbook in the stove. Determined that Egon's secondary schooling should prepare him to study engineering at a university, his parents sent him to attend a Gymnasium in the distant town of Krems. Here, homesickness exacerbated the eleven-year-old boy's disdain for academics, and he became permanently alienated from the rigid school system. Even Adolf Schiele had to admit that the Krems experiment was a failure, but Egon's grades hardly improved when, in 1902, he was transferred to a Gymnasium closer to Tulln, in Klosterneuburg. By the time Schiele was fourteen, he'd been left back so often that he was two or three years older than most of his classmates. He received satisfactory marks only in physical education, drawing, and calligraphy.

At the end of 1904, Schiele's faltering academic career was permanently derailed by the death of his father. Adolf Schiele had been suffering from syphilis for a number of years before the disease claimed him. As the illness progressed, his behavior became increasingly erratic. No longer able to do his job, he retired and, it is said, burned the family's railroad stocks in a fit of madness. With his death, the family's economic position declined precipitously. Since Adolf had not yet earned a full pension from the railroad service, Marie became dependent on the benevolence—and sometimes intrusive advice—of wealthier relatives. Egon's sense of alienation deepened profoundly.

Art and nature now became Schiele's principal enduring solaces. The two were often combined, for Schiele became accustomed to taking long walks along the streams and through the fields near Klosterneuburg, sketchbook in hand. He began associating with local artists, who, despite a significant age difference, were impressed by the teenager's talent and earnestness. But Schiele's most important mentor during this painful period was the new art teacher at the Klosterneuburg Gymnasium, Ludwig Karl Strauch.

Strauch, a graduate of Vienna's prestigious Academy of Fine Arts, joined the Gymnasium faculty in 1905. An experienced traveler, he provided Schiele intellectual entrée to a vast world beyond the borders of provincial Klosterneuburg. Schiele's artwork had until then been characterized by a rather dogged, if sometimes exquisite realism. Strauch introduced him to the latest trends: *Stimmungsimpressionismus*—'mood' Impressionism, an Austrian interpretation of the French style—and Jugendstil, the German version of Art Nouveau.

Strauch recognized Schiele as a master draftsman, but he felt that the student's sense of color could be improved. So he assigned him a series of carefully structured exercises, starting with the primary colors—red, yellow, and blue—and then proceeding to the secondary hues—orange, lavender, and green. Schiele obediently followed this lesson plan, but his attempts to assimilate Jugendstil's formal stylization and to master abstract color remained amateurish, if not exactly childlike (pages 24–25, bottom, and 26–27). At the same time, however, he was turning out masterpieces of academic realism that amply justify his reputation as a prodigy (pages 20, 21, and 22–23).

Yet within the Schiele family, Egon was seen more as a ne'er-do-well than as a wunderkind. Now that Adolf was dead and Marie all but destitute, nosy relatives insisted that the boy had a filial duty to pursue a reasonable middle-class profession. Instead, Egon was on the verge of flunking out of the Gymnasium. In the spring of 1906, Strauch and one of his colleagues summoned Marie to the school and recommended that Schiele not return for the next semester. This can hardly have come as bad news to Egon, who immediately set his sights on applying to the Vienna Academy of Fine Arts. But even Strauch did not think he was ready. Schiele's family—particularly his Uncle Czihaczek (figure 1)—was adamantly opposed to the idea.

Egon's will, however, was indomitable when it came to art. Though he had little formal training (and the Academy's entrance standards were extremely stringent), he began putting together a portfolio. Despite the fact that none of her relatives had endorsed the plan—or (more to the point) would agree to help pay the boy's tuition—Marie was persuaded to bring Egon and his portfolio to Vienna. Application to the Academy of Fine Arts entailed a two-step procedure. Once a portfolio was accepted, the applicant had to take a rigorous exam that involved drawing from nature and an assigned theme. Egon Schiele passed both steps of the process with flying colors. At sixteen, he was the youngest student admitted to his class.

Realism had been Schiele's artistic forte prior to entering the Academy, and undoubtedly it was that aspect of his talent which got him in. Yet, curiously, once he was ensconced in this bastion of academicism, he lost both his taste and, to some degree, his facility for conventional representational verisimilitude. Part of the problem, undoubtedly, was the lifelessness of the Academy's curriculum, which had not been updated in over a century. Furthermore, Schiele had the misfortune of landing in the class of the notoriously strict and reactionary Professor Christian Griepenkerl, who must have evoked the most rigid and hateful aspects of Schiele's Gymnasium days.

Academy students were not permitted to paint until well advanced in their studies. The introductory curriculum revolved around drawing: first from plaster casts, and then from life. A good deal of work from Schiele's first year at the Academy

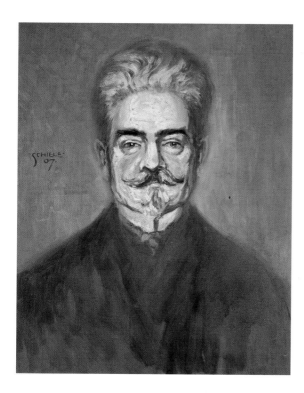

Fig. 1: Egon Schiele.
Portrait of Leopold Czihaczek. 1907.
Oil on canvas. Signed
and dated, center left.
62.5 × 49.5 cm. Kallir P. 16.

survives, and as most classroom assignments were precisely dated, it is fairly easy to follow his progress. From this, we can see that in October 1906 Egon began the academic program by dutifully drawing plaster casts of antique sculptures (pages 30 and 31). His lack of enthusiasm is palpable in the blank eyes and conspicuously inanimate contours of these objects. Toward the end of 1906, Schiele was permitted to advance to drawing the male nude, a subject he seems to have embraced with only slightly more gusto (page 33). In the spring of 1907, the theme was portraiture, and now the students were allowed to draw women as well as men (pages 34–38). Again, these sitters—anonymous models with whom the artist had no relationship—are rendered faithfully but without much trace of personal feeling.

It is understandable that Schiele, used to a progressive teacher like Strauch and the freedom to do as he pleased, would have chafed against the restrictions imposed by Griepenkerl. Color was rarely permitted, not even white chalk. In the strict academic manner, highlights had to be wrought from the white of the sheet. Sometimes the students were allowed to draw in light chalk on a colored ground, and then the opposite criteria usually applied: darker pencil or crayon could not be used. Students were thereby taught to capture the effects of light on a three-dimensional object, and to

Fig. 2: Egon Schiele. *House with Bay Window in Flower Garden*. 1907.
Oil on cardboard. Signed and dated, upper left.
36 × 26.5 cm. Kallir P. 57.

create a sense of volume through shading and cross-hatching. For Schiele, this emphasis on rote academic technique effectively robbed drawing of its expressive vitality. It is almost painful to observe how little facility the artist—one of the greatest draftsmen of all time—shows for drawing in these academic works. Equally dispiriting is the lack of emotion that this future master of the human figure evidences in his academic nudes and portraits. Nor is it altogether surprising, considering the lack-luster nature of the work, that Griepenkerl never gave Schiele a grade higher than 'satisfactory'—the equivalent of an American 'C.' If Schiele's genius was percolating in the winter of 1906–07, it was not doing so at the Vienna Academy of Fine Arts.

Few of Schiele's drawings can conclusively be dated to the second half of 1907. Coursework from the fall semester—devoted to color theory and chemistry—cannot readily be found and may have subsequently been destroyed by the artist. During this period, Schiele focused chiefly on painting, which he presumably did independently of his class assignments (figure 2). Mainly landscapes painted on cardboard, his 1907 oils evidence a continuing attempt to internalize Strauch's lessons. Unusual color triads—favoring pink, lavender, and green—as well as the buttery impasto of *Stimmungsimpressionismus* dominate these little works, which are not yet marked by a distinct creative personality.

Self-Portrait. 1906.
Charcoal. Initialed, lower right. Kallir D. 28a.

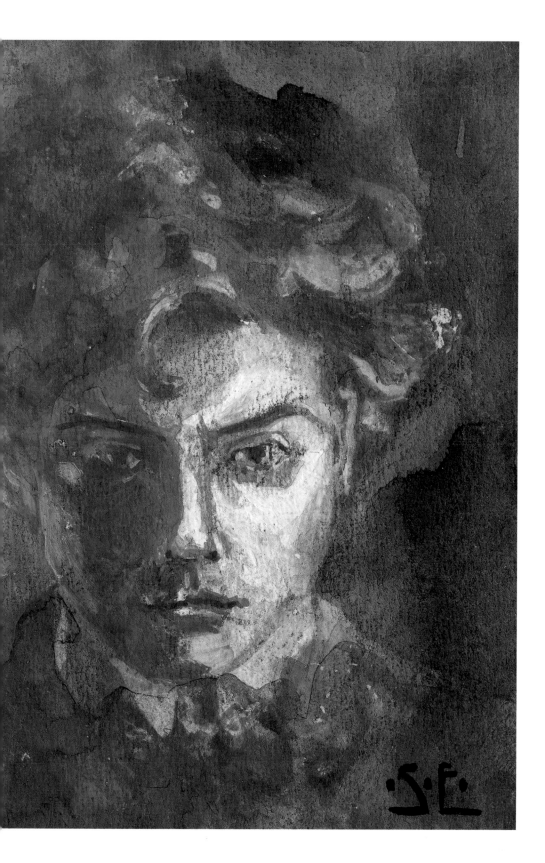

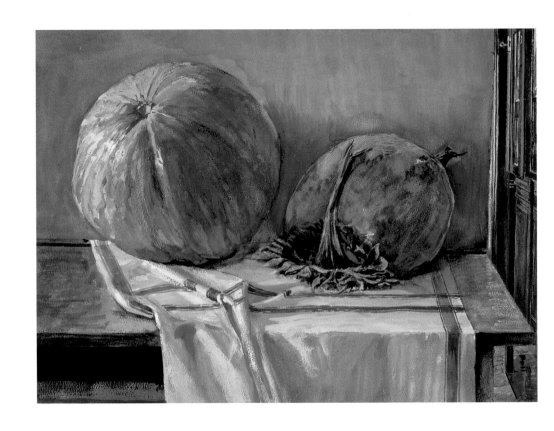

Above: *Melons*. 1905.
Gouache. Signed and dated, lower right. 31.5 × 41.7 cm. Kallir D. 50.
Niederösterreichisches Landesmuseum, St. Pölten.
Opposite: *View of Klosterneuburg*. Ca. 1905.
Watercolor and colored crayon. Signed, lower right.
29.7 × 19.6 cm. Kallir D. 52. The Israel Museum, Jerusalem;
Gift of Mr. Herman Elkon, New York.

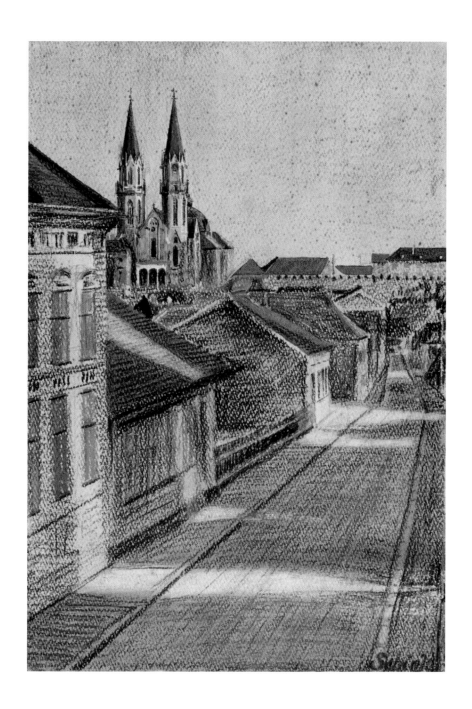

Following pages:
View from the Drawing Classroom, Klosterneuburg. Ca. 1905.
Gouache. 37 × 46 cm. Kallir D. 49.
Niederösterreichisches Landesmuseum, St. Pölten.

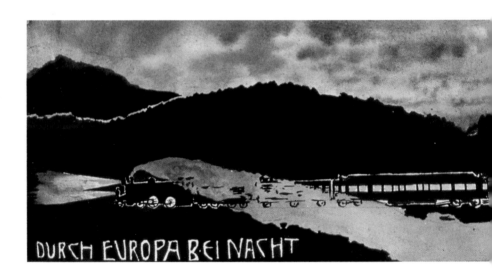

DURCH EUROPA BEI NACHT

Top: *Railroad Train*. Ca. 1906.
Pen and ink. Signed, lower right. 3 x 21 cm. Kallir D. 74.
Niederösterreichisches Landesmuseum, St. Pölten.
Middle: *Railroad Train*. Ca. 1906.
Pen and ink. Signed, lower right. 3 x 28 cm. Kallir D. 75.
Niederösterreichisches Landesmuseum, St. Pölten.

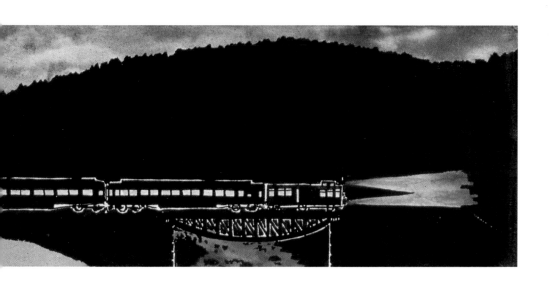

Bottom: *Through Europe by Night*. Ca. 1906.
Watercolor and ink. Inscribed 'Durch Europa bei Nacht',
lower left. 9.4 × 39.2 cm. Kallir D. 76.
Niederösterreichisches Landesmuseum, St. Pölten.

Silhouette of Klosterneuburg. Ca. 1906.
Watercolor and ink. Signed, upper right. 8.9 × 13.8 cm. Kallir D. 55.
Niederösterreichisches Landesmuseum, St. Pölten.

Landscape near Klosterneuburg. Ca. 1906.
Gouache and watercolor. Signed, upper right. 23.6 x 34.5 cm. Kallir D. 67.
Niederösterreichisches Landesmuseum, St. Pölten.

Plaster Cast of Houdon's Bust of Voltaire. 1906.
Charcoal. Signed and dated, lower right. 52.5 × 37.8 cm. Kallir D. 78.
Graphische Sammlung Albertina, Vienna.

Academic Study of Homer. 1906.
Charcoal. Signed, upper right; signed and dated, lower right. 49.4 × 35.5 cm.
Kallir D. 83. Salzburger Landesmuseum Rupertinum, Salzburg;
Gift of Norbert Gradisch, 1979.

Standing Male Nude (Academic Drawing). 1907.
Pencil and charcoal. Signed and dated, center left.
71.3 × 49.5 cm. Kallir D. 146a.

Portrait of a Woman in High-Buttoned Dress. 1907.
Black crayon. Signed and dated, center right. 49.5 × 32.7 cm. Kallir D. 99.
Niederösterreichisches Landesmuseum, St. Pölten.

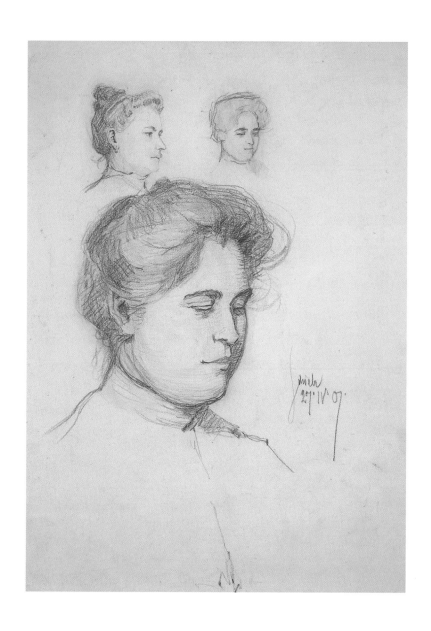

Three Studies of a Woman's Head. 1907.
Charcoal. Signed and dated, center right. 53.5 × 38.1 cm. Kallir D. 104.
Courtesy of Galerie St. Etienne, New York.

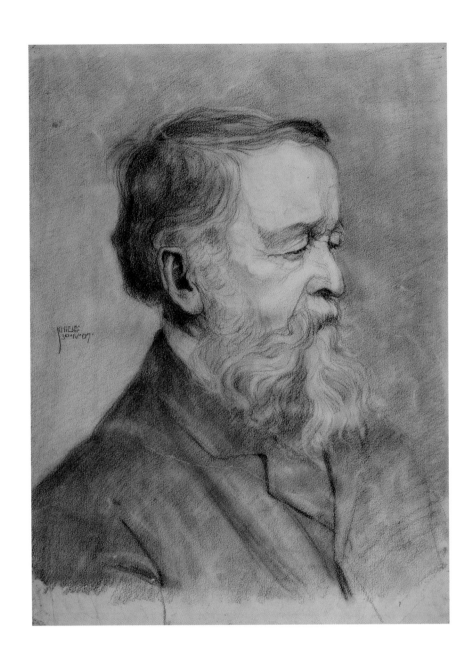

Bust of a Bearded Man Facing Right. 1907.
Charcoal. Signed and dated, center left. 53.2 × 37.9 cm. Kallir D. 130.
Graphische Sammlung Albertina, Vienna.

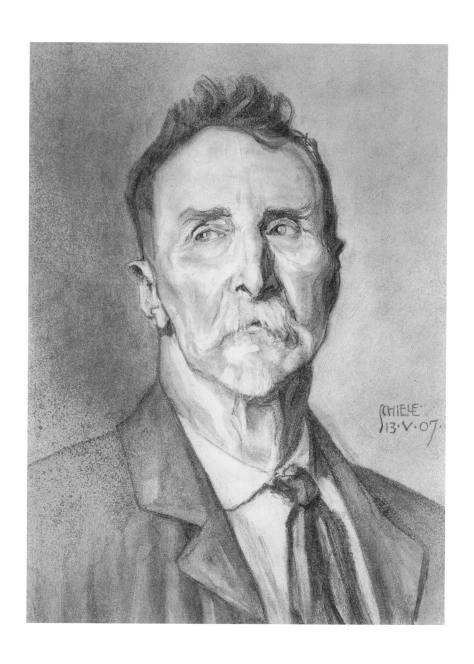

Portrait of a Man. 1907.
Charcoal. Signed and dated, center right. 51 × 37 cm. Kallir D. 134.
Courtesy of Galerie St. Etienne, New York.

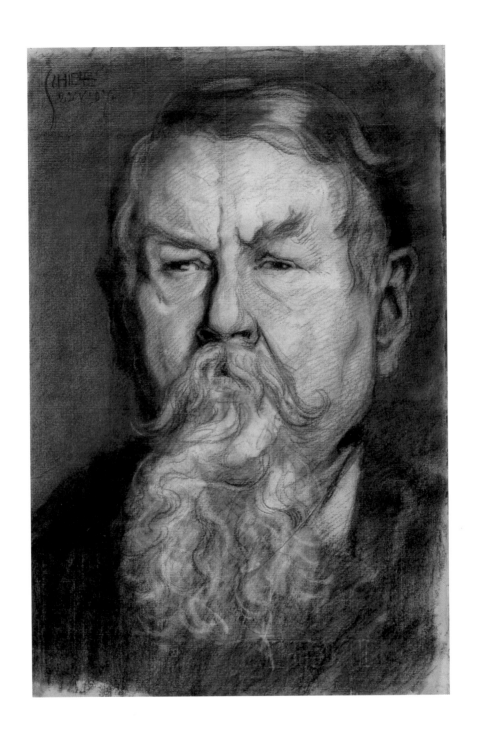

Portrait of a Man with Beard. 1907.
Charcoal. Signed and dated, upper left. 48 × 31 cm. Kallir D. 135.
Niederösterreichisches Landesmuseum, St. Pölten.

Head of a Girl, Academic Study. 1907.
Charcoal. 37.9 × 26.6 cm. Kallir D. 109.
Graphische Sammlung Albertina, Vienna.

On the Beach. 1907.
Watercolor and ink on gray wove paper. Signed and dated,
center right; titled, lower left. 20.4 × 11.3 cm. Kallir D. 157.
Courtesy of Galerie St. Etienne, New York.

AM STRAND•••

1 9 0 8 – 1 9 0 9

Schiele's admission to the Vienna Academy of Fine Arts in 1906 had produced an uneasy détente within his family. He had won this round in the battle of wills, and even his skeptical uncle, Leopold Czihaczek, was content to suspend judgment and let events take their natural course. After all, academically certified professors had vouched for the boy's talent—perhaps something might come of him after all. Still, Czihaczek, who together with Marie Schiele now served as Egon's guardian, kept a wary eye on the student's progress.

Marie had moved her entire family to Vienna to facilitate Egon's studies. However, it was decided that the student should take his midday meal at Czihaczek's apartment—for both economic and social reasons. The Czihaczek home, near the Prater amusement park in Vienna's Second District, typified the highest aspirations of the late nineteenth-century Austrian bourgeoisie. Swaddled in thick curtains, stuffed with heavy furnishings that included not one but two pianos, the spacious apartment was a symbol of Czihaczek's cultural as well as material attainments. The conditions under which Egon was accepted into this august environment were clear: Czihaczek would buy him art supplies and sweets, provided that the boy defer to him completely. Egon was expected to listen attentively when his elderly uncle played the piano, to accompany him gratefully to the Imperial Burgtheater, and—needless to say—to make a success of himself at the Academy.

The problem was that Schiele not only hated the Burgtheater, but, increasingly, he was coming to hate the Academy. After the spring of 1907, it is impossible to conclusively identify any of his work with school assignments, at least in part because Schiele had begun making himself scarce in the classroom. That said, it was not difficult for him to keep up with his classmates: Griepenkerl required the students to produce one drawing a day, which was far below Schiele's normal quota. Even if little of his coursework

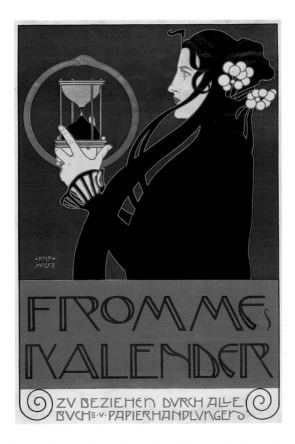

Fig. 3: Koloman Moser. Poster for the *Frommes Kalender*. 1898.
Color lithograph. 95.3 × 62.2 cm. Printed by Albert Berger.
Courtesy of Galerie St. Etienne, New York.

survives, it seems he took readily to the professor's practice of giving the students timed assignments. Schiele became something of a speed demon in his drawings, at times literally racing against a hand-held stopwatch. He began a lifelong quest for the perfect line: an unbroken continuum in which speed and accuracy were inseparable.

If Schiele, in 1908 and early 1909, deigned to stop by the Academy at all, it is probable that he was most attracted to the life-drawing class. Free access to models was not something to be disdained by a student who could never have afforded to hire his own. The nudes and portraits that Schiele drew during this period evidence his growing mastery and self-confidence (pages 52–57). The student had suddenly emerged, like a butterfly, from the cocoon of ponderous academic technique, to a new place, where realistic verisimilitude could be attained through clean, spare line. In part, Schiele's

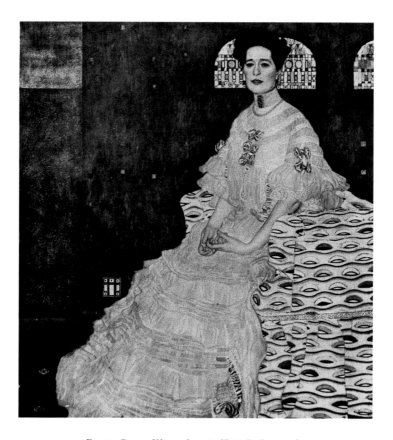

Fig. 4: Gustav Klimt. *Portrait of Fritza Riedler*. 1906.
Oil on canvas. 153 × 133 cm. Novotny/Dobai 143.
Österreichische Galerie, Vienna.

new facility for line may have been an unwitting legacy of Griepenkerl, who stressed contour drawing as a prerequisite to fresco painting. However, the clarity and precision of Schiele's lines came not from the academic tradition, but from contemporary Jugendstil: a trend that Griepenkerl naturally loathed.

Jugendstil, to which Schiele had been introduced several years earlier by Strauch, was basically a commercial style. Named for the turn-of-the-century German periodical *Jugend* (Youth), the style combined crisp, simple outlines with flat, bright colors. The entire pictorial surface tended to be treated two-dimensionally: figures were not shaded or modeled in the round, and thus background and foreground became equal components in an overall design scheme (figure 3). In Austria as well as in Germany, Jugendstil was primarily used for illustrations and posters, but it did strongly influence the work of one major painter: Gustav Klimt.

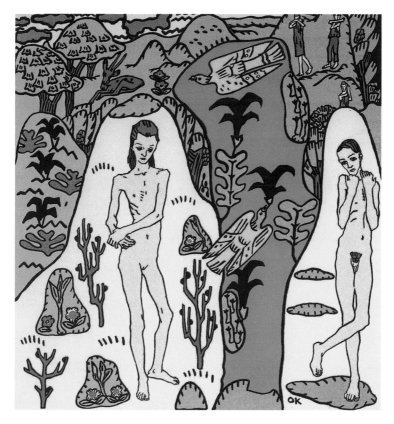

Fig. 5: Oskar Kokoschka. *The Girl Li and I.* Ca. 1906-08.
Color lithograph. 24.1 × 28.9 cm. Illustration for *Die träumenden Knaben*, published by the
Wiener Werkstätte. Private collection, courtesy of Galerie St. Etienne, New York.

Schiele's relationship to Klimt has been so frequently romanticized and exaggerated by the younger artist's biographers that it is difficult to separate fact from myth. It seems idle to speculate about whether the fatherless Schiele really identified Klimt as a paternal figure, or whether Klimt consciously reciprocated. Klimt was, simply, the most important artist in Austria at the time, and it would have been surprising had Schiele *not* fallen under his spell. Klimt was also so universally generous toward younger colleagues that it is hard to know whether the favors he bestowed upon Schiele were in any sense exceptional. The most substantive part of the story, in any case, is told in Schiele's art.

Schiele's first biographer, Arthur Roessler, dates the artist's initial meeting with Klimt to 1907, but there is no other evidence for this. In an artistic sense, it can be said that their first meaningful encounter took place in 1908, when all the leading

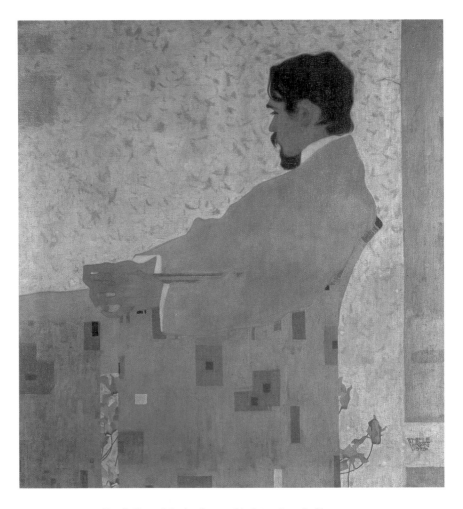

Fig. 6: Egon Schiele. *Portrait of the Painter Anton Peschka*. 1909.
Oil and metallic paint on canvas. Signed and dated, lower right.
110.2 x 100 cm. Kallir P. 150. Private collection.

artists of the day gathered together for a big 'Kunstschau' (art show). Klimt exhibited
sixteen recent paintings in a special room, and his work obviously hit Schiele like a
thunderbolt. For the next year, the young artist devoted much of his time to para-
phrasing the master's paintings, in the process gradually assimilating Klimt's style and
transforming it into something of his own.

The 1908 'Kunstschau,' part of an elaborate series of events celebrating the
sixtieth anniversary of the Emperor Franz Josef's reign, was a watershed moment in
the history of the turn-of-the-century Viennese avant-garde. Since the founding of

the Vienna Secession in 1897, the most advanced Austrian painters, including Klimt, had been allied with architects and designers in a mission to create totally coordinated aesthetic environments. This movement found its most sustained institutional outlet in the Wiener Werkstätte (Vienna workshops), a design collective established in 1903. From the essentially abstract orientation common to much Jugendstil illustration, the Werkstätte derived a unifying formula of geometric motifs that could be applied to two-dimensional, representational images, as well as to utilitarian objects such as glassware and metalwork. Klimt, who during this period became Vienna's leading society portraitist, combined this decorative formula with the Jugendstil tendency to merge figure and background. Many of his portraits virtually smother the sitters, whose realistically rendered faces and hands protrude awkwardly from the surfeit of colorful, sometimes gilded, ornamentation that seems to consume both their clothes and their surroundings (figure 4).

Left out of the picture—literally and figuratively—was the darker side of life. Klimt was also a master of morbid allegory, but disturbing elements had no place in his society portraits. Nor, of course, were such elements welcome in the lavish environments that the Wiener Werkstätte crafted for its wealthy clients. By 1908, the pursuit of the decorative at the expense of the expressive had produced a creative vacuum that was just waiting to be filled. That year's 'Kunstschau' provided the first inclination that Vienna was turning away from abstract ornamentation and back toward evocative figuration. Among the younger exhibitors was a student at the Vienna School of Applied Arts, Oskar Kokoschka. His most substantial surviving contribution to the 1908 'Kunstschau,' an illustrated book titled *Die träumenden Knaben* (*The Dreaming Youths*), revealed how easily Jugendstil stylization could be turned to expressive ends (figure 5). It was a lesson that Schiele, in his own way, was also learning.

At first glance, there is little to distinguish Schiele's 1909 drawings from those done in 1908. One sees a similar, Jugendstil-derived use of simplified, elegant contour, sometimes articulated by flat, unmodulated swathes of watercolor (page 57). Gradually, however, Schiele began to explore and exploit the conflict between the human content of these drawings and their decorative style. In some of his drawings, he substituted gnarly curlicues of colored pencil for watercolor (pages 58–60). These color 'nuggets' superficially resemble Klimt's ornamental devices, but they also provide more texture and tactile presence. The artist's hand, all but effaced in classical Jugendstil design, has become newly palpable. Next, Schiele began to play off the contrast between realistic figure and abstract ground that was so central to Klimt's society portraits. By emphasizing the representational element in his 1909 self-portraits and limiting the abstract component to smaller segments of drapery, Schiele turned the tables on Klimt (pages 61, 62, and 65). The human aspect now assumes dominance.

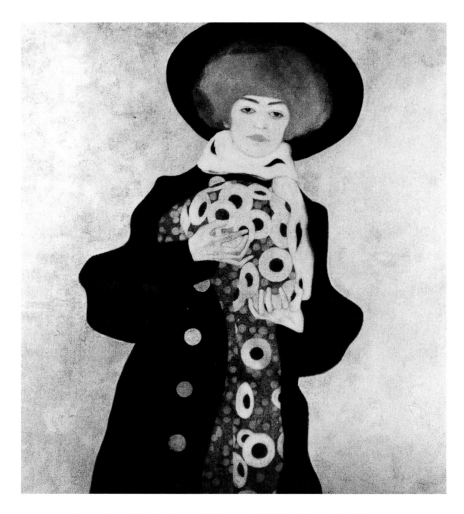

Fig. 7: Egon Schiele. *Portrait of a Woman with Black Hat (Gertrude Schiele)*. 1909.
Oil and metallic paint on canvas. Initialed and dated, upper left.
100 × 99.8 cm. Kallir P. 151. Private collection.

The *horror vacui* of Klimt's ornament-crammed backgrounds has changed with Schiele into simple horror, as the figures are thrust into a pictorial void that accentuates their vulnerability.

In the spring of 1909, Klimt asked Schiele to participate in a second 'Kunstschau.' This was to be the last major exhibition mounted by the turn-of-the-century Viennese avant-garde, and unlike its immediate predecessor, it also included contributions by foreign artists. Schiele, who had somewhat presumptuously taken to calling himself the 'Silver Klimt,' submitted three portraits: one of his younger sister Gerti, and two

of Academy classmates (figure 6). All three paintings employed a good measure of Klimtian ornamentation, but they also toyed with exposing the background void. The portrait of Gerti, in fact, was eventually repainted with a completely blank background, similar to those found in Schiele's drawings of the time (figure 7). He was on the verge of emerging as a full-fledged artist in his own right.

As such, Schiele probably had no qualms about the fact that it was against Academy rules for students to exhibit publicly. He and a cohort of like-minded classmates had recently united under the name 'Neukunstgruppe' (New art group). Following in the footsteps of prior avant-garde renegades, the Neukunstgruppe proceeded to submit a formal letter of protest to Professor Griepenkerl, detailing all they found despicable about the Academy's curriculum. Threatened, as a result, with expulsion, Schiele and many of his friends voluntarily left school. Old Uncle Czihaczek was of course livid, but Schiele felt sure he was on his way professionally. In December 1909, the Neukunstgruppe had its first formal show at a commercial gallery, the Kunstsalon Pisko.

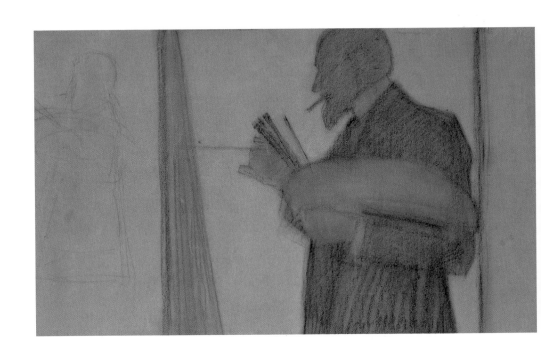

Professor Ludwig Karl Strauch Painting at His Easel. 1908.
Charcoal on gray paper. 22.5 × 35 cm. Kallir D. 216.
Niederösterreichisches Landesmuseum, St. Pölten.

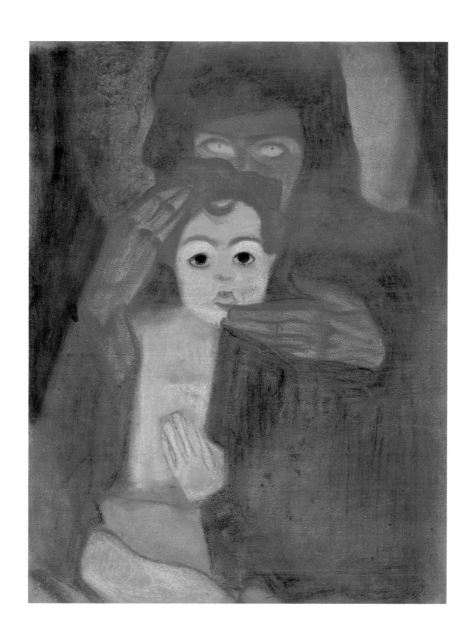

Mother and Child (Madonna). 1908.
Sanguine, charcoal, and white chalk. 60 × 43.5 cm. Kallir D. 245.
Niederösterreichisches Landesmuseum, St. Pölten.

Head of a Young Woman, Seen from Below. 1908.
Red crayon and charcoal. Initialed and dated, lower right. 11.1 × 11.6 cm.
Kallir D. 184. Private collection.

Reclining Female Nude. 1908.
Charcoal and pencil on blue-gray paper. Signed and
dated, lower left. 22.2 × 36.5 cm. Kallir D. 206.
Graphische Sammlung Albertina, Vienna.

Reclining Female Nude. 1908.
Watercolor and charcoal. Signed and dated, lower right. 21.9 × 42.4 cm. Kallir D. 210.
Kunsthaus Zug, Kamm Collection, Zug.

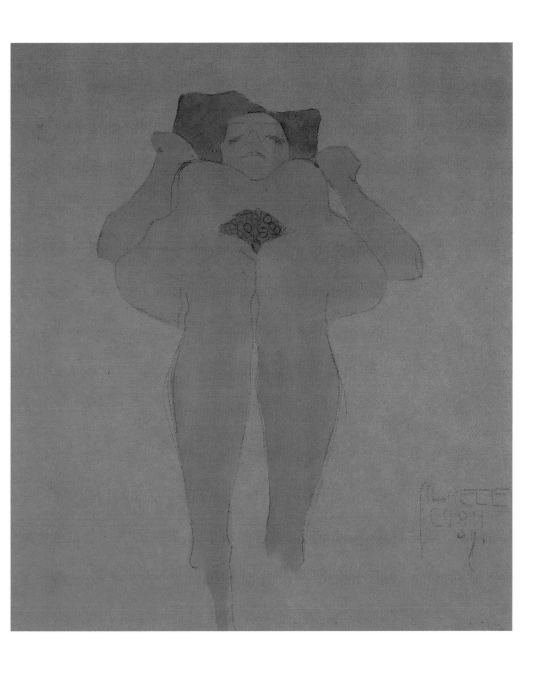

Nude Woman on Her Back. 1908.
Watercolor and charcoal. Signed and dated, lower right. 26.5 × 23 cm.
Kallir D. 211. Private collection.

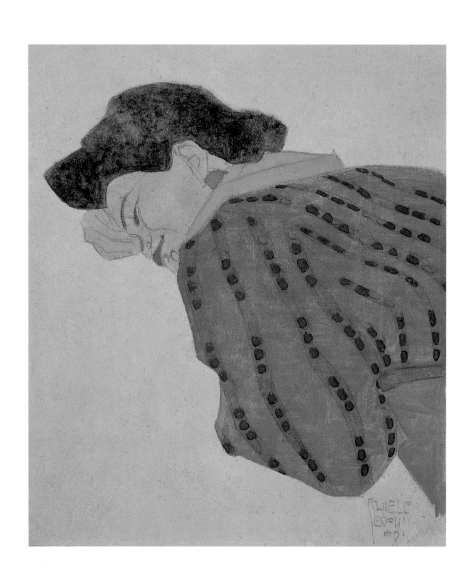

Reclining Woman with Red Blouse. 1908.

Watercolor and gold paint. Signed and dated, lower right. Kallir D. 194.

Private collection.

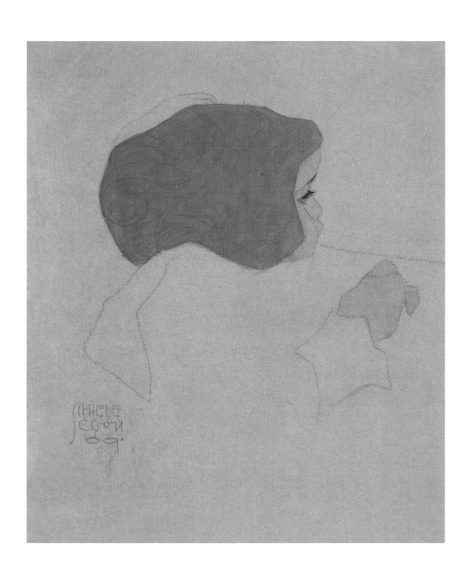

Child Facing Right. 1909.
Watercolor and pencil. Signed and dated, lower left. Kallir D. 250.
Private collection.

Above: *Autumn-Colored Plumtree*. 1909.
Colored pencil. Initialed, lower right. 22.5 × 21.7 cm.
Kallir D. 378. Private collection.
Opposite: *Standing Male Nude*. 1908.
Colored crayon. Signed and dated, upper left. 39.8 × 28.5 cm. Kallir D. 229.
Historisches Museum der Stadt Wien, Vienna.

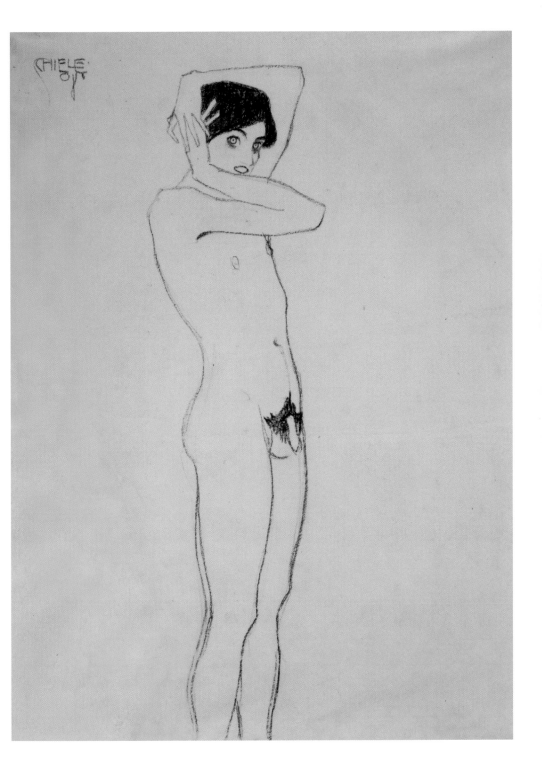

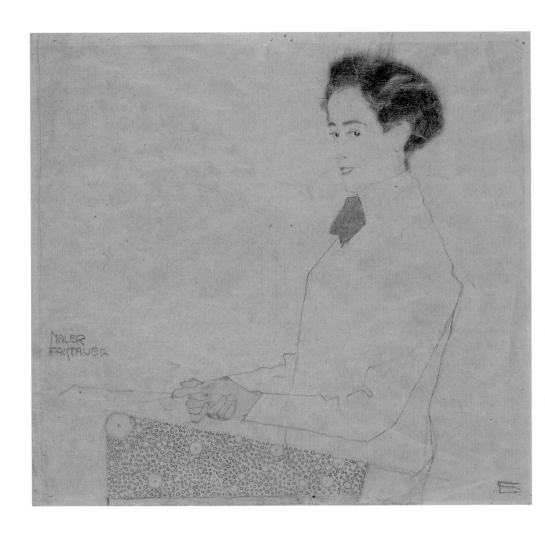

Above: *Portrait of the Painter Anton Faistauer*. 1909.
Colored crayon, pencil, and watercolor. Initialed, lower right.
Inscribed 'Maler Faistauer', center left. 28.7 × 30 cm. Kallir D. 319.
Graphische Sammlung Albertina, Vienna.
Opposite: *Self-Portrait*. 1909.
Colored crayon. Initialed, lower left. 40.2 × 20 cm. Kallir D. 348.
Historisches Museum der Stadt Wien, Vienna.

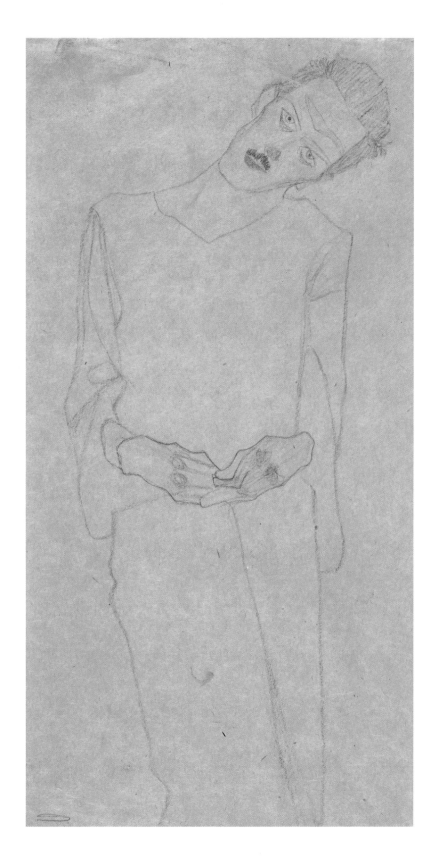

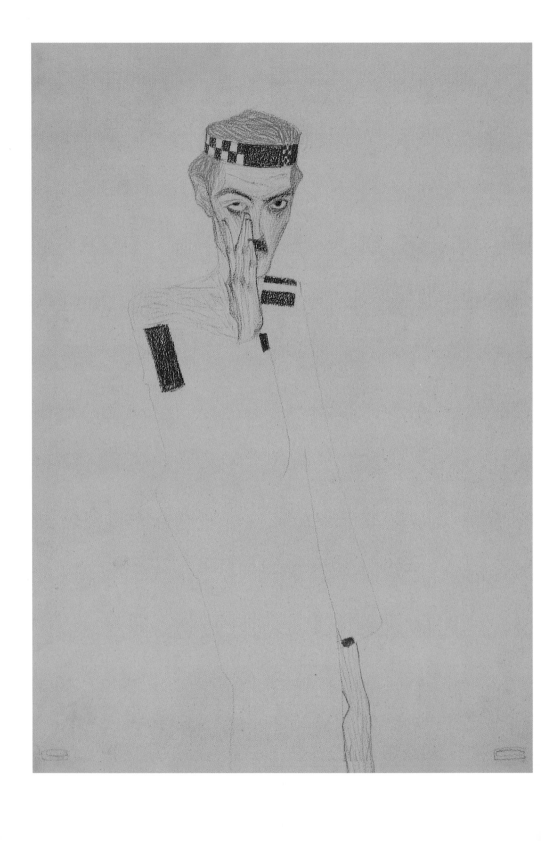

Man with Blue Headband and Hand on Cheek (Self-Portrait). 1909.
Colored crayon and charcoal. Initialed, lower right and lower left.
40.2 × 29.7 cm. Kallir D. 344.
Graphische Sammlung Albertina, Vienna.

Couple. 1909.
Watercolor and pencil. Initialed, lower right. 44.5 × 31 cm. Kallir D. 363.
Museum of Art, Carnegie Institute, Pittsburgh.

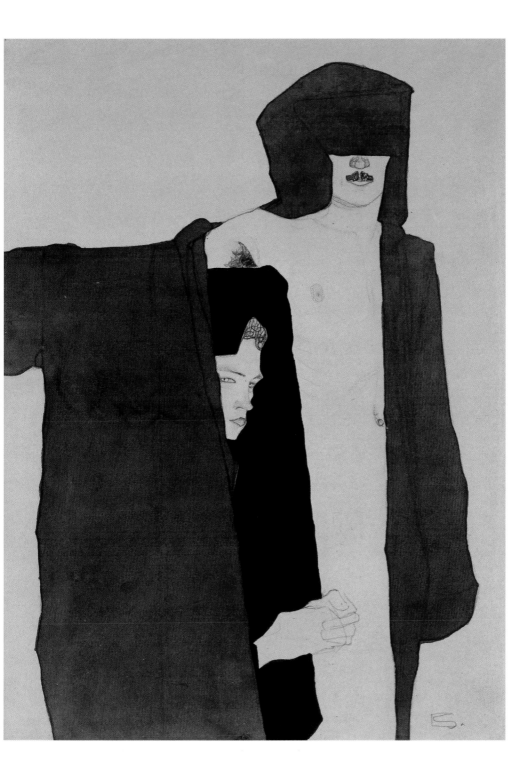

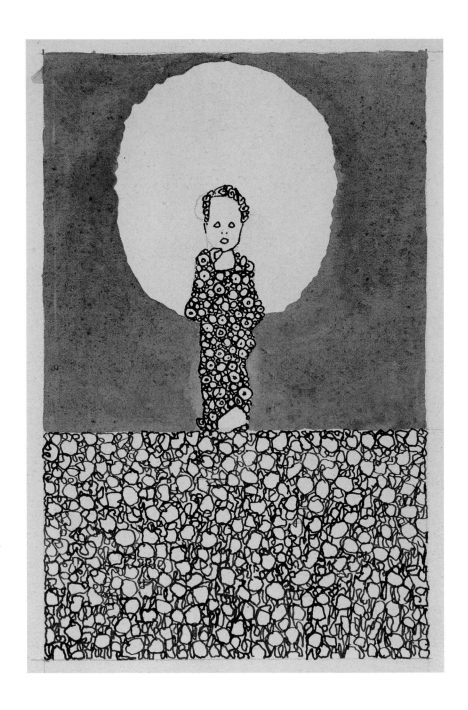

Child with Halo in a Field of Flowers. 1909.
Ink, wash, and pencil. 15.7 x 10.2 cm. Kallir D. 369.
Graphische Sammlung Albertina, Vienna.

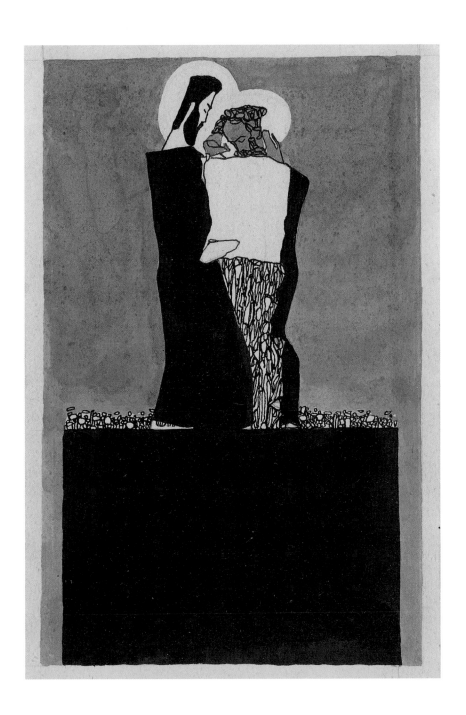

Two Men with Halos. 1909.
Ink, wash, and pencil. 15.4 × 9.9 cm. Kallir D. 366.
Graphische Sammlung Albertina, Vienna.

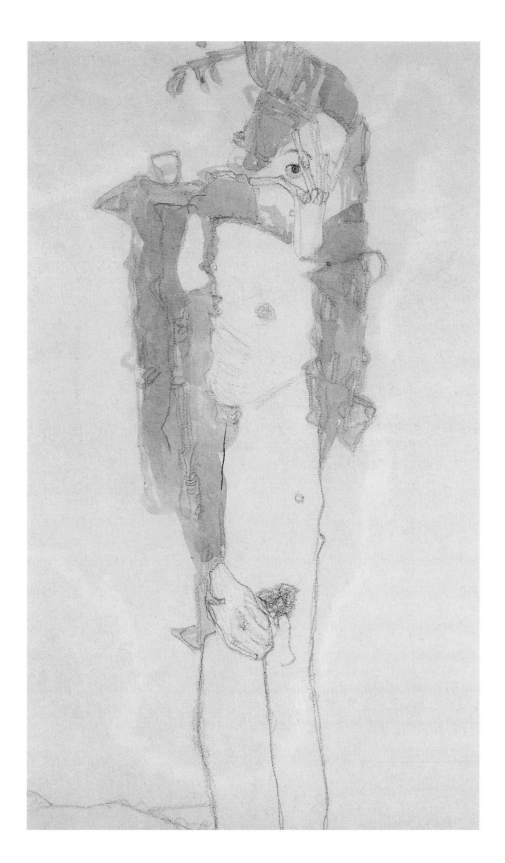

1910

The year 1910 proved a decisive turning point in Schiele's creative development. He abandoned his coy emulation of Klimt and emerged with an Expressionist style that, while not wholly uninfluenced, was distinctly his own. Barely twenty at the time, Schiele evidenced a precocity that is rare among painters, who generally undergo a more protracted period of apprenticeship. As a result, he was able to give creative voice to adolescent anxieties that, though universally compelling, are almost always repressed by older artists. For all his artistic precocity, however, Schiele himself was personally no more mature than the average teenager—perhaps slightly less so. Especially in the early years of his brief career, he was plagued by adolescent conflicts: sexual ambivalence, disapproving grown-ups, squabbles over spending money, and the like.

Leopold Czihaczek was not in the least bit pleased with the turn matters had taken in the second half of 1909. And he had a simple solution to what he saw as his nephew's professional dilemma: Egon should join the army. By completing three years at the Academy, Schiele had earned the privilege of volunteering for officer's training. Czihaczek felt that nothing would do the boy more good than a year of military service—preferably somewhere remote from distracting artistic enticements.

Schiele certainly did not share his uncle's view of his professional options, but he had to admit that money was becoming a problem—and it would remain so until almost the end of his life. On the face of it, Schiele believed that he was entitled to material support: first of all, because he *was* still a boy, and second of all, because he was an artist. It would scarcely be an exaggeration to say that Schiele saw his artistic mission as something akin to a religious vocation: a service he was prepared to perform for humanity, and which therefore merited subsidy on moral grounds. Outlandish as this proposition may seem (and certainly did seem, to the likes of Czihaczek), it was fully in keeping with the attitude prevalent among the Austrian avant-garde. The

lavish creations of Klimt and the Wiener Werkstätte were largely financed by a handful of extremely wealthy patrons who saw themselves as integral partners in the pursuit of a creative life-style. These collectors were not merely *buying* art, just as the artists were not merely *selling* it; they were engaged in a spiritual collaboration. While Marie Schiele groused that any decent son would help the family out by getting a normal job, Egon was not unrealistically hopeful of jumping aboard the same gravy train that had nourished the preceding generation of artists, including Klimt.

Considering that Schiele was only nineteen when he dropped out of the Academy, he had made a pretty good start. As the leader of the Neukunstgruppe, he was prominently featured at the Pisko gallery show in late 1909. There, his work caught the attention of the critic Arthur Roessler, who became one of the artist's first and most important patrons. Partly courtesy of Roessler's connections, other patrons soon followed: Carl Reininghaus, an industrialist; Oskar Reichel, a wealthy doctor; and Heinrich Benesch, a railroad inspector who was the least financially endowed but most devoted of the group. Probably as a result of his exposure at the 1909 'Kunstschau,' Schiele had established ties to the Wiener Werkstätte, and it, too, served as a source of ongoing support. Not only did Schiele receive periodic assignments from the Werkstätte (pages 66, 67, 104, and possibly 118 and 119), but the organization and many of its leaders also regularly purchased his independent work.

Nevertheless, it proved almost impossible for Schiele to derive an adequate income from this motley group of supporters. There are any number of reasons for this, starting with the fact that Schiele was an inveterate spendthrift who readily indulged in entertainments such as the cinema, rather than saving for essentials. But there were also profound intrinsic problems with the Austrian system of direct patronage, which depended on a steady stream of continuous funding from a small group of super-wealthy collectors, rather than relying on professional middlemen, such as dealers, to secure support from a broader client-base. Schiele's patrons were not all that rich, and while many of them did at first buy in considerable quantity, they grew increasingly annoyed with the artist's repeated demands for money. Moreover, whereas Klimt and the Wiener Werkstätte appealed to their backers by providing the accoutrements of an attractive, all-encompassing life-style, Schiele's work had taken a disturbing turn that made it far less appealing to such a sybaritic audience.

Expressionism emerged in Austria around the time of the 1909 'Kunstschau' and may in part be considered a response to the foreign art exhibited there. Kokoschka, Schiele, and their peers had never before seen the work of artists such as Vincent van Gogh and Edvard Munch, whose humanistic visions meshed conveniently with their own growing distaste for excessive ornamentation. In the second half of 1909,

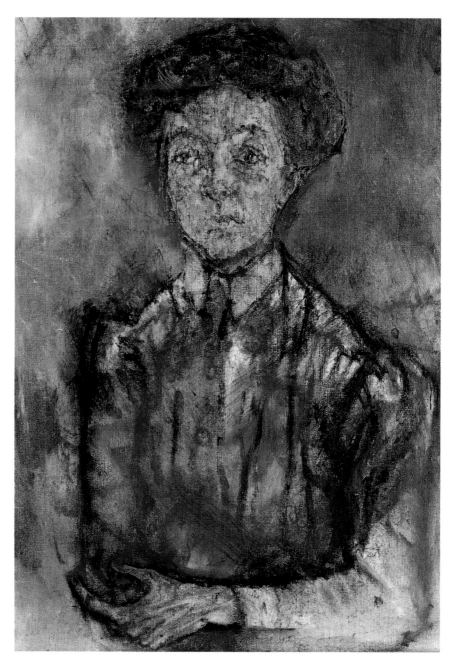

Fig. 8: Oskar Kokoschka. *Dr. Veronika Sanders*. 1910.
Oil on canvas. 82.7 × 56.7 cm. Initialed, upper right. Winkler 47.
The Museum of Modern Art, New York;
Gift of Mr. and Mrs. William Mazer.

Kokoschka and another young painter, Max Oppenheimer (known as Mopp), more or less simultaneously forged a new style of portraiture, in which the sitter, rather than being laden with decorative frippery, was metaphorically stripped bare. Somber colors and scraped, incised paint surfaces stylistically abetted a psychological orientation that aimed to expose the subject's inner soul (figure 8).

There is no doubt that Schiele was influenced by this more personal approach to portraiture, and particularly by Mopp (pages 82 and 83), whom he befriended. Nonetheless, Mopp and Kokoschka cultivated a raw primitivism that was fundamentally at odds with the inherent elegance of Schiele's line. Especially in his drawings, Schiele came to Expressionism via a unique route wherein realistic rendering, a legacy of his academic training, was combined with an expressive stylization that derived from his earlier Jugendstil experiments. By focusing on the contours of his subjects, he had learned to perfect a line that was both emotionally charged and dead-on accurate. At the beginning of 1910, the more representational components of Schiele's drawings and watercolors were still sometimes set off by flat expanses of (usually black) pigment (pages 82 and 83). Even after abandoning this last vestige of Jugendstil formalism, however, Schiele retained a heightened awareness of negative space. The placement of figure on ground in his drawings is never random, and the resulting tension between the lines and the edge of the sheet thus serves to animate the surrounding void (pages 84 and 85).

Schiele resolved the conflict between decorative abstraction and conventional realism that had plagued Klimt's figural paintings by creating a new expressive pictorial language that leveled the formal and the representational aspects of his compositions. Whereas Klimt had encased his subjects in nests of ornament but kept the fleshy areas relatively realistic, Schiele confined his colors to the figure and left his backgrounds blank. However, while Schiele's rendering of the figure was more or less naturalistic, his colors were decidedly not: they were bright, gaudy, and almost totally unresponsive to the demands of three-dimensional modeling. By substituting emotional effect for decorative effect in his use of color, Schiele achieved a synthesis between form and content that had eluded Klimt.

One wonders whether anyone in Vienna had ever seen red, green, and yellow nudes before Schiele began painting them in early 1910 (pages 86–93, 95–97, 100, and 101). The Fauves in France and the Expressionists in Germany were trying similar experiments, but it is not clear that Schiele knew this. Maybe his use of jarring complementary hues came from the theoretical color exercises given him by Strauch and Griepenkerl—a kind of smart-aleck student's revenge. Certainly neither Kokoschka nor Mopp—both of whom tended toward quite muted tones—used color in this way at the time.

The nude had not previously been a significant presence in Schiele's work, but from here on it would play a central role in his watercolors and drawings. Although the artist had attended the Academy's life class, the subject he heretofore identified with most personally was landscape. Landscapes dominate his paintings through 1908, and constitute roughly one third of his mature oeuvre in oil. However, in the first months of 1910, Schiele began work on a cycle of five large canvases depicting nudes (three male, for which he himself posed, and two female, depicting his favorite sister, Gerti). The acridly colored studies of naked men and women done during this period all relate to these paintings (figure 9).

Given that sex is a major preoccupation of late adolescence, it is perhaps natural that nudes figure so strongly in Schiele's output of drawings and watercolors from 1910 on. That said, the 1910 nudes hold little sexual charge. Schiele was at this point not ready for a mature sexual relationship. Gerti—whom Egon had always pushed around and whose embarrassment at posing naked is palpable in his studies—was a far less threatening subject than a more available female would have been (pages 86–88, and 129). The artist was, however, able to draw grown women, courtesy of Erwin von Graff, a gynecologist who gave him access to the patients at his clinic (pages 95–97). (It is hard to imagine what these models, undoubtedly lower-class women who could not afford to pay much, if anything, for their treatment, thought of performing this extra 'service.') Schiele's depictions of Graff's patients—frequently identifiable by their advanced states of pregnancy—are exceptionally impersonal. Often their facial features are blurred or obliterated entirely. Almost never do they make eye contact with the artist, or vice versa. Here, and also in the male nudes from this period (pages 89–93), the human body is used as a vehicle for formal experimentation that has scarcely anything to do with the subject per se.

Yet Schiele cannot have been entirely celibate, if one takes as an indication the plight of a female friend, identified only by the initials 'L.A.,' who turned up at Graff's clinic in May 1910, presumably to obtain an abortion. This was just one of a number of problems that made Schiele think it might be a good idea to leave town for a while. Czihaczek was pressing his campaign to get his nephew to join the army, and had actually drawn up the necessary papers. And Schiele's erstwhile ambitions as leader of the Neukunstgruppe were falling prey to the squabbling and infighting that perennially troubled the Austrian avant-garde. 'How ugly it is here,' he wrote his colleague Anton Peschka. 'Everybody is jealous and deceitful. . . . There is a shadow over Vienna. The city is black.'

So it was that on 12 May Schiele set out for the Bohemian town of Krumau (today Çesky Krumlov in the Czech Republic), accompanied by Peschka and Erwin van Osen, a sometime painter who also worked in cabarets as a mime. Krumau, a

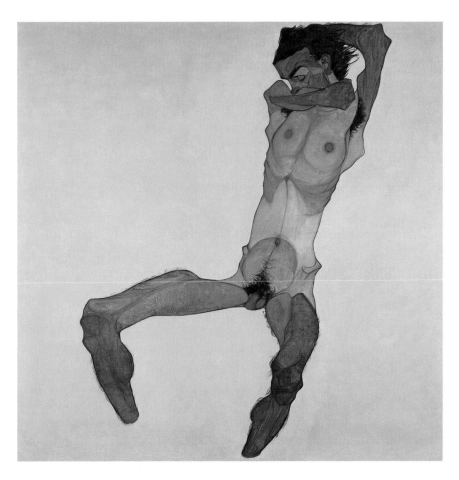

Fig. 9: Egon Schiele. *Seated Male Nude (Self-Portrait)*. 1910.
Oil and gouache on canvas. 152.5 × 150 cm. Kallir P. 172.
Leopold Museum, Vienna.

Renaissance city built into the tall, twisting banks of the Moldau River, was Marie
Schiele's hometown, and Egon had fallen in love with the place on a family visit shortly
before his father's death in 1904. The artist affectionately called it 'The Dead City'—
a city whose ancient walls evoked not merely decay, but the persistence of human
creation in the face of mortality (page 103). With his two friends, he talked about
forming a Barbizon-like painters' colony there.

However, things did not get off to a good start. Although Schiele had withdrawn
his meager savings from the bank before leaving Vienna, he cabled Czihaczek for more
cash immediately upon arrival in Krumau. Czihaczek was livid, not only because he

knew Egon had money, but because the cable had been misaddressed, causing his neighbors to be awakened in the middle of the night. 'When one has no money', the old man fumed, 'one does not travel, especially not with an entourage.' This was the last straw in Schiele's already significantly deteriorated relationship with his uncle. Czihaczek renounced the guardianship, and the young artist lost the last tattered vestiges of a financial safety net.

Apparently Schiele's relations with his artist companions did not fare much better. Osen, whose theatrical gestures may well have influenced the expressive body language of the artist's early 1910 nudes, turned out to be a flamboyant poseur (page 84). He concocted an exotic autobiography, based in part on the life of the French poet Arthur Rimbaud, and persuaded Schiele to write puerile poetry. Though Schiele was enthralled by Osen's mystique, it is probable that the mime also got on his nerves. At the same time, Schiele was being followed all over Krumau by Willy Lidl, a local schoolboy who had developed a crush on him. Though Schiele at this stage in his life was surrounded by male friends and patrons, Lidl's infatuation is the only evidence of a homosexual encounter. If indeed they had a summer fling, Schiele cut the boy off almost completely after returning to Vienna in the fall.

In 1910, most of Schiele's feelings—sexual and otherwise—were focused on himself. The proliferation of self-portraits during this period can be likened to a kind of pictorial masturbation (pages 81, 111–113, 115, and 120–122). The artist's sexual ambivalence is further reflected in the hermaphroditic quality of many of his nudes: females whose enlarged pudenda suggest penises (page 86), males whose genitalia have been strangely truncated and whose enlarged nipples protrude like breasts (pages 91, 93, 111, and 120). In addition to their ambiguous, abstracted sexuality, Schiele's 1910 self-portraits can also be shockingly ugly. At times, the artist resembles a corpse, with sunken eyes and a shrunken torso (pages 120 and 121). Elsewhere, he grimaces fero-ciously or gesticulates wildly (pages 111 and 115). And then again, he can be beautiful (as in reality he was and knew himself to be): preening, elegant, and self-satisfied (pages 81 and 113). Schiele was simultaneously probing his inner feelings and trying on a multitude of selves. Sincerity and affectation thus balanced one another in his self-portraits, keeping them from becoming either maudlin or mannered.

If Schiele felt most at ease with himself as a model, he gradually discovered that children could be nearly as congenial. Since he was (in his own words) an 'eternal child' and barely out of school himself, it is understandable that he would relate more readily to children than to adults. Vienna was teeming with little urchins who could be persuaded to pose for a few coins or a bit of candy. However, it seems that Schiele first began making extensive use of child models in Krumau, possibly because

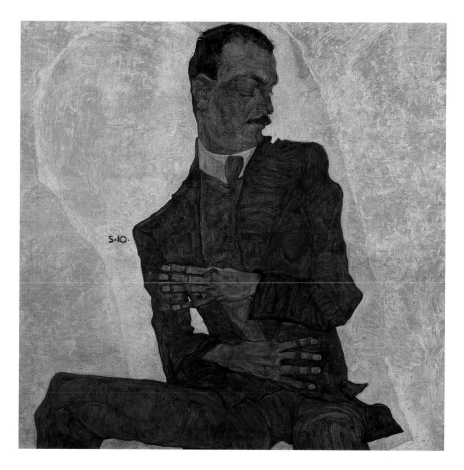

Fig. 10: Egon Schiele. *Portrait of Arthur Roessler*. 1910. Oil on canvas.
Initialed and dated, center left. 99.6 × 99.8 cm. Kallir P. 163.
Historisches Museum der Stadt Wien, Vienna.

he no longer had access to Graff's clinic. His 1910 drawings of children stand in stark
contrast to the clinic nudes. The children are intensely real human beings, depicted in
a completely natural, unaffected manner (pages 100, 101, 107–109, and 125–127).

Schiele's portraits of children are the first cohesive body of images to reveal the
stylistic shift that gradually transformed his approach in the second half of 1910. The
acidic, jarring color combinations that predominated in the first part of the year
eventually gave way to a more subdued palette that may have owed something to the
influence of Kokoschka and Mopp. Dusky mauves, dark blues, browns, and blacks
became Schiele's new favorite colors (pages 115, 117, and 120–123). Whereas formerly
he had applied watercolor in slightly overlapping side-by-side patches of differing hues,

he now became more interested in blended transitions from one color to the next. In order to give himself more control over the wet paint, the artist switched to thicker, more tractable gouache or occasionally mixed a synthetic glue with the pigment. He also used his brush to score and shape the paint, so that it fit snugly into its assigned compositional space (pages 115, 117, 124, 125, 128, and 129). There was now a tensile animation within each block of color that corresponded to the tension between figure and ground. Lighter touches of watercolor were sometimes balanced against heavier blocks of gouache, much as Schiele had earlier played his realistic drawings off against flat, Jugendstil design elements (pages 123, 130, 131, and 133).

Schiele's 1910 watercolors of children were also among his first true Expressionist portraits. Back in Vienna that fall, aided by Roessler and his other new clients, the artist made a valiant attempt to pursue this line of work (figure 10; pages 116 and 117). In a world where one-on-one patronage was still the rule, portraiture was a painter's most logical source of income. Yet Schiele soon learned—as did Kokoschka—that Expressionist portraits were not nearly as saleable as Klimt's jewel-encrusted extravaganzas. Not only did the new style do little to flatter the sitter's vanity, but there is some question as to whose soul was really being exposed: the subject's or the artist's? At any rate, Schiele found that his prospects at the end of 1910 were suddenly not as promising as they had seemed at the beginning.

Self-Portrait. 1910.
Gouache, watercolor, and black crayon. Initialed and
dated, lower right. 44.3 × 30.5 cm. Kallir D. 694.
Leopold Museum, Vienna.

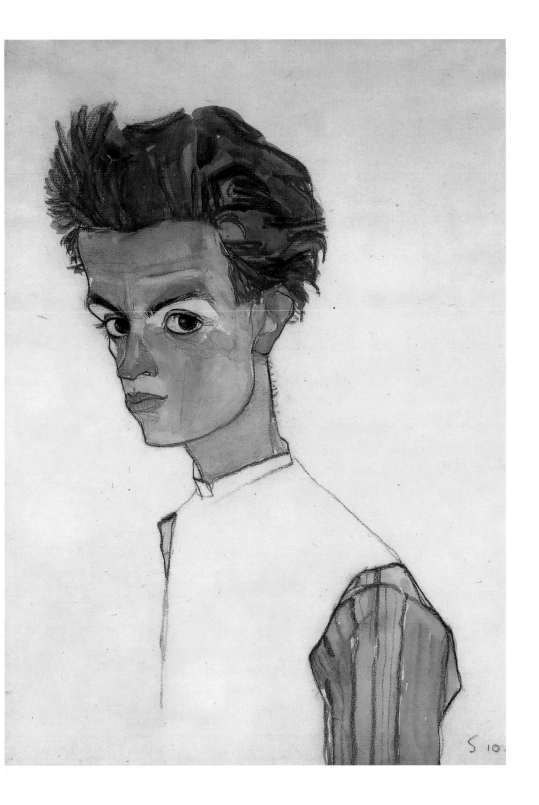

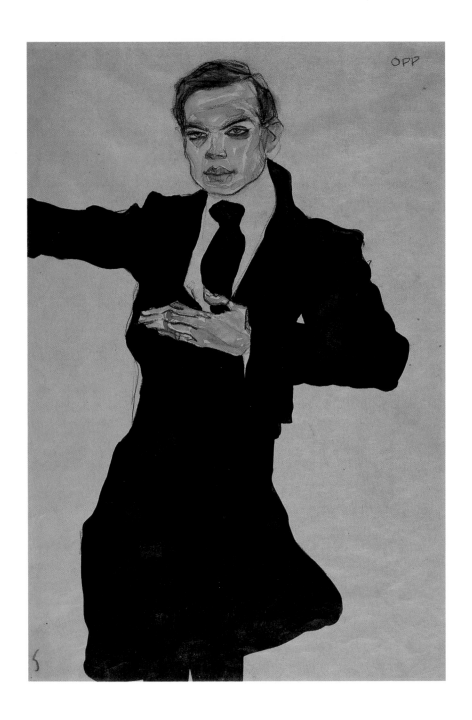

The Painter Max Oppenheimer, Three-Quarter Length. 1910.
Watercolor, ink, and black crayon. Initialed, lower left.
Inscribed 'OPP', upper right. 45 × 29.9 cm. Kallir D. 587.
Graphische Sammlung Albertina, Vienna.

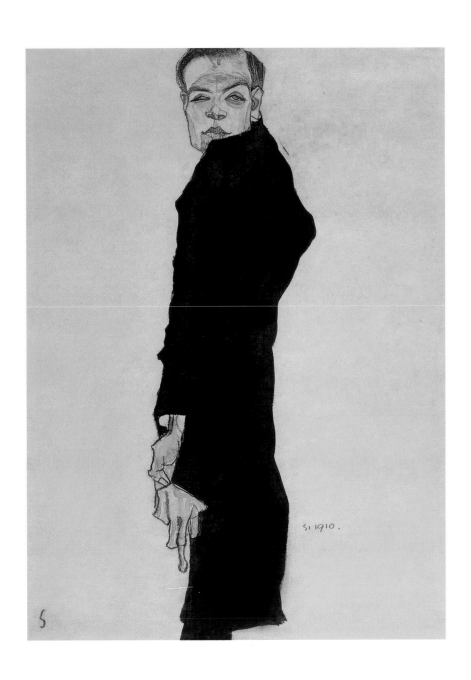

Portrait of the Painter Max Oppenheimer. 1910.
Gouache, watercolor, ink, and black crayon. Initialed and dated,
lower right; initialed, lower left. 45.1 × 31.7 cm. Kallir D. 588.
Serge Sabarsky Collection, New York, courtesy of Neue Galerie, New York.

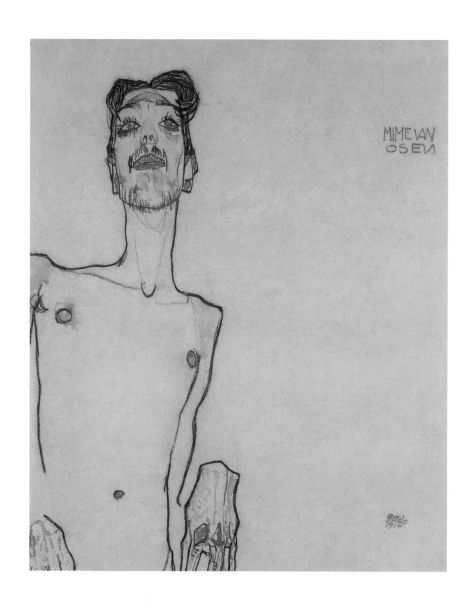

Mime van Osen, Nude with Wrists Raised. 1910.
Watercolor and charcoal. Signed and dated, lower right.
Inscribed 'Mime van Osen', upper right. 37.8 × 29.7 cm. Kallir D. 597.
Neue Galerie am Landesmuseum Joanneum, Graz.

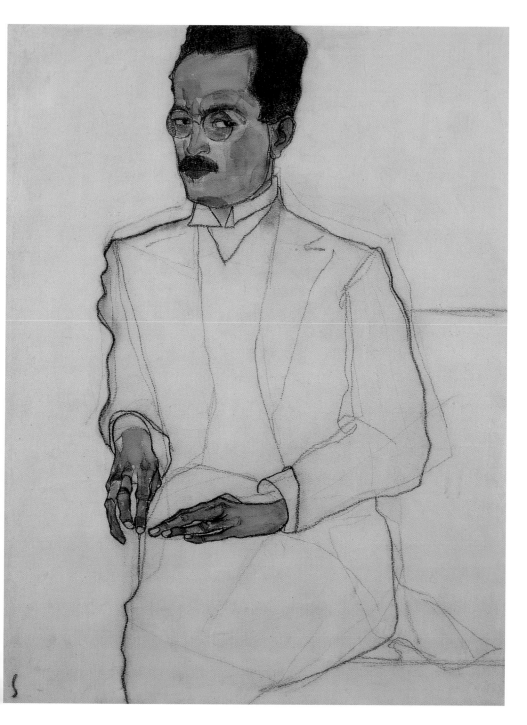

Portrait of a Gentleman. 1910.
Watercolor and charcoal. Initialed, lower left.
39.7 × 29.1 cm. Kallir D. 606. Private collection Australia,
courtesy of Richard Nagy, Dover Street Gallery, London.

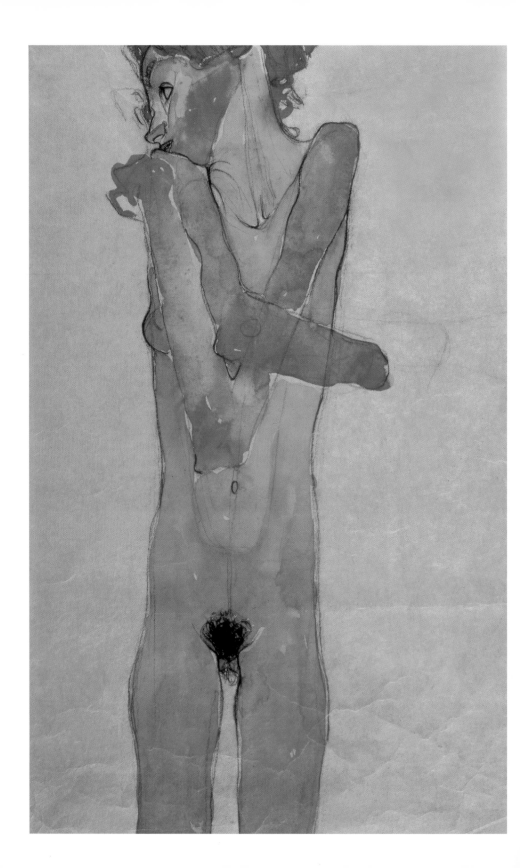

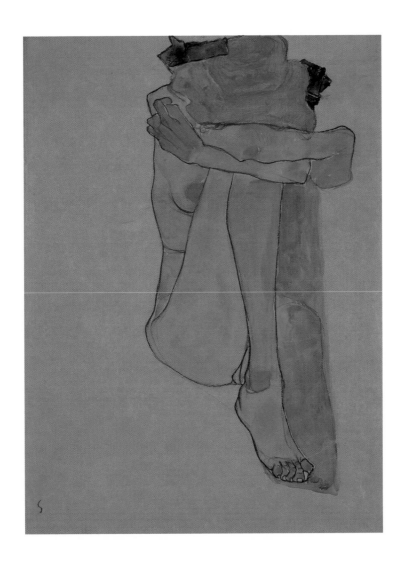

Above: *Seated Female Nude with Bent Knees and Green Pillow*. 1910.
Watercolor and charcoal. Initialed, lower left. 44.9 × 32.2 cm. Kallir D. 520.
Neue Galerie am Landesmuseum Joanneum, Graz.
Opposite: *Nude Girl with Folded Arms (Gertrude Schiele)*. 1910.
Watercolor and black crayon. Initialed, lower right. 48.8 × 28 cm. Kallir D. 516.
Graphische Sammlung Albertina, Vienna.

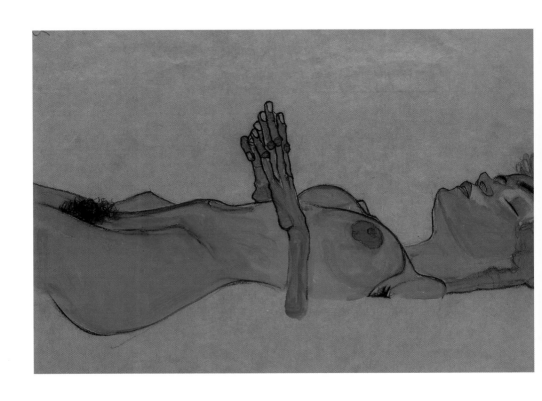

Dead Girl. 1910.

Watercolor and charcoal. Initialed (as vertical), upper left.

30.5 × 44 cm. Kallir D. 521.

The Earl and Countess of Harewood.

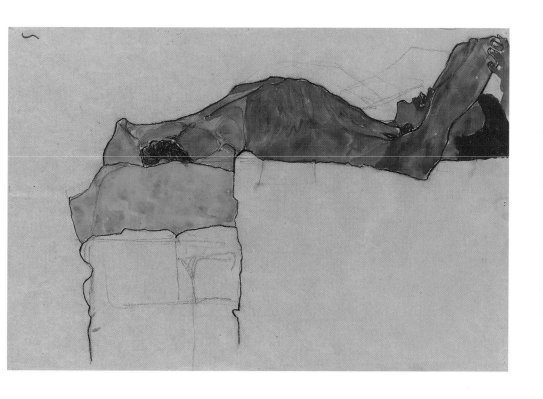

Reclining Male Nude with Green Cloth. 1910.
Watercolor and charcoal. Initialed (as vertical), upper left.
31.4 × 45.1 cm. Kallir D. 665.
Private collection.

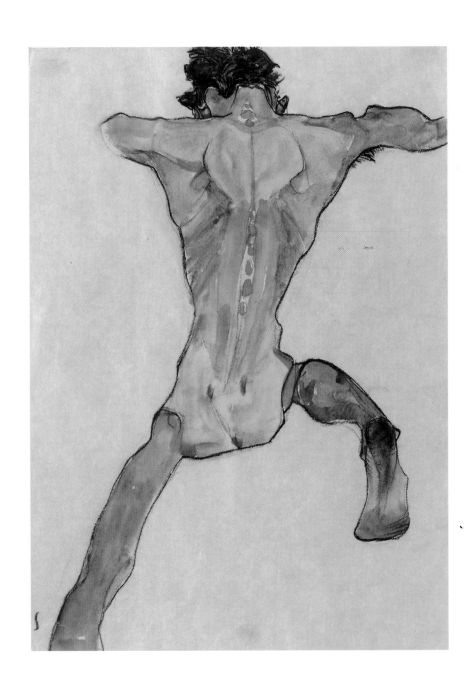

Male Nude from the Back. 1910.
Watercolor and charcoal. Initialed, lower left. 45.7 × 30.5 cm. Kallir D. 654.
Private collection.

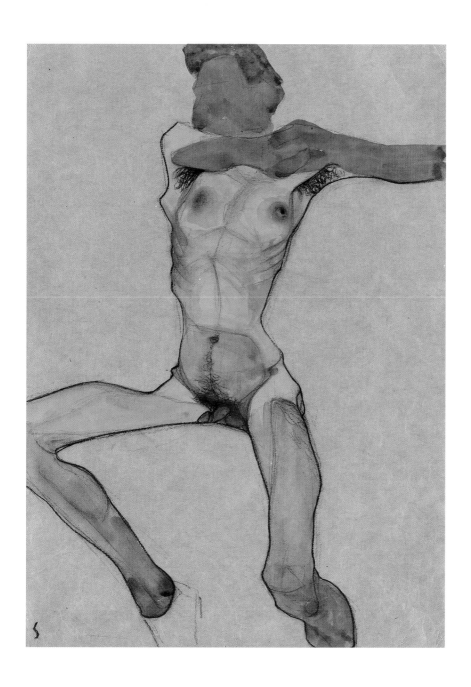

Male Nude, Yellow. 1910.
Watercolor and charcoal. Initialed, lower left. 45 × 31.4 cm. Kallir D. 673.
Private collection.

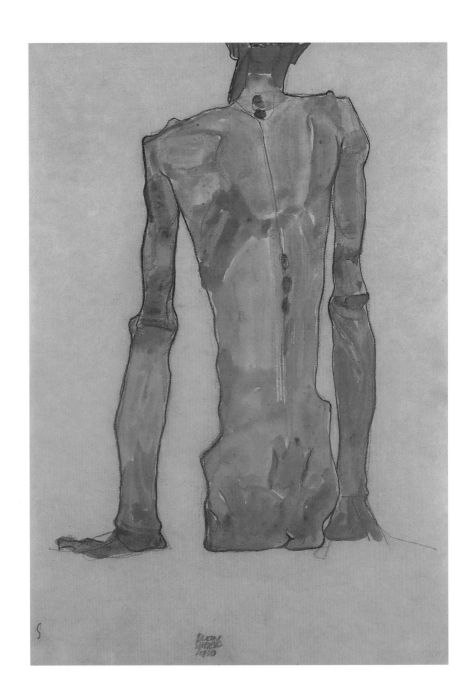

Seated Male Nude, Back View. 1910.
Watercolor and black crayon. Signed and dated, lower center;
initialed, lower left. 45 × 24.8 cm. Kallir D. 653.
Private collection.

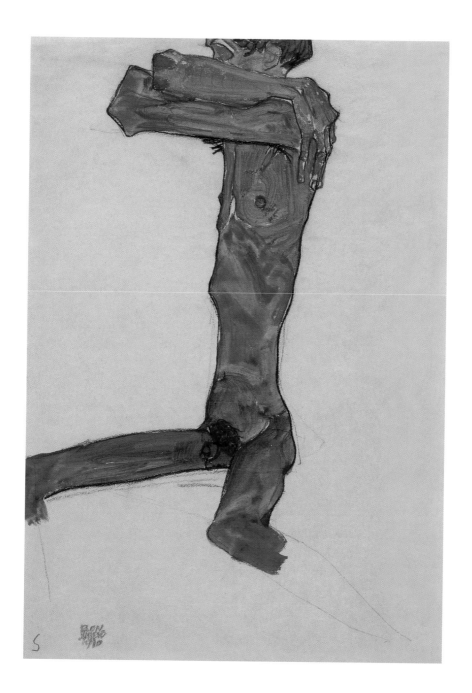

Male Nude with Crossed Arms. 1910.
Gouache and black crayon. Signed and dated, lower left;
initialed, lower left. 45 × 26.5 cm. Kallir D. 659.
Oberösterreichisches Landesmuseum, Linz.

Standing Female Nude with Red Stockings. 1910.
Watercolor and black crayon. Initialed and dated, lower right; initialed, lower left.
44.8 × 29.7 cm. Kallir D. 531.

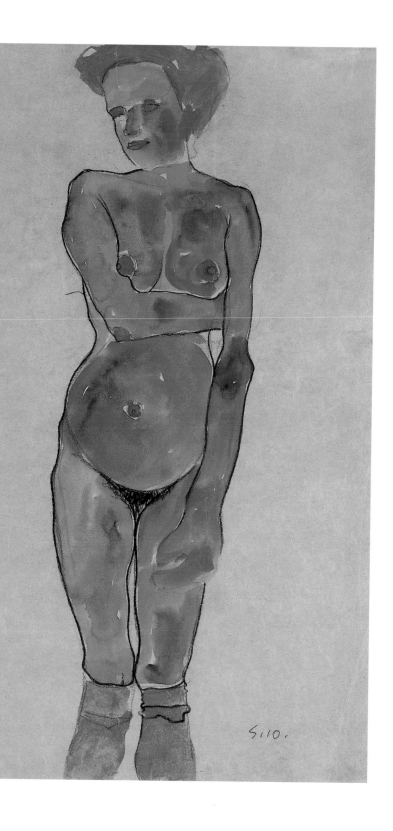

S S110.

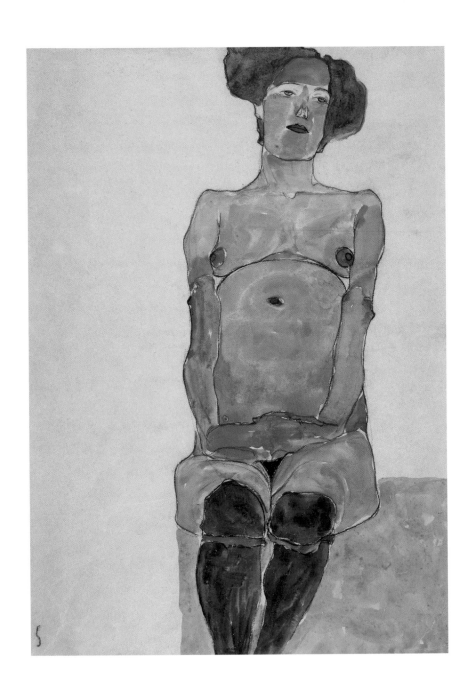

Seated Female Nude with Dark Blue Stockings, Facing Front. 1910.
Watercolor and black crayon. Initialed, lower left. 45.2 × 31.5 cm. Kallir D. 534.
Miyagi Museum of Art, Sendai.

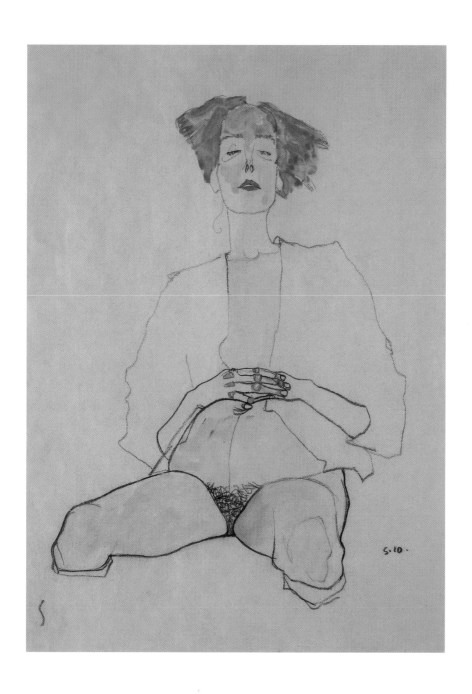

Seated Semi-Nude with Red Hair. 1910.
Watercolor and charcoal. Initialed and dated, lower right;
initialed, lower left. 44.5 × 31 cm. Kallir D. 537.
The Earl and Countess of Harewood.

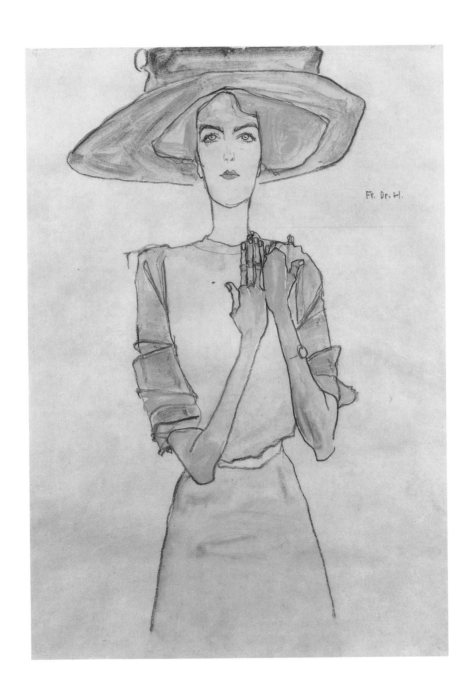

Frau Dr. Horwitz with Large Hat. 1910.
Watercolor and charcoal. Inscribed 'Fr. Dr. H.', upper right.
43.2 × 29.8 cm. Kallir D. 496.
Private collection.

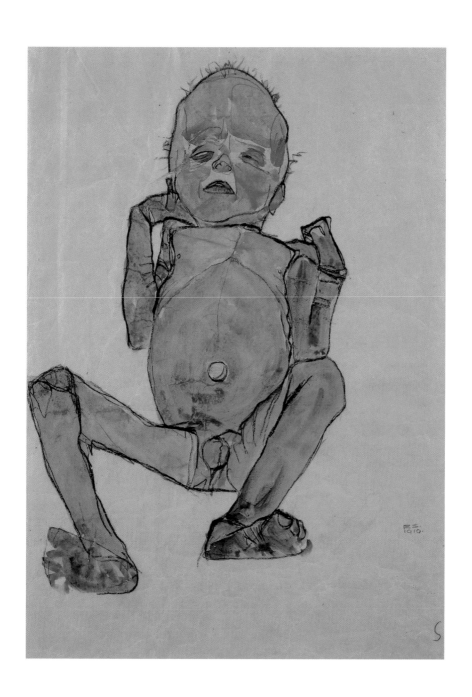

Newborn Baby. 1910.
Watercolor and charcoal. Initialed and dated, lower right.
46 × 32 cm. Kallir D. 382.
Private collection.

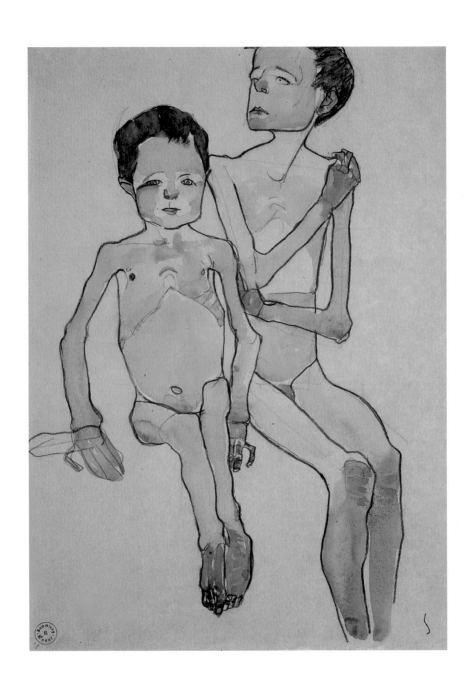

Two Seated Nude Boys. 1910.

Watercolor and charcoal. Initialed, lower right.

45.1 x 31.8 cm. Kallir D. 430.

Private collection.

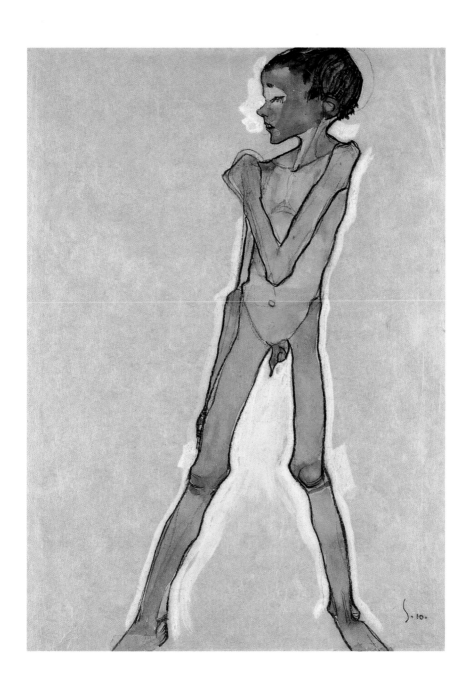

Standing Nude Boy. 1910.
Watercolor and black crayon with white heightening.
Initialed and dated, lower right. 44.8 × 22.9 cm. Kallir D. 432.
Szépmüvészeti Múzeum, Budapest.

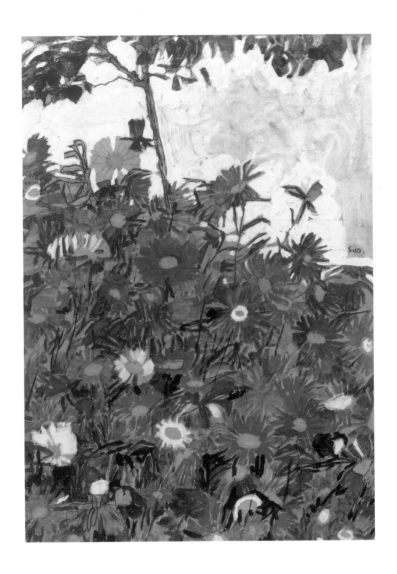

Above: *Field of Flowers.* 1910.
Gouache, metallic paint, and black crayon.
Initialed and dated, center right. 44.2 × 30.7 cm. Kallir P. 179.
Private collection.
Opposite: *Town on the Blue River (Krumau).* 1910.
Gouache, watercolor, and charcoal. Initialed and dated, lower right.
45 × 31.5 cm. Kallir D.742.
Private collection.

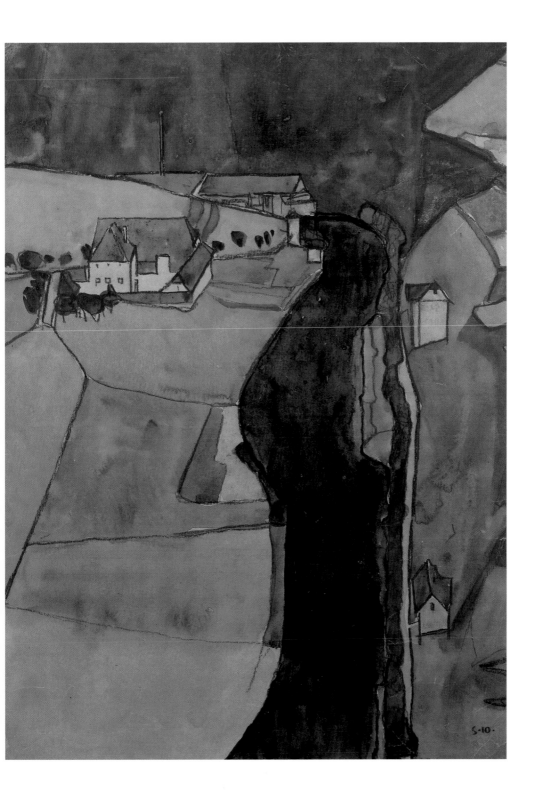

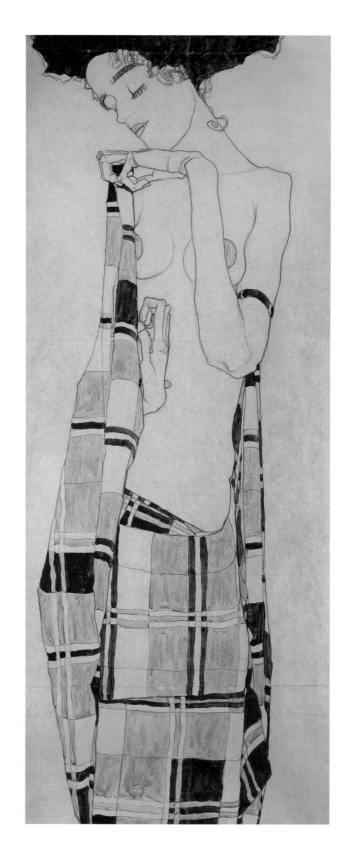

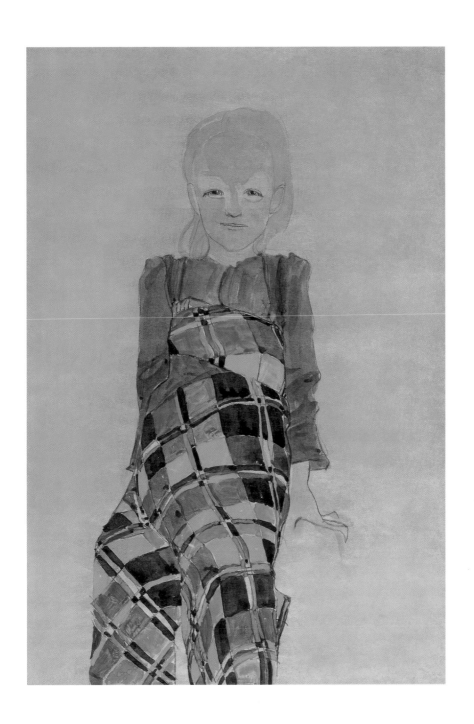

Seated Girl. 1910.
Watercolor and pencil. 45 × 29.8 cm. Kallir D. 402.
Szépmüvészeti Múzeum, Budapest.

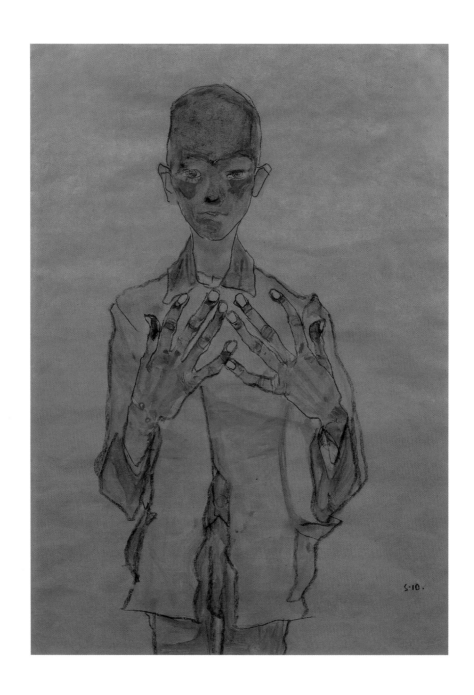

Standing Boy with Hands on Chest. 1910.
Watercolor and charcoal. Initialed and dated, lower right.
45.1 × 31.8 cm. Kallir D. 439.
Private collection.

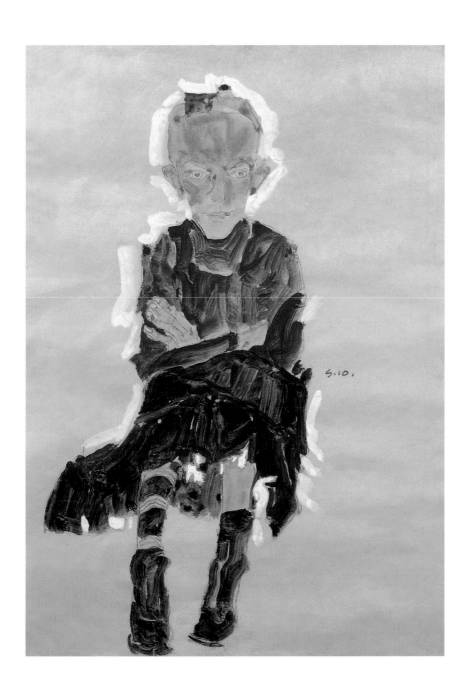

Proletarian Girl in Black. 1910.
Gouache and pencil. Initialed and dated,
center right. 45 × 31.4 cm. Kallir D. 413.
Private collection, courtesy of Galerie St. Etienne, New York.

Self-Portrait with Arm Twisting Above Head. 1910.
Watercolor and charcoal. Initialed, lower right. 45.1 × 31.7 cm. Kallir D. 688.
Private collection, New York.

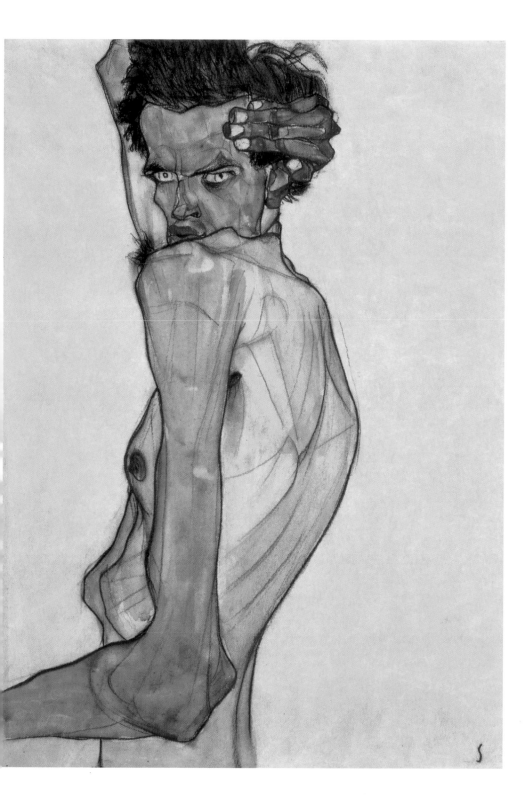

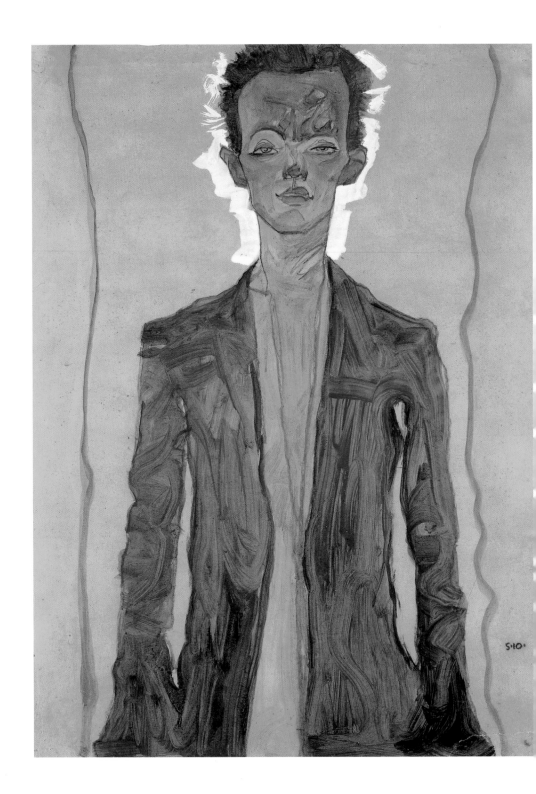

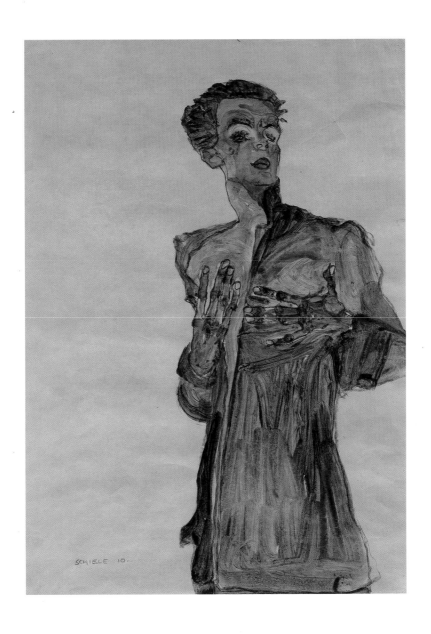

Above: *Self-Portrait in Street Clothes, Gesturing.* 1910.
Watercolor and pencil. Signed and dated, lower left. 42.5 × 27.3 cm. Kallir D. 695.
Private collection, courtesy of Galerie St. Etienne, New York.
Opposite: *Self-Portrait in Brown Coat.* 1910.
Gouache, watercolor, and black crayon with white heightening.
Initialed and dated, lower right. 49.5 × 31.7 cm. Kallir D. 698.
Serge Sabarsky Collection, New York, courtesy of Neue Galerie, New York.

Self-Portrait with Hand to Cheek. 1910.

Gouache, watercolor, and charcoal. Signed and dated, lower left. 44.3 × 30.5 cm. Kallir D. 706.

Graphische Sammlung Albertina, Vienna.

114

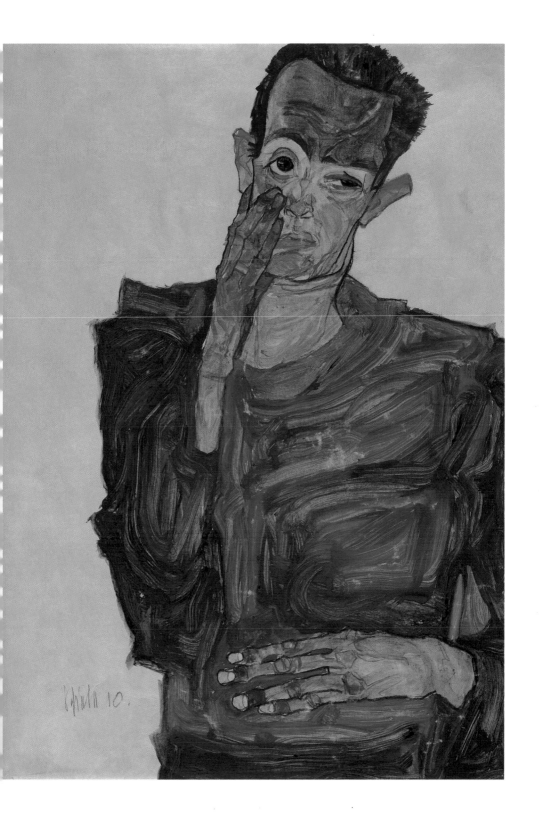

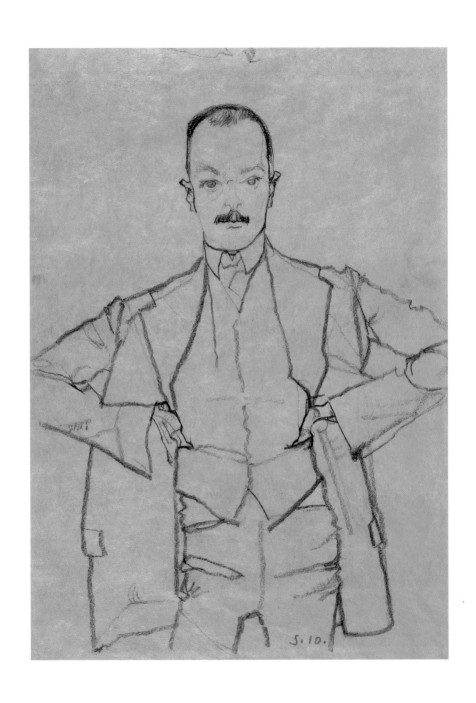

Arthur Roessler Standing with Arms Akimbo. 1910.
Black crayon. Initialed and dated, lower center. 45.2 × 31 cm. Kallir D. 626.
Graphische Sammlung Albertina, Vienna.

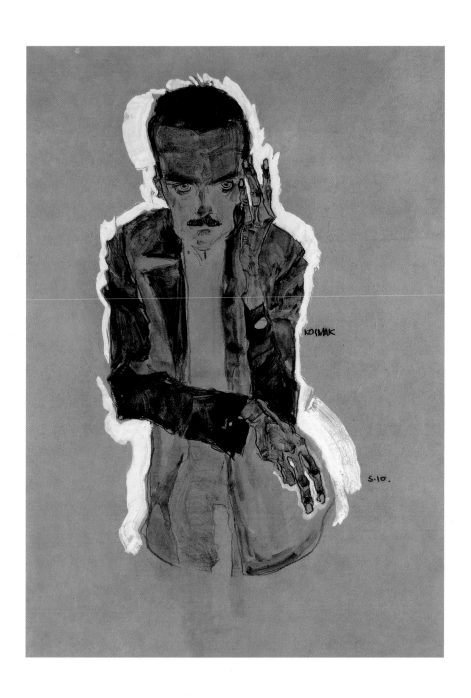

Portrait of Eduard Kosmack, with Raised Left Hand. 1910.
Gouache, watercolor, and charcoal with white heightening. Initialed and dated,
lower right. Inscribed 'Kosmak' (sic), center right. 44.7 × 30.5 cm.
Kallir D. 634. Private collection.

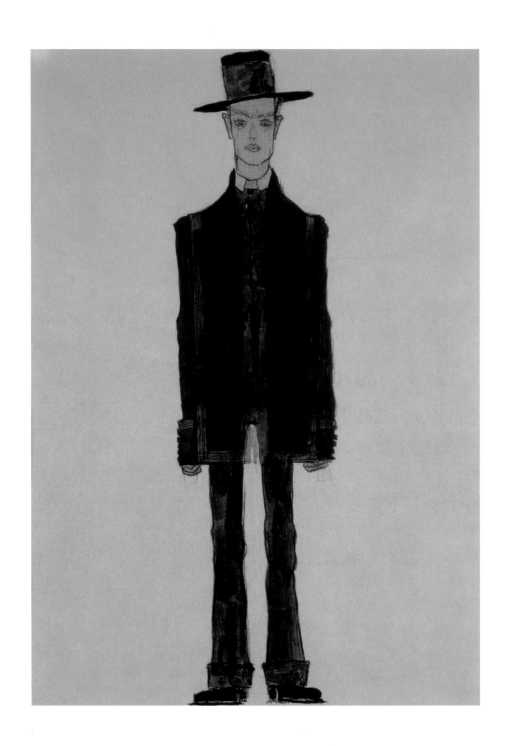

Fashion Design: Dark Suit, Hat with Wide Band. 1910.
Gouache, watercolor, and pencil.
41.9 × 29.2 cm [sight]. Kallir D. 729.

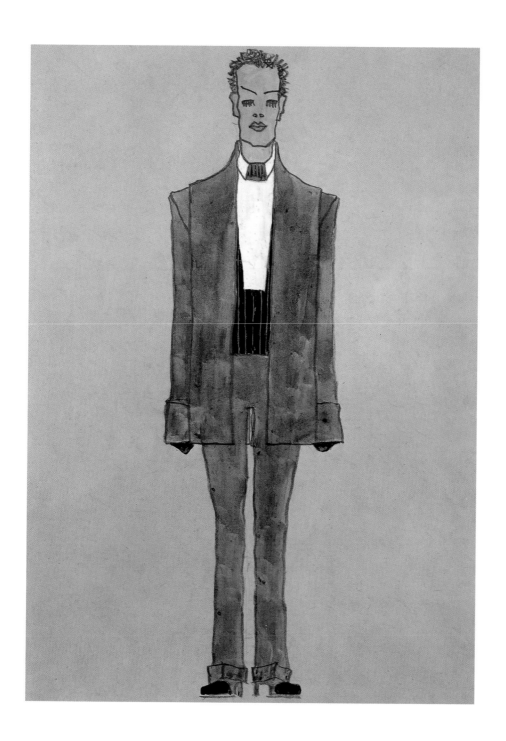

Fashion Design: Suit with Black and Red Striped Vest and Tie. 1910.
Gouache, watercolor, and pencil. 45 × 31.8 cm.
Kallir D. 734. Private collection.

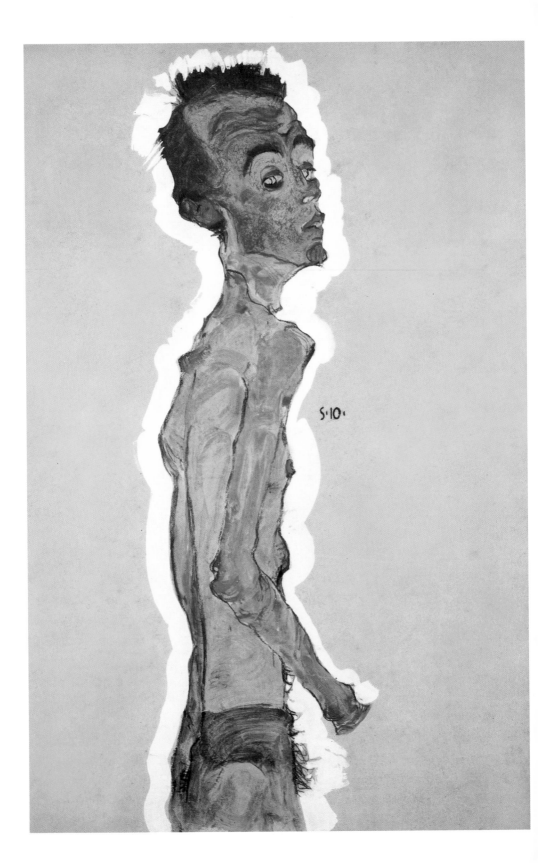

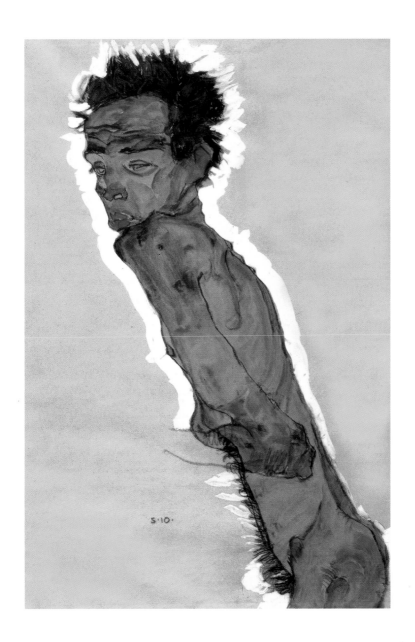

Above: *Male Nude in Profile Facing Left (Self-Portrait)*. 1910.
Gouache, watercolor, and black crayon with white heightening.
Initialed and dated, lower left. 43.1 × 27.5 cm. Kallir D. 707.
Graphische Sammlung Albertina, Vienna.
Opposite: *Self-Portrait*. 1910.
Gouache, watercolor, and charcoal with white heightening.
Initialed and dated, center right. 45 × 30 cm. Kallir D. 711.
Private collection, courtesy of Richard Nagy, Dover Street Gallery, London.

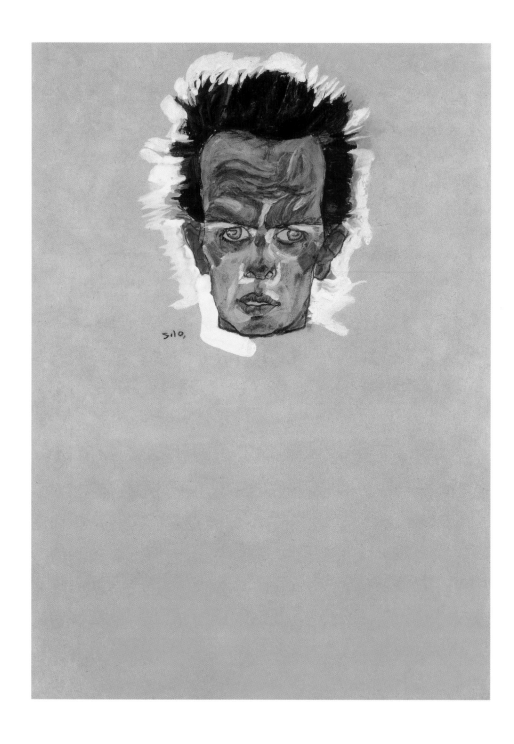

Self-Portrait, Head. 1910.
Gouache, watercolor, and charcoal with white heightening.
Initialed and dated, center left. 42.5 × 29.5 cm. Kallir D. 714.
Serge Sabarsky Collection, New York, courtesy of Neue Galerie, New York.

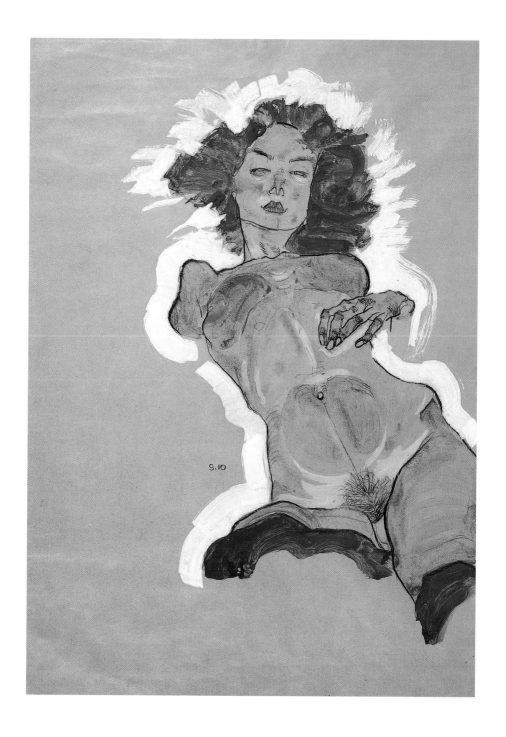

Female Nude. 1910.
Gouache, watercolor, and black crayon with white heightening.
Initialed and dated, lower left. 44.3 × 30.6 cm. Kallir D. 555.
Graphische Sammlung Albertina, Vienna.

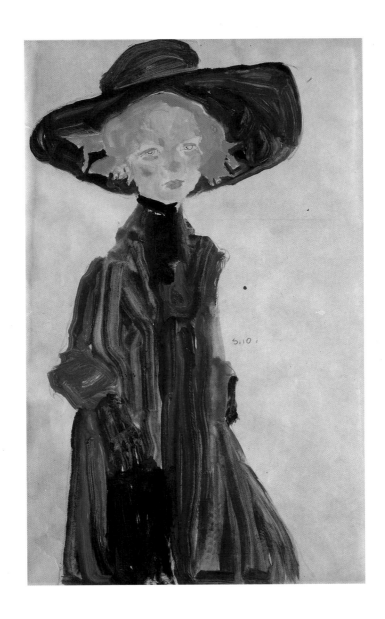

Above: *Girl in Blue*. 1910.

Watercolor. Initialed and dated, center right. 43.5 × 27.5 cm.

Kallir D. 502. Nissenhaus-Nordfriesisches Museum, Husum; Gift of Dr. Wassily.

Opposite: *Two Boys*. 1910.

Gouache, watercolor, and pencil. Initialed and dated, lower right.

44.2 × 31.2 cm. Kallir D. 463. Private collection.

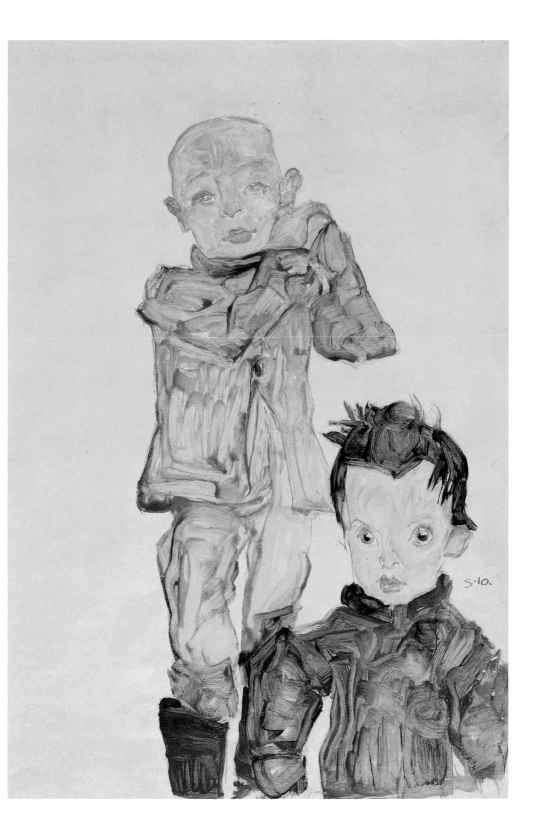

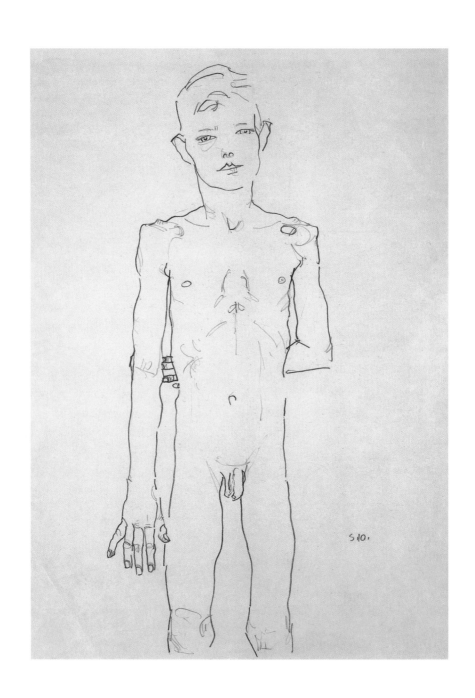

Standing Nude Boy, from the Knees Up. 1910.
Pencil. Initialed and dated, lower right. 36.6 × 26.8 cm. Kallir D. 459.
Neue Galerie am Landesmuseum Joanneum, Graz.

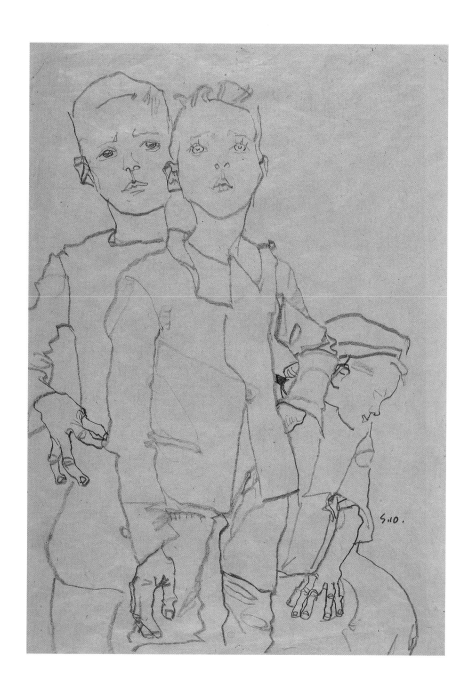

Three Street Urchins. 1910.
Pencil. Initialed and dated, lower right. 44.6 x 30.8 cm. Kallir D. 461.
Graphische Sammlung Albertina, Vienna.

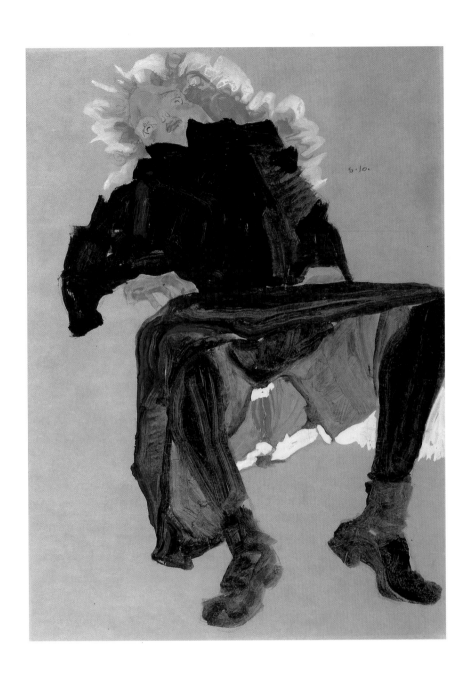

Reclining Girl in Dark Blue Dress. 1910.
Gouache, watercolor, and pencil with white heightening.
Initialed and dated, upper right.
45 × 31.3 cm. Kallir D. 417.

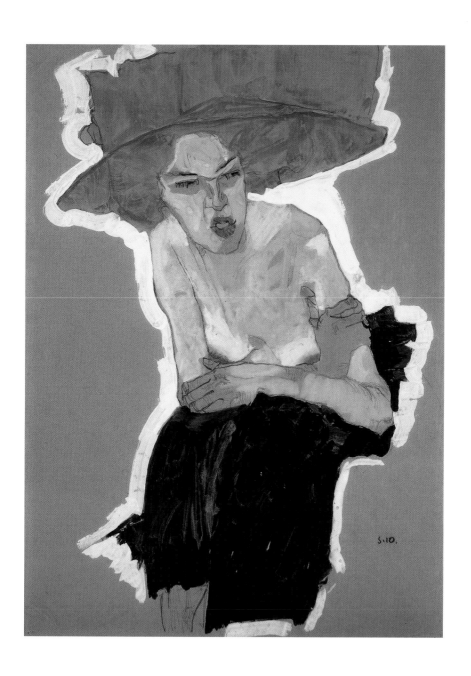

The Scornful Woman (Gertrude Schiele). 1910.

Gouache, watercolor, and charcoal with white heightening.

Initialed and dated, lower right.

45 × 31.4 cm. Kallir D. 546.

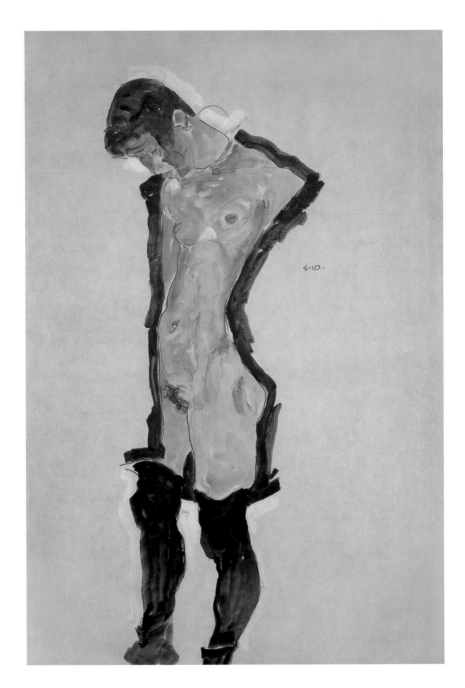

Standing Nude with Black Stockings. 1910.
Watercolor and pencil with white heightening.
Initialed and dated, center right. 56 × 37.2 cm. Kallir D. 567.
Neue Galerie am Landesmuseum Joanneum, Graz.

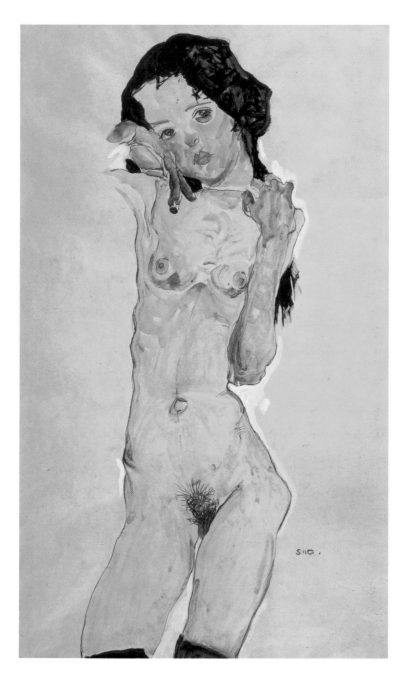

Black-Haired Nude Girl, Standing. 1910.
Watercolor and pencil with white heightening.
Initialed and dated, lower right. 54.3 × 30.7 cm. Kallir D. 575.
Graphische Sammlung Albertina, Vienna.

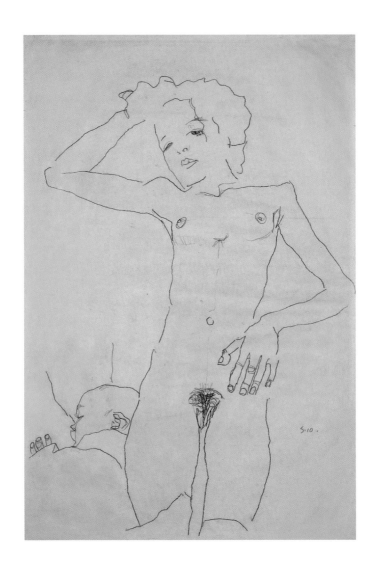

Above: *Female Nude with Infant*. 1910.

Pencil. Initialed and dated, lower right. 50.4 × 35.2 cm. Kallir D. 394a.

Opposite: *Mother and Child*. 1910.

Gouache, watercolor, and pencil. Initialed and dated, lower right.

55.6 × 36.5 cm. Kallir D. 396.

Serge Sabarsky Collection, New York, courtesy of Neue Galerie, New York.

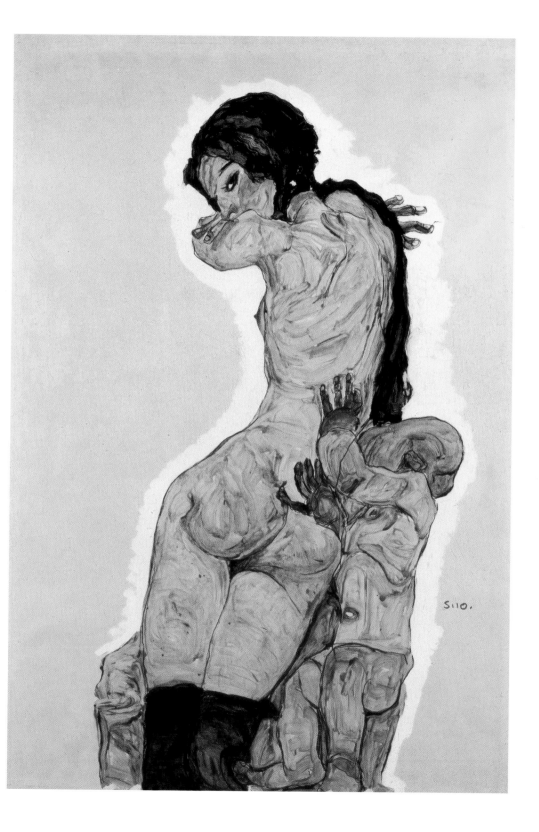

Schiele, Drawing a Nude Model Before a Mirror. 1910.
Pencil. Initialed and dated, lower right. 55.2 × 35.3 cm. Kallir D. 737.
Graphische Sammlung Albertina, Vienna.

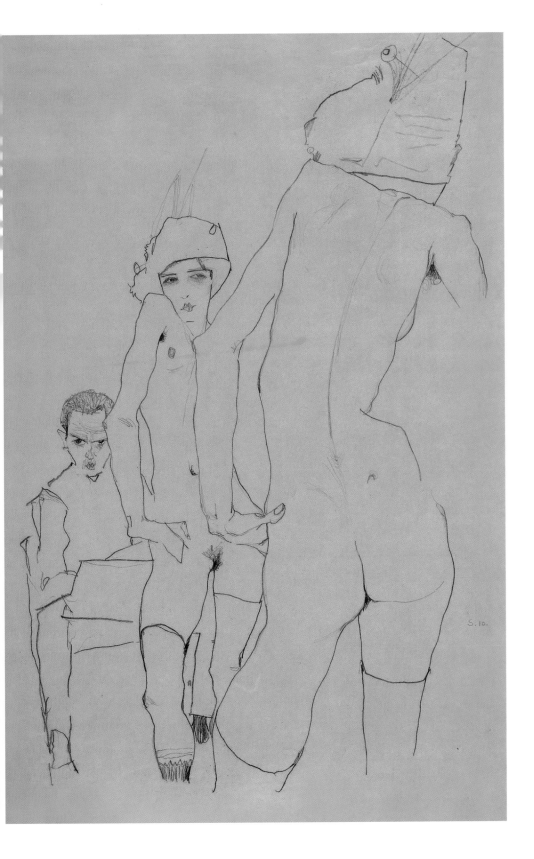

1911

The early months of 1911, punctuated by few concrete biographical markers, none-
theless brought significant changes to Schiele's creative and psychological orientation.
During this period, the artist developed his first serious relationships with women,
and it is therefore understandable that sex was among the topics that were uppermost
on his mind. The growing complexity of his liaisons with women generated a fair
amount of anxiety for Schiele, who had learned first-hand that sex could kill. Not
only had his father succumbed to a sexually transmitted disease, but the artist knew
from his family's experiences that motherhood could also be extremely risky, both
for women and for their babies, who so often died. Even if a mother survived child-
birth, she was nonetheless bound (in Schiele's opinion) to be drained of her youthful
vitality. Whereas many people see a path to immortality in the bearing of children,
Schiele sought a parallel route in art. Only art, in his view, could truly conquer death.
In his work, a trio of interrelated themes began to emerge: mortality, procreation,
and artistic transcendence.

Toward the end of 1910, Schiele had developed an interest in allegory that was
to exert a decisive influence on his paintings for the remainder of his life. Inspired in
part by the monumental murals that established Klimt's career, the younger artist's
take on allegorical subject matter was characteristically far more personal. Paintings
of mothers (chaste, pregnant, or dead; figure 11) and self-portraits predominate
among his 1911 allegories. Permeated by Schiele's own ambivalence, the mothers in
these paintings are mere expedients who nevertheless are also indispensable. Their
sole role, he makes clear, is to produce and nurture genius. Schiele, as an artist,
considered himself to be genius personified, and he was not shy about using himself
as a stand-in for humankind at large. Paintings in which the artist's image is haunted
by an eerie double suggest an encounter both with the creative muse and with death.

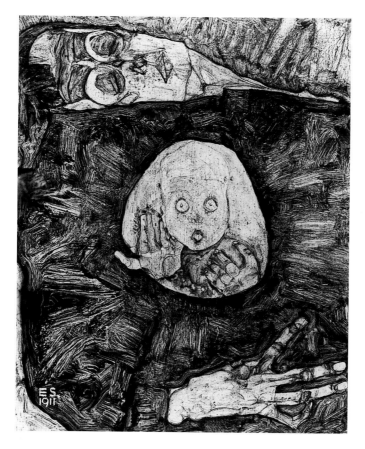

Fig. 11: Egon Schiele. *The Birth of Genius (Dead Mother II)*. 1911.
Oil on wood. Initialed and dated, lower left. 32.1 x 25.4 cm. Kallir P. 195.
Presumed destroyed. Photograph courtesy of Galerie St. Etienne, New York.

In double self-portraits such as *Prophets* (figure 12), Schiele anthropomorphized his
vision of art as a vehicle for spiritual enlightenment.

Schiele's shift toward allegorical subject matter created a pronounced and
persistent dichotomy between the content of his works on paper and that of his oils.
Although he routinely made studies for his commissioned portraits, the compositions
of his allegories and landscape oils were commonly worked out only in small thumb-
nail sketches. On those occasions where it is possible to establish a connection between
a full-sized drawing and one of the allegorical paintings, that connection is usually
tangential: part of a pose, gesture, or facial expression. Schiele's landscape water-
colors and drawings are as beautiful as they are rare—and bear an even less direct
relationship to his paintings than do his other drawings. Whereas the artist's oeuvre in

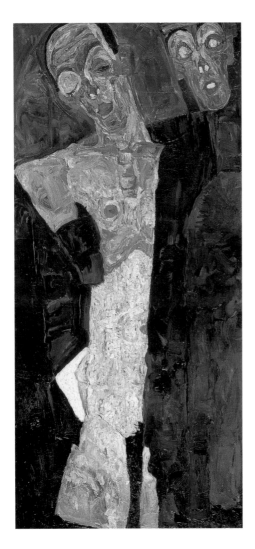

Fig. 12: Egon Schiele.
Prophets (Double Self-Portrait). 1911. Oil on
canvas. Initialed and dated, upper left.
110.3 × 50.3 cm. Kallir P. 191.
Staatsgalerie, Stuttgart.

oil is composed in roughly equal parts of landscapes, allegories, and portraits, his
works on paper are almost entirely figural.

The differences in subject matter between the two principal branches of Schiele's
oeuvre derive from his dissimilar approach to each. Despite the enormous amount of
time and energy that the artist devoted to his works on paper, he considered the oils
to be his more important works. Whereas he saw his allegories and landscape paintings
(in which decrepit houses and frail trees often symbolize mortality; figure 13) as vehicles
for delivering grand, sweeping pronouncements on the human condition, his water-
colors and drawings, executed with uncanny speed, record fleeting encounters and

emotional responses. The underlying concerns—fear of death, sexual anxiety, a yearning for certainty and absolution—are the same throughout, but the results are very different. In his works on paper, Schiele asks questions; in his paintings, he attempts to answer them.

In tandem with the expanding allegorical cosmology of his oils, 1911 brought a greater level of refinement to Schiele's watercolors and drawings. As was the tendency during the first part of his career (at least until 1915), the artist rapidly passed through a number of distinct developmental stages in this single year. Drawings from early 1911—angular and bold (pages 148–152)—contrast markedly with the soft, delicate forms of late 1911 (pages 177, 179, 181, and 185). During these twelve or so months, Schiele's figures became less jagged and boxy, more rounded and almost ethereal. The artist's palette underwent a concomitant shift. At the beginning of 1911, he employed stark contrasts, with a predilection for black, white, and orange (pages 150–153). Continuing a practice begun in 1910, outlines were often edged with white gouache for further emphasis (pages 101, 109, 112, 117, 120–123, 128–131, 133, 147, 150–153, and 156). By midyear, with occasional exceptions (pages 165, 167, 172, and 173), white outlining had become less common and Schiele's colors shifted toward a bruiselike melange of blue, black, and purple (pages 157, 158, and 160–162). And then, toward the end of 1911, his palette changed again. Often during this later phase, he favored bright pastels (pages 174, 175, 177, 179, 181, and 185), occasionally dropping colored pigment into a base layer of white, which he used to modulate the flow of the inherently unstable watercolor.

Schiele achieved a remarkable degree of control over the watercolor medium in 1911, although his technique was entirely unorthodox. Instead of the heavy, absorbent papers used by the traditional watercolorist, he favored smooth sheets, sometimes treated with chemical sizing, that tended to repel water. This enabled the artist to manipulate the pigment on the surface of the paper. His turn to gouache (more viscous and hence more tractable than watercolor) in late 1910 and early 1911 was a means to gain command over the paint. However, by mid 1911 Schiele had managed to achieve an equivalent degree of control with looser watercolor. His mastery of wet-on-wet transitions from one hue to another has seldom been equaled.

As previously, Schiele liked to divide the sheet into discrete color areas, each bounded and determined by the contours of the underlying drawing and treated in a distinctive manner. With improved command of the watercolor medium, he could play these areas off one another with greater subtlety: for example, by contrasting delicately tinted flesh with densely worked drapery (pages 147, 168–174, 179, and 181–185). Sometimes the artist edged his forms with paint, allowing the brush to caress the surface lightly and deposit a residue of pigment along the periphery. For the

weapon (pages 160 and 181). The artist's unusual lopping and cropping of female body parts may be interpreted similarly, as an attempt to reign in potentially devastating sexual forces (pages 147, 151, 154–156, 161, and 173). Yet Schiele is one of the only male artists ever to credit female sexuality with its true power, a power that academic convention through the ages has sought to deny and conceal.

If Schiele's drawings of the female nude were highly idiosyncratic, his personal sexual liaisons were, for their day, fairly typical. The mores of the late Austro-Hungarian Empire encouraged males to enjoy an extended adolescence. Whereas girls were expected to marry young, men were not supposed to wed until their mid twenties or later, at which time they were deemed ready, both emotionally and professionally, to take their place within bourgeois society. The years between puberty and marriage were a time when boys were expected to 'sow their wild oats,' and Vienna was well provided with prostitutes and 'sweet young things' from the provinces to service these randy males. This system effectively reinforced contemporary moral propriety by segregating sexual activity in a zone apart from 'decent' society. Schiele's escapades with his models conformed to the norm.

It perhaps goes without saying that turn-of-the-century Vienna was governed by a strict double standard. 'Good' girls were not permitted to indulge in the same promiscuity as their male counterparts, and women who engaged in extramarital sex were tainted for life. Artists' models were only slightly less disreputable than prostitutes, since both professions required a woman to remove her clothing for money. Often, however, lower-class women had little choice. This seems to have been the case with Valerie Neuzil ('Wally'), who came to Vienna from the countryside to seek her fortune, but found that modeling was the only way she could make ends meet. It is said that she worked at first for Klimt, who eventually passed her on to Schiele. Schiele's prior encounters with models had been brief, but this relationship turned out to be profoundly different. In his enduring commitment to Wally, Schiele for a time flew in the face of prevailing convention—at least until his marriage to a socially acceptable 'good' girl in 1915.

Wally Neuzil met Egon Schiele in the spring of 1911, when she was seventeen years old. Both as companion and as muse, she was to play a major role in his personal and professional life for the next four years. Despite his feelings for Wally, however, Egon endeavored to maintain a degree of distance between them. This may be attributed to the artist's continuing sense of sexual vulnerability, or to his model's inferior social station, or perhaps to a combination of both. While Wally was probably Egon's only lover during the period that they were together, she was most certainly not his only model. He insisted that she keep her own apartment in Vienna and at one point made her sign a statement confirming that she was not in love with him. Never-

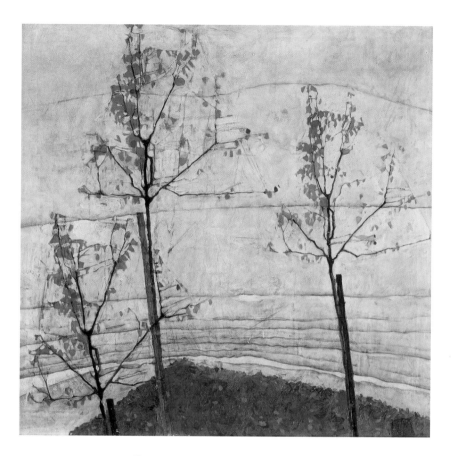

Fig. 13: Egon Schiele. *Autumn Trees*. 1911.
Oil on canvas. Signed and dated, lower right.
79.5 × 80 cm. Kallir P. 218. Private collection.

theless, their regular and open cohabitation was bound to raise eyebrows, particularly after Schiele decided to abandon Vienna for smaller, more conservative locales.

In May 1911, Schiele returned to Krumau with Wally in tow. This time, he intended to settle permanently. He even went to the trouble of booking two studios: one with a garden for the summer months, and a second, heated apartment for winter. However, he did not last until winter in Krumau. Offenses quickly piled up. The denizens of the town were disturbed by the artist's avant-garde clothing and his habit of yelling insults during the ritual evening promenade on the town square. Wally's presence naturally sparked unpleasant gossip. It was also remarked that the couple did not attend church. And then, of course, there was the matter of Egon's profession, which many deemed inherently immoral. Matters came to a head after

the artist was observed drawing a nude model in his garden. This gave his landlord an excuse to evict him, and Schiele, taking the hint, decided it would be best to leave town.

At that point, it might have been prudent simply to return to Vienna, but after a few weeks staying there with his mother, Schiele set off for yet another small village, Neulengbach. Like Krumau, Neulengbach had family associations: it was the location of Leopold Czihaczek's summer home. Given Schiele's fractious relations with his uncle, this connection hardly seems auspicious, though perhaps it gave the artist an extra level of comfort and the ability to request credit when his funds ran low. Neulengbach, in the rolling meadows of Lower Austria about twenty miles west of Vienna, was blissfully bucolic, and once again Schiele announced his intention 'to stay forever.' In August 1911, he rented another garden studio, which, as a further sign of permanence, he equipped with his own furniture. Again Wally came along, and again her illicit relationship with Egon was a harbinger of trouble to come. For the short term, however, the artist was quite content.

Although Neulengbach is much closer to Vienna than Krumau, Schiele's retreat into the provinces had inevitably diminished his professional opportunities in the city. His colleague Anton Faistauer, who had long been jockeying for leadership of the Neukunstgruppe, now took over. Schiele's incipient career as a portraitist went into a sharp decline in 1911, and would not regain the prior year's level until near the end of his life. Relations with his small cadre of patrons were also becoming increasingly strained. The artist demanded a degree of support that they were simply unwilling to give, and he was (in their eyes) not sufficiently grateful for the support they *did* give. Furthermore, because Schiele was constantly asking for little handouts, many of his patrons soon built up considerable credit, which only served to drive him further into arrears.

Schiele's ties to commercial dealers were equally problematic. Due to the entrenched system of private patronage, Vienna did not have a strong network of galleries willing to support the avant-garde. Schiele had his first one-man show at the city's progressive Galerie Miethke in April 1911, but no lasting relationship developed from this. The director, Carl Moll, did not care for Schiele. Nor did the artist particularly get along with his next dealer, Munich gallerist Hans Goltz. Pressured by Schiele's patron Arthur Roessler, Goltz agreed to include the artist in a group show in October 1911. Although this grew to be a sustained business contact, Schiele was never warmly received in Germany. Furthermore, he believed in principle that dealers were corrupted by commerce, and he had absolutely no sympathy for the fact that Goltz (unlike a private collector) hoped to make a profit in addition to meeting substantial overhead costs. When Roessler, after considerable pleading, managed to persuade Goltz to offer Schiele an exclusive contract, the artist balked completely. 'This sort of

contractual stipulation should only apply to operetta singers, not to me,' Schiele said. 'If I feel like it, I will send my work wherever I want.' Still, requests for Schiele's work were not exactly pouring in, and the precariousness of his financial situation was becoming acute.

Nude with Red Garters. 1911.
Watercolor and pencil. Initialed and dated, lower right.
54.6 x 35.6 cm. Kallir D. 794.

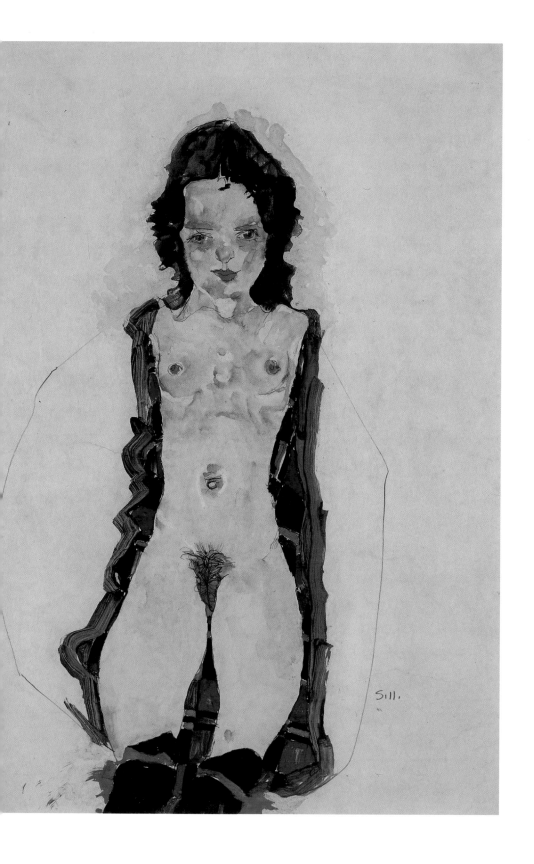

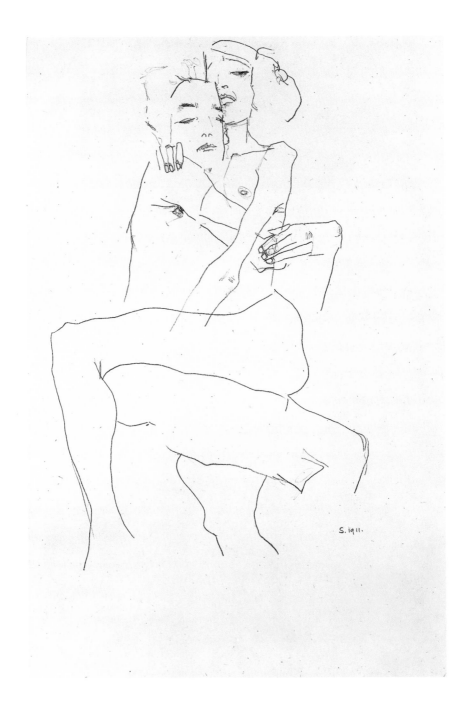

Embracing Couple. 1911.
Pencil. Initialed and dated, lower right. 57.6 × 38 cm. Kallir D. 966.
The Metropolitan Museum of Art, New York; Bequest of Scofield Thayer, 1982.

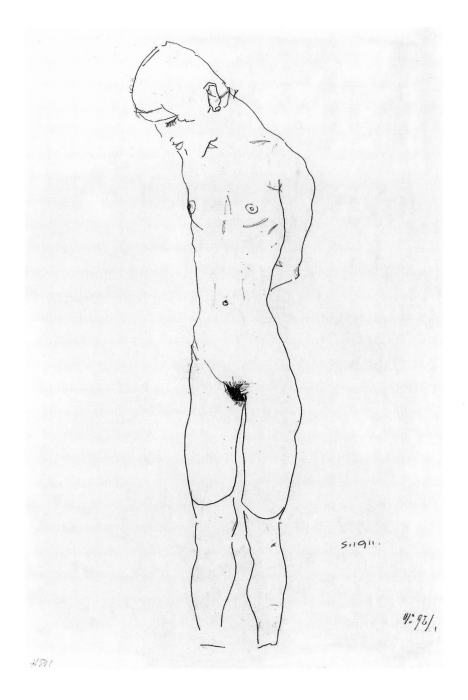

Standing Nude Girl. 1911.

Pencil. Initialed and dated, lower right.

50.2 × 34 cm. Kallir D. 819.

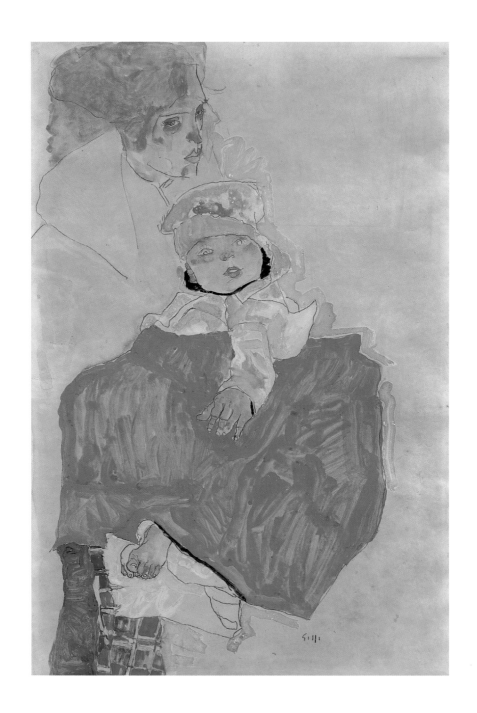

Mother and Child. 1911.
Gouache and pencil. Initialed and dated, lower right. 54 × 35 cm.
Kallir D. 751. Private collection.

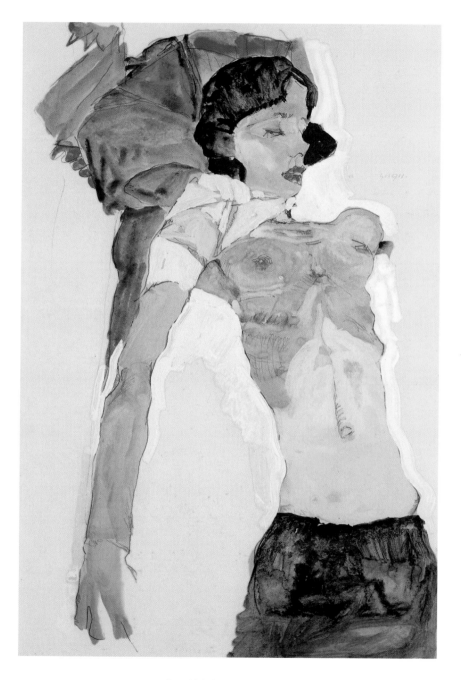

Semi-Nude Girl, Reclining. 1911.
Gouache, watercolor, and pencil with white heightening. Initialed and dated,
upper right. 45.9 × 31.1 cm. Kallir D. 812.
Graphische Sammlung Albertina, Vienna.

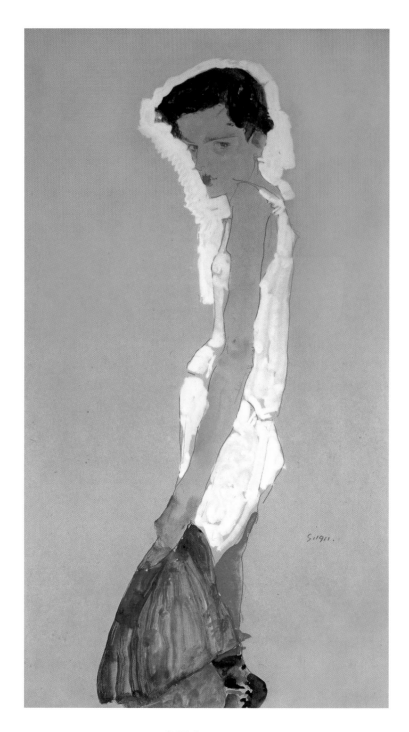

Girl Undressing. 1911.
Gouache, watercolor, and pencil. Initialed and dated,
lower right. 56 × 30.5 cm. Kallir D. 821.
Private collection.

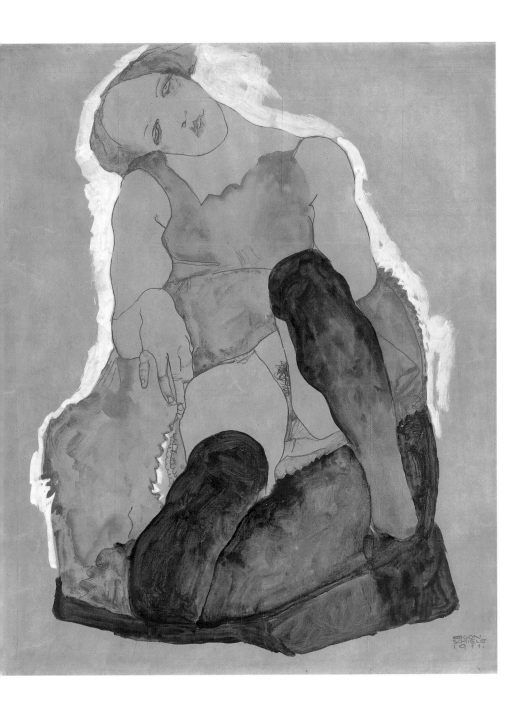

Girl with Black Stockings. 1911.

Gouache, watercolor, and pencil. Signed and dated, lower right.

47.5 × 38 cm. Kallir D. 829.

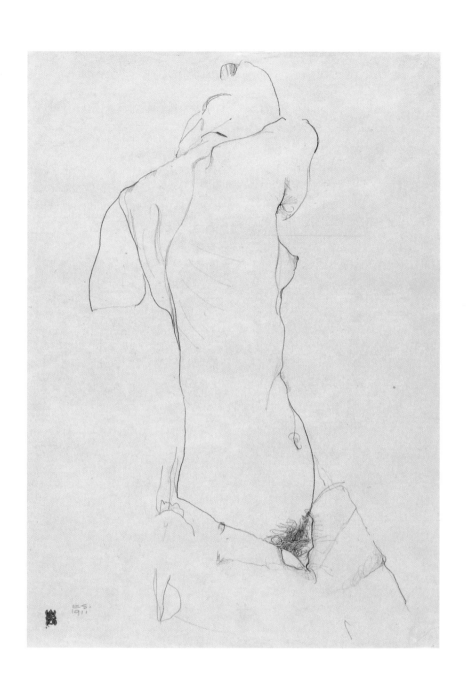

Female Semi-Nude. 1911.
Pencil. Initialed and dated, lower left.
44.8 × 32 cm. Kallir D. 845.
Werner Coninx-Stiftung, Zurich.

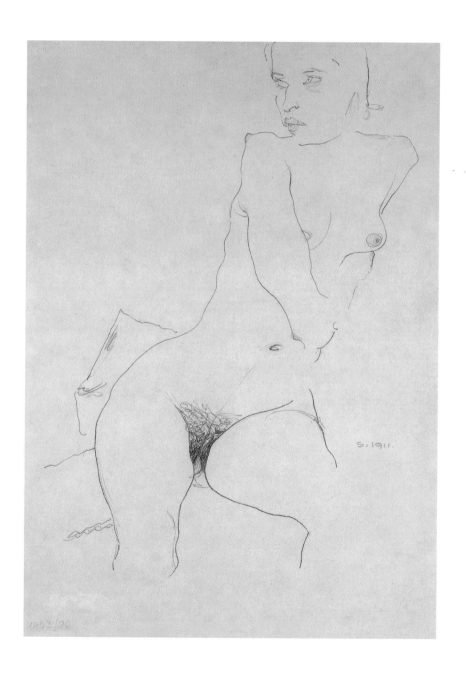

Seated Female Nude. 1911.
Pencil. Initialed and dated, lower right.
40.5 × 29 cm. Kallir D. 839. Private collection,
courtesy of Richard Nagy, Dover Street Gallery, London.

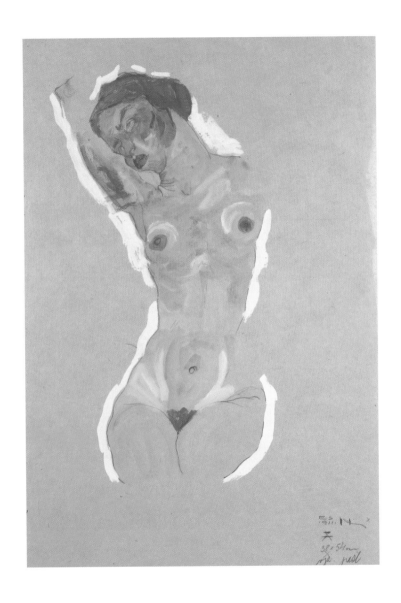

Above: *Female Nude*. 1911.
Gouache and pencil. Initialed and dated,
lower right. 40.7 × 26 cm. Kallir D. 837.
Moravská Galerie, Brno.
Opposite: *Two Girls on Fringed Blanket*. 1911.
Gouache, watercolor, ink, and pencil. Signed and dated 'Juli', lower left.
56 × 36.6 cm. Kallir D. 849.

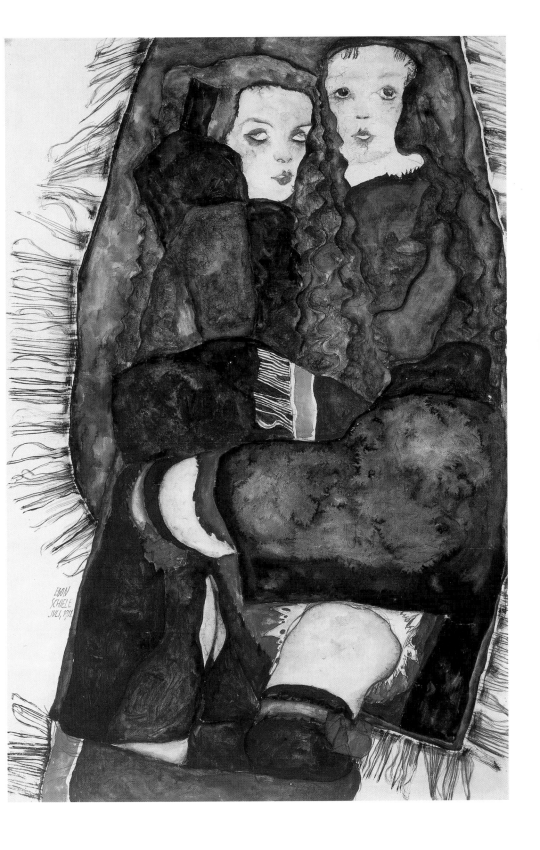

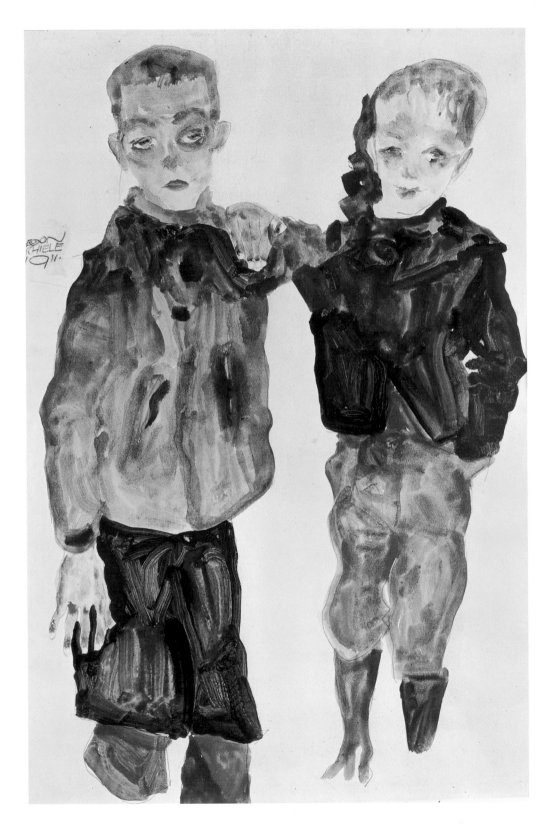

Two Boys. 1911.
Gouache, watercolor, and pencil. Signed and dated, upper left.
40.7 × 30.5 cm. Kallir D. 760. Private collection.

159

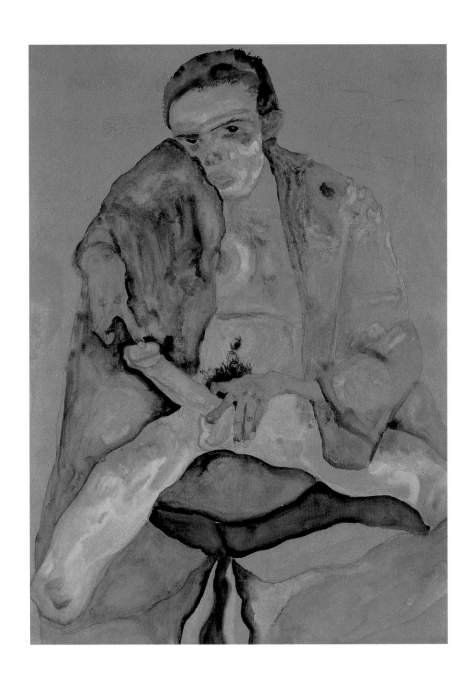

Eros. 1911.
Gouache, watercolor, and black crayon. Signed and dated, upper left.
Inscribed 'Eros', upper right. 55.9 × 45.7 cm. Kallir D. 948. Private collection, Australia,
courtesy of Richard Nagy, Dover Street Gallery, London.

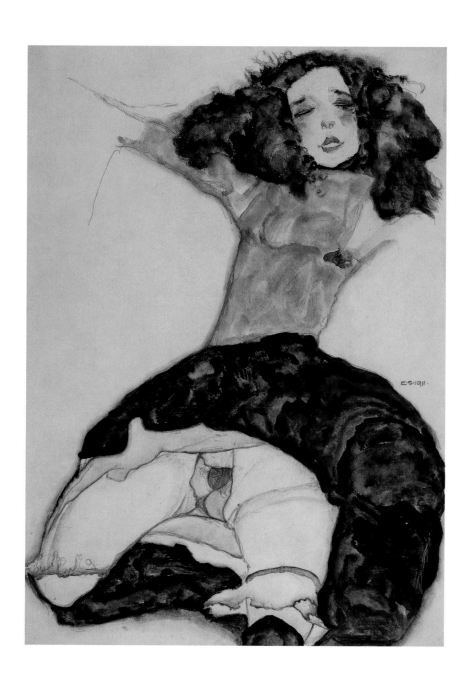

Black-Haired Girl with Raised Skirt. 1911.
Gouache, watercolor, and pencil. Initialed and dated,
center right. 55.9 × 37.8 cm. Kallir D. 859.
Leopold Museum, Vienna.

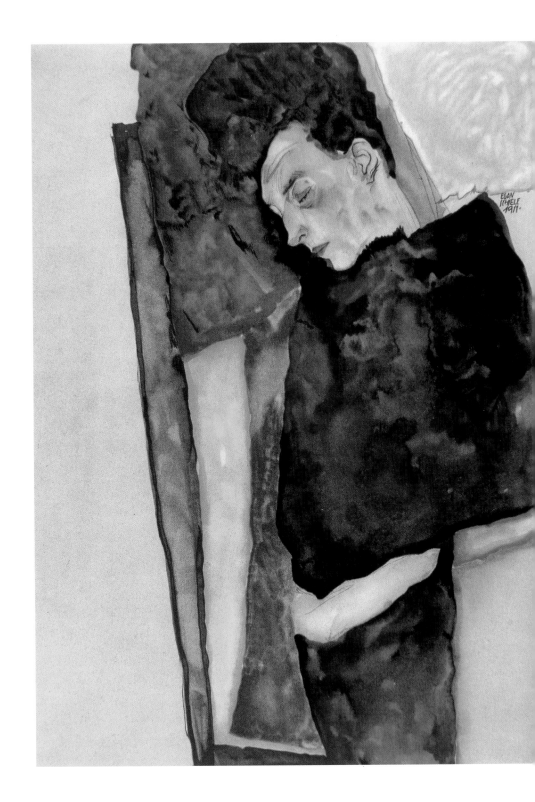

The Artist's Mother, Sleeping. 1911.
Watercolor and pencil with white heightening. Signed and dated,
upper right. 45 × 31.6 cm. Kallir D. 865.
Graphische Sammlung Albertina, Vienna.

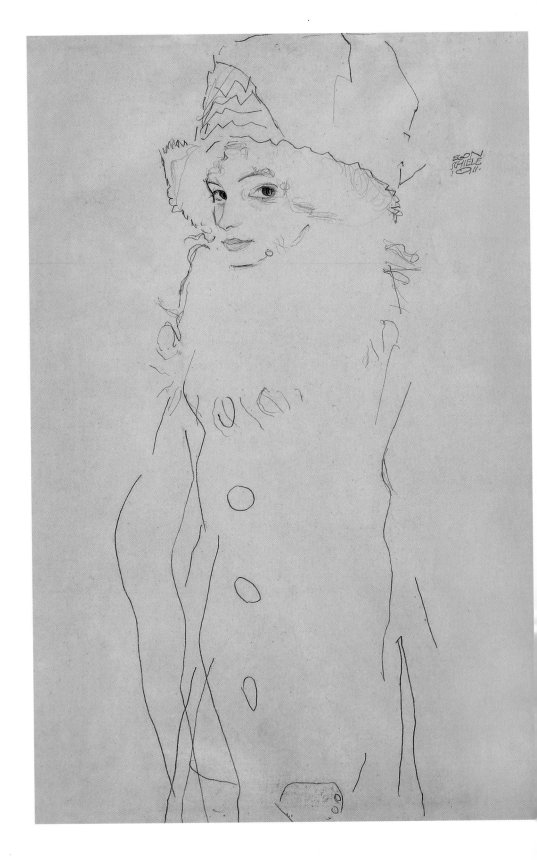

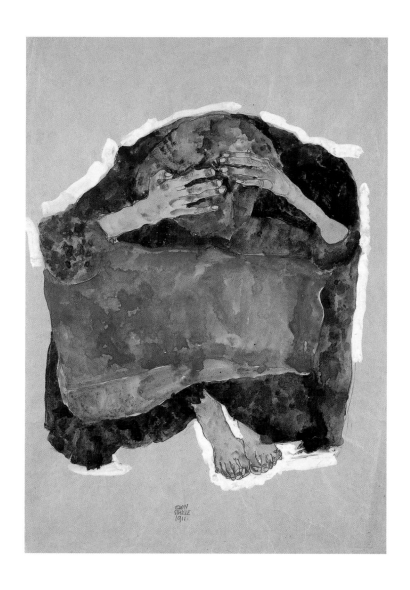

Above: *Seated Girl with Bent Head*. 1911.
Gouache, watercolor, and pencil with white heightening. Signed and dated,
lower center. 44.5 × 30.8 cm. Kallir D. 870. Private collection.
Opposite: *Portrait of Gerti Schiele Looking at the Viewer*. 1911.
Pencil. Signed and dated, upper right.
48.1 × 32 cm. Kallir D. 893.
Graphische Sammlung Albertina, Vienna.

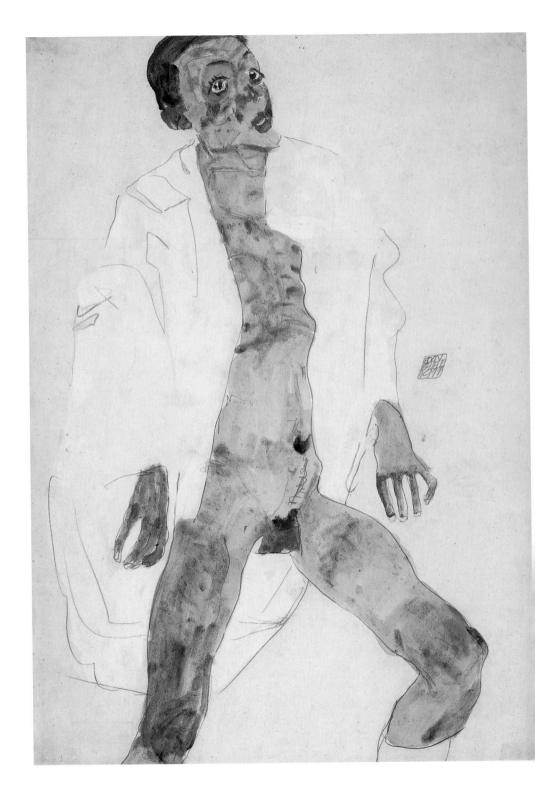

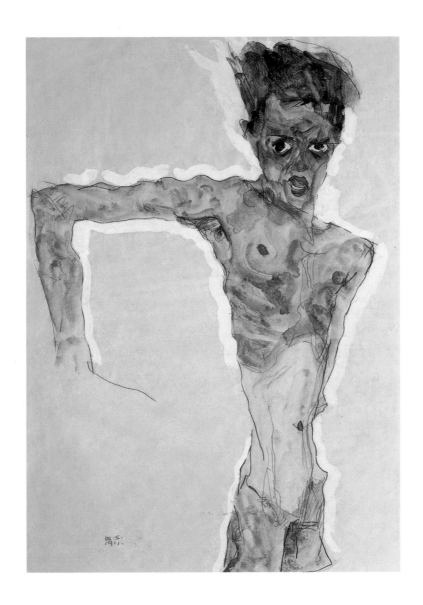

Above: *Self-Portrait*. 1911.
Gouache, watercolor, and pencil with white heightening.
Initialed and dated, lower left. 51.4 × 35 cm. Kallir D. 953.
The Metropolitan Museum of Art, New York; Bequest of Scofield Thayer, 1982.
Opposite: *Male Figure*. 1911.
Watercolor and pencil. Signed and dated, center right.
44.5 × 31.1 cm. Kallir D. 937.

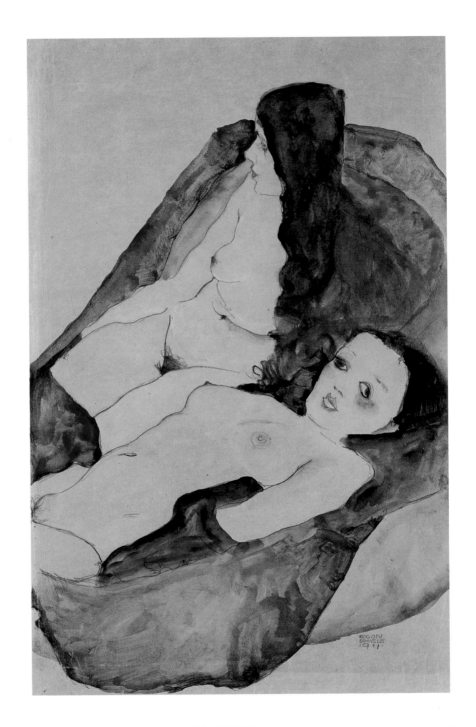

Nude Girls Reclining. 1911.

Watercolor and pencil. Signed and dated, lower right. 56.5 × 36.8 cm. Kallir D. 884.

The Metropolitan Museum of Art, New York; Bequest of Scofield Thayer, 1982.

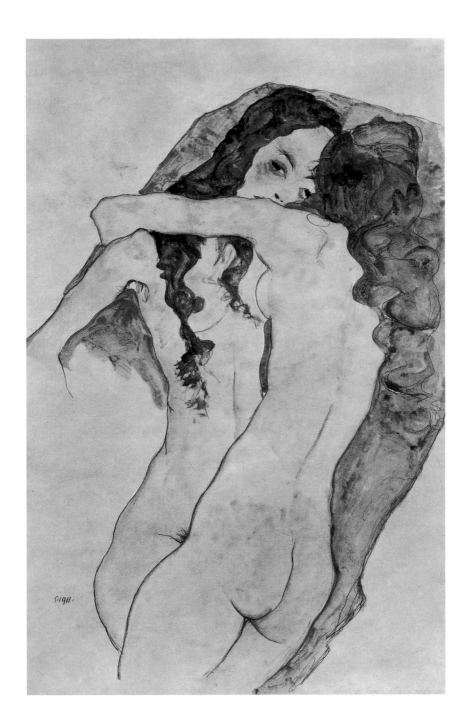

Two Women Embracing. 1911.
Watercolor and pencil. Initialed and dated, lower left. 56 × 37 cm. Kallir D. 885.
Private collection, courtesy of Richard Nagy, Dover Street Gallery, London.

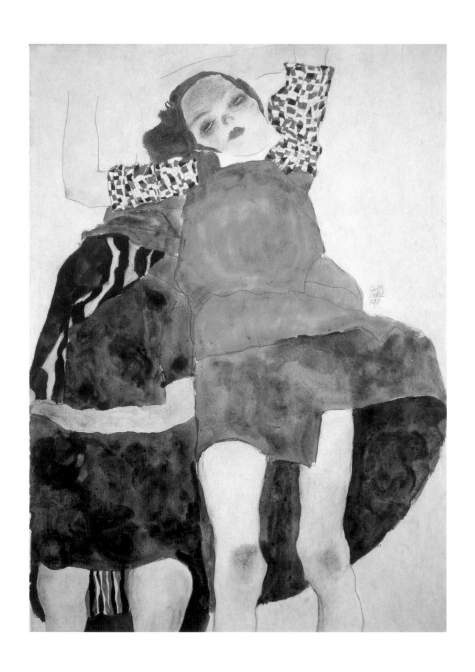

Two Seated Girls. 1911.
Watercolor and pencil with white heightening. Signed and dated,
center right. 43.7 × 30.3 cm. Kallir D. 772.
Private collection.

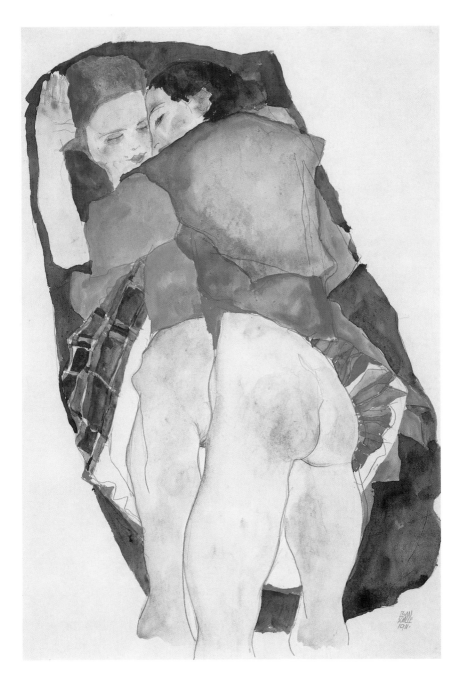

Two Girls (Lovers). 1911.
Gouache, watercolor, and pencil. Signed and dated,
lower right. 48.3 × 30.5 cm. Kallir D. 774. Private collection,
courtesy of Richard Nagy, Dover Street Gallery, London.

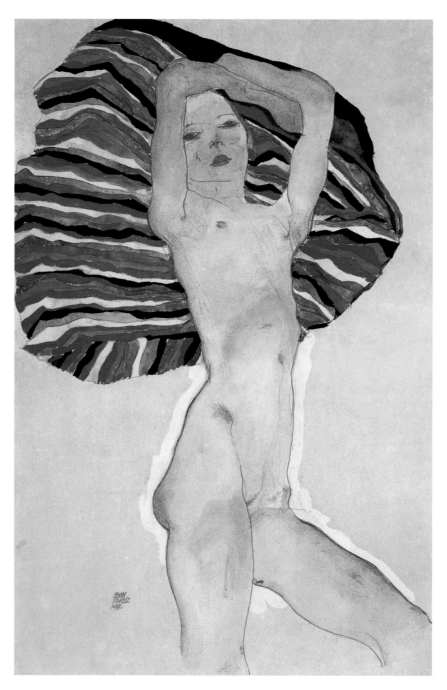

Nude on Colored Fabric. 1911.
Watercolor and pencil with white heightening. Signed and
dated, lower left. 47.9 × 31.1 cm. Kallir D. 776.
Private collection.

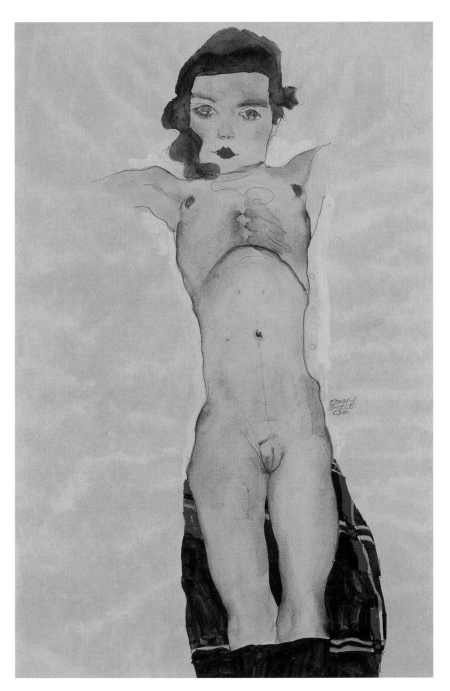

Standing Female Nude. 1911.
Watercolor, ink, and pencil. Signed and dated,
center right. 48 × 31 cm. Kallir D. 778.
Thyssen-Bornemisza Collection, Lugano.

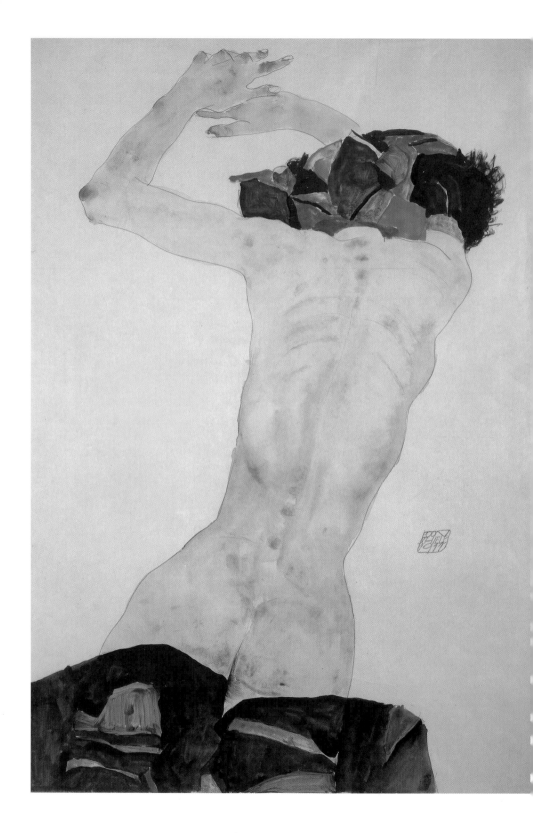

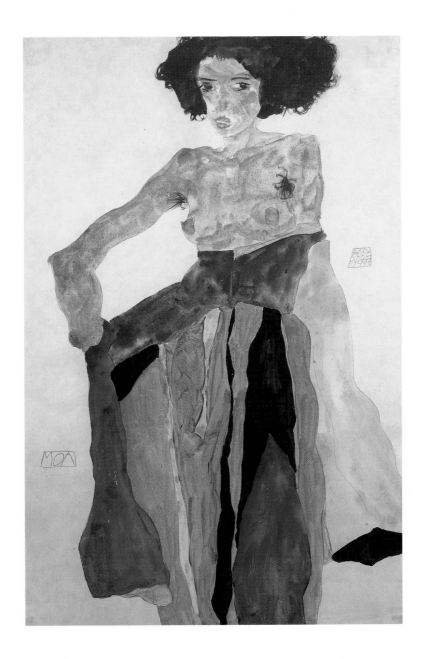

Above: *Moa.* 1911.

Gouache, watercolor, and pencil. Signed and dated, center right.

Inscribed 'Moa', lower left. 48 × 31 cm. Kallir D. 908. Private collection.

Opposite: *Female Nude with Colorful Kerchief, Back View.* 1911.

Gouache, watercolor, and pencil. Signed and dated, center right.

48.2 × 32.2 cm. Kallir D. 904.

Historisches Museum der Stadt Wien, Vienna.

Seated Girl with Bare Torso and Light Blue Skirt. 1911.
Watercolor and pencil. Signed and dated, center right.
48 × 31.5 cm. Kallir D. 919.
Haags Gemeentemuseum voor Moderne Kunst, The Hague.

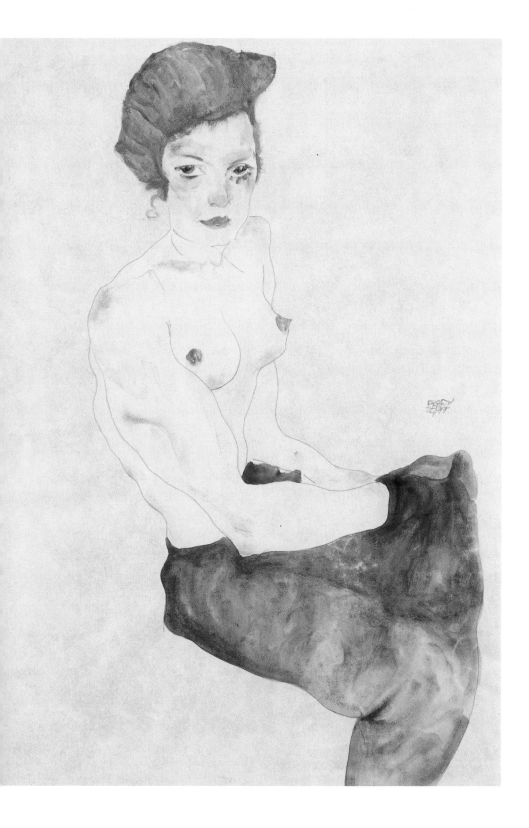

Observed in a Dream. 1911.
Watercolor and pencil. Signed and dated, center right. Inscribed
'Die Traum Beschaute', upper right. 48 × 32 cm. Kallir D. 922.
The Metropolitan Museum of Art, New York; Bequest of Scofield Thayer, 1982.

178

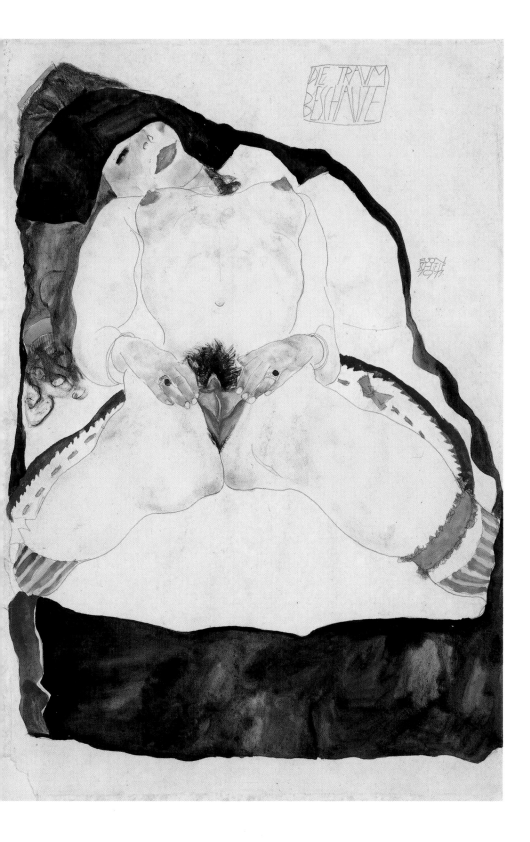

The Red Host. 1911.
Watercolor and pencil. Signed and dated, lower right, and titled
'Die rote Hostie', upper right. 48.2 × 28.2 cm. Kallir D. 972.
Private collection, courtesy of Galerie St. Etienne, New York.

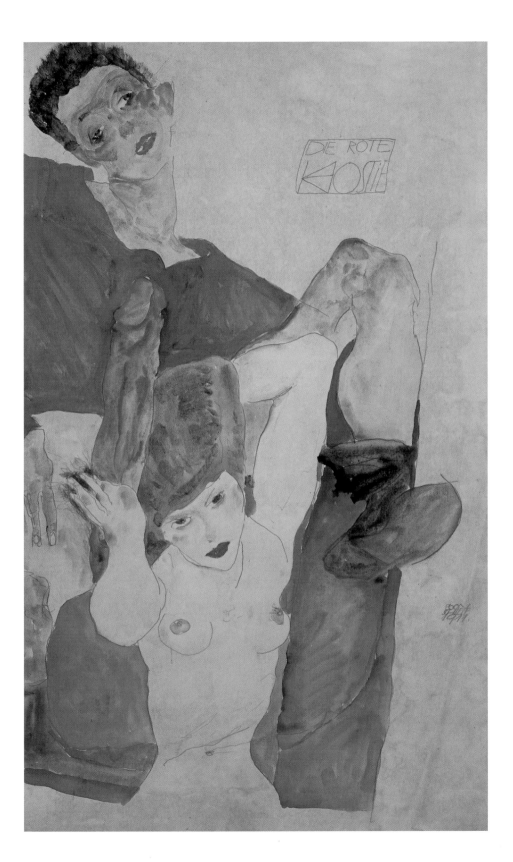

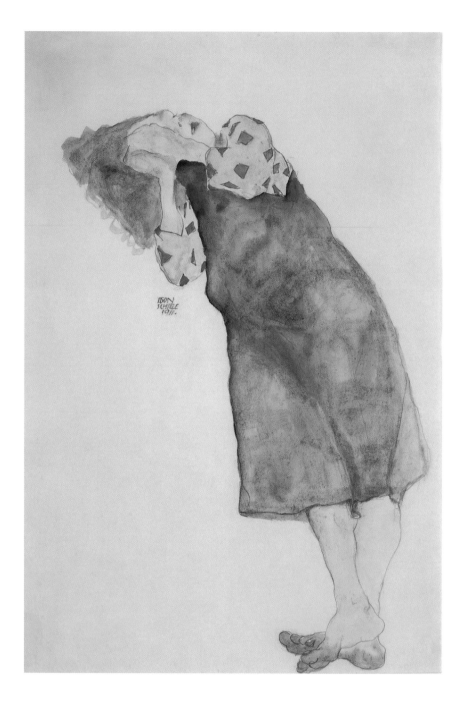

Sleeping Girl. 1911.
Watercolor and pencil. Signed and dated, center left.
48.6 × 31.4 cm. Kallir D. 769.
Private collection.

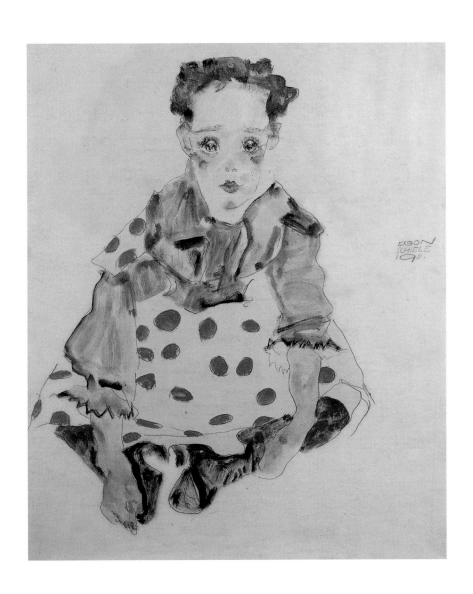

Girl in Polka-Dot Dress. 1911.

Watercolor and pencil. Signed and dated, center right. 43.3 × 30.3 cm. Kallir D. 786.

Private collection, courtesy of Galerie St. Etienne, New York.

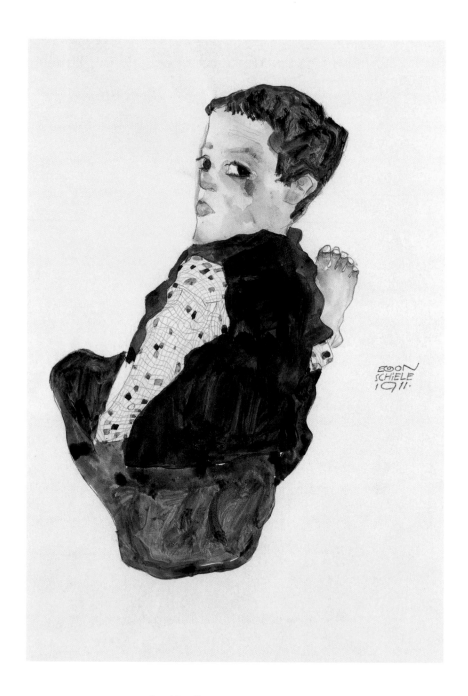

Seated Boy, Turning Around, Back View. 1911.
Watercolor and pencil. Signed and dated, center right.
48.1 x 31.6 cm. Kallir D. 787.
Bayerische Staatsgemäldesammlungen, Munich.

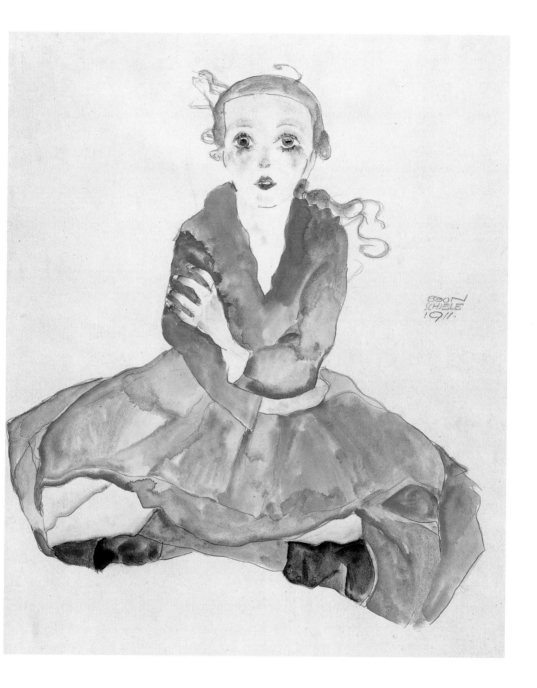

Seated Girl Facing Front. 1911.
Watercolor and pencil. Signed and dated, center right.
46.5 × 31.8 cm. Kallir D. 789.
Bayerische Staatsgemäldesammlungen, Munich.

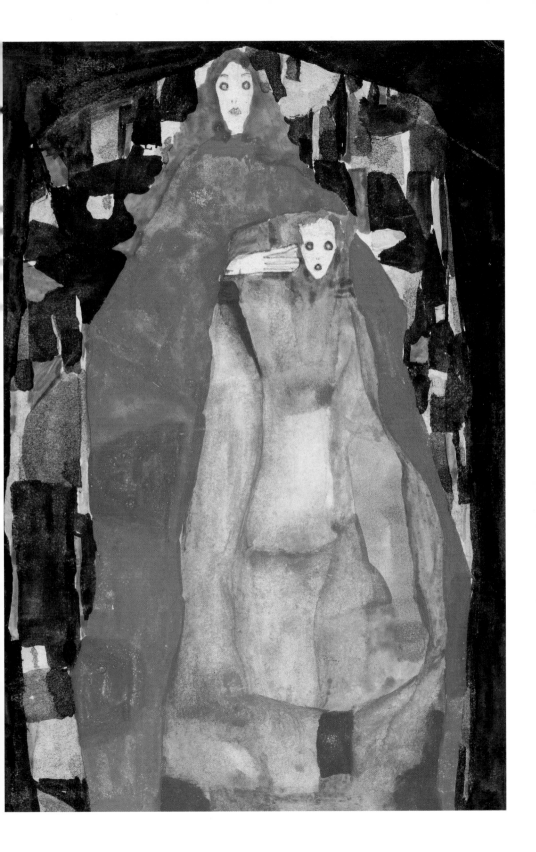

1912

In 1912, Schiele's refusal to bow to societal dictates finally generated serious reper-
cussions. The artist should not, however, be mistaken for a deliberate rebel. As he
himself put it, he was at heart 'a nice young man from a respectable middle-class . . .
family,' who not unreasonably believed that the sanctity of his creative mission gave
him special dispensation to do essentially as he pleased. Why, after all, should he
kowtow to patrons or dealers? It was *they* who should be grateful to *him* for allowing
them to share his vision. Nor did Schiele particularly care that his professional
viability was being compromised by his insistence on painting virtually unsalable
allegories, works that (he freely admitted) 'have value only for me.' The patronage
model offered by Klimt and the Wiener Werkstätte encouraged him to expect un-
conditional support as his due. That even Klimt and his cronies occasionally ran
afoul of Austrian tastes and financial realities was an unpleasant detail that somehow
eluded Schiele. All these artists on some level considered themselves above the rules
that ordinary mortals must obey.

Just as Schiele's ideas about patronage were not totally out of sync with those of
his colleagues, his sexual indiscretions transgressed contemporary protocol more in
style than in substance. It was perfectly permissible for a young, unattached male to
indulge in extramarital sex, provided he did so discreetly. People in Krumau and
Neulengbach were offended by Egon's *open* cohabitation with Wally—the fact that they
had a real relationship—not per se by the fact that they were sleeping together. The
artist's greatest offense—the one that eventually landed him in real trouble—was his
use of underage models. But here too, the prevailing Austrian attitude was shot
through with hypocrisy. It was at the time quite acceptable for a man to have sex with
a thirteen- or fourteen-year-old child, if she was a professional prostitute. The
brothels and streets of Vienna were full of young whores. Schiele, in all likelihood,

did *not* sleep with his child models in Neulengbach. But they were the children of respectable middle-class parents. And therein lay the artist's big mistake.

In Vienna, Schiele's child models had been destitute street urchins, glad for the warmth of his studio and whatever small payment he could afford. No one cared what happened to these youngsters. In Krumau and then in Neulengbach, the mutual attraction between Schiele and children persisted. He identified and empathized strongly with them, and they must have found him incredibly alluring. He was their first contact with an outer world more sophisticated than any they'd known. Schiele's skill in working with young models derived from his ability to put them totally at ease, to allow them simply to be who they were. For the most part, his portraits of children are entirely chaste.

Nevertheless, Schiele knew that children are not devoid of sexual impulses. With this admission, like his contemporary Sigmund Freud, he violated a powerful prevailing taboo. At the time, grown men, fearful of adult female sexuality, tended to idealize young girls, who were popularly considered to be totally asexual. The fetishized photographs of little girls that were collected by the early twentieth-century Austrian poet Peter Altenberg, or taken by the Victorian British writer Lewis Carroll, exude a subliminal eroticism that belies their surface innocence. The girls became safe objects of desire precisely because they were presumed to be so completely innocent, and this illusion needed to be preserved at all costs. In the eyes of Neulengbach's parents, Schiele was exposing their youth to a forbidden world merely by allowing them in his studio. It almost did not matter what he did (or did not do) with these children; their presence alone was scandal enough.

Schiele's downfall was precipitated by a retired naval officer's daughter, Tatjana Georgette Anna von Mossig. Apparently, this teenager had developed a crush on the artist. She followed him around constantly, and one day in the spring of 1912 showed up at his studio, announcing that she had run away from home. Egon and Wally (who was present the entire time) did not quite know what to do with the girl, so they agreed to bring her to her grandmother in Vienna. However, when the trio arrived in Vienna the next day, Tatjana changed her mind. She and Wally spent the night together there in a hotel room, and then they all returned to Neulengbach. By that time, however, Tatjana's father had gone to the police. Complaints of kidnapping and rape had been filed against Schiele, and a full-scale investigation ensued.

Eventually, the kidnapping charge was dropped. But the police began to focus on Schiele's artistic practices. They raided his studio, where erotic works were found and confiscated. Had children seen these? Had Schiele perhaps touched the youngsters as they posed? The first offense could justify a charge of 'public immorality.' The second could substantiate the rape complaint, even if Schiele and Tatjana did

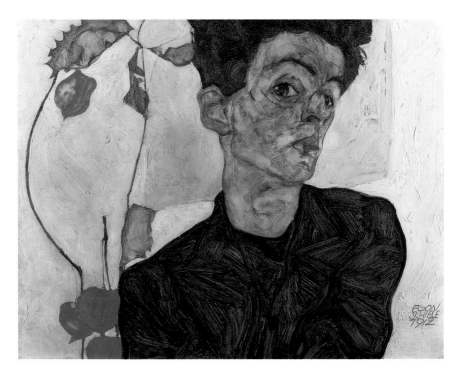

Fig. 14: Egon Schiele. *Self-Portrait with Chinese Lantern Plant.* 1912.
Oil and gouache on wood. Signed and dated, lower right. 32.4 × 40.2 cm.
Kallir P. 233. Leopold Museum, Vienna.

not engage in sexual intercourse. On 13 April 1912, Schiele answered a summons to appear for questioning at the Neulengbach police station. There, he was detained for eleven days without being formally charged. Finally, on 30 April, he was re-manded to the district jail in St. Pölten, where he was ultimately tried only for the morality offense. Of this he was found guilty. Taking into account the time already served, the judge sentenced him to three additional days, for a total of twenty-four days in jail.

Most of Schiele's friends and patrons agreed that he was lucky to get off so easily. The maximum sentence for 'public immorality' was six months. Tried and convicted of the more serious charges, he could have been imprisoned for twenty years. Nevertheless, even his relatively brief period of incarceration was a horrifying violation of Schiele's personal freedom and sense of artistic entitlement. The drawing and twelve watercolors that he executed in prison graphically record his mounting sense of panic and isolation. The first of these is dated 19 April, six days after his arrest (page 206). Wally, whose loyalty during the entire ordeal touched

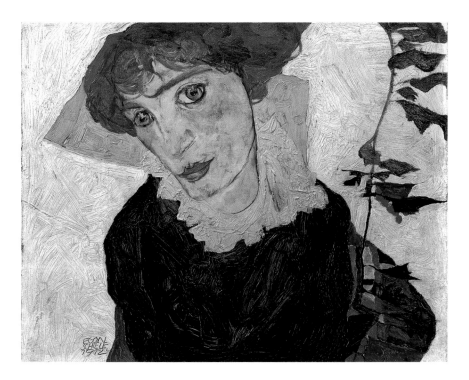

Fig. 15: Egon Schiele. *Portrait of Valerie Neuzil*. 1912. Oil on wood.
Signed and dated, lower left. 32.7 × 39.8 cm. Kallir P. 234.
Leopold Museum, Vienna

Schiele deeply, brought him art supplies as well as occasional treats such as fresh fruit. It is interesting that the artist, who had shown so little prior interest in the specifics of place or three-dimensional objects, devoted his first prison watercolors to recording his environment in painstaking detail (pages 206 and 207). As always for Schiele, art was a way to gain mastery over threatening forces, but in this case it did not work.

By 23 April, Schiele was painting anguished self-portraits (pages 208 and 209). Although he is clearly supine in most of these, all are signed as verticals. It is virtually the only time that the artist subjected his own image to the kind of spatial dislocation he routinely used in his drawings of the female nude. Schiele's sense of disorientation is conveyed even more directly in his tortured face, which protrudes helplessly from the encircling shroud of a heavy coat or coarse prison blanket. For many months after his release from the St. Pölten jail, the artist remained 'completely shattered.'

Stylistically, the prison works are of a piece with the drawings and watercolors of the preceding months, which continue trends seen in late 1911. During this period,

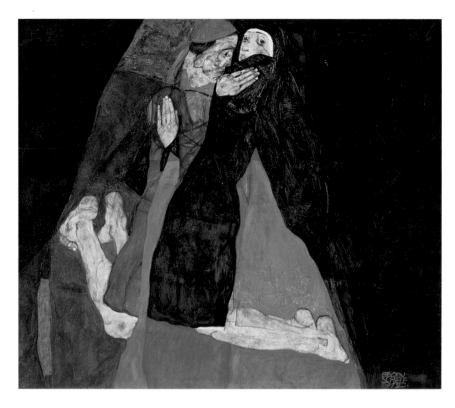

Fig. 16: Egon Schiele. *Cardinal and Nun (Caress)*. 1912. Oil on canvas.
Signed and dated, lower right. 70 × 80 cm. Kallir P. 232.
Leopold Museum, Vienna.

Schiele tended to use very hard pencils, which produce extremely faint lines (pages 198 and 200). Although he sometimes reinforced the contours of his drawings with short, feathery strokes, the overall effect remains ethereal. The round outlines of his nudes are so soft they appear almost to be melting (page 199). His colors, often diluted with white, are equally delicate (pages 199, 202, 203, and 205). Over the course of 1912, however, Schiele's approach gradually toughened. Softer leads yielded darker, more substantial lines, and his forms became more angular (pages 216–220). He mixed less water with his watercolors, or combined water-color with denser, drier gouache. This allowed him once again to stress the contrast between thickly brushed areas, such as hair or clothing, and wash-tinted flesh (pages 218 and 219). The propensity to deposit a narrow band of color along the principal edges of a form, observed already in 1911, became more pronounced: color washes glide across the central surface and then accumulate in darker gullies along the periphery (page 216).

Fig. 17: Gustav Klimt. *The Kiss*. 1907-08.
Oil on canvas. 180 x 180 cm. Novotny/Dobai 154.
Österreichische Galerie, Vienna.

For the first time in 1912, Wally Neuzil became a significant presence in Schiele's work. The difficulty of conclusively identifying her among the subjects of his prior paintings, watercolors, or drawings is hard to explain. Perhaps she had a completely different persona for the artist in 1911, and therefore looks different in those works. As always, Schiele's stylistic decisions were dictated by emotional considerations. Despite Wally's presence in Krumau the year before, it seems that the couple grew truly close only in 1912, after jointly facing the adversity of the prison incident. The matched portraits of himself and Wally that Schiele painted not long after his release from jail are like a pictorial declaration of betrothal (figures 14 and 15). (This pair of images is far more intimate and tender than either of the paintings the artist later did of his wife; figures 25 and 30.) From mid 1912 on, Wally's flashing green eyes, generous mouth, and tawny hair (often pulled up in a colorful headband) are instantly recognizable in Schiele's drawings (pages 217 and 218). She has now literally become real to him, and hence to us.

Wally was obviously the model for the most flagrantly subversive of Schiele's paintings, *Cardinal and Nun* (figure 16). Generally interpreted as a response to his imprisonment, the painting shows the artist and his lover/model in a passionate embrace that loosely parodies Klimt's gilded icon *The Kiss* (figure 17). There is no question that Schiele's painting would have been considered profoundly sacrilegious in Catholic Austria, but it is also apparent that the artist in some sense meant his allegory seriously. He was in his own mind a priest of art, and Wally, his consort and helpmate, was thus his acolyte in a shared spiritual undertaking. Even before his arrest, Schiele's allegorical paintings had taken on pronounced religious overtones, and he sometimes donned monklike robes for his self-portraits (page 205). Now, he began to assume a new guise: the artist as martyred saint (pages 290–291). In Schiele's view, his jailers were brutal philistines, incapable of recognizing the redemptive significance of his creative mission. *They* were the guilty ones. 'Hindering the artist is a crime, it is murdering life in the bud!' he wrote fervently on one of the prison watercolors.

Schiele could not initially comprehend that his own behavior might at least in part have been responsible for his arrest. However, he did have to face the disagreeable fact that even his staunchest supporters refused to condone his actions. Some of the artist's patrons, such as Heinrich Benesch (who had frequently warned him to be careful when drawing children and to always get advance permission from the parents), adopted a paternalistic 'I-told-you-so' attitude. Others, while at first rallying to Schiele's defense, were less inclined to be forgiving when faced with the reality of a criminal conviction. Ironically, it was Carl Reininghaus—the most licentious of the artist's steady customers—who now felt most compelled to distance himself. Schiele's relationship with Oskar Reichel, already antagonistic before his imprisonment, subsequently deteriorated further. Of the artist's early core group of collectors, only Benesch and Arthur Roessler played significant roles in the later years of his career.

Schiele endured some of his most serious economic privations to date in the wake of the prison incident. The loss of income during and after his confinement, plus the attendant legal costs, could not quickly be recouped. In Neulengbach, his landlord was holding his personal effects hostage in lieu of rent. For obvious reasons, Schiele felt he could not go back there. He stayed briefly with his mother in Vienna, then sublet space from his old friend Erwin van Osen—who ended up stealing his supplies and artwork. Apartment prices had risen drastically since Schiele had last lived in Vienna, and he could not afford his own studio. Instead, he traveled sporadically through the summer of 1912, visiting old haunts, such as Trieste (where he'd often gone with his sister Gerti) and new places, such as Lake Constance. The landscape watercolors he made on these trips are alternately cheery and elegiac. Schiele took comfort in the brightly colored fishing boats bobbing in Trieste harbor (page 210),

but on the shores of Lake Constance painted a spindly tree that mirrored his own feelings of isolation and fragility (page 215). Looking across the choppy lake to the sunny mountains in nearby Switzerland, he imagined a better place. 'I long for free people,' he wrote. 'I want to begin a new life.'

Despite the lingering emotional and financial aftereffects of the prison incident, it proved a watershed that in some ways did mark the beginning of a 'new life.' Schiele's career was progressing, albeit slowly. Even as he languished in jail, his paintings were being exhibited in a group show at the Hagenbund, a Viennese artists' association. For the first time, his work was widely reviewed in the local press, and the publicity (though by no means entirely favorable) attracted new clients, foremost among them the collector Franz Hauer. In October 1912, the artist finally managed to rent a studio in Vienna on the Hietzinger Hauptstrasse, which he retained for the rest of his life. Mustering his old contacts, he had approached Klimt for financial assistance. Toward the end of the year, Klimt came through with an introduction to one of his most important patrons, the wealthy industrialist August Lederer. Schiele was invited to spend the Christmas holidays at Lederer's mansion in Györ, Hungary, and commissioned to paint a portrait of his fifteen-year-old son Erich. This was the start of an ongoing relationship—less with August and his wife Serena than with Erich, who became a passionate collector of Schiele's watercolors and drawings. As with his 1912 portraits of Wally, Schiele's studies of Erich evidence a greatly expanded awareness of character and a newly generous humanism (pages 220 and 221). Professionally, personally, and artistically, Schiele was developing a more constructive relationship with his environment.

Standing Woman (Prostitute). 1912.
Watercolor and pencil. Signed and dated, lower right.
48.2 × 31.4 cm. Kallir D. 1045. The Museum of Modern Art, New York;
Mr. and Mrs. Donald B. Straus Fund, 1957.

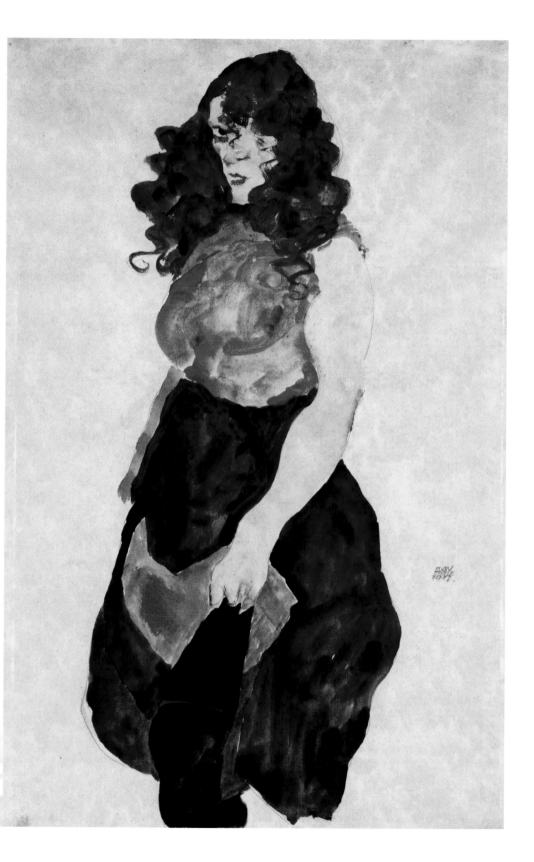

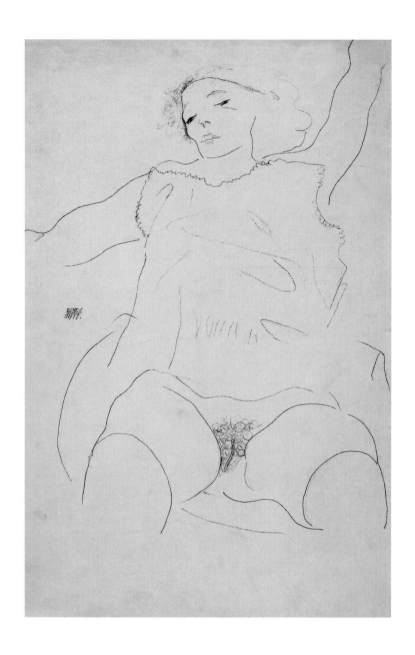

Above: *Frontal Female Semi-Nude, Stretching*. 1912.
Pencil. Signed and dated, center left. 48.2 × 31.9 cm. Kallir D. 1040.
Werner Coninx-Stiftung, Zurich.
Opposite: *Kneeling Female Nude, Front View*. 1912.
Watercolor and pencil. Signed and dated, lower right.
Inscribed 'Für Arthur Roessler', lower right. 48.3 × 31.5 cm. Kallir D. 1046.
Historisches Museum der Stadt Wien, Vienna.

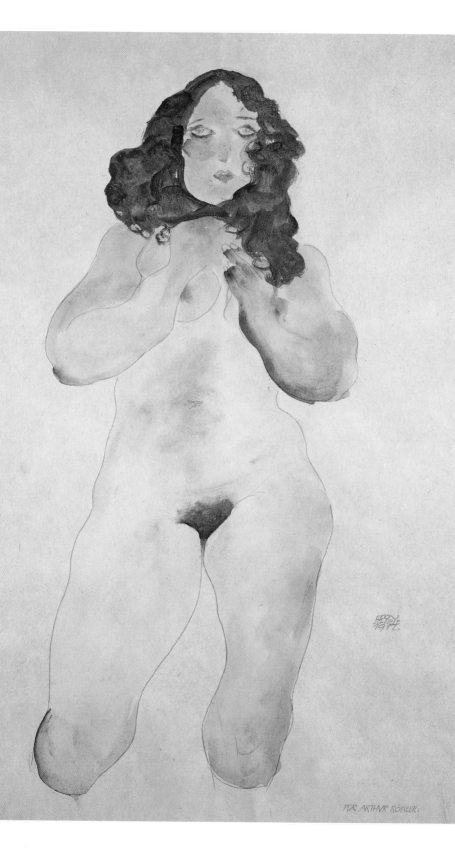

FÜR ARTHVR RÖSLER.

Above: *Seated Nude, Back View*. 1912.

Pencil. Signed and dated, lower right. 48.2 × 32.4 cm. Kallir D. 1145.

Historisches Museum der Stadt Wien, Vienna.

Opposite: *Nude Self-Portrait*. 1912.

Ink and black crayon. Signed and dated, lower right.

46 × 29.1 cm. Kallir D. 1160.

Leopold Museum, Vienna.

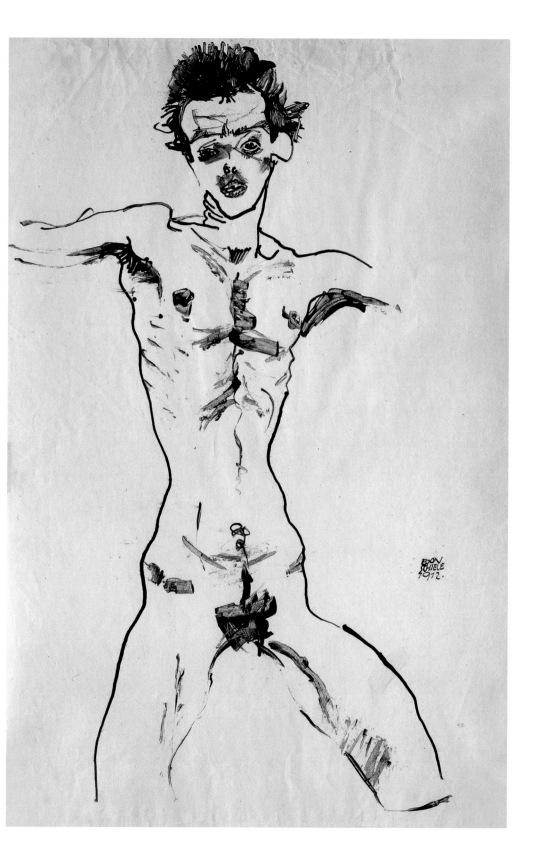

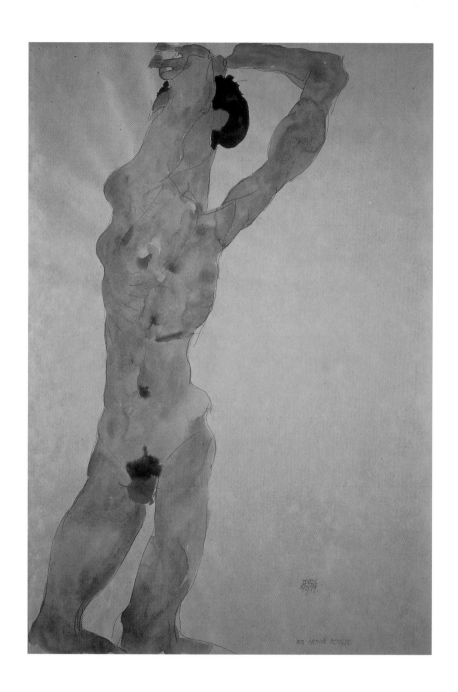

Male Nude. 1912.
Watercolor and pencil. Signed and dated, lower right.
Inscribed 'Für Arthur Roessler', lower right. 48.2 × 31.2 cm. Kallir D. 1148.
Historisches Museum der Stadt Wien, Vienna.

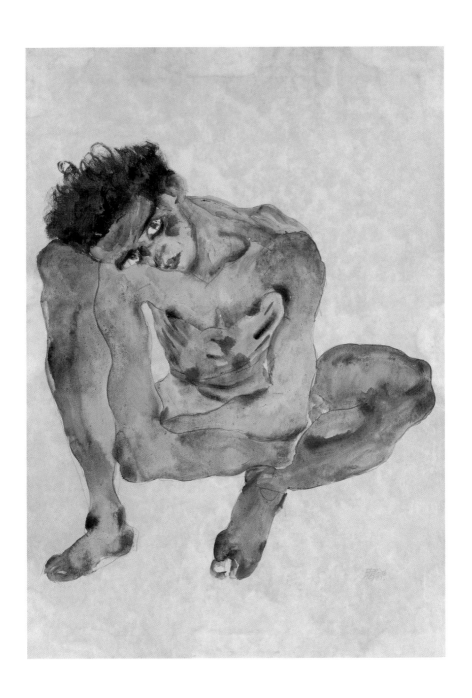

Squatting Man (Self-Portrait). 1912.
Watercolor and pencil. Signed and dated, lower right.
43.8 × 29.8 cm. Kallir D. 1167. Private collection,
courtesy of Richard Nagy, Dover Street Gallery, London.

Self-Portrait. 1912.
Gouache, watercolor, and pencil. Signed and dated, lower left. 47 × 30.5 cm.
Kallir D. 1172. Private collection.

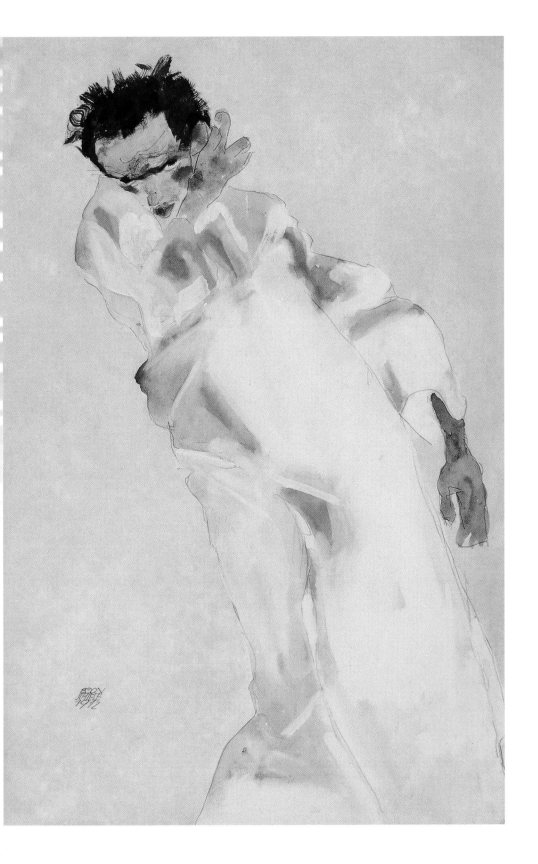

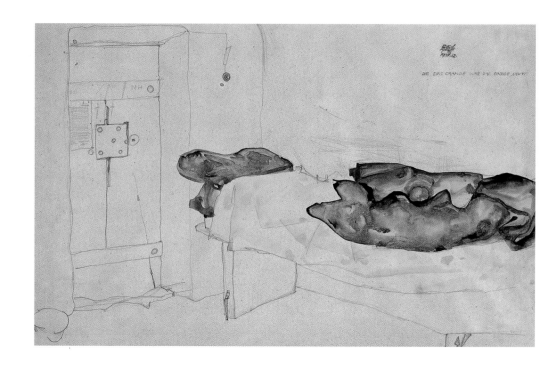

Above: *The Single Orange Was the Only Light*. 1912.
Gouache, watercolor, and pencil. Signed, dated, and inscribed
'Die eine Orange war das einzige Licht', upper right. 31.9 × 48 cm. Kallir D. 1179.
Graphische Sammlung Albertina, Vienna.
Opposite: *The Door to the Open*. 1912.
Watercolor and pencil. Signed, dated, and inscribed
'Die Tür in das Offene', lower left. 48.2 × 32 cm. Kallir D. 1181.
Graphische Sammlung Albertina, Vienna.

DIE TÜR IN DAS
OFFENE!

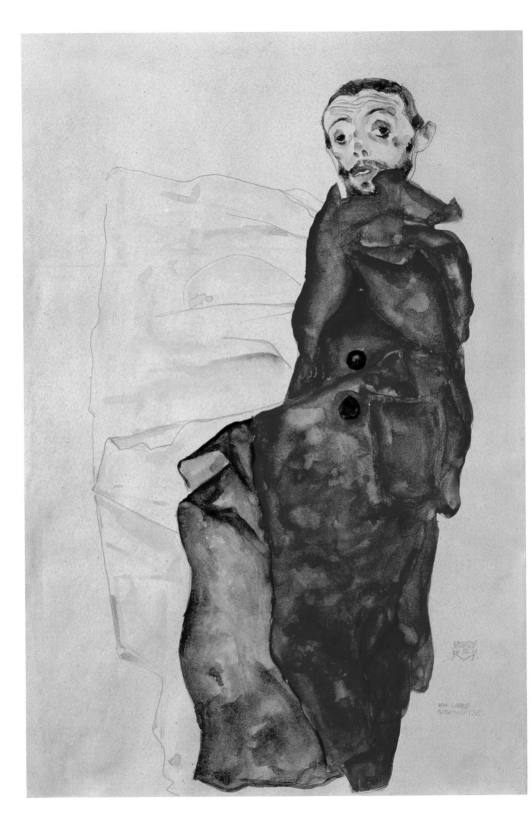

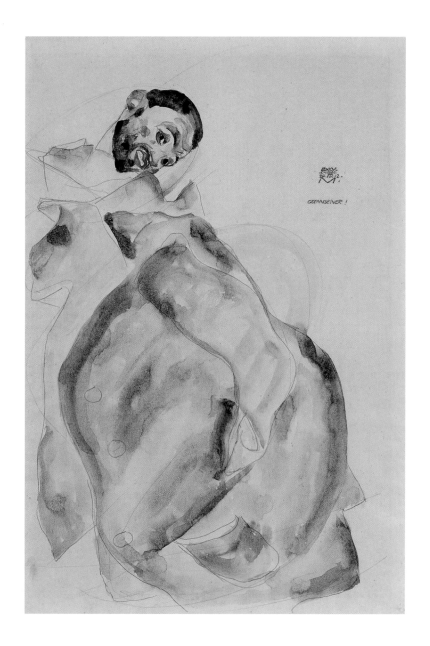

Above: *Prisoner!* 1912.
Watercolor and pencil. Signed, dated, and inscribed
'Gefangener!', upper right. 48.2 × 31.7 cm. Kallir D. 1188.
Graphische Sammlung Albertina, Vienna.
Opposite: *I Love Antitheses*. 1912.
Watercolor and pencil. Signed, dated, and inscribed
'Ich liebe Gegensätze', lower right. 48 × 31.4 cm. Kallir D. 1187.
Private collection, New York.

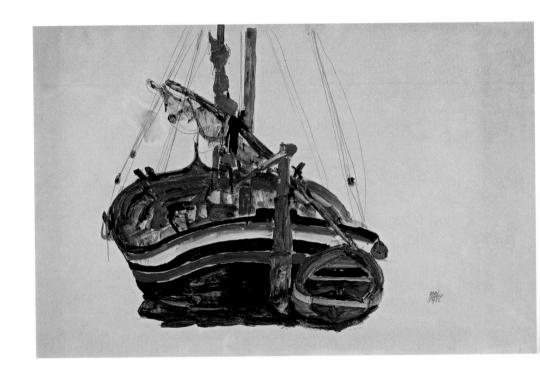

Above: *Trieste Fishing Boats.* 1912.

Gouache, watercolor, and pencil. Signed and dated,

lower right. 32 × 48.3 cm. Kallir D. 1207.

Graphische Sammlung Albertina, Vienna.

Opposite: *Wilted Sunflower.* 1912.

Gouache and pencil. Signed and dated, lower left.

45 × 30 cm. Kallir D. 1212.

Private collection, courtesy of Galerie St. Etienne, New York.

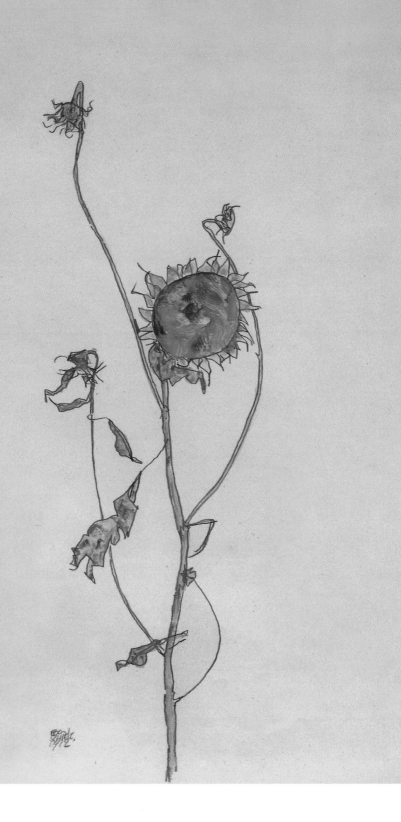

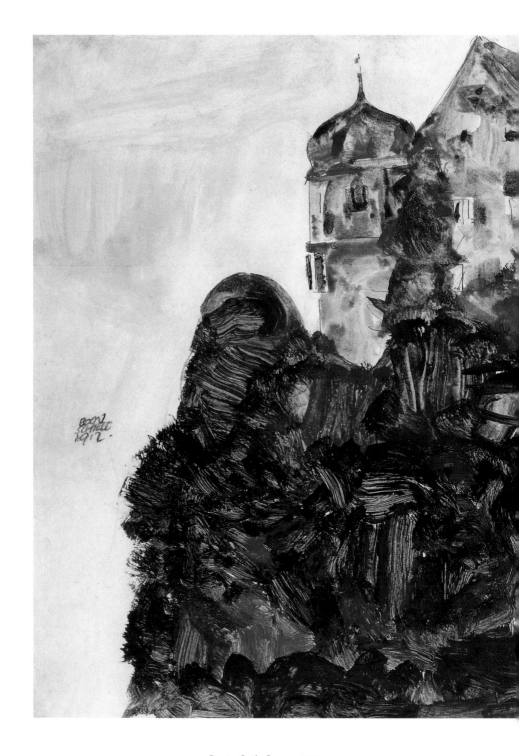

Deuring Castle, Bregenz. 1912.

Gouache, watercolor, and pencil. Signed and dated, center left. 31.5 × 48 cm.

Kallir D. 1216. Leopold Museum, Vienna.

Little Tree (Chestnut Tree at Lake Constance). 1912.
Watercolor and pencil. Signed and dated, lower left. 45.8 × 29.5 cm. Kallir D. 1215.
Private collection, courtesy of Galerie St. Etienne, New York.

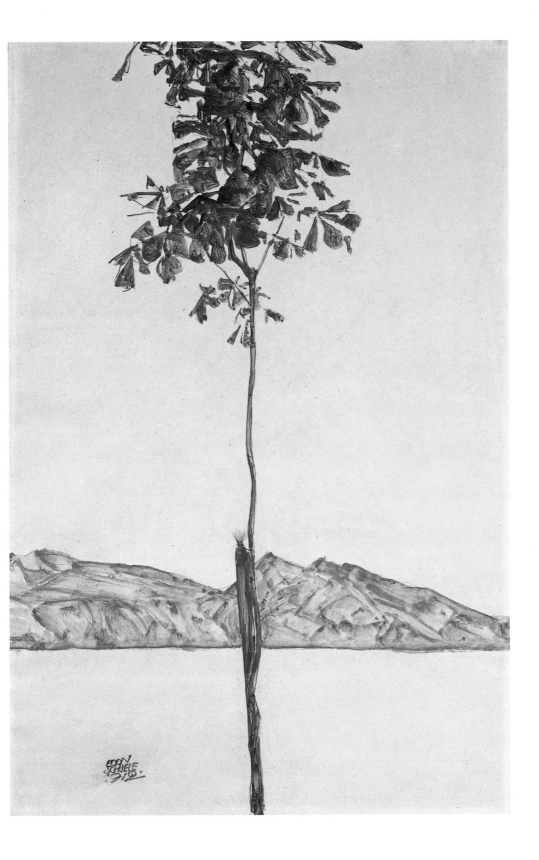

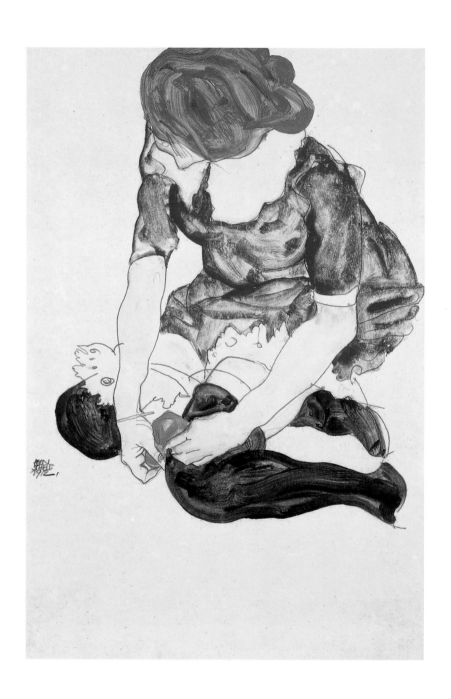

Woman in Blue Dress, Tying Her Garter. 1912.
Gouache, watercolor, and pencil. Signed and dated, lower left. 48.2 × 32 cm. Kallir D. 1120.
Private collection, courtesy of Galerie St. Etienne, New York.

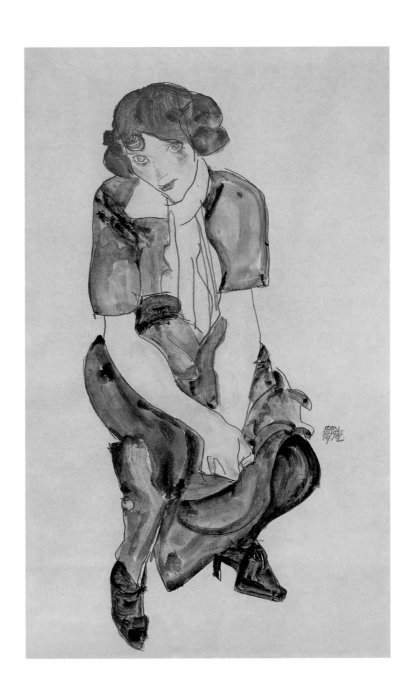

Seated Woman in Black Dress (Valerie Neuzil). 1912.
Watercolor and pencil. Signed and dated, lower right. 48.5 × 31.5 cm. Kallir D. 1124.
Private collection.

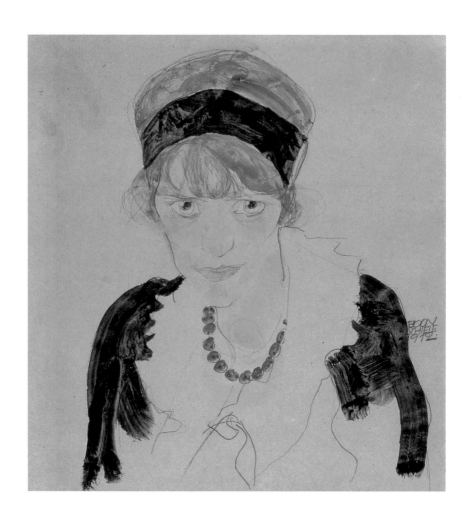

Above: *Wally*. 1912.

Gouache and pencil. Signed and dated, center right. 29.7 × 26 cm. Kallir D. 1118.

Private collection, courtesy of Galerie im Griechenbeisl, Vienna.

Opposite: *Self-Portrait, Bust*. 1912.

Watercolor and pencil. Signed and dated, lower right.

35 × 25.3 cm. Kallir D. 1174. National Gallery of Art, Washington, D.C.;

Gift (partial and promised) of Hildegard Bachert in memory of Otto Kallir, 1997.

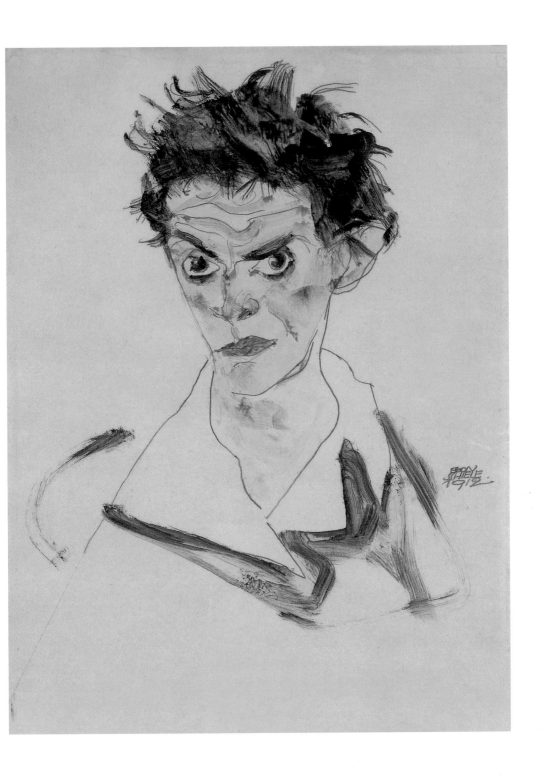

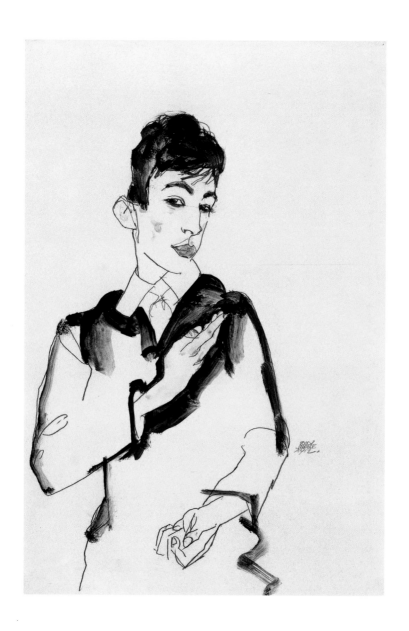

Above: *Portrait Study of Erich Lederer*. 1912.

Watercolor and pencil. Signed and dated, lower right.

48.1 × 31.9 cm. Kallir D. 1001.

Staatliche Graphische Sammlung, Munich.

Opposite: *Erich Lederer in Front of a Window, Györ*. 1912.

Watercolor and pencil. Signed and dated, lower right.

49 × 34 cm. Kallir D. 1000.

Private collection.

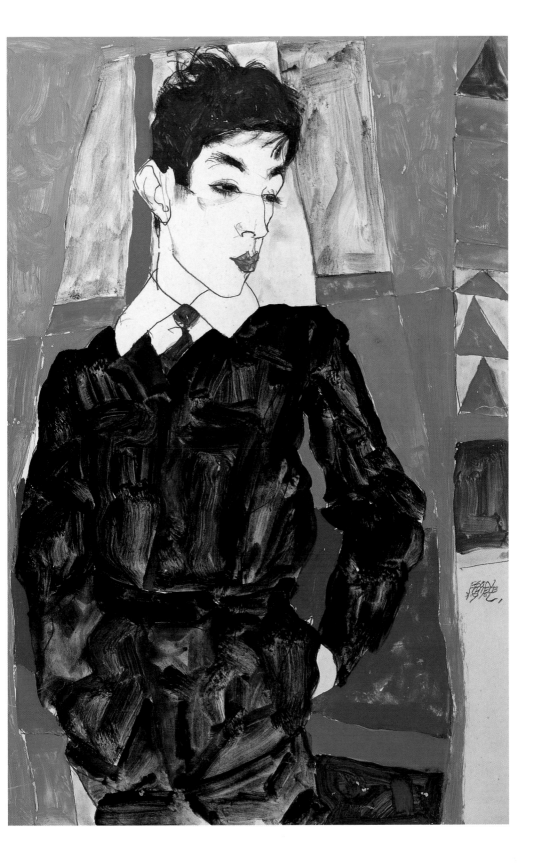

1913

After the turmoil of 1912, 1913 was a relatively placid year for Schiele. Undoubtedly he needed a bit of quiet and repose to get his bearings after what he'd endured. Settling into his new studio in Vienna, trying to get his career back on track, pursuing his deepening relationship with Wally: these were the mundane tasks at hand. Whereas formerly his artistic development had mimicked the rapid metabolism of a growing boy, Schiele's pace now slowed slightly. Nonetheless, he continued to evolve markedly. From the chrysalis of the next few years would emerge the adult artist. Schiele was leaving the solipsistic world of late adolescence. His imprisonment had forced him to acknowledge, for the first time, that in order to pursue his artistic mission he would somehow have to accommodate the sensibilities of society at large.

The most direct practical lessons of the prison experience involved Schiele's treatment of erotic subject matter, and it is apparent that he made concessions in this regard right away. For one thing, he almost entirely stopped drawing children. Very few such works survive from 1912—possibly because they were confiscated by the court or destroyed by the artist himself. Until 1917–18, when he employed a professional woman and child modeling team, the artist rarely drew children. From 1913 on, the few underage subjects in his drawings and watercolors are mainly relatives or friends, depicted without any sexual connotations.

Schiele's drawings of grown women, too, became less explicitly erotic. It was not so much that the artist intentionally toned down his subject matter, as that he introduced an element of aesthetic distancing that placed more emphasis on unusual compositional angles and poses (pages 237, 238–239, 241–243, and 259). His lines became increasingly loose and erratic. In some drawings from 1913, bizarrely foreshortened figures seem to hurtle through space or walk with stiff, uneasy steps on wedgelike, triangulated feet. Interior forms are subdivided into harsh, angular

subsections, sometimes heightened by similarly modulated blocks of color (pages 237, 238–239, 241, 246, 247, 259, and 263). This increased geometricity—which appears concurrently in the artist's paintings—has been attributed to the influence of Cubism. Schiele had become aware of the French style indirectly, through its impact on his German colleagues and through magazine reproductions. His idiosyncratic assimilation of Cubist geometry had a paradoxical effect, bringing with it not only a greater degree of abstraction, but also a greater awareness of volume. The artist's 1913 nudes begin a subliminal return to three-dimensional verisimilitude.

Over the course of 1913, Schiele showed a growing tendency to sculpt his figures in the round (pages 253, 254, 259–261, and 265–267). He had always been especially interested in highlighting the perimeters of his drawings: outlining them with white gouache in 1910 and 1911, and later edging them with thin washes of watercolor. In 1913, he occasionally accented contours with the broad side of a soft pencil (pages 238–239 and 251). All these edging devices were essentially two-dimensional. But now, for the first time, Schiele deliberately began to build up from the edge, which became the boundary between the flatness of the sheet and a palpable human body. With a relatively dry brush, the artist drew pale veils of color inward from the darker bands along the periphery, alternating tones of ochre, red, and green to suggest subtle mounds and valleys of flesh. Denser accents in these same colors were then superimposed on particularly prominent or significant areas, such as cheekbones, elbows, and knuckles. The artist's drawing style, too, became more three-dimensional. By the end of the year, his lines readily evoke an underlying structure of bone and muscle.

What Schiele's nudes gained in three-dimensionality, they lost in personality (pages 237, 238–239, 241, 242, 253, and 254). Frequently in 1913, his models avert their eyes. Sometimes their features are so stylized as to suggest caricature. There is no longer any sense of how the artist's subjects are responding to him, nor does he seem at all interested in their interior lives. This dehumanizing approach is carried to an extreme in a series of torso studies, in which the heads are unceremoniously lopped off by the edge of the sheet (pages 246, 247, 255, and 256). Yet at the same time, Schiele's formal portraits of women grew in sensitivity. This is seen not only in his depictions of his lover Wally, but also in his studies of Erich Lederer's sister Elisabeth (pages 232 and 233). Schiele was beginning to assimilate the split that is intrinsic to the double standard: only a chaste, 'good' woman is a full-fledged human being; a sexualized model, like a prostitute, is merely an object. Wally, when she takes her clothes off for Egon, is more noticeably animated than her anonymous colleagues (pages 236 and 240)—but even she is a far more substantial person in his straight portraits.

Fig. 18: Egon Schiele. *Resurrection (Graves)*. 1913.
Oil on canvas. Signed and dated, lower right. 200 × 220 cm. Kallir P. 251. Present
whereabouts unknown. Photograph courtesy of Galerie St. Etienne, New York.

Schiele's 1913 male nudes and self-portraits naturally share the stylistic attributes
of that year's female nudes. Oblique views and skewed angles, in tandem with the
absence of any location markers, create the feeling that the men are dangling in space
(pages 248–249 and 265–267). Some seem to jerk about like marionettes on a string.
However, perhaps because Schiele served as his own model even for the generic male
figures, they are always viewed straight-on, rather than from above. This holds in
check the unnerving sense of disorientation that is often seen in the artist's female
nudes. The men as a rule possess a gravitas that is lacking in the women.

Particularly toward the end of 1913, Schiele occasionally inscribed his drawings
with short titles (pages 253–257, 259, 265–267). Their significance, however, is hard
to discern. As a rule, the artist never titled his works on paper, and it may be that the
inscriptions were merely a short-lived attempt to keep track of the pieces when he sent
them out on exhibition. Some of the inscriptions are purely descriptive ('Torso,'
page 255), while others appear to reflect the artist's overarching allegorical concerns

('The Truth Unveiled,' page 265). The inscriptions on some of his self-portraits recall the role-playing of 1910, as when he calls himself a 'Preacher,' 'Caller,' or 'Fighter' (page 267). In other, more introspective self-portraits, Schiele seems newly vulnerable, a bit quizzical, and almost endearingly open (page 251).

Many of Schiele's 1913 drawings and watercolors relate to a series of monumental canvases conceived during the same year. In the aftermath of his prison experience, the artist had become obsessed with codifying his quasi-religious visions in huge allegories. He wanted, as it were, to confront his critics on their own terms: to justify himself with mural-sized statements worthy of his mentor, Klimt, or his one-time academic nemesis, Christian Griepenkerl. In early 1913, Schiele completed his largest work to date: *Resurrection* (200 by 220 cm; figure 18). The title needs little explanation. Schiele painted himself as an entombed figure waking from a deep slumber, much as he was now emerging from the shock of his recent imprisonment. His two next paintings were even larger and more ambitious. Through the latter half of 1913 and on into 1914, most of the artist's efforts revolved around the pictures *Conversion* and *Encounter* (also called *Self-Portrait with Saint*).

Unfortunately, Schiele was unable to complete either *Conversion* or *Encounter*, and all we know of them comes from the surviving fragments and studies. It is to be assumed that the artist, whose forte was intimacy, was simply unable to make the compositions work on such a large scale. (*Conversion* measured 200 by 300 cm before it was cut up; *Encounter*, measuring 199 by 119 cm, was meant to be complemented by an additional canvas extending five or six meters.) In both these paintings, Schiele pursued the themes of suffering, enlightenment, and redemption that had preoccupied him for some time. Each of the canvases was to have depicted a spiritual interchange between a column of seekers and a godlike leader. Many of the figures in the artist's 1913 drawings and watercolors would have become characters in these allegories, their short tunics punctuating and unifying a friezelike tableau (pages 245–247, 256, 265, and 269). During this period, Schiele added a new metaphor to his allegorical mix: blindness. Although it was his role, as an artist, to lead the blind, he now portrayed himself less as a 'seer' (a dominant trope in his 1911 self-portraits) than as a fellow seeker. Schiele showed himself alternately as leader and as acolyte: sometimes he wore the halo (page 270), but at other times the role of 'saint' was played by someone else (page 271).

A more successful distillation of Schiele's evolving allegorical cosmology than that attempted in *Conversion* and *Encounter* can be found in the paired gouaches *The Blind I* and *Holy Family* (pages 230 and 231). The former work depicts the unfortunate victims of spiritual or artistic ignorance; in the latter, Egon and Wally (playing the two main characters) offer redemption. As with *Cardinal and Nun* (figure 16), it is possible to see sacrilegious intent in this small gouache. But this time it is far less likely that

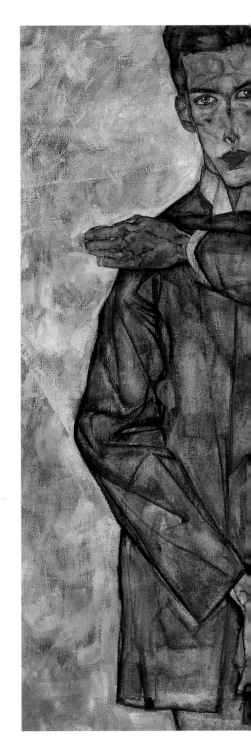

Fig. 19: Egon Schiele.
*Double Portrait (Chief Inspector Heinrich Benesch
and His Son Otto)*. 1913. Oil on canvas.
Signed and dated, lower right. 121 × 131 cm.
Kallir P. 250. Neue Galerie der Stadt Linz,
Wolfgang-Gurlitt-Museum, Linz.

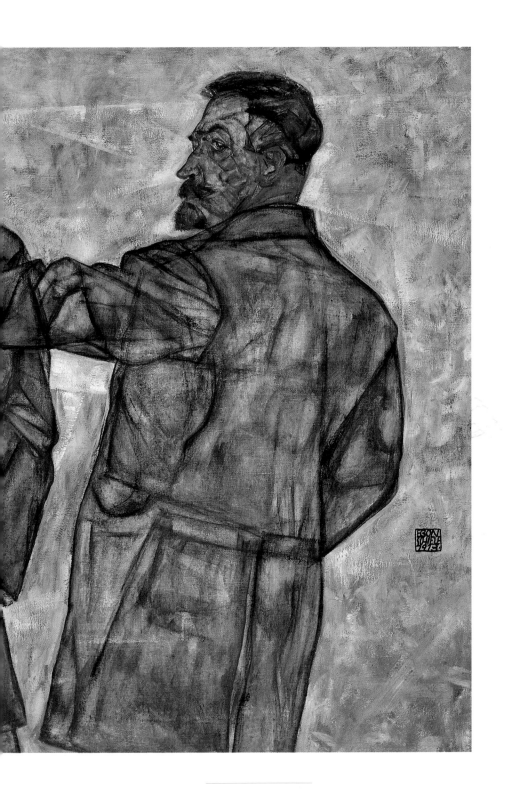

Schiele meant any offense. It is the infant (representing art) who is the focal point here. Rather than identifying himself with the baby (as he did in the 1911 painting *Dead Mother* [figure 11]), the artist presents himself as merely a means to an end. In this, Schiele evidences a newfound humility. The inclusion of a female partner and an imagined audience likewise suggests a more wholesome integration of the self with society.

Schiele's inability to complete *Conversion* and *Encounter* is indicative of the extent to which his reach exceeded his grasp. Such paintings were impractical in every way. For if Schiele's smaller allegories were hard to sell, large ones were even less likely to appeal to collectors. And they were costly: for an artist who, in early 1913, had been reduced to using sewn-together scraps of canvas, the materials for such big paintings were an enormous extravagance. Schiele in 1913 was still basically living hand-to-mouth. Perhaps in a desperate attempt to get into the black, he tried to raise his prices, but this further alienated his early patrons, who were used to paying less. 'One sacrifices when one loves,' he would retort when customers complained that he was forcing them to spend above their means.

Unfortunately, Schiele's most devoted supporters, Benesch and Roessler, were also his poorest. Benesch often complained that he was being neglected in favor of wealthier clients. 'It is bitter to be treated as an expendable commodity by a friend,' he lamented. For some time, apparently, he had wanted Schiele to paint his portrait, and finally in 1913 the artist acquiesced (figure 19; pages 234 and 235). The result—a double portrait of Heinrich and his teenage son Otto—is one of Schiele's strongest paintings of his patrons. The subject must have resonated deeply with the artist, who still mourned the loss of his own father and could also readily identify with young Otto. Given the pairings of monklike leaders and acolytes that had populated Schiele's allegories for the past two years, it is interesting that the real father-son relationship in the double portrait is shown not as an idealized exchange of wisdom, but as an entirely realistic power struggle. Heinrich's outstretched arm (unlike the divine hands in Schiele's allegories) does not anoint or empower, but instead clearly seems to be blocking his son's path.

Schiele's need to appease his patrons while simultaneously protecting his own interests placed him in an awkward position. Benesch, as it turned out, could not afford to purchase the double portrait, and Schiele was lucky that Carl Reininghaus instead agreed to buy it. Yet notwithstanding the personal and financial complications of dealing directly with clients, the artist continued to harbor profound disdain for the commercial realm occupied by professionals such as Hans Goltz. Goltz, in turn, was not particularly delighted with Schiele. In 1913, after repeated nagging from Roessler, the Munich dealer finally agreed to give the artist a one-man show.

Unfortunately, Roessler's attempt to advance his protégé's career backfired. Goltz's expanded commitment to Schiele meant greater expenses, and the investment did not pay off. The solo exhibition took place in the summer of 1913, and in October the dealer terminated his representation of Schiele. 'Your paintings', Goltz coolly informed him, 'are, in the present phase of your development, unsalable in Germany.'

Despite Schiele's nascent efforts to accommodate the demands of other human beings, he remained uncompromising in many key respects. He was steadfast in his commitment to arcane allegory, no matter the direct and indirect costs. And he still had not relinquished the notion that society owed him a living. It would take further shocks—looming financial disaster, marriage, and a world war—for him to complete the process of maturation begun in the aftermath of the prison incident.

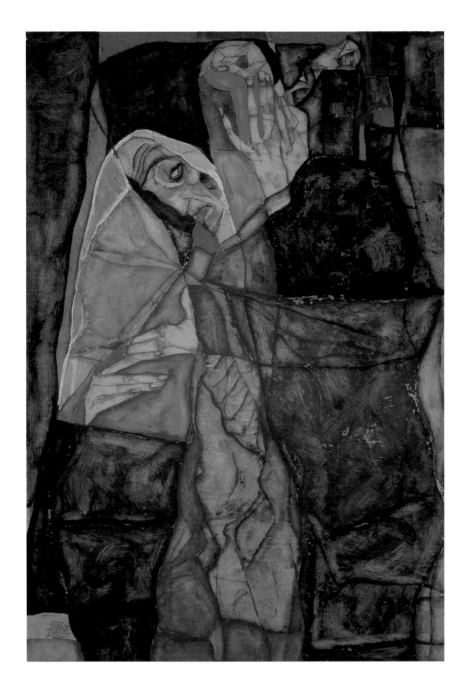

The Blind I. 1913.
Gouache and pencil on parchmentlike paper. Signed and dated,
lower left. 46.7 × 31.5 cm. Kallir P. 249. Private collection,
courtesy of Richard Nagy, Dover Street Gallery, London.

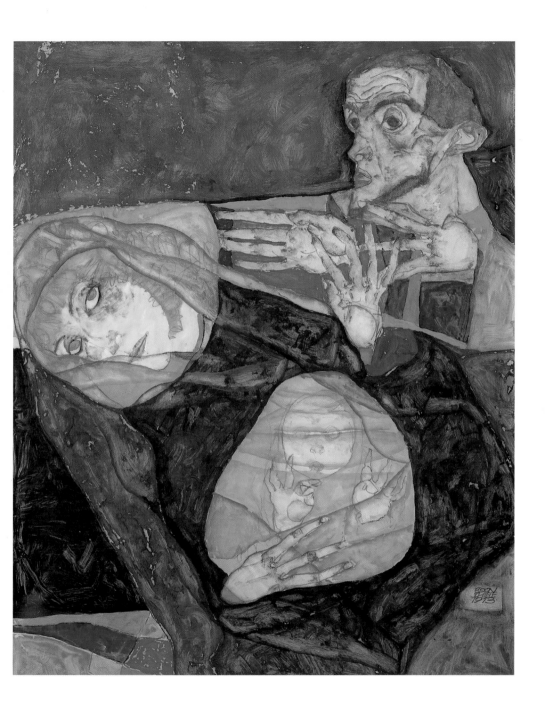

Holy Family. 1913.
Gouache and pencil on parchmentlike paper. Signed and dated, lower right.
47 × 36.5 cm. Kallir P. 248. Private collection.

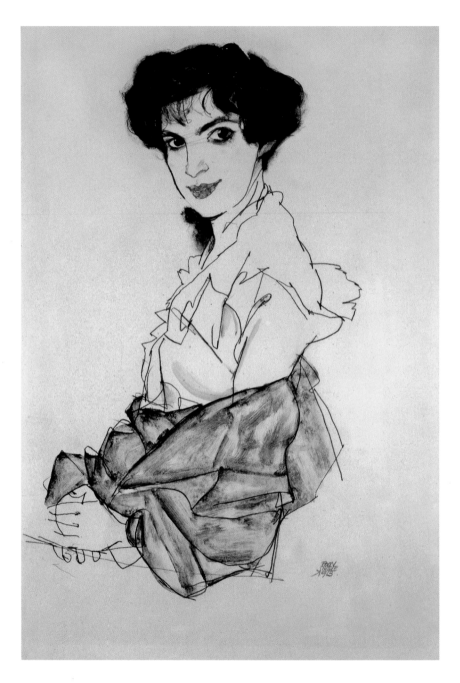

Elisabeth Lederer, Seated with Hands Folded. 1913.
Gouache and pencil. Signed and dated, lower right.
48.2 × 32.4 cm. Kallir D. 1232.
Serge Sabarsky Collection, New York, courtesy of Neue Galerie, New York.

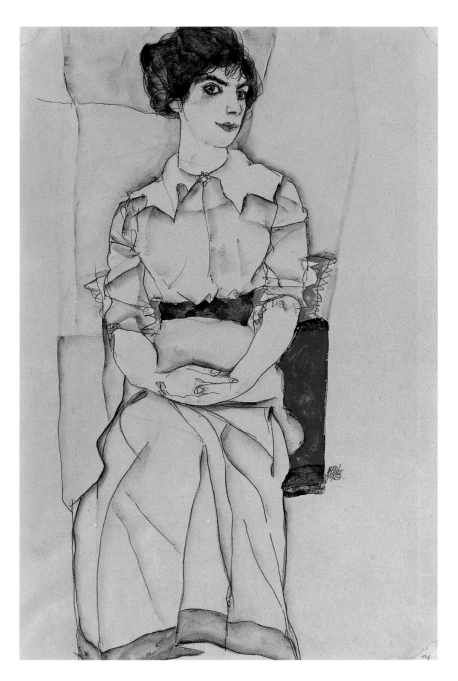

Portrait of Elisabeth Lederer. 1913.

Gouache, watercolor, and pencil. Signed and dated, lower right.

48 × 29 cm. Kallir D. 1263.

Private collection, courtesy of Galerie St. Etienne, New York.

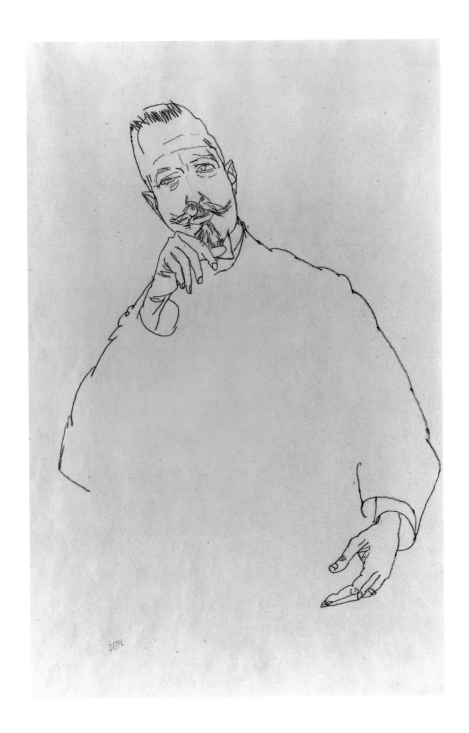

Portrait Sketch of Heinrich Benesch. 1913.
Pencil. 48 × 32 cm. Kallir D. 1395.
Private collection.

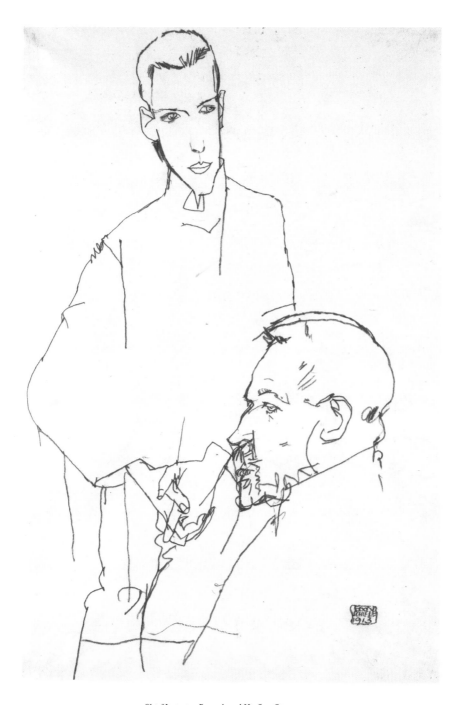

Chief Inspector Benesch and His Son Otto. 1913.
Pencil. Signed and dated, lower right. 47 × 30.8 cm. Kallir D. 1403.
Courtesy of the Fogg Art Museum, Harvard University Art Museums,
Gifts for Special Uses Fund—Shelter Rock Foundation and an Anonymous Donor.

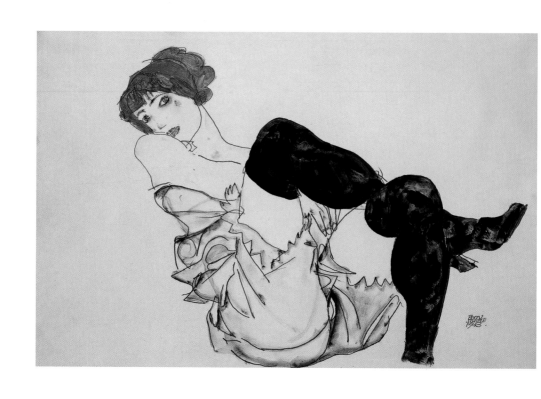

Woman in Black Stockings (Valerie Neuzil). 1913.
Gouache, watercolor, and pencil. Signed and dated, lower right. 32.2 × 48 cm. Kallir D. 1240.
Private collection.

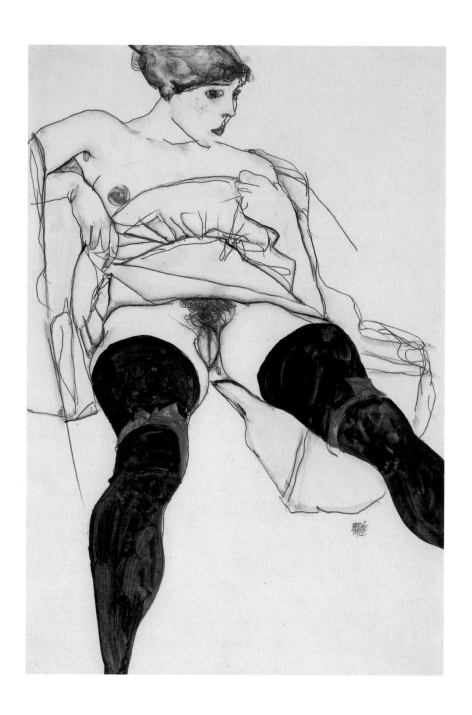

Woman with Black Stockings. 1913.
Gouache, watercolor, and pencil. Signed and dated, lower right.
48.3 × 31.8 cm. Kallir D. 1245.

Lovers (Self–Portrait with Model). 1913.
Pencil. Signed and dated, center right. 31.5 × 47 cm. Kallir D. 1449a.
Private collection.

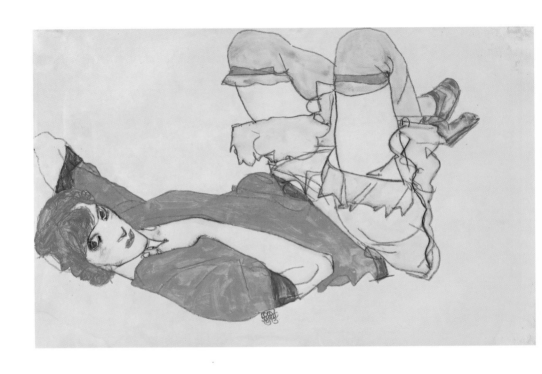

Wally in Red Blouse with Raised Knees. 1913.

Gouache, watercolor, and pencil. Signed and dated,

lower center. 31.8 × 48 cm. Kallir D. 1335.

Serge Sabarsky Collection, New York, courtesy of Neue Galerie, New York.

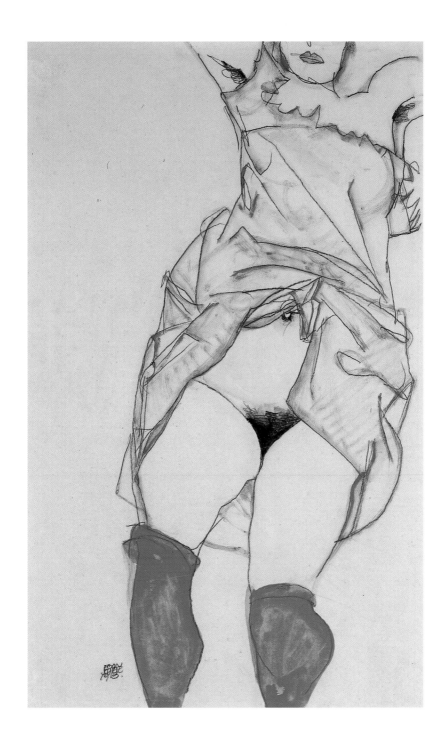

Woman with Raised Skirt. 1913.
Watercolor and pencil. Signed and dated, lower left.
47.6 × 29.5 cm [sight]. Kallir D. 1252.

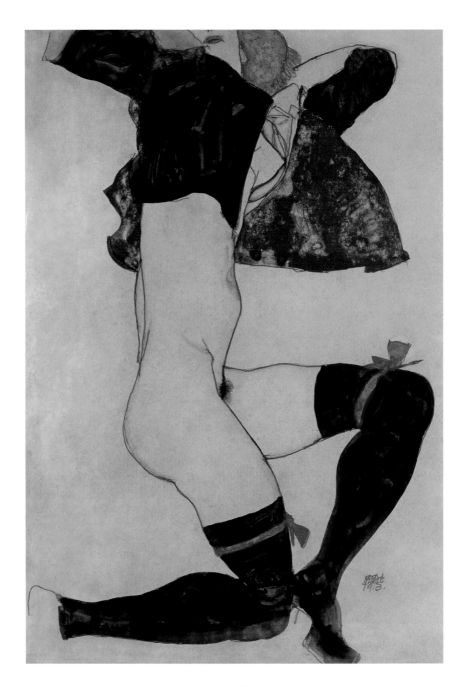

Reclining Semi-Nude with Black Stockings. 1913.
Gouache and pencil. Signed and dated, lower right.
48.3 × 31.4 cm. Kallir D. 1249. Private collection Australia,
courtesy of Richard Nagy, Dover Street Gallery, London.

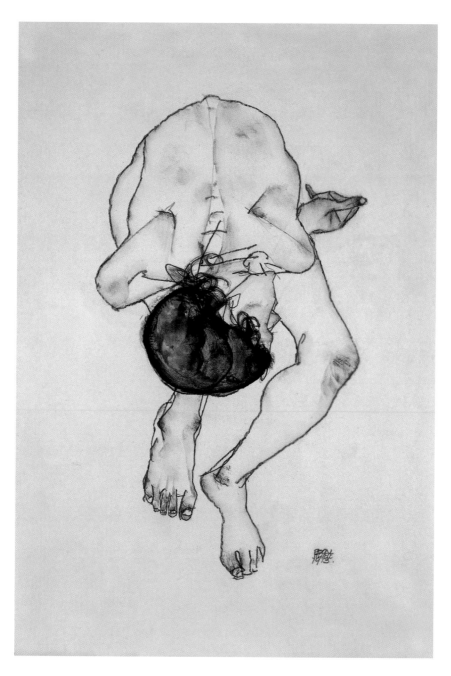

Nude. 1913.
Watercolor and black crayon. Signed and dated, lower right.
41.4 × 29.1 cm. Kallir D. 1277.
Private collection.

Standing Girl in Blue Dress and Green Stockings, Back View. 1913.
Watercolor and pencil. Signed and dated, lower right. 47 × 31 cm. Kallir D. 1271.
Private collection.

244

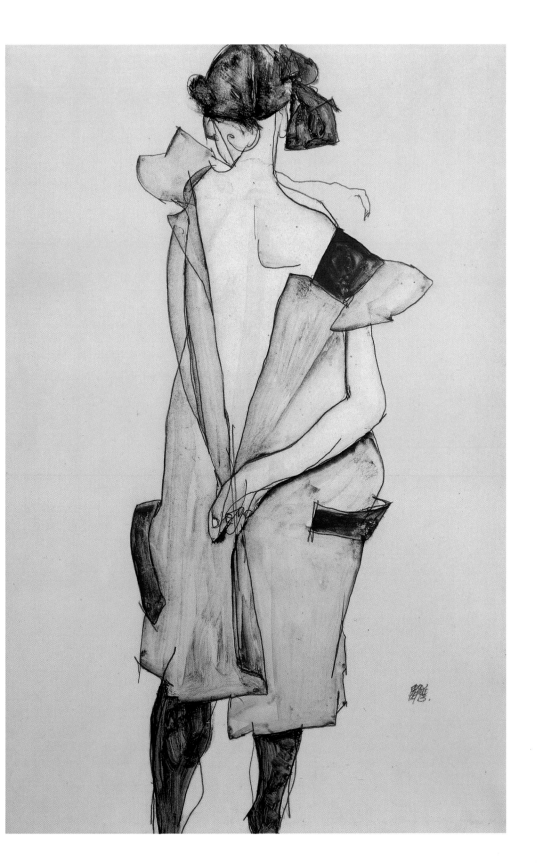

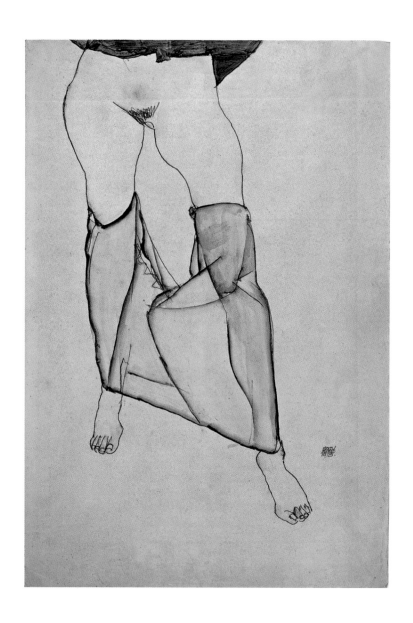

Above: *Standing Female Nude from the Waist Down with Green Garment*. 1913.
Watercolor and pencil. Signed and dated, lower right. 48.2 × 31.6 cm.
Kallir D. 1368. Graphische Sammlung Albertina, Vienna.
Opposite: *Female Torso with Raised Shirt*. 1913.
Gouache, watercolor, and pencil. Signed and dated,
lower right. 48 × 32 cm. Kallir D. 1388.
Graphische Sammlung Albertina, Vienna.

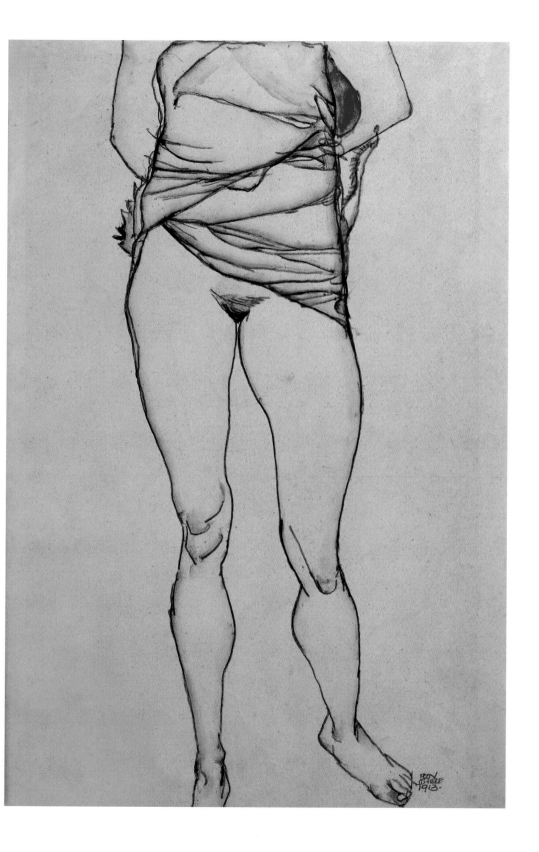

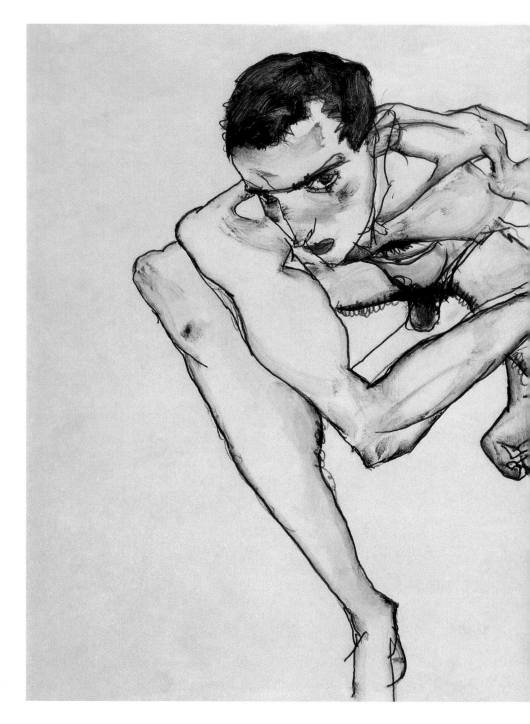

Self-Portrait in Crouching Position. 1913.
Gouache and pencil. Signed and dated, lower right.
32.3 × 47.5 cm. Kallir D. 1424.
National Museum, Stockholm.

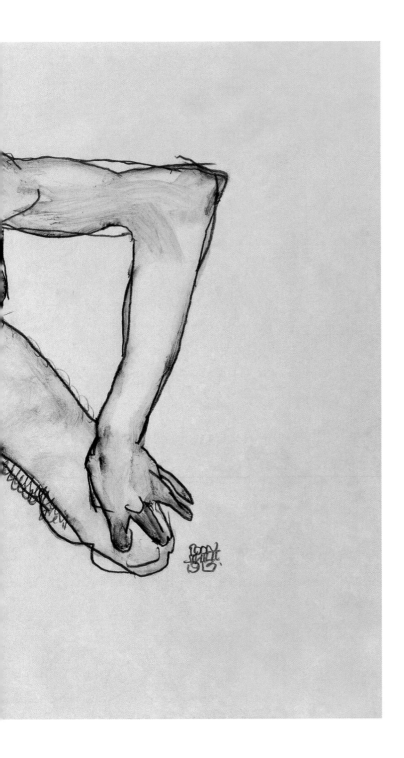

Self-Portrait. 1913.
Pencil. Signed and dated, center right. 48 × 31.5 cm. Kallir D. 1432.
Private collection.

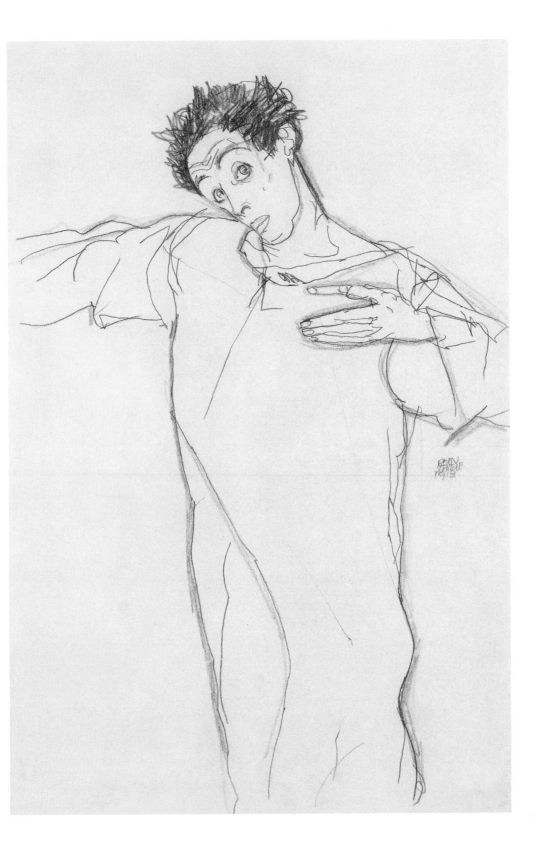

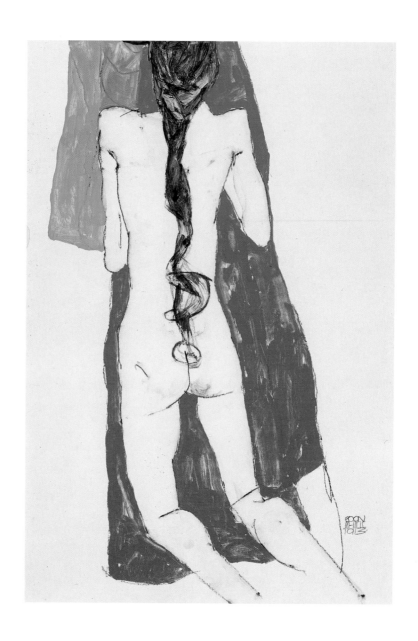

Above: *Kneeling Girl, Back View (Mother and Daughter)*. 1913.
Gouache, watercolor, and pencil. Signed and dated, lower right. 47.7 × 32 cm.
Kallir D. 1296. Private collection.
Opposite: *Friendship*. 1913.
Gouache, watercolor, and pencil. Signed and dated, lower right.
Inscribed 'Freundschaft', lower left. 48.2 × 32 cm. Kallir D. 1355.
Serge Sabarsky Collection, New York, courtesy of Neue Galerie, New York.

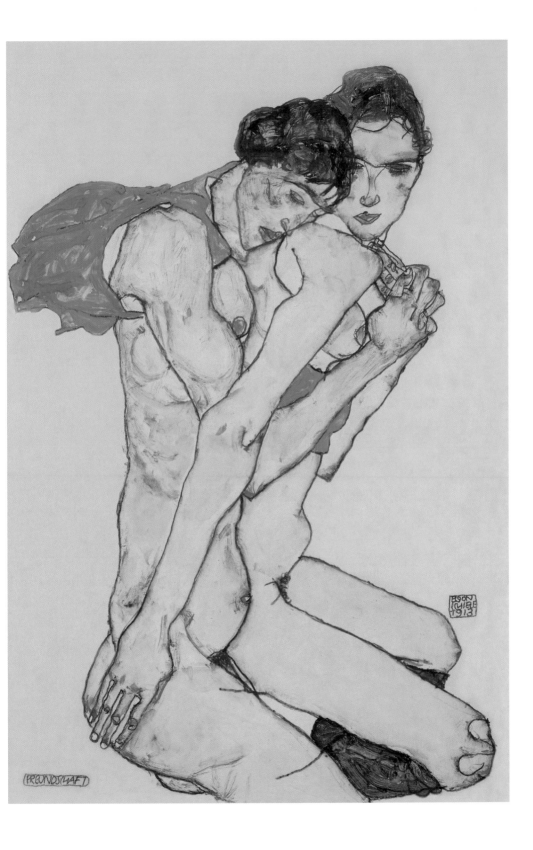

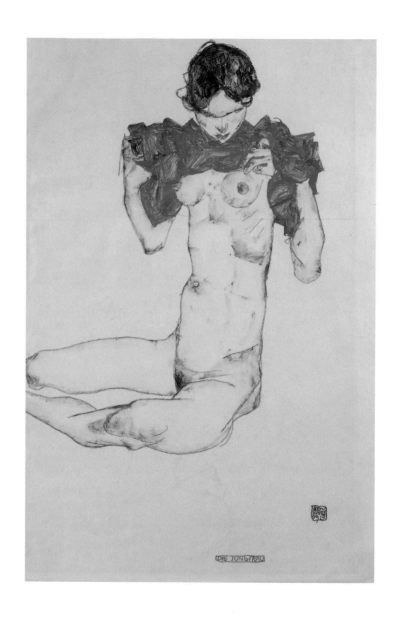

Above: *The Virgin*. 1913.
Gouache and pencil. Signed and dated, lower right.
Inscribed 'Die Jungfrau', lower right. 49.0 × 31.6 cm. Kallir D. 1361.
Graphische Sammlung der Eidgenössischen Technischen Hochschule, Zurich.
Opposite: *Torso*. 1913.
Pencil. Signed and dated, lower right. Inscribed 'Torso',
lower right. 47 × 29 cm. Kallir D. 1390.
E. W. Kornfeld Collection, Bern.

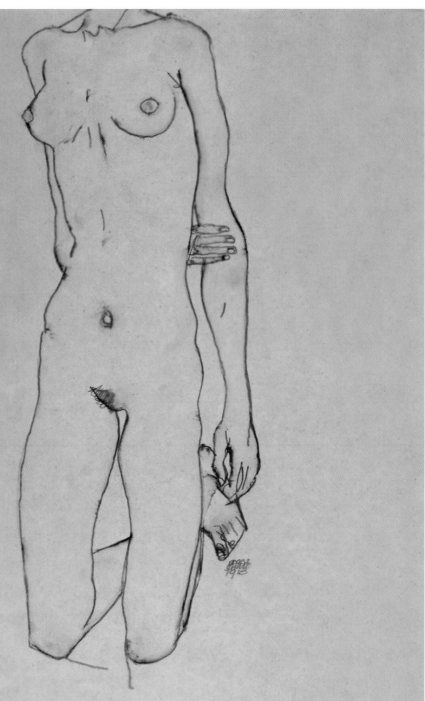

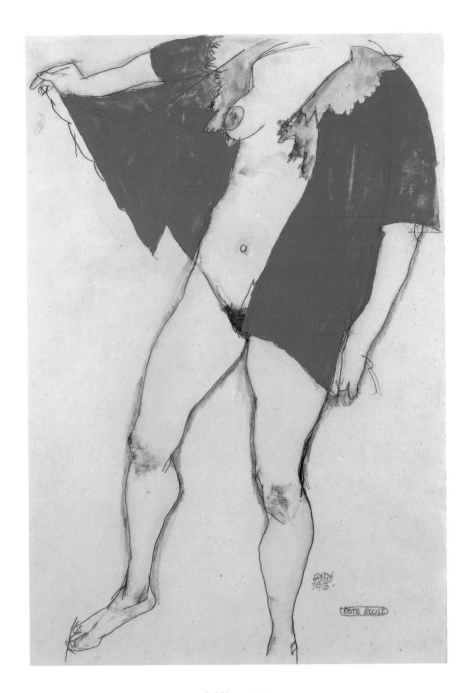

Red Blouse. 1913.
Gouache, watercolor, and pencil. Signed and dated, lower right.
Inscribed 'Rote Bluse', lower right. 48 × 31.2 cm. Kallir D. 1394.
Leopold Museum, Vienna.

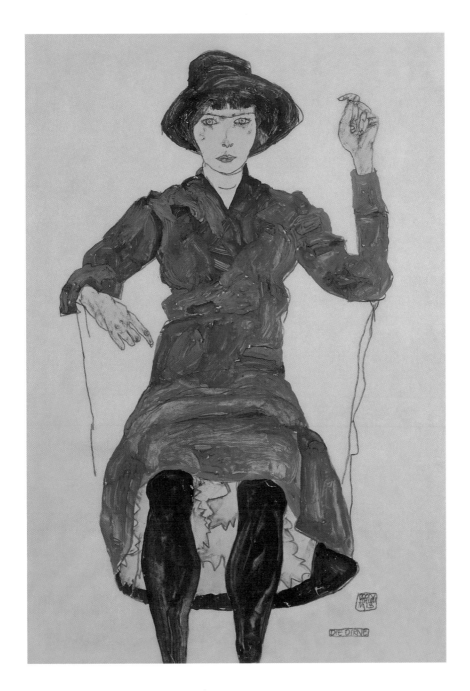

The Prostitute. 1913.
Gouache and pencil. Signed and dated, lower right.
Inscribed 'Die Dirne', lower right. 48 × 31.5 cm. Kallir D. 1358.
Tel Aviv Museum, Tel Aviv.

Lovers. 1913.
Gouache, watercolor, and pencil. Signed and dated, lower center.
Inscribed 'Liebespaar', lower left. 48.5 × 32 cm. Kallir D. 1456.
Private collection.

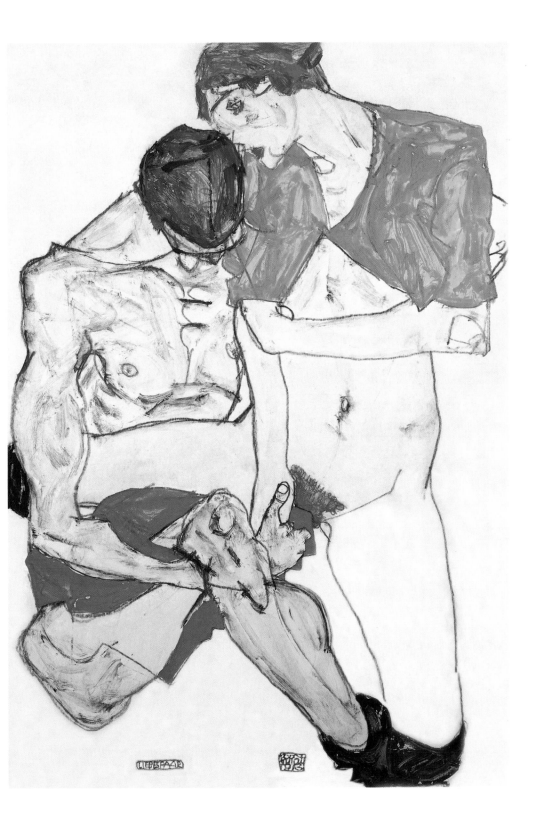

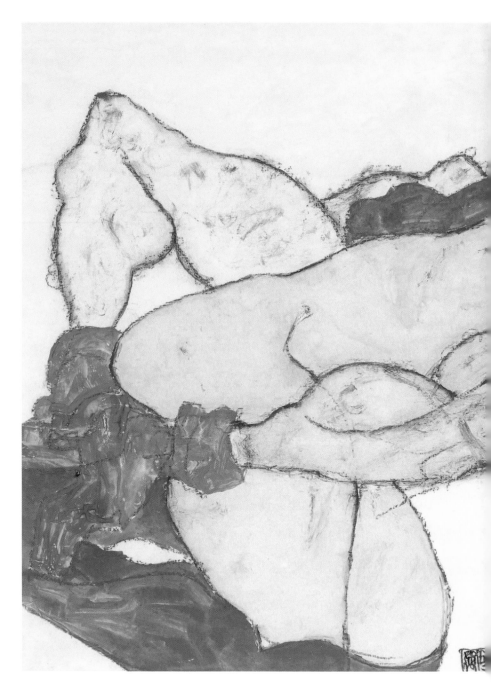

Embrace. 1913.
Gouache, watercolor, and pencil. Signed and dated,
lower center. 32 × 48.2 cm. Kallir D. 1455.
Private collection.

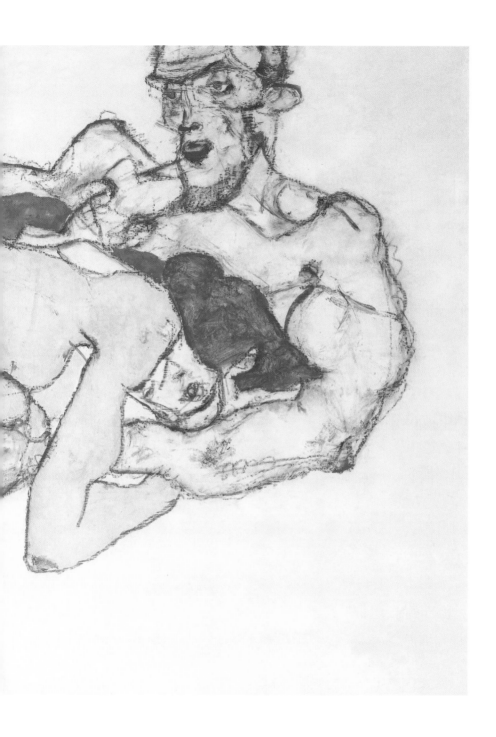

Bearded Man, Standing. 1913.
Gouache and pencil. Signed and dated, lower right. 46.5 × 32 cm. Kallir D. 1413.
Private collection, courtesy of Galerie St. Etienne, New York.

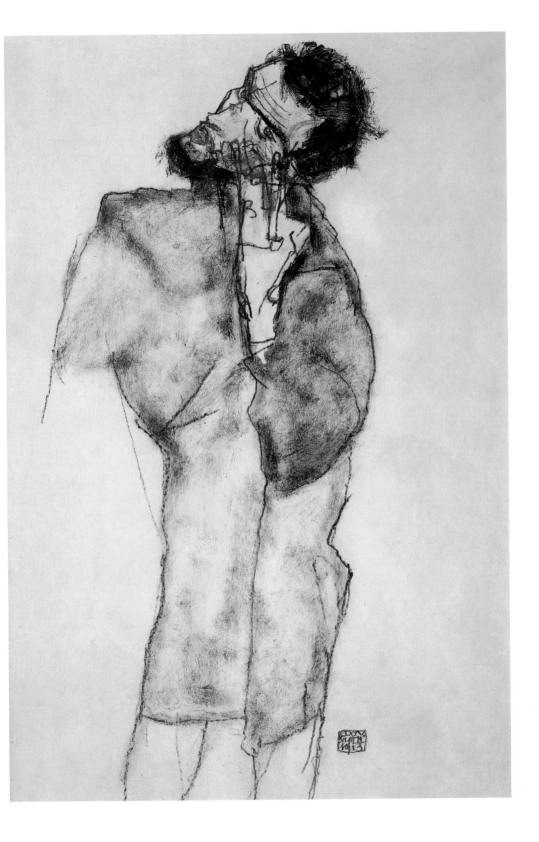

The Truth Unveiled. 1913.
Gouache, watercolor, and pencil. Signed, dated, and titled
'Die Wahrheit wurde enthüllt', lower left. 48.3 × 32.1 cm. Kallir D. 1443.
Private collection.

264

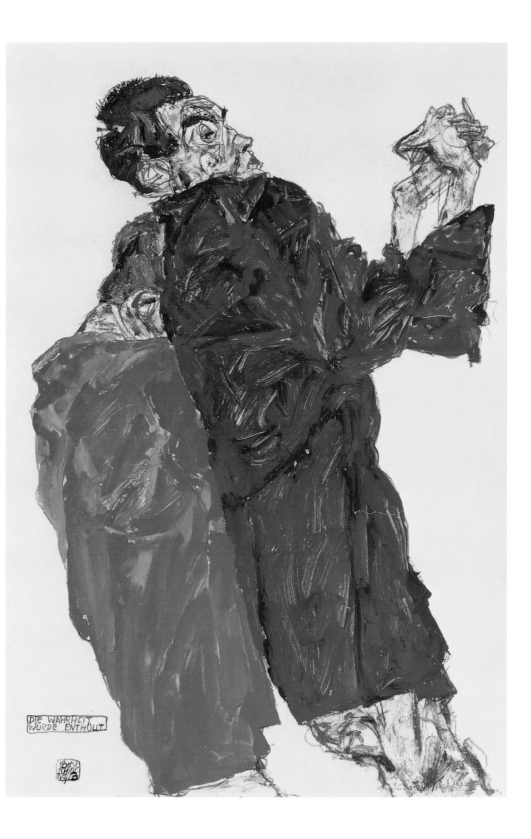

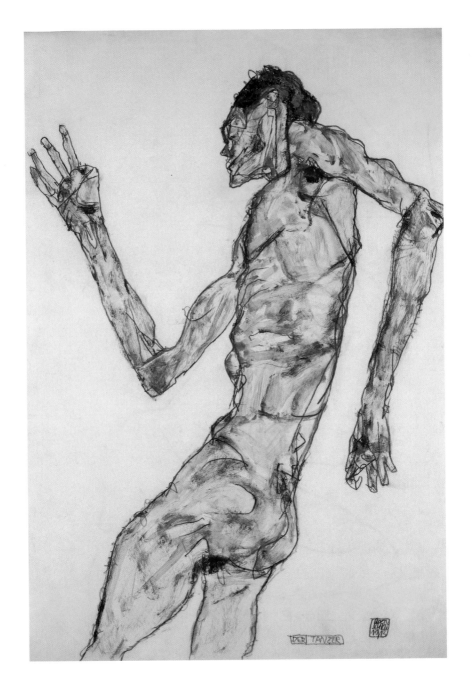

The Dancer. 1913.
Gouache, watercolor, and pencil. Signed and dated, lower right.
Inscribed 'Der Tänzer', lower center. 46.5 × 31.6 cm. Kallir D. 1414.
Leopold Museum, Vienna.

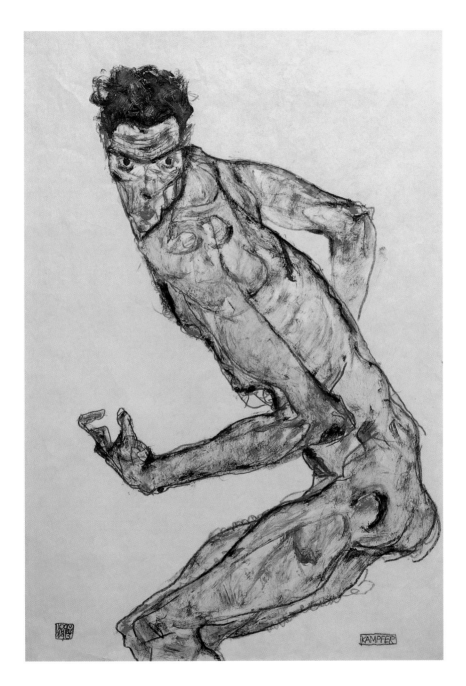

Fighter. 1913.
Gouache and pencil. Signed and dated, lower left, and titled
'Kämpfer', lower right. 48.8 × 32.2 cm. Kallir D. 1438.
Private collection.

Above: *Self-Portrait with Orange Cloak*. 1913.
Watercolor, gouache, and pencil. Signed and dated, lower right.
48 × 31.5 cm. Kallir D. 1444.
Graphische Sammlung Albertina, Vienna.

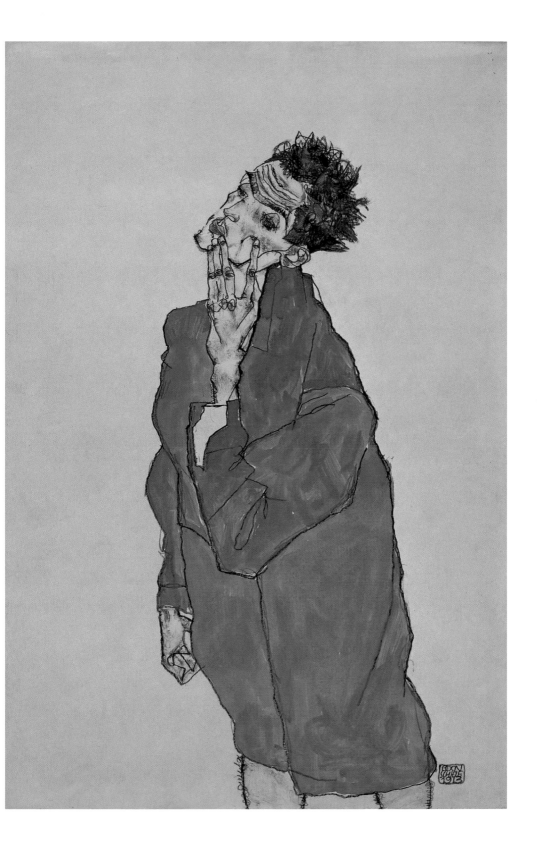

Above: *Head of a Saint*. 1913.

Oil, gouache, and charcoal. 23 × 23.5 cm. Kallir D. 1446.

Private collection.

Opposite: *Standing Figure with Halo*. 1913.

Gouache, watercolor, and pencil. 48.3 × 31.7 cm. Kallir D. 1421.

1914

The outbreak of World War I in July 1914 had almost no immediate impact on Schiele. Even as his friends began to be called up for military service, he remained confident that a congenitally weak heart would keep him from being drafted. Though this ultimately proved not to be the case, his relative physical frailty did earn the artist a brief respite, during which he concentrated resolutely on his professional and personal life. His mounting debts made it imperative, finally, that he bring some order to his finances. And the marriage of his younger sister Gerti pushed Egon to consider settling down himself. These nagging concerns naturally had an impact upon his artwork. To earn money, Schiele investigated printmaking and renewed his activity as a portraitist, while simultaneously seeking pictorial correlatives for his ongoing emotional travails.

Schiele's persistent financial troubles have long been a subject of debate among the artist's biographers. Was he merely a spoiled brat, an unsympathetic victim of his own fiscal irresponsibility? Or was he a martyr to a society too ignorant and conservative to recognize the true value of his work? Considering the artist's age, both judgments are overly harsh. Under different circumstances, Schiele might have been a university student subsidized by his family. Fatherless and rejected by his well-to-do uncle, he sought support from other older men, such as Heinrich Benesch and Arthur Roessler. These men were understandably surprised that Schiele expected them to act 'in loco parentis,' and yet when the artist was in dire straits, they usually bailed him out. Society at large may not immediately have hailed Schiele as a genius, but his fledgling career was not unimpressive. In 1914, at the age of twenty-four, he already had a substantial exhibition history.

With the help of his motley group of patrons, Schiele lurched from one financial crisis to the next. Although his expenses regularly exceeded his income, he somehow always managed to avert disaster. However, by early 1914, his accumulated debt had

Fig. 20: Egon Schiele. *Portrait of Friederike Maria Beer*. 1914.
Oil on canvas. Signed and dated, lower left. 190 × 120.5 cm. Kallir P. 276.
Private collection.

273

Fig. 21: Egon Schiele. *Squatting Woman*. 1914.
Drypoint. 48.2 x 32 cm. Kallir G. 6.
Courtesy of Galerie St. Etienne, New York.

reached 2,500 kronen—roughly the annual income of a prosperous working-class family. By April, his landlord (an architect who had heretofore indulged the artist) was threatening to evict him. For the first time, Schiele began to think concretely about what he could do to make money. He considered teaching or seeking employment with a cartographer. However, in the end, rather than getting a 'real' job, he was able to solve his problems more organically, within preestablished professional pathways.

Through his contacts at the Wiener Werkstätte, Schiele was introduced to Heinrich Böhler, an art aficionado who not only hired him as a private art tutor but began to collect his work (page 352). When the two painted side by side, Böhler paid for all the materials and models; later on, during the war years, he gave Schiele a monthly stipend. Heinrich's cousin Hans Böhler, an artist of some stature, also bought Schiele's work. And Hans's lady-friend, Friederike Maria Beer, commissioned a full-length portrait. Whereas the portrait frightened Friederike's maid (who thought it made her look like a corpse), the sitter herself was satisfied (figure 20; page 317). Schiele also did a number of portrait drawings in 1914, some of patrons such as Franz Hauer, Erich Lederer, and Roessler (page 295), and others commissioned by the left-wing German magazine *Die Aktion*. By the end of the year, he had found a Viennese dealer, Guido Arnot, who was willing to give him a one-man show. With relief, Schiele was able to write to his mother, 'I have the feeling that I am finally out of my precarious existence.'

Schiele's more pro-active attitude toward generating income led him on a brief yet interesting creative detour: he began to make prints. Previously, he had done only a pair of lithographs, at the behest of the German artists' society 'Sema.' However, Roessler, who was always trying to get Schiele to establish ties to potentially lucrative areas of the commercial marketplace, suggested that he pursue printmaking more aggressively. In early 1914, the artist asked his colleague Robert Philippi to teach him the method of drypoint (which Schiele considered 'the only honest and artistic etching technique'). Roessler agreed to bankroll the experiment by buying the tools and plates, and Schiele was on his way. Within the next few months, he created his total oeuvre of six drypoints, achieving a surprisingly rapid mastery of the medium (figure 21). Then, in late summer, he suddenly gave it up. 'In the time needed to etch one plate, I can well and easily create fifty to sixty—no, even more, surely about a hundred—drawings,' he averred.

Drypoint entails scratching into a metal plate with a sharp stylus. The resulting exclusive emphasis on the expressive power of line prompted Schiele to further hone devices already nascent in his drawings. He embellished contours with tightly wound curlicues (pages 280, 286, 290–293, and 296), and in both his drypoints and his contemporaneous drawings, he augmented the edges of his figures with stitch-like cross-hatching (pages 295, 301, 302, and 313). It is hard to know whether these stylistic

idiosyncrasies were specifically spurred by the artist's experiences with drypoint, or whether he simply transferred an approach first developed in his drawings to the printmaking medium.

As in 1913, Schiele's erratic and abstract linework had the paradoxical effect of heightening the plasticity of his figures. Their outlines, over the course of 1914, grew ever rounder, firmer, and more voluptuous (pages 297, 299, 301–303, and 316). The artist's coloring progressed apace, as he refined the approach first seen in 1913. From here on, using principally the relatively dry medium of gouache, Schiele characteristically defined flesh with a lightly modeled underglaze of ochre or brown. Upon this, he superimposed accents in red, green, and blue. He still enjoyed balancing delicate areas, such as skin, against densely worked patches of clothing or hair (pages 285, 287, 289, 309, 311, and 314). However, these denser areas, too, were treated in a three-dimensional manner, the paint subtly manipulated and scored so as to evoke a tangible substance.

Whereas formerly Schiele's oils had emulated the limpid washes typical of watercolor, now his works on paper mirrored the painterly expressiveness of his oils. Colors became bolder and brighter. There was also a closer relationship between the content of Schiele's works on paper and that of his paintings. Starting with the unfinished 1913 canvases *Encounter* and *Conversion*, the artist had begun more consciously to develop poses in preliminary studies. Various favorite motifs—among them the reclining female (pages 280, 303, and 412) and the bent-over figure (figures 21 and 22; pages 281, 307, 330, 331, and 428–429)—worked and reworked from 1914 on, turn up in later oils. Schiele returned to Krumau in 1914 (pages 320–321), and the fund of studies produced there would provide fodder for landscape paintings through 1918. Nevertheless, Schiele's watercolors and drawings remained essentially autonomous, and the overall organizational schemes of his canvases were still usually formulated in small sketchbooks, rather than on larger sheets.

The palpable volumes in Schiele's 1914 drawings and watercolors exacerbated the sense of spatial dislocation produced by his unorthodox compositional angles. More realistically three-dimensional figures seemed to call for more realistic placement in a recognizable space. Schiele, however, refused to bow to this demand and instead persisted in signing drawings of recumbent figures as verticals (pages 299, 301, and 303). The push-pull between conventional realism and Schiele's insistence on maintaining a self-contained artistic realm was the aesthetic counterpart to an ongoing personal conflict between society and self. Where did he want to live, literally and metaphorically? In the world of his fantasies, or in the real world? This conflict found an additional outlet in Schiele's treatment of women—both in his work and in his life.

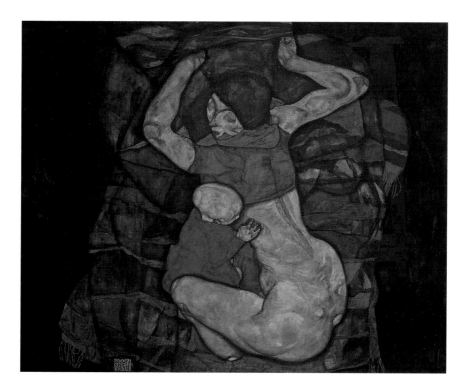

Fig. 22: Egon Schiele. *Young Mother*. 1914.
Oil on canvas. Signed and dated, lower left.
100 x 110 cm. Kallir P. 273.

In contrast to the waifs of 1910 and 1911, Schiele's 1914 nudes were lusty, full-grown women. But whereas his earlier models evinced a palpable human presence, in 1914 the artist tended to view the female figure principally in formal terms. At one extreme, his models resemble nothing so much as rag dolls—their bodies tossed about on the sheet, their masklike faces punctuated by vacant button eyes (pages 297, 299–301, 303, 304, and 306). Wally, though still part of Schiele's life, is recognizable in very few 1914 drawings (pages 305 and 307). Other models—such as the unidentified black-haired woman who appears frequently in the early months of the year—are depicted with almost clinical detachment (pages 282, 283, and 285). Artist and model seem in full agreement: this is just a business relationship.

Schiele's dehumanizing of his models in general, and of Wally in particular, reflected a gradual adaptation to prevailing sexual mores. Through a combination of emotional and stylistic distancing, Schiele was simultaneously sublimating his own sexual feelings and defusing the erotic volatility of his work. His internalization of the

double standard is concretely evidenced in his anxiety over Gerti's growing romantic involvement with the artist Anton Peschka. At one point, Schiele attempted to prevent them from seeing one another. When that proved futile, he tried to erect obstacles to their marrying: his sister must wait until she reached her majority; her suitor must wait until he could support her professionally. Given Schiele's own promiscuity, his worry that Anton would 'pick the plant before it is ripe' seems especially hypocritical. And also futile. The couple finally wed in November 1914, and their son, Anton, Jr., was born about a month later.

Just as Schiele wanted Gerti to emulate the behavior expected of a 'good' girl, he came to accept that Wally could not, in the eyes of society, pass muster as a long-term mate. In 1914, he began a flirtation with two sisters, Adele and Edith Harms, who lived across the street from his studio on the Hietzinger Hauptstrasse. Either of the Harms girls would have made a socially acceptable partner; furthermore—as if to seal Schiele's fate—their father Johann (like so many in the artist's own family) worked for the Austrian railroad. At first it was not clear whether Schiele favored Adele, at twenty-four the older of the siblings, or Edith, twenty-one in 1914. Wally, in a role that must surely have been excruciating, was recruited to play chaperone. Behind the back of Frau Harms (who disapproved of Schiele), the unusual foursome made furtive outings to the cinema.

Schiele's ambivalence about capitulating to societal norms was expressed by his standing cast of allegorical characters. In the first months of 1914, he again essayed the theme of maternity in two canvases: *Blind Mother* and *Young Mother* (later a wedding gift to Gerti; figure 22). His own looming foray into domesticity notwithstanding, Schiele's view of maternity had not softened much since 1911. Neither of the 1914 mothers is especially nurturing: the blind one is handicapped by her affliction, and the sighted one does not even touch her child. Sightlessness—a metaphor carried over from 1913— also affects many of the figures in Schiele's drawings and watercolors. Although the women are sometimes literally robbed of their eyes (page 301), Schiele, too, in his self-portraits, on occasion has the glazed, dilated pupils or hollow sockets of a blind man (pages 286, 289, 292–293, and 311–313). He is his own puppet: a dancing, gesticulating figure posing for a multitude of allegorical roles (pages 286, 290–293, and 311–314).

Schiele's allegorical self-representations were not intended to be autobiographical statements, but it is nonetheless obvious that blindness, for an artist, was an unfortunate choice of theme. As a 'self-seer' (a title used for several of the 1910–11 allegories), Schiele had formerly been extraordinarily attuned to his own internal responses, but at times blind to the outside world. In order to make more meaningful contact with others, would the artist have to lose touch with himself?

Given the constraints of late Habsburg-era society, it did seem to be an either-or choice. Faced with an imminent change in direction, Schiele felt confused and fearful that he was losing his 'vision'—which is to say, the adolescent vision that had informed his earlier work.

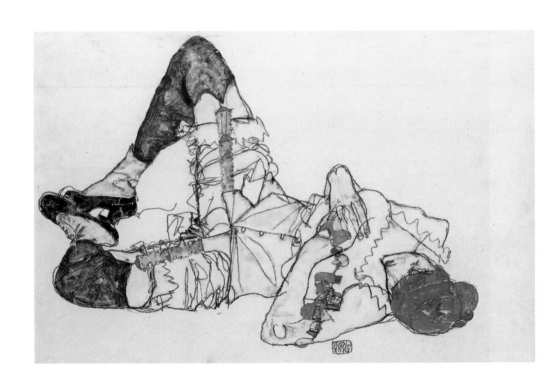

Woman Reclining on Her Back. 1914.
Watercolor and pencil. Signed and dated,
lower center. 31.7 × 48.2 cm. Kallir D. 1478.
Kupferstichkabinett, Öffentliche Kunstsammlung, Basel.

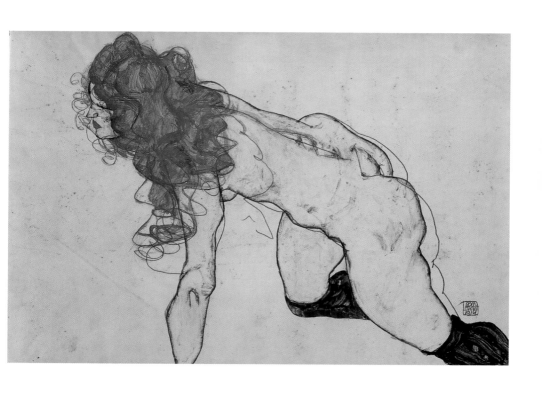

Crouching Blond Nude with Extended Left Arm. 1914.

Gouache and pencil. Signed and dated, lower right. 32.4 x 48 cm.

Kallir D. 1481. Private collection.

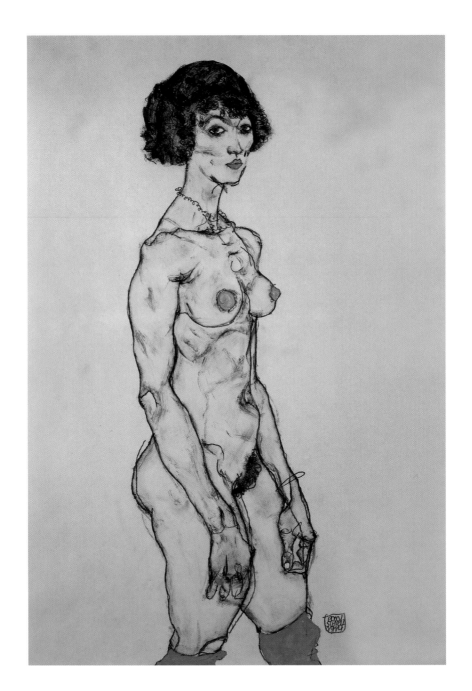

Standing Nude with Orange Stockings. 1914.
Gouache and pencil. Signed and dated, lower right.
47.5 × 27.9 cm. Kallir D. 1487. Private collection,
courtesy of Richard Nagy, Dover Street Gallery, London.

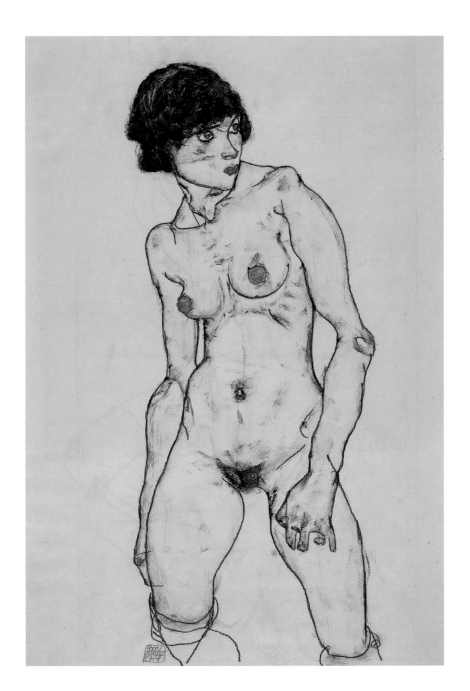

Standing Female Nude with Stockings. 1914.
Gouache, watercolor, and pencil. Signed and dated,
lower left. 48.3 × 32.2 cm. Kallir D. 1489.
Germanisches Nationalmuseum, Nuremberg.

Standing Nude with Spread Legs and Yellow-Brown Shawl. 1914.
Gouache and pencil. 47.7 × 31.7 cm. Kallir D. 1499.
Private collection.

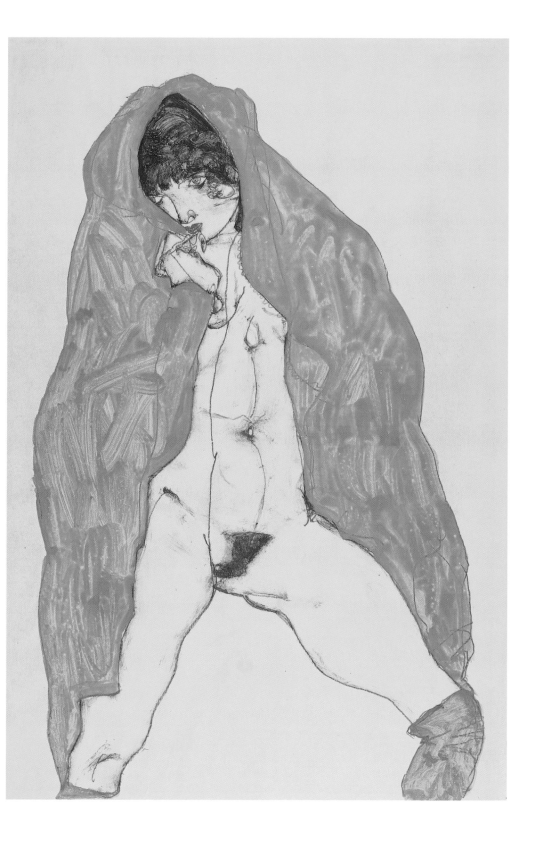

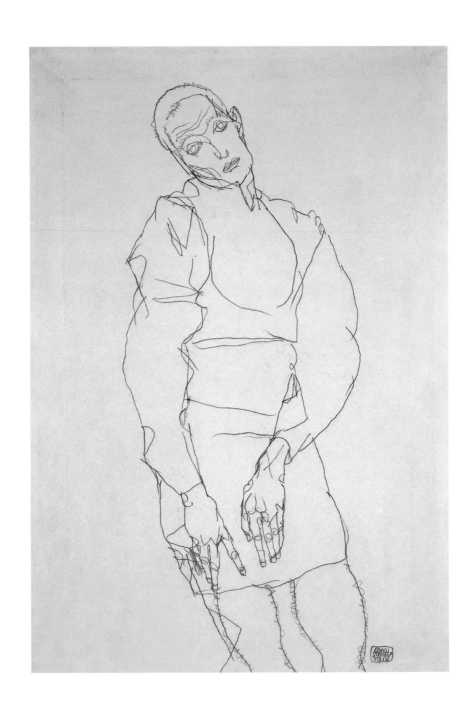

Standing Male Figure (Self-Portrait). 1914.
Pencil. Signed and dated, lower right. 48.2 × 31.5 cm. Kallir D. 1653.
National Museum, Stockholm.

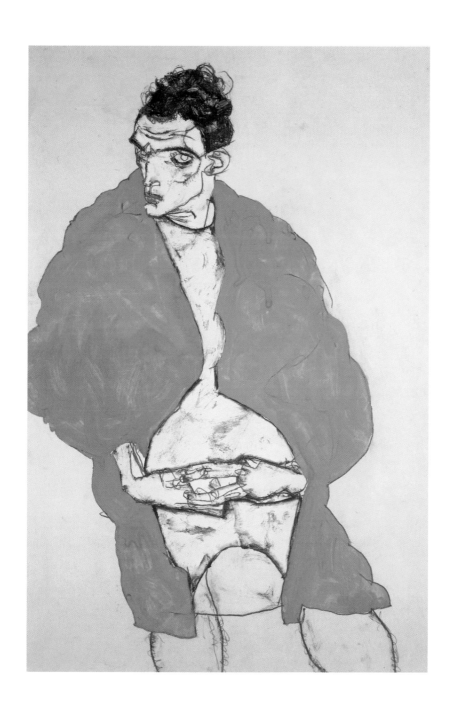

Standing Male Figure (Self-Portrait). 1914.
Gouache and pencil. 46 × 30.5 cm. Kallir D. 1649.
Národní Galerie, Prague.

Self-Portrait in Lavender Shirt and Dark Suit, Standing. 1914.
Gouache, watercolor, and pencil. Signed and dated, lower center.
48.4 × 32.2 cm. Kallir D. 1654.

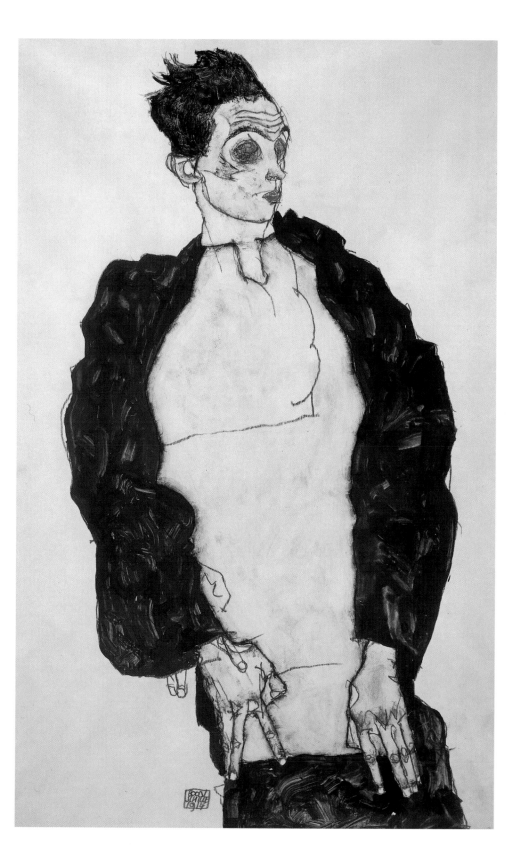

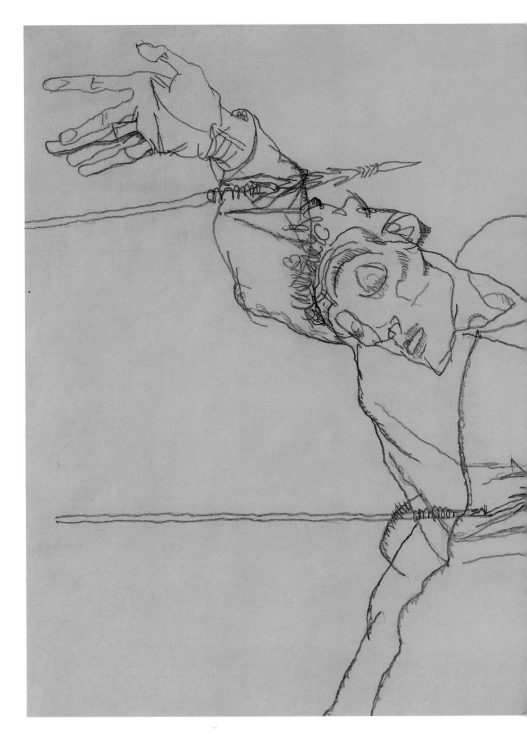

Self-Portrait as St. Sebastian. 1914.
Pencil. Signed and dated, lower right. 32.4 × 48.2 cm.
Kallir D. 1658. Private collection.

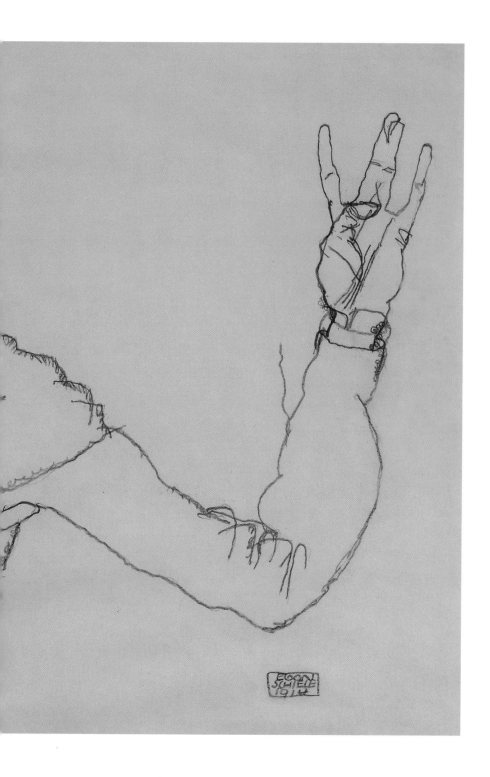

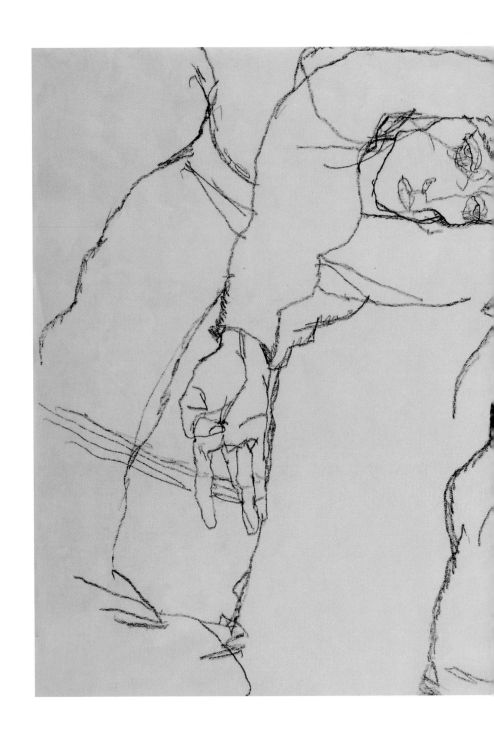

Two Figures Bent to the Right (Double Self-Portrait). 1914.
Pencil. Signed and dated, lower right. 31.9 × 47.5 cm. Kallir D. 1657a.

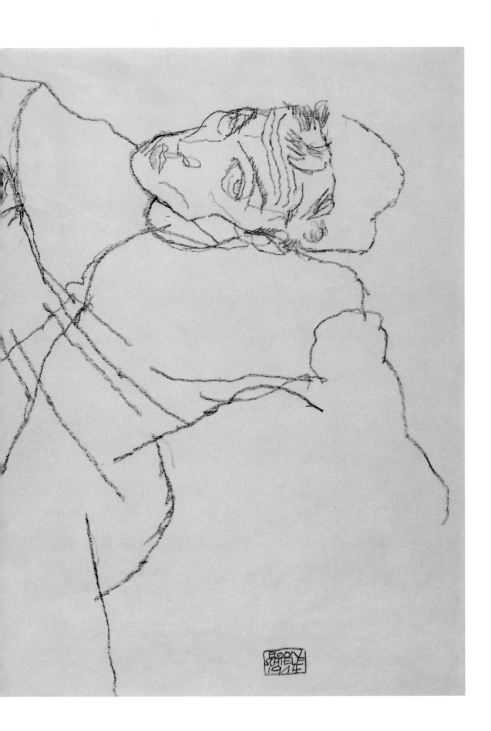

Portrait of the Art Critic Arthur Roessler. 1914.
Pencil. Signed and dated, lower right. 48.6 × 31 cm. Kallir D. 1630.
Historisches Museum der Stadt Wien, Vienna.

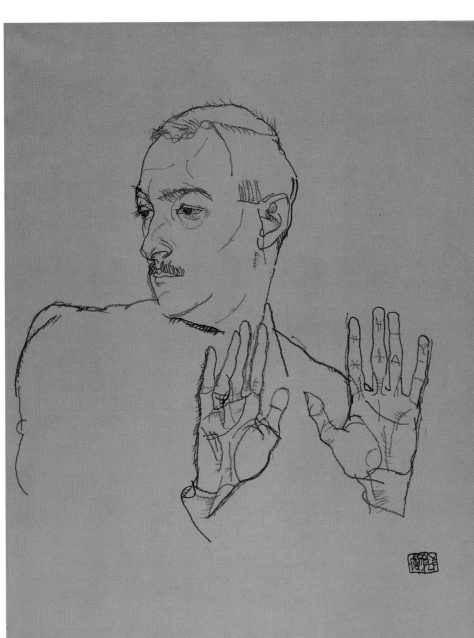

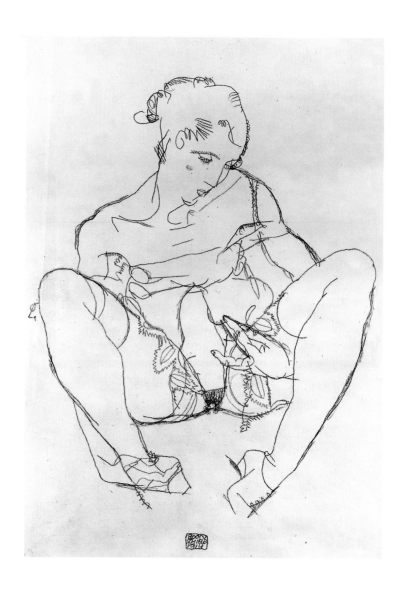

Above: *Seated Female Semi-Nude*. 1914.

Pencil. Signed and dated, lower center. 45.8 × 30.9 cm. Kallir D. 1528.

The Metropolitan Museum of Art, New York; Bequest of Scofield Thayer, 1982.

Opposite: *Blond Girl in Green Stockings*. 1914.

Watercolor and pencil. Signed and dated, lower center. 48.1 × 32.3 cm.

Kallir D. 1533. Private collection.

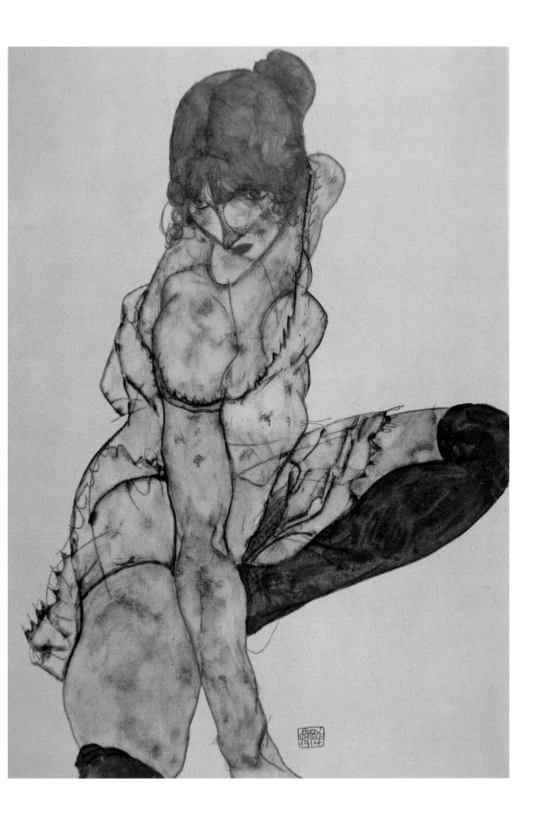

Woman Undressing. 1914.

Gouache and pencil. Signed and dated, lower right. 48.1 × 31.3 cm. Kallir D. 1549.

Miyagi Museum of Art, Sendai.

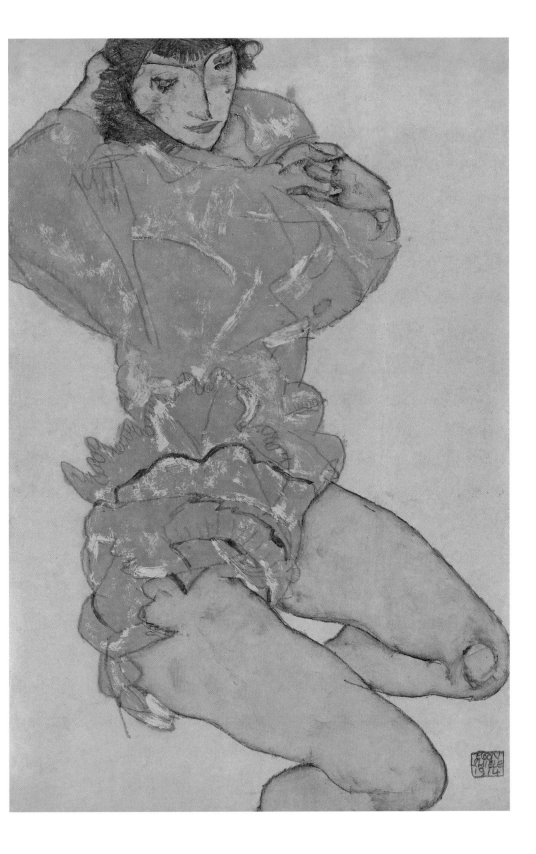

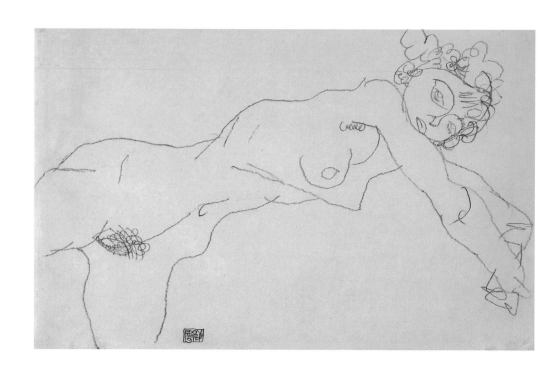

Reclining Nude. 1914.

Pencil. Signed and dated, lower left. 30.5 × 46.5 cm. Kallir D. 1536.

Mr. and Mrs. Estorick.

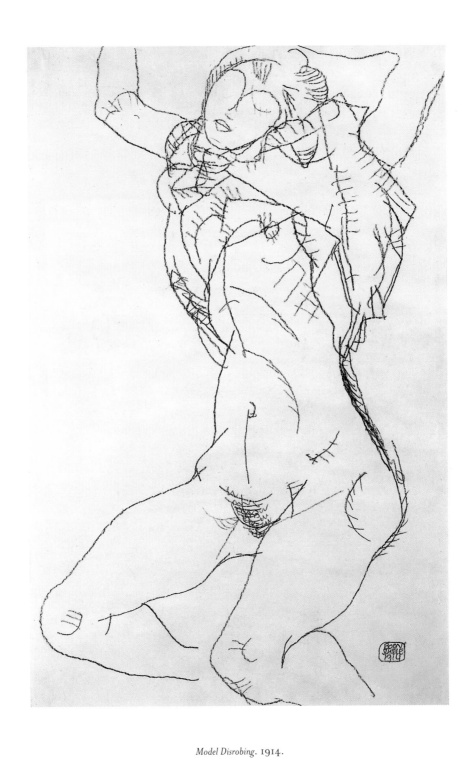

Model Disrobing. 1914.
Pencil. Signed and dated, lower right. 48.5 × 30.8 cm. Kallir D. 1551.
The Metropolitan Museum of Art, New York; Bequest of Scofield Thayer, 1982.

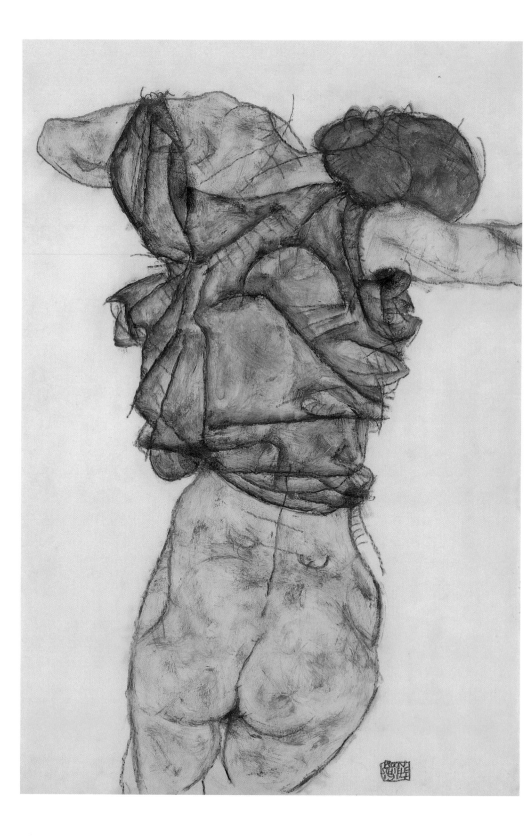

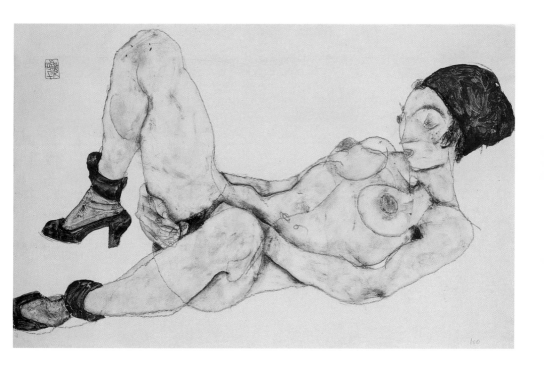

Above: *Nude with Green Turban*. 1914.

Gouache and pencil. Signed and dated (as vertical), upper left. 32 × 48 cm.

Kallir D. 1563. Private collection.

Opposite: *Woman Undressing*. 1914.

Gouache and pencil. Signed and dated, lower right. 47 × 32.4 cm.

Kallir D. 1554. Private collection.

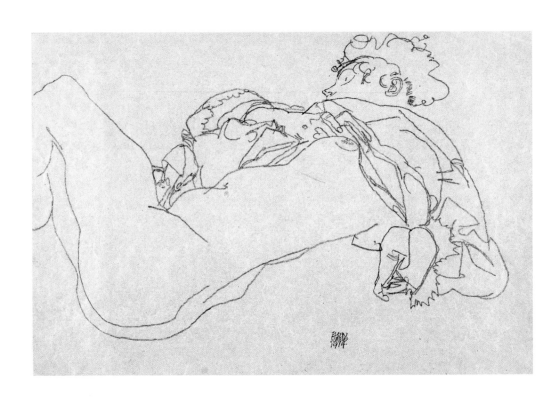

Reclining Female Nude with Raised Shirt. 1914.
Pencil. Signed and dated, lower center. 31.4 × 45 cm.
Kallir D. 1580a. Private collection.

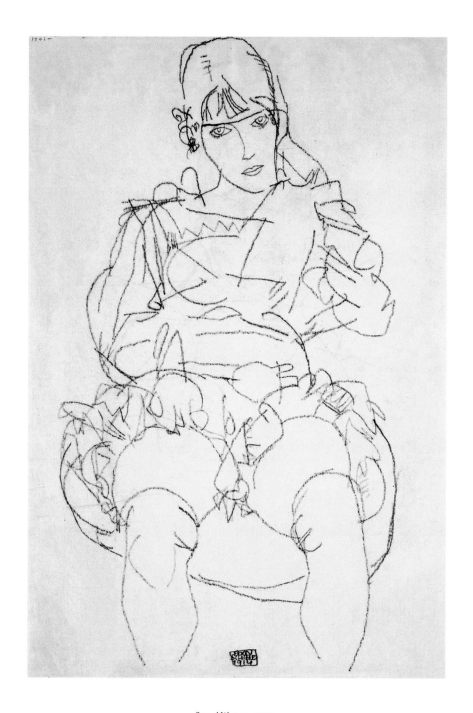

Seated Woman. 1914.
Pencil. Signed and dated, lower center. 48.8 × 32.2 cm. Kallir D. 1574.
National Museum, Stockholm.

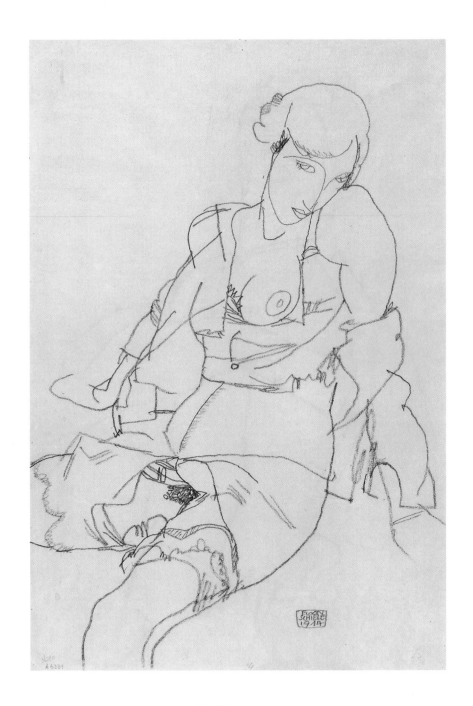

Seated Woman. 1914.

Pencil. Signed and dated, lower right. 48 × 31.5 cm. Kallir D. 1577.

Werner Coninx-Stiftung, Zurich.

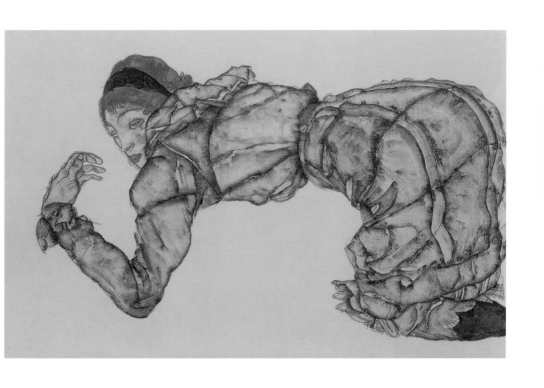

Kneeling Woman in Blue Blouse. 1914.

Gouache and pencil. 30.5 × 47.6 cm. Kallir D. 1594a.

Private collection.

Mother and Child. 1914.
Gouache and pencil. Signed and dated, lower left.
48.2 × 31.9 cm. Kallir D. 1673.
Leopold Museum, Vienna.

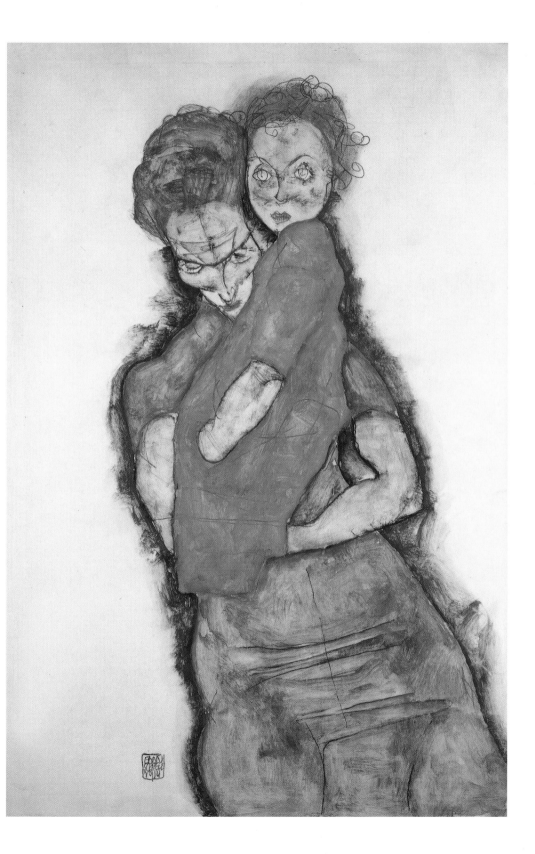

Self-Portrait in Jerkin with Right Elbow Raised. 1914.
Gouache, watercolor, and black crayon. Signed and dated,
lower right. 47.6 × 31.1 cm. Kallir D. 1668.
Private collection.

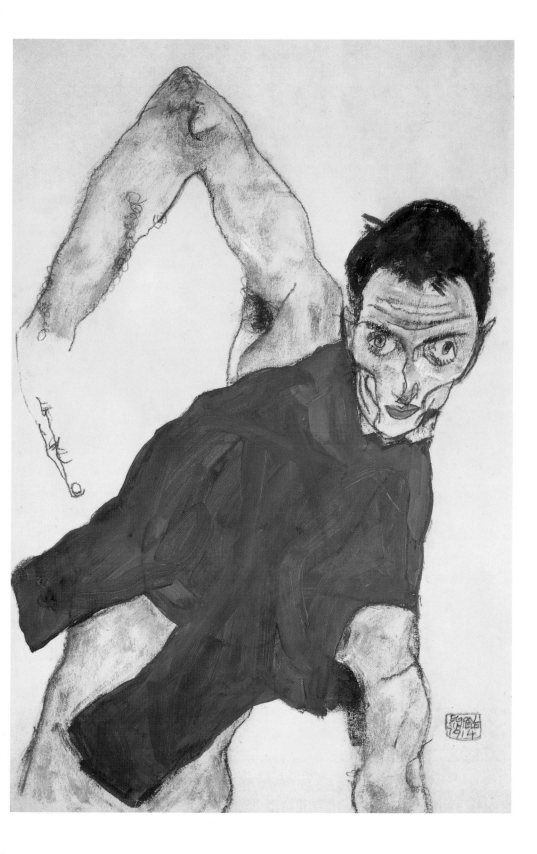

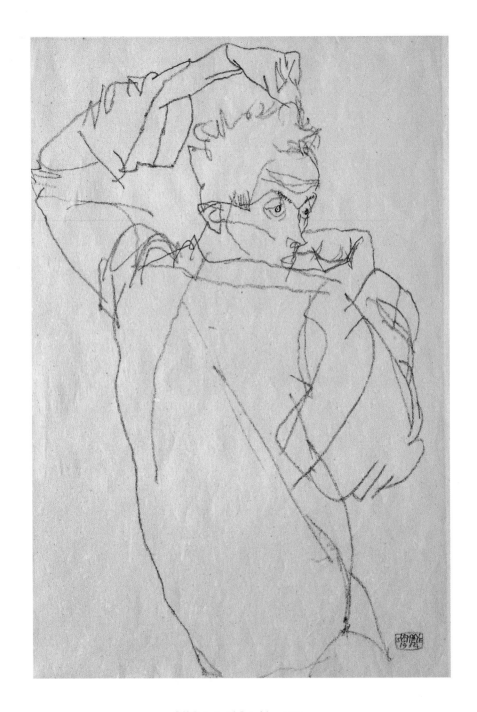

Self-Portrait with Raised Arm. 1914.
Pencil. Signed and dated, lower right. 47.3 × 30.3 cm. Kallir D. 1660.
Leopold Museum, Vienna.

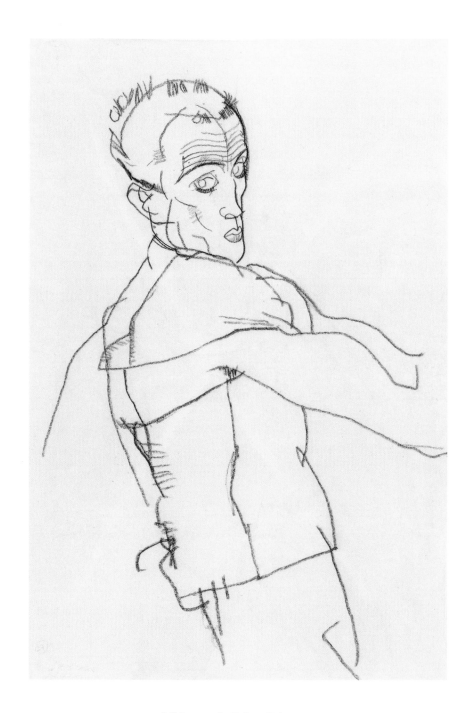

Self-Portrait in Profile Facing Right. 1914.
Black crayon. 48 × 31.5 cm. Kallir D. 1667.
Werner Coninx-Stiftung, Zurich.

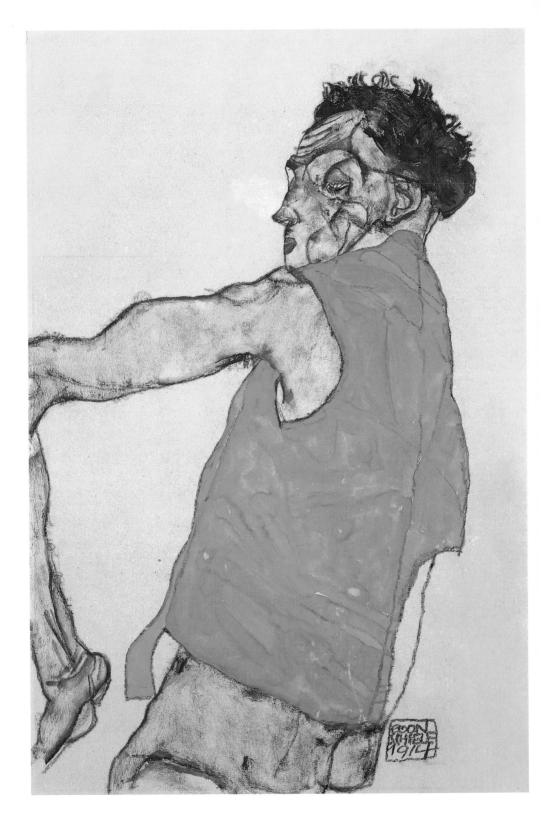

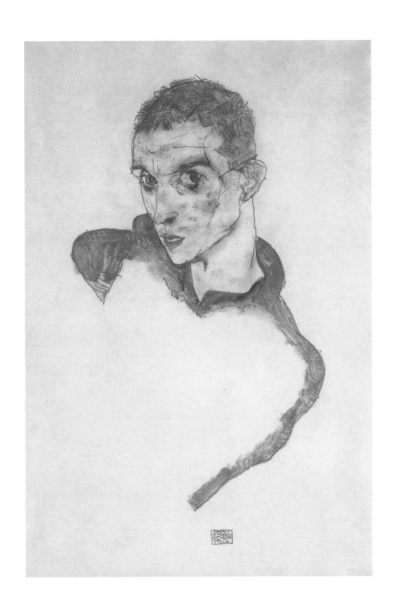

Above: *Self-Portrait*. 1914.
Watercolor and pencil. Signed and dated, lower center.
47.3 × 30.9 cm. Kallir D. 1657.
Private collection.
Opposite: *Self-Portrait in Yellow Vest*. 1914.
Gouache, watercolor, and pencil. Signed and dated,
lower right. 47.7 × 31.2 cm. Kallir D. 1665.
Graphische Sammlung Albertina, Vienna.

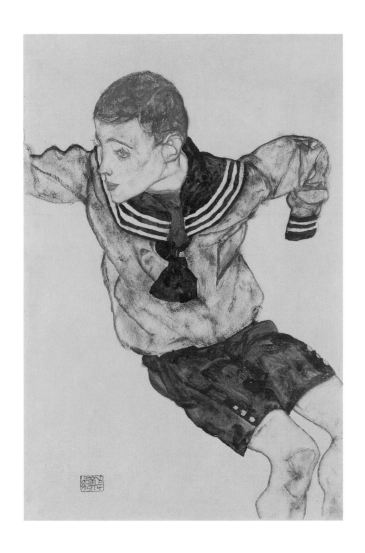

Above: *Boy in Sailor Suit*. 1914.
Gouache, watercolor, colored crayon, and pencil.
Signed and dated, lower left. 47.8 × 31.2 cm. Kallir D. 1633.
Private collection.
Opposite: *Friederike Beer in Striped Dress with Raised Arms*. 1914.
Watercolor and pencil. Signed and dated,
lower right. 48 × 32 cm. Kallir D. 1597.
E. W. Kornfeld Collection, Bern.

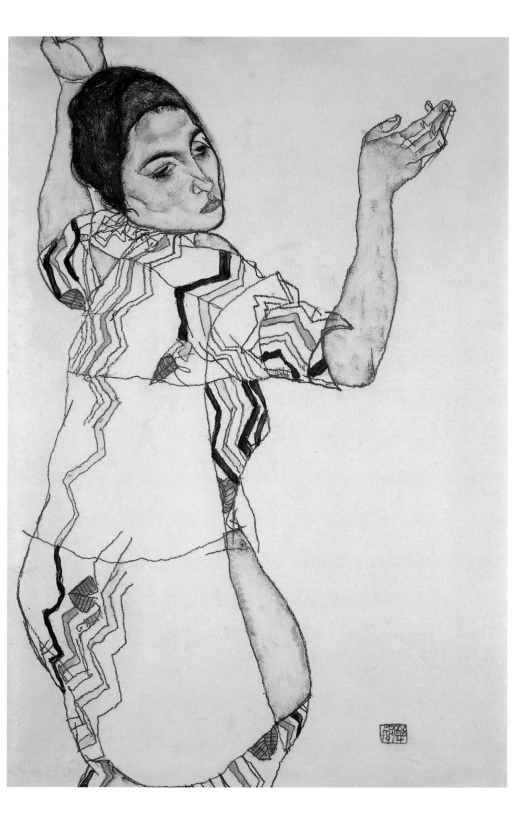

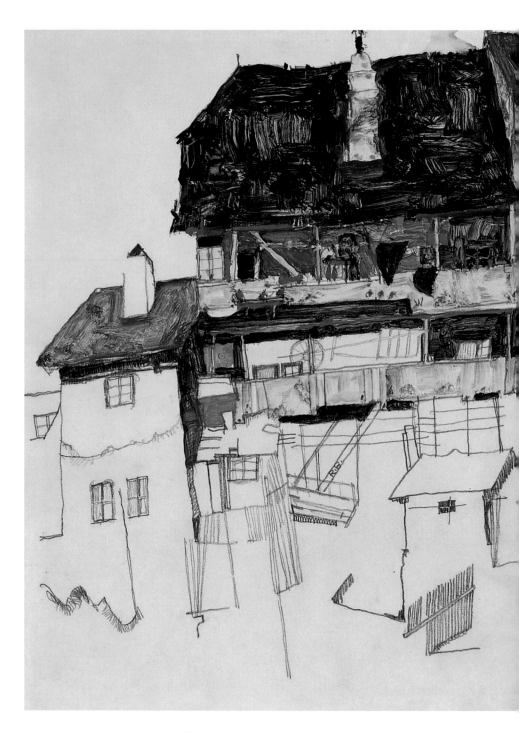

Previous pages: *Street Booth*. 1914.
Gouache, watercolor, and pencil.
Signed and dated, lower right. 31.3 × 47.8 cm. Kallir D. 1685.
The Metropolitan Museum of Art, New York; Bequest of Scofield Thayer, 1982.

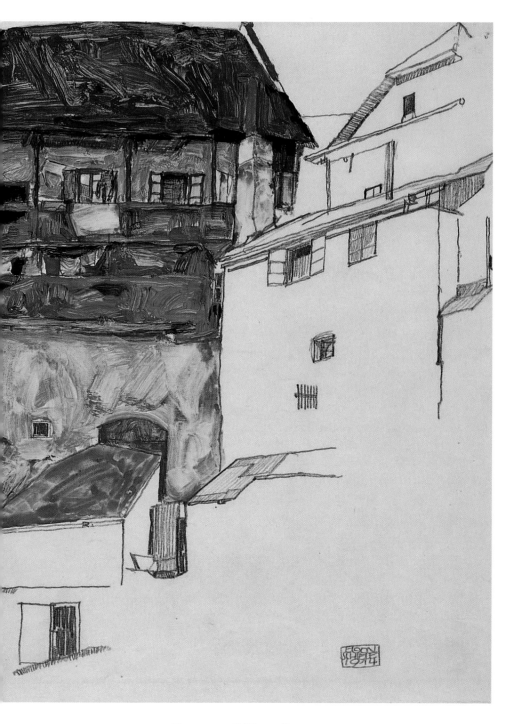

These pages: *Old Houses in Krumau*. 1914.
Gouache and pencil. Signed and dated, lower right.
32.5 × 48.5 cm. Kallir D. 1691.
Graphische Sammlung Albertina, Vienna.

1915

In 1915, Schiele, like a man in a hypnotic trance, yielded to the inexorable commands of bourgeois society. He picked his 'good' girl—the younger, fair-haired Harms sister, Edith—and on 17 June they married. Three days later, finally unable to avoid the draft, Schiele reported for military service in Prague. It was apparent that the artist was not the only one pulling the strings to which his puppetlike self-portraits danced. Military duty would drastically curtail his creative output, but the works executed in the first half of 1915 show that Schiele was, as always, acutely aware of the choices and sacrifices he felt compelled to make.

The consummation of Schiele's romance with Edith Harms was not easily achieved. By early 1915, Egon had formally asked for her hand in marriage, but the Harms parents remained firmly opposed to the union. They objected not only to an artist's implicitly immoral life-style, but to their future son-in-law's lack of financial security. The uncertainty of wartime, they furthermore believed, was not a propitious atmosphere in which to make life-altering decisions. War, however, forces exactly those decisions upon people, and it seems that Schiele's imminent induction into the Austro-Hungarian Army ultimately precipitated the wedding.

Of course, Egon and Edith faced an obstacle slightly more unusual than parental opposition: Wally was still very much a part of the artist's life, and he was not inclined to give her up. Even after Edith put her foot down, insisting on a clean and total break, her fiancé tried to engineer a surreptitious compromise. Egon arranged to meet Wally in a café, where he presented her with a quasi-legalistic document mutually obligating them to share an annual vacation. Wally, not surprisingly, rejected the offer and walked out in a huff. The two never again saw one another. Schiele's former lover volunteered as a Red Cross nurse soon thereafter. She died of scarlet fever in Dalmatia in December 1917.

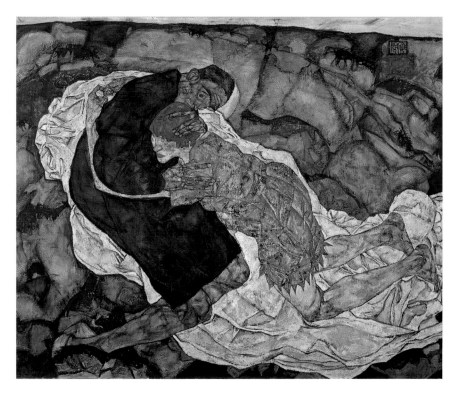

Fig. 23: Egon Schiele. *Death and Maiden (Man and Girl)*. 1915.
Oil on canvas. Signed and dated, upper right. 150 × 180 cm. Kallir P. 289.
Österreichische Galerie, Vienna.

During the period of his transition from Wally to Edith, Schiele executed a
remarkable series of drawings depicting various types of couples: man-woman,
woman-woman, and woman-child. Ambiguity and ambivalence are paramount in many
of these works. In some, the images are so frenzied that it is hard to say if the male is
a child or a man (page 338). Edith and her young nephew Paul Erdmann (page 354)
are the subjects of all the woman-child pairings, but their embrace in some cases seems
eerily sexual (pages 339 and 340). Often in Schiele's 1915 drawings of couples, one
member is a fully sentient human being, the other a button-eyed, puppetlike creature.
The female couples thus do not necessarily represent actual lesbian relationships, but
rather may portray two idealized feminine archetypes: the sexualized 'bad' girl (i.e.,
Wally) and the limp, sexless doll (i.e., Edith) (pages 335–337). Yet in a chilling
self-portrait with his new wife, it is Egon who is the limp, saucer-eyed doll (page
343). Schiele's 'blind' puppet figures, familiar already from his 1914 nudes and self-
portraits, are revealed to be symbols of the artist's sexual alienation. The aesthetic

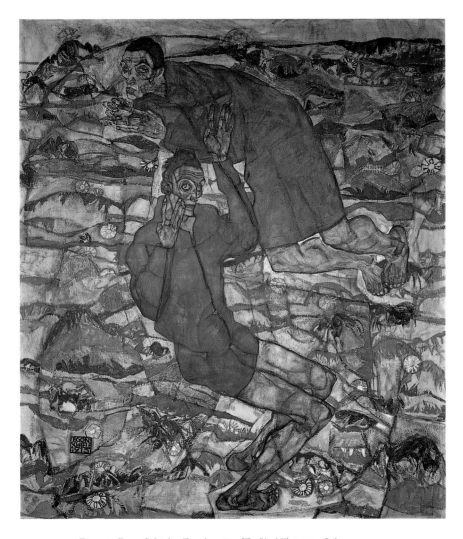

Fig. 24: Egon Schiele. *Transfiguration (The Blind II)*. 1915. Oil on canvas.
Signed and dated, lower left. 200 × 172 cm. Kallir P. 288.
Leopold Museum, Vienna.

distancing imposed upon his models and the repression of his own feelings are two
sides of one coin. To be part of a couple, as Schiele sees it, is to sacrifice self.

The capstones to Schiele's 1915 depictions of couples are two monumental oils,
Death and Maiden (figure 23) and *Transfiguration* (figure 24). *Death and Maiden* is commonly
interpreted as a parting gesture to Wally. However, while Egon personifies death in the
painting, the maiden's face is not fully revealed, and the couple is, in any case, allegorical

rather than autobiographical. As such, the image can be interpreted in several ways. On the most basic level, it is a quintessential evocation of love gone cold: of two lovers who cling, out of habit and fear, despite the sure knowledge that their relationship is doomed. It is interesting that the male in the composition represents death—as though Schiele were not only taking personal responsibility for ending his liaison with Wally, but taking upon his entire sex responsibility for an incapacity to sustain a mutually satisfying relationship. On yet another level, *Death and Maiden* can be interpreted as depicting a kind of cosmic stasis, in which male and female—death and life—meet in an eternal circle.

Transfiguration is in many ways a more personal canvas than *Death and Maiden*, since it is difficult to interpret this double self-portrait as anything but an autobiographical statement. Whatever overriding allegorical sentiments Schiele may have had in mind (enlightenment, transcendence, his own spiritual ascension), they are overshadowed by the stricken expressions on the artist's two faces. In *Transfiguration*, Schiele is plainly saying good-bye to his youthful self. Both selves—as stated in the painting's alternate title, *The Blind*—are sightless. Schiele's adolescent persona, now ascending to heaven, was blind to others. The saucer-eyed adult, who remains on earth, is blind to himself. In this painting, as in many of the 1915 self-portrait drawings, Schiele displays a wistful tenderness toward himself, toward the boy he is leaving behind (pages 346–347). In one curious watercolor, he cradles his own head on his shoulder (pages 344–345). The pictorial disassociation of the artist's past and present selves mirrors a painful split in his psyche.

Nevertheless, Schiele had made his decision. Once he was married to Edith, events simply took their course. The couple spent their brief three-day honeymoon in Prague, and then Egon reported for military duty, at a large exhibition hall that was, ironically, annexed to the modern museum the newlyweds had just visited as tourists. Conditions there were hardly better than those Schiele experienced in prison. At first—when he did not have a blanket, soap, or eating utensils—they may have been even worse. The Austro-Hungarian Army was broken down according to nationality. Because Schiele's father had officially been a Czech citizen, the artist was inducted with un-educated Czech peasants who, given their way, would long before have seceded from the Empire. Discipline was harsh. Deserters were shot in cold blood, and all were confined to the premises for the duration of their stay.

Schiele called his initial days in the army 'perhaps the hardest of my life,' but he showed little of the self-pitying despair manifested during his imprisonment. 'I see that we are too comfortable in our attitudes,' he noted. 'We must grow hard and primitive.' Schiele expected a concomitant toughness of his bride, but Edith—who had never before even taken a train trip by herself—was totally unprepared for her new

position. Stuck in a strange hotel room in Prague with dwindling funds, she was frightened and lonely. She waited for the moments when she might catch a glimpse of her husband in the yard behind the exhibition hall and speak to him through the surrounding fence. Then, just five days into her ordeal, she ran into an old friend, Jenö Farkas, with whom she began a sustained flirtation. Schiele eventually learned of this innocent affair, and jealousy naturally inflamed his own feelings of vulnerability and isolation. The marriage was off to a rocky start.

It is probable that Egon had never known a woman like Edith, whose background and expectations were so vastly different from those of his models. Though undoubtedly a virgin when they married, she was not, as it turned out, the chaste idol he may have expected. On the one hand, this may have come as a pleasant surprise. Notations in both Edith's and her husband's diaries indicate that, once they were physically reunited, they spent much of their time making love. 'We are in bed all the time,' Edith wrote. 'We are pressed against one another as closely as possible so as to forget the world around us.' On the other hand, Egon was incensed by his wife's flirtatiousness and stymied by her selective prudery. While she did not want her husband using other models, Edith herself was understandably embarrassed about posing, because she was then expected to peddle the resulting drawings to collectors. The ordinary demands of propriety that she placed on their relationship irritated her mate, as did the fact that, unlike Wally, she was not a devoted servant but a partner who felt entitled to certain prerogatives. Edith made it clear to Egon that, if things did not suit her, she could easily return to Vienna. 'He grew quite desperate when I threatened to leave,' she coolly informed her parents. 'He cried like a child. He said . . . he would go crazy. . . . He would throw himself in the lake.'

Nevertheless, at Schiele's insistence, Edith loyally followed him from one military assignment to the next. On 27 June, Egon was transferred to Neuhaus in Bohemia for basic training and guard duty. Here, the academic credentials that Leopold Czihaczek had long wanted him to parlay into a military career served him in good stead: he was billeted with other potential officer candidates, rather than with lower-class draftees. Schiele's commanding officer, like him a native German speaker, took pity on the artist's plight and often allowed him to visit his bride. In Vienna, where he was transferred in July, he was able to spend almost every night with Edith in their Hietzing apartment.

Schiele applied for extended sick leave in August, and during the ensuing days was able to paint a full-length portrait of his wife (figure 25). By this time, he had

Fig. 25: Egon Schiele. *Portrait of the Artist's Wife, Standing (Edith Schiele in Striped Dress)*. 1915. Oil on canvas. Signed and dated, lower right. 180 x 110 cm. Kallir P. 290. Haags Gemeentemuseum voor Moderne Kunst, The Hague.

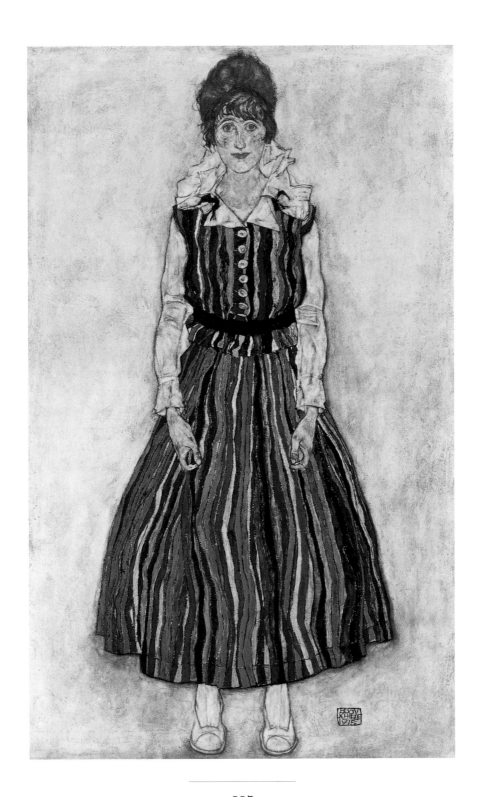

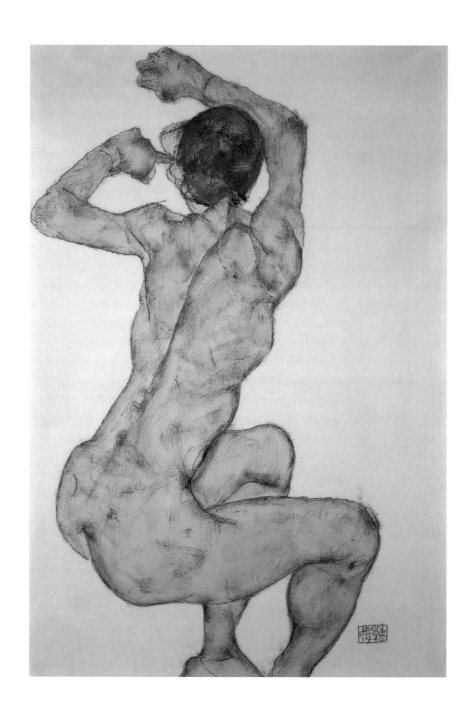

Nude with Raised Arms. 1915.

Gouache and pencil. Signed and dated, lower right. 48 × 32 cm.

Kallir D. 1732. Private collection.

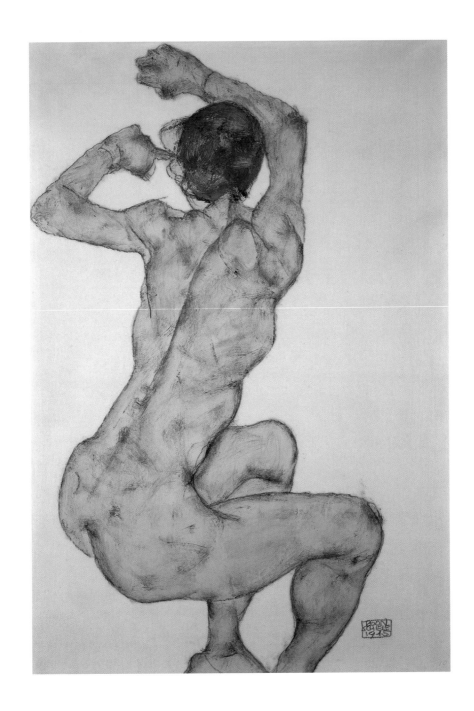

Nude with Raised Arms. 1915.
Gouache and pencil. Signed and dated, lower right. 48 × 32 cm.
Kallir D. 1732. Private collection.

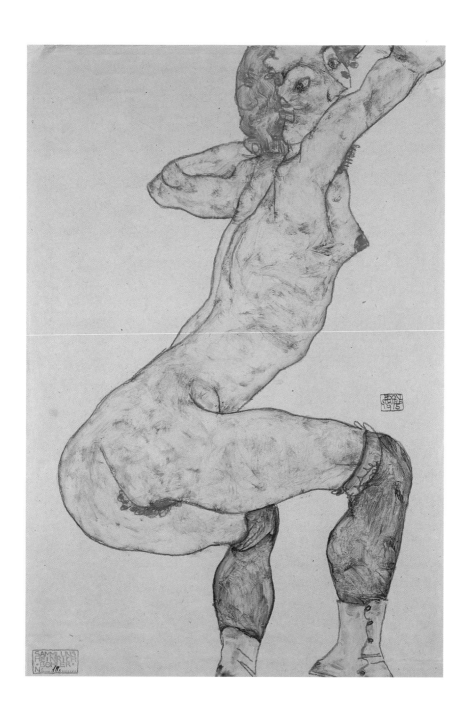

Kneeling Nude. 1915.
Gouache, watercolor, and pencil. Signed and dated, center right.
49.8 × 33 cm. Kallir D. 1733. Private collection.

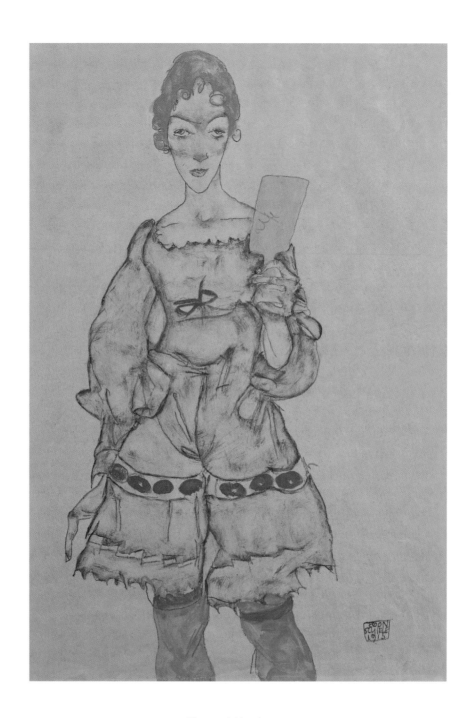

Woman with Mirror. 1915.
Gouache and pencil. Signed and dated, lower right. 49.6 x 32.5 cm.
Kallir D. 1744. Tel Aviv Museum, Tel Aviv.

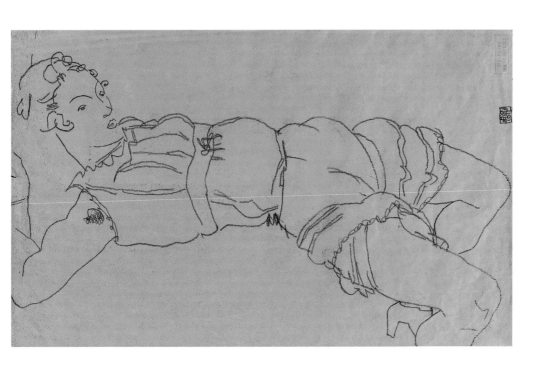

Reclining Woman. 1915.
Pencil. Signed and dated (as vertical), lower right.
37 × 30.5 cm. Kallir D. 1753.

Two Girls Embracing (Two Friends). 1915.
Gouache, watercolor, and pencil. Signed and dated, lower center.
48 × 32.7 cm. Kallir D. 1742. Szépmüvészeti Múzeum, Budapest.

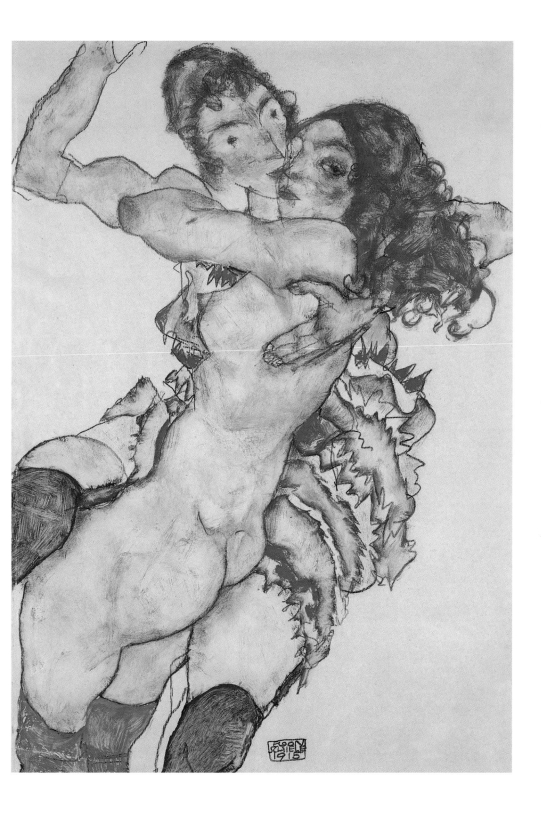

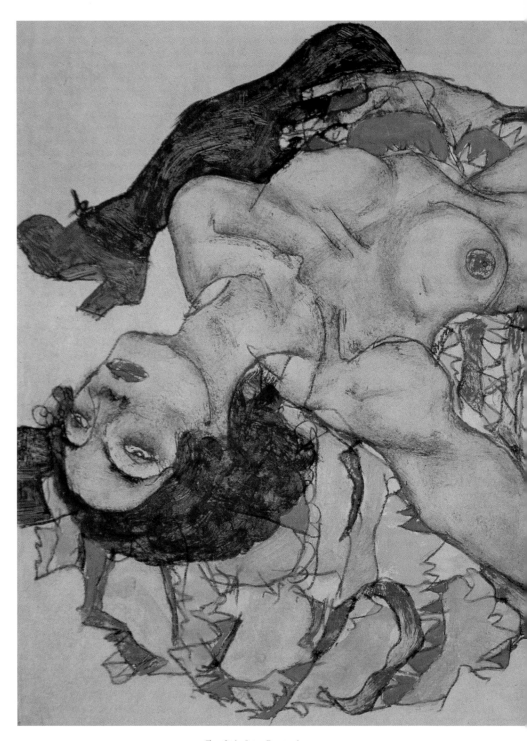

Two Girls, Lying Entwined. 1915.
Gouache and pencil. Signed and dated, lower center. 32.8 × 49.7 cm. Kallir D. 1743.
Graphische Sammlung Albertina, Vienna.

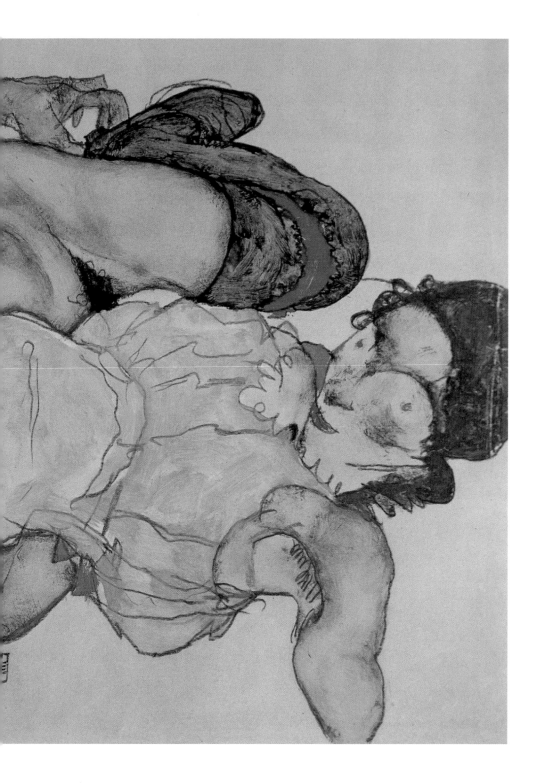

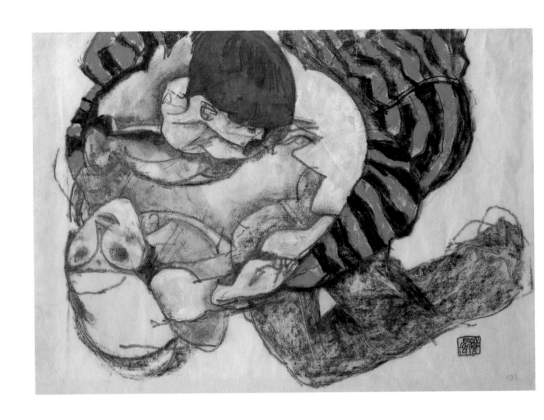

Above: *The Embrace (Lovers)*. 1915.

Gouache, charcoal, and black crayon. Signed and dated, lower right.

32.4 × 45 cm. Kallir D. 1794. Private collection.

Opposite: *Dancing Couple*. 1915.

Pencil. 48.5 × 34.1 cm. Kallir D. 1795.

Kupferstichkabinett, Akademie der Bildenden Künste, Vienna.

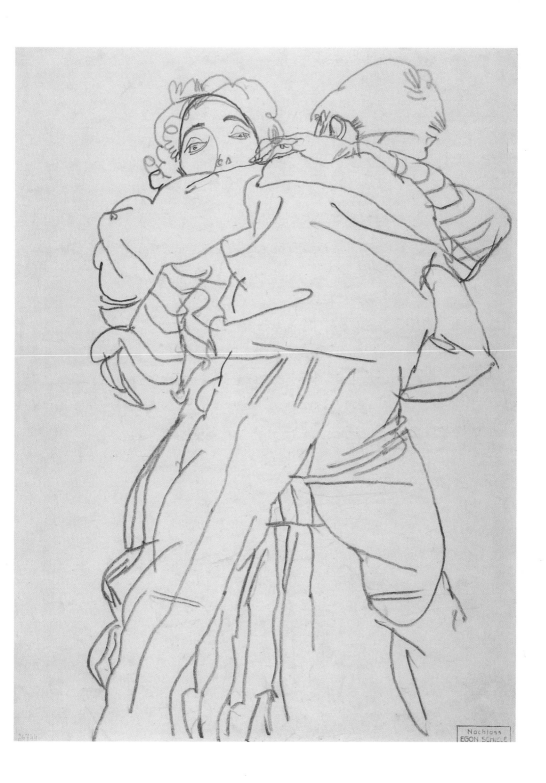

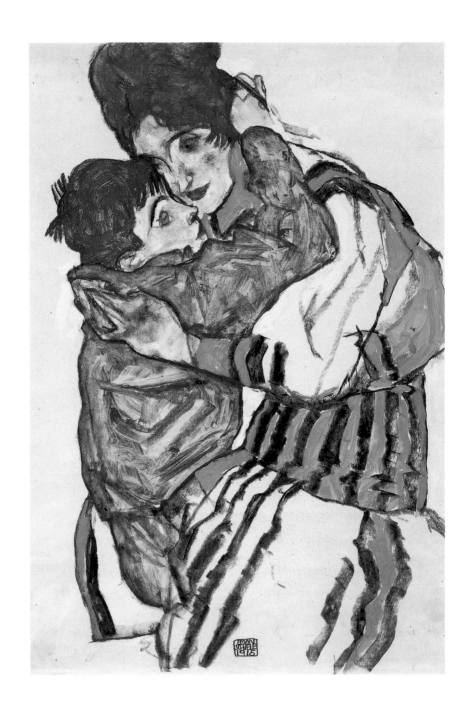

Schiele's Wife with Her Little Nephew. 1915.
Gouache, watercolor, and black crayon. Signed and dated, lower center. 48.2 × 31.9 cm.
Kallir D. 1798. Museum of Fine Arts, Boston; Edwin L. Jack Fund.

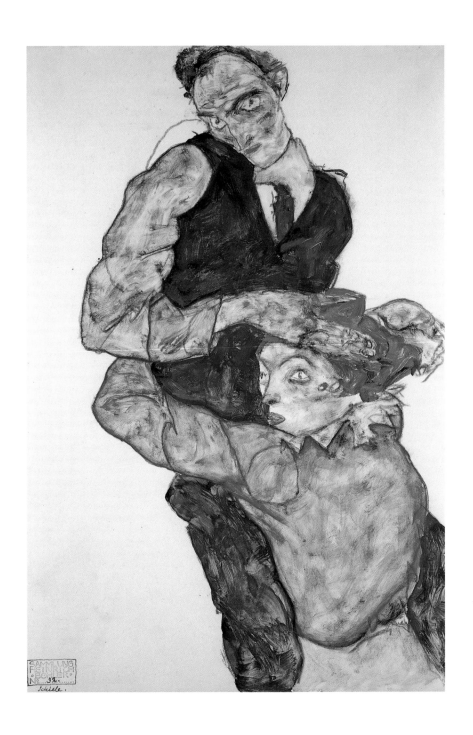

Lovers (Self-Portrait with Wally). 1915.
Gouache, watercolor, and pencil. 47.4 × 30.5 cm. Kallir D. 1784.
Leopold Museum, Vienna.

Seated Couple (Egon and Edith Schiele). 1915.
Gouache and pencil. Signed and dated, lower center. 52.5 × 41.2 cm. Kallir D. 1788.
Graphische Sammlung Albertina, Vienna.

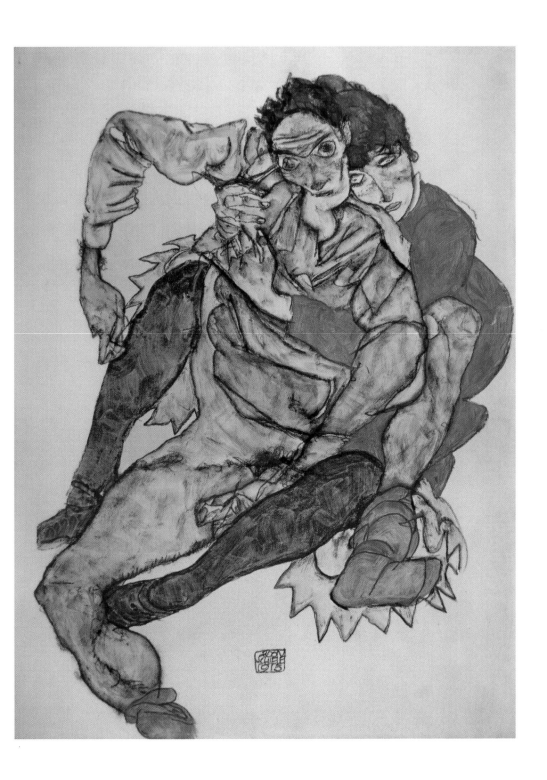

Double Self-Portrait. 1915.
Gouache, watercolor, and pencil. Signed and dated, lower left. 32.5 × 49.4 cm.
Kallir D. 1781. Private collection.

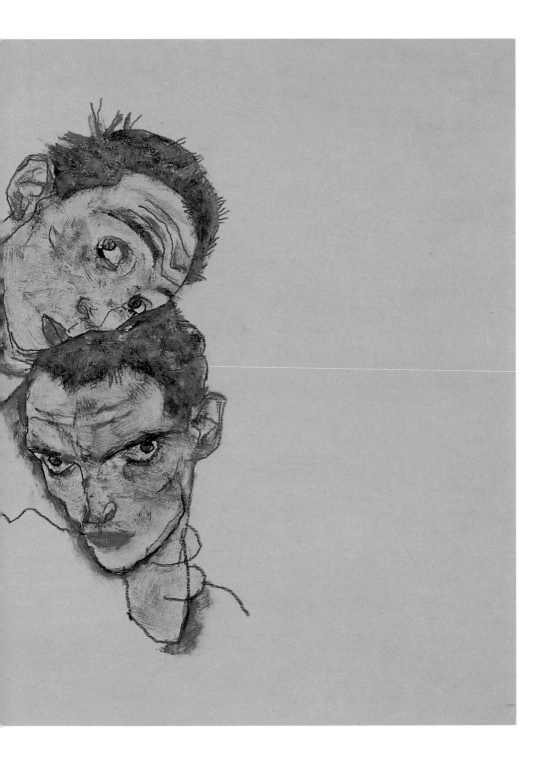

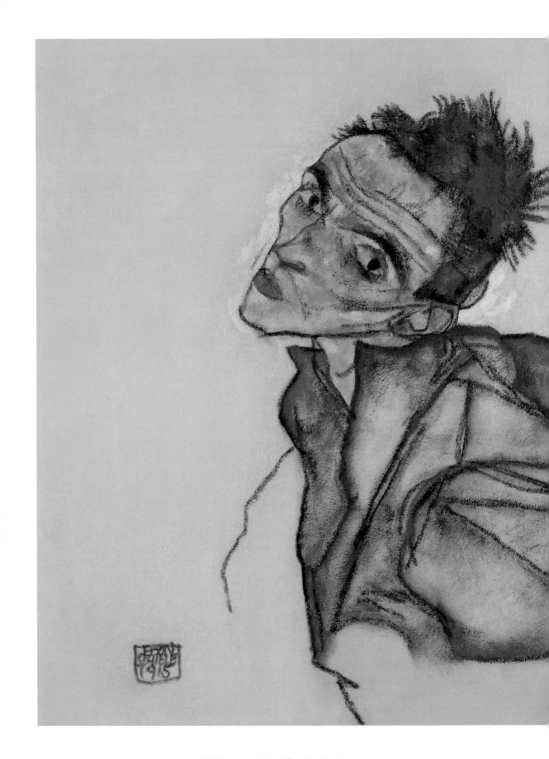

Self-Portrait with Arms Thrust Backwards. 1915.

Gouache, pastel, and charcoal. Signed and dated, lower left. 32.9 × 44.8 cm.

Kallir D. 1783. E. W. Kornfeld Collection, Bern.

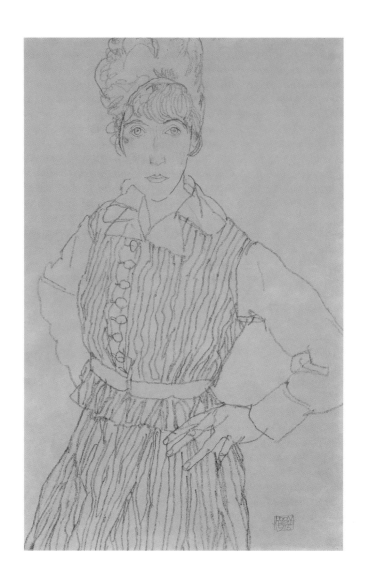

Above: *Portrait of the Artist's Wife, Standing, with Hands on Hips.* 1915.
Black crayon. Signed and dated, lower right. 45.7 × 28.5 cm. Kallir D. 1719.
Private collection, courtesy of Galerie St. Etienne, New York.
Opposite: *Woman with Greyhound (Edith Schiele).* 1915.
Gouache and black crayon. Signed and dated, lower right.
49.5 × 31.5 cm. Kallir D. 1710. Private collection.

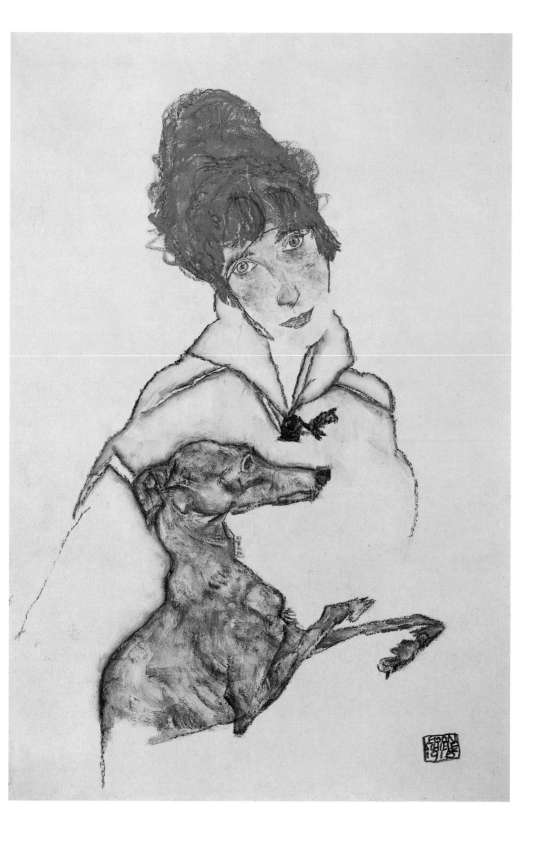

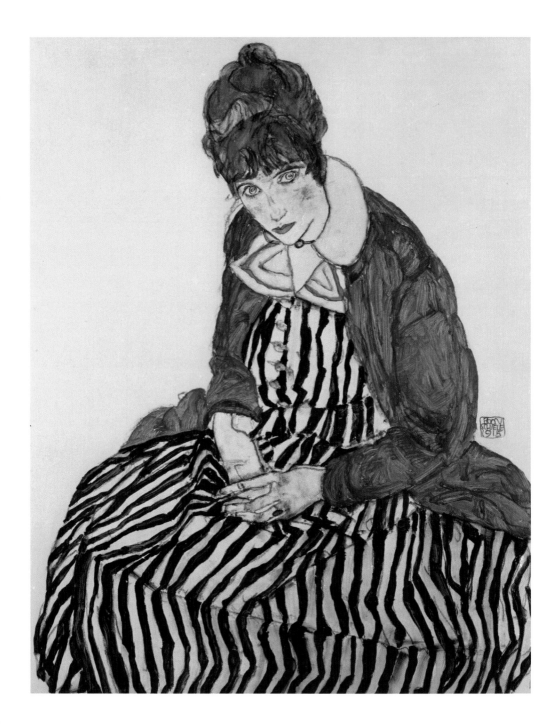

Edith Schiele, Seated. 1915.
Gouache, watercolor, and black crayon. Signed and dated, center right.
50.5 × 38.5 cm. Kallir D. 1717. Private collection.

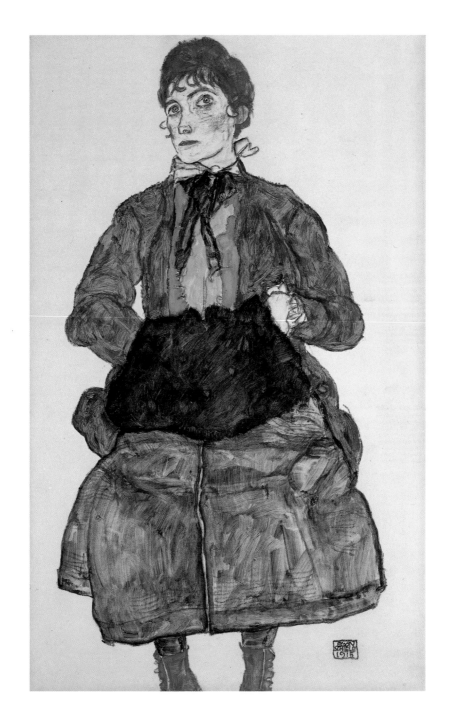

Woman in Green Blouse with Muff. 1915.
Gouache and black crayon. Signed and dated, lower right.
47.6 × 30.5 cm. Kallir D. 1721. Private collection.

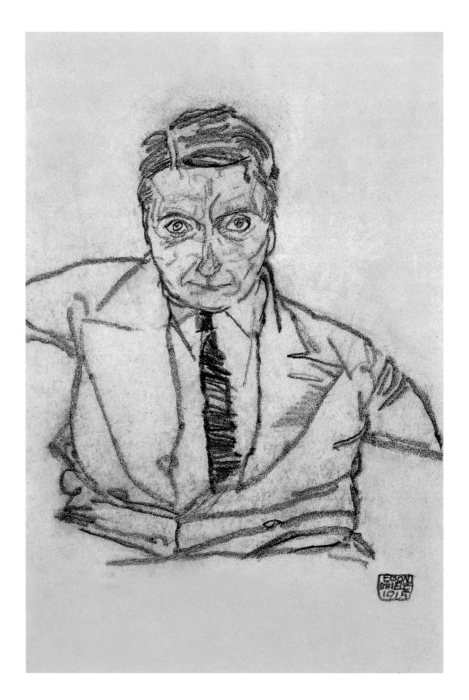

The Artist Böhler. 1915.
Charcoal. Signed and dated, lower right. 48 × 31 cm.
Kallir D. 1763. National Museum, Stockholm;
Gift of Thorsten Laurin through Friends of Museum.

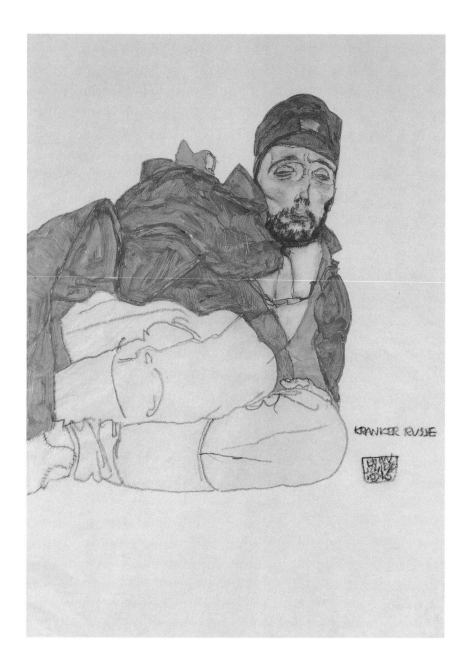

Sick Russian Soldier. 1915.
Gouache and pencil. Signed and dated, lower right.
Inscribed 'Kranker Russe', lower right. 43.8 × 29.8 cm.
Kallir D. 1767. Private collection.

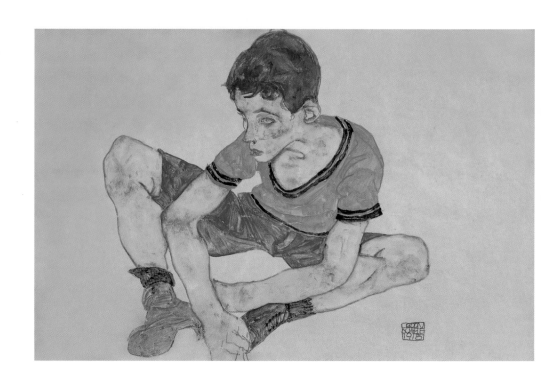

Above: *Cowering Boy*. 1915.
Gouache and pencil. Signed and dated, lower right.
31.3 × 47.5 cm. Kallir D. 1699. The Israel Museum, Jerusalem.
Opposite: *Baby (Anton Peschka, Jr.)*. 1915.
Gouache and pencil. Signed and dated, lower right.
44.5 × 31.1 cm. Kallir D. 1704. Private collection,
courtesy of Galerie St. Etienne, New York.

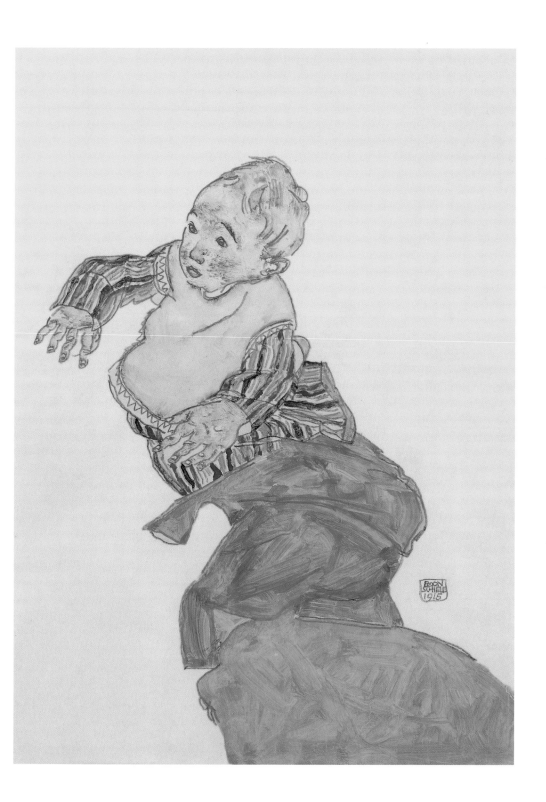

1916

Nineteen-sixteen was Schiele's least productive year artistically. While his military duties were largely responsible for this hiatus, the artist also needed time to adjust, emotionally and creatively, to the changes of the past twelve months. Much of his time was spent dealing with the minutiae of ordinary existence: haggling with the military bureaucracy and trying to finagle assignments that would accommodate both his artistic and his domestic life. When, in May, he and Edith were finally comfortably settled near an army installation in the rural hamlet of Mühling, Schiele used the occasion to enjoy his first real honeymoon. He passed his spare time making love to his bride or taking her on outings to the surrounding countryside. In the evenings, he went bowling or played billiards with his army comrades. The scant artwork that Schiele produced during this period has a matter-of-fact quality. Rather than grand allegories, the artist was immersed in capturing the people and places that figured in his daily routine.

The Austro-Hungarian Army, like the Empire itself, was ruled by an arcane bureaucratic hierarchy. As Schiele had discovered in Prague and Neuhaus, social class, educational background, and connections made a critical difference in how one was treated—even in whether one survived. Not all draftees were equal. Most of Schiele's art-world colleagues quickly found ways to minimize if not entirely eliminate their military obligations. Many with artistic credentials or mere creative pretensions found shelter from active duty by serving in the War Press Headquarters, the Army Museum, or the War Archive. Some, like Schiele's patron Erich Lederer or the artists Berthold Löffler and Ludwig Heinrich Jungnickel, managed to get protracted periods of leave. Thus, while the war quickly cut down some of the leading German Expressionists— among them Franz Marc and August Macke—Austria lost no major artists in battle.

Schiele, presumably due to his weak heart, was classified as 'Unarmed—Fit for Office Duty,' yet he worried that a change in personal or military circumstances could

still get him sent to the front. He enlisted all his contacts—Heinrich Böhler, Carl Reininghaus, and the Wiener Werkstätte—to try to have himself either excused from service altogether, or transferred to some safe haven where he would be permitted to paint. But his artistic bona fides and connections notwithstanding, Schiele had a surprisingly difficult time obtaining the sinecure he desired. Although he managed to stay out of active combat, he was assigned the onerous and time-consuming duties of a common soldier: digging trenches, escorting prisoners, and the like.

In early 1916 Schiele was stationed near the Exelberg, a mountain in the Vienna Woods that was a long (though not impossible) commute from his Hietzing apartment. The commanding officers continued to look the other way when he went home to Edith at night, but one morning he got caught coming back after inspection. Denying they had ever given him permission to leave, his superiors ordered him confined to quarters. Egon asked Edith to come immediately to the nearby town of Sophienalpe, and when she refused, he apparently made invidious comparisons between her behavior and Wally's loyalty during his Neulengbach imprisonment. The incident provides another glimpse into the feelings of disappointment and loss that were slowly coloring Schiele's view of his marriage. 'This morning I recognized that you are not prepared to make the same sacrifices as I,' he wrote his wife. 'I have already lived too long in another world, and I want to go back there again.' Alluding to her inveterate flirtatiousness, he added bitterly, 'I do not want you to walk the streets—do you hear me!'

Schiele's Exelberg 'arrest' proved relatively short-lived, and in March his regiment was transferred to Liesing, a suburb slightly closer to Vienna. The artist was assigned guard duty in neighboring Atzgersdorf, where Russian prisoners of war were housed in an abandoned factory. As he'd done when guarding prisoners in 1915, Schiele took advantage of the opportunity to draw his charges (pages 353, 370, and 371). These portraits are an amazing testament to the artist's growing humanism and compassion. Shaken, demoralized, sometimes visibly ill or injured, the prisoners are most emphatically not a faceless enemy. (It is interesting that, because the artist routinely had the prisoners inscribe their names on the drawings, the subjects are actually easier to identify than many of his Austrian sitters.) Schiele was instinctively inclined to sympathize with the Russians. And while he did not speak their language, he was also evidently able to communicate with them. 'Their desire for eternal peace was as great as mine,' he observed, adding prophetically, 'The idea of a single Europe composed of united states appealed to them.'

Schiele was one of the very few Austrians who never embraced the war with patriotic zeal. Most members of the artistic and literary avant-garde, which later turned against the war almost en masse, were initially gung-ho supporters of the military effort. It was not that Schiele was particularly political (although the Berlin

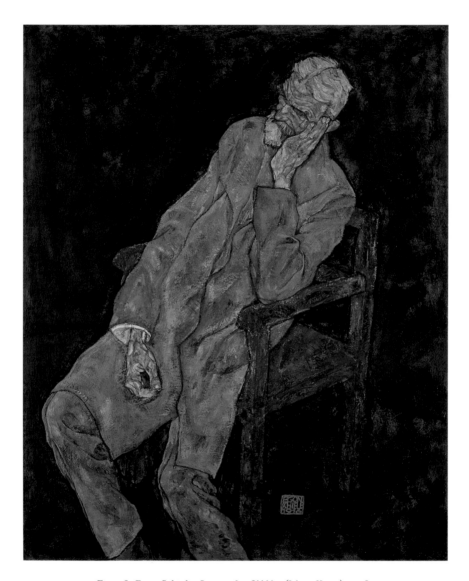

Fig. 26: Egon Schiele. *Portrait of an Old Man (Johann Harms)*. 1916.
Oil on canvas. Signed and dated, lower center. 138.4 × 108 cm.
Kallir P. 300. Solomon R. Guggenheim Museum, New York;
Partial gift of Dr. and Mrs. Otto Kallir, New York, 1969.

periodical *Die Aktion*, with which he was loosely associated, had a pacifist slant). However, the artist had always been skeptical of organized authority, and the ties of nationality were meaningless to him. 'It is all the same to me where I live—that is, to what nation I belong,' he wrote. Not only did he feel no special loyalty to the Austro-Hungarian Empire, he suspected that the enemy countries might actually be superior to his own: more interesting, more tolerant, more supportive of individual dignity. Schiele's longstanding battle for personal freedom had metamorphosed into a generalized plea for what he now perceived to be a universal human right.

The months that Schiele spent in Liesing seem to have been his most fertile period in 1916. Not only did he create the poignant prisoner drawings, but relatively easy access to Vienna enabled him to complete a number of studies of his infant nephew, Anton Peschka, Jr. (pages 362 and 363), as well as three oil paintings: two landscapes and an eloquent portrait of Johann Harms (figure 26; page 372). Despite the Harms family's initial opposition to his marriage, Schiele was extremely fond of his father-in-law, a withdrawn, worn-out elderly gentleman who would not survive the next twelve months. The economy of means, simple lines, and muted palette with which the artist captured the *Old Man* (the oil's primary title) presage Neue Sachlichkeit (New Objectivity), the post-Expressionist German style of the 1920s. Works such as the Harms portrait show what Schiele had gained by trading the expressive flair of his earlier years for a more subdued realism. His mature style made it possible for the artist to far more incisively explore the unique individual essence of his sitters.

In May 1916, the office job Schiele had been waiting for finally came through. It was not, as he hoped, in Vienna, but in Mühling, a tiny village about three hours west of the city. Nor was this new assignment in any special way tailored to take advantage of his artistic talents. He was, owing to his elegant handwriting, asked to keep the account books at the military camp. Nevertheless, the facilities in Mühling were relatively luxurious: 'like a modern spa,' Schiele commented, without irony. Eggs, butter, and produce—already in short supply in Vienna—were bountiful in the countryside. The area was not in a war zone, so Edith was allowed to come along, and the couple found a nice cottage apartment near the army base. After they had been there about a month, the first lieutenant, Gustav Hermann, gave the artist an empty storeroom to use as a studio.

Hermann's generosity notwithstanding, Schiele executed only two paintings during his eight months in Mühling, one of them an extremely anomalous hunting scene commissioned by the first lieutenant. To further curry favor with his commanding officers, Schiele also occasionally sketched their portraits. These rather perfunctory drawings stand in stark contrast to the far warmer and more personal prisoner portraits. During this period, images of men actually outnumber women in Schiele's oeuvre. Though his wife consented (reluctantly and provided that her face be hidden or dis-

guised; pages 368–369) to pose for the artist, Schiele did relatively few nudes in 1916. His production of landscape and nature drawings, on the other hand, increased somewhat, probably as an outgrowth of his excursions with Edith (pages 378 and 379). In almost all these works (with the notable exception of a few drawings of the couple in bed; pages 366–367), the wild stylization of the past has vanished. Schiele's assimilation of realism is virtually complete.

Once settled in Mühling, the Schieles' joint life fell into what was, on the surface, a placid and comfortable routine. The artist does not appear to have regretted his lack of productivity, but instead contentedly recorded his mundane daily activities in a journal that, for the moment, all but replaced his more customary means of expression. Edith's diary from the same period, however, gives a totally different picture of the couple's evolving marital life. She felt stranded in Mühling, far from home and family. 'I would find it quite nice here, if the loneliness did not weigh on me so heavily,' she wrote. 'The short time in which Egon is with me rushes by, the rest of the time creeps past endlessly.' Several weeks later, she noted, 'My nerves are sick, so that my body aches terribly. . . . Any kind of thought may torment me, any trivial little thing may drive me into a frenzy. They all call me spiteful and disgusting, but believe me when I tell you that I am sick, sicker than you think. Nowhere do I find understanding, and this hurts me so.'

Evidently, Schiele had won the battle of wills that, from the start, had punctuated his marriage. The artist's first months of military service had evoked feelings of impotence and confinement reminiscent of those he'd experienced in prison, and this gave Edith—who remained 'free' in the outer world—the upper hand. But in Mühling, Schiele had relative autonomy, while she felt completely lost. Of course in the society of the time, it was ordained that the husband rule supreme; a wife had little choice but to submit. On a more intimate level, both Egon and Edith were equally disappointed to realize that their bond was not so close as to obviate the possibility of any disagreement. Neither was willing to compromise, to engage in the closely calibrated balancing of divergent needs and interests that is at the heart of every successful marriage. A process of mutual emotional withdrawal had begun.

Schiele's artistic hiatus was accompanied by a decline in his other professional activities. His distance from Vienna made it difficult to sustain steady contact with his patrons, who in any case had more pressing matters on their minds than art or the artist. The war did not entirely eliminate exhibition possibilities, but import/export restrictions and the uncertain business climate greatly reduced the frequency of artistic events. Furthermore, Schiele's own lack of productivity gave him little new to offer, either to clients or to the public at large.

Schiele awoke gradually from his creative slumber in the autumn of 1916. The precipitating event may have been the publication of a long-awaited 'Egon-Schiele issue' of *Die Aktion* in September. The artist began to make more frequent trips into Vienna and rekindled his friendships with art-world colleagues such as Felix Albrecht Harta and Paris von Gütersloh. He also asked the dealer Guido Arnot—with whom he had maintained friendly contact since his 1914 exhibition—to give him another show. Although the dealer readily consented, the venture eventually foundered due to Schiele's unrealistic demands. The two men haggled over prices and the commission structure. At the last minute, after the invitations had already been sent out, Arnot felt compelled to cancel the show. 'The Galerie Arnot cannot survive simply by the honor of exhibiting the work of Mr Egon Schiele,' the dealer sarcastically informed him. Reprising his experiences with Hans Goltz, Schiele was totally unwilling to accommodate what he perceived as the mercenary requirements of a commercial gallery.

During his lazy summer 'honeymoon,' Schiele had suspended his attempts to obtain a transfer back to Vienna. But now, his rekindled professional ambitions prompted him to renew the effort. Through Leopold Liegler, a friend who had written an essay for the Schiele issue of *Die Aktion*, he made contact with Karl Grünwald at the Imperial and Royal Military Supply Depot. Grünwald, the son of an antiques dealer, helped secure the artist's transfer. Though it took some time for the army to find a recruit with equally lovely handwriting to replace him in Mühling, Schiele was finally released from his duties there on 12 January 1917. He returned to Vienna full of ideas; at long last, his career was back on track.

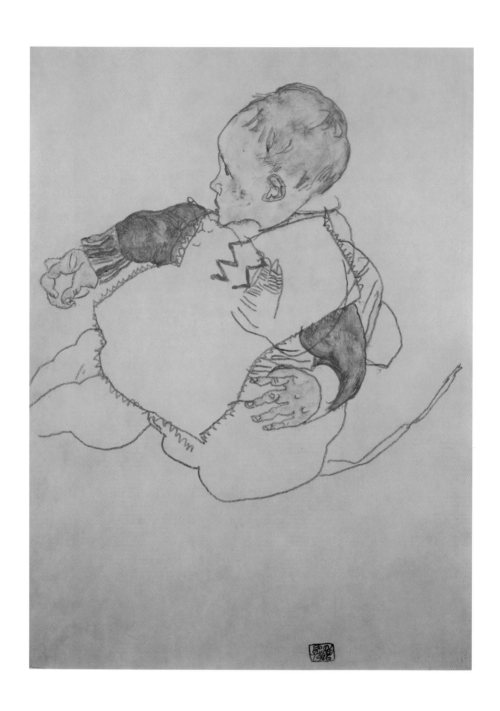

Child with Green Sleeves (Anton Peschka, Jr.). 1916.
Gouache and black crayon. Signed and dated, lower right. 47.3 × 31.8 cm.
Kallir D. 1813. Private collection.

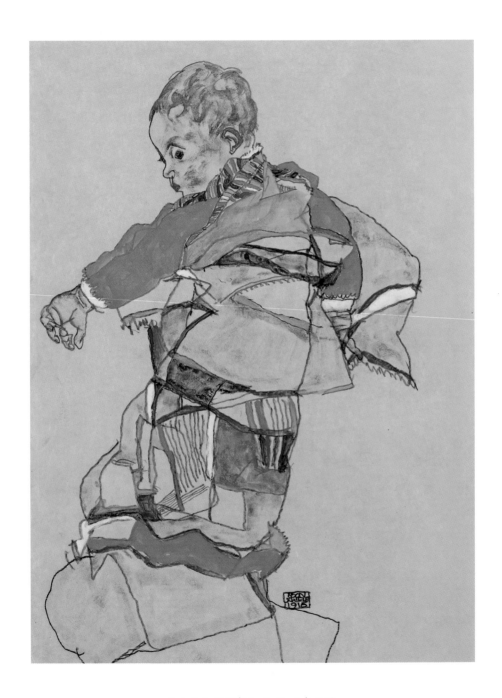

Portrait of a Child (Anton Peschka, Jr.). 1916.
Gouache and pencil. Signed and dated, lower right.
50 × 32 cm. Kallir D. 1814. The Cleveland Museum of Art, Cleveland;
Severance and Greta Milliken Collection.

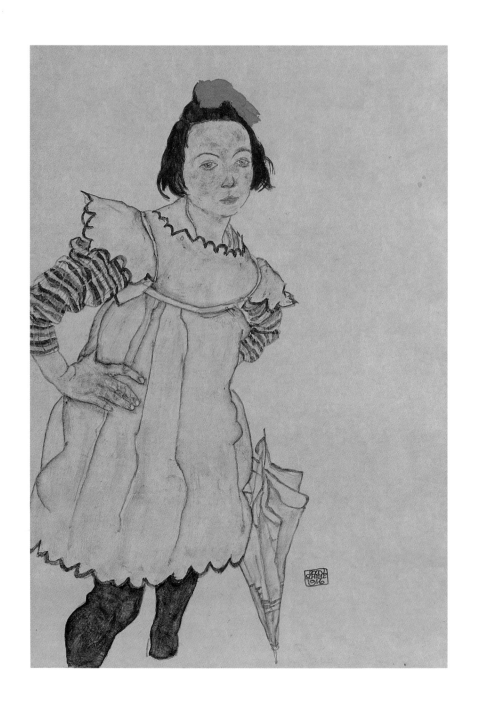

Girl with Umbrella. 1916.
Gouache and pencil. Signed and dated, lower right. 46.2 x 30.8 cm.
Kallir D. 1818a.

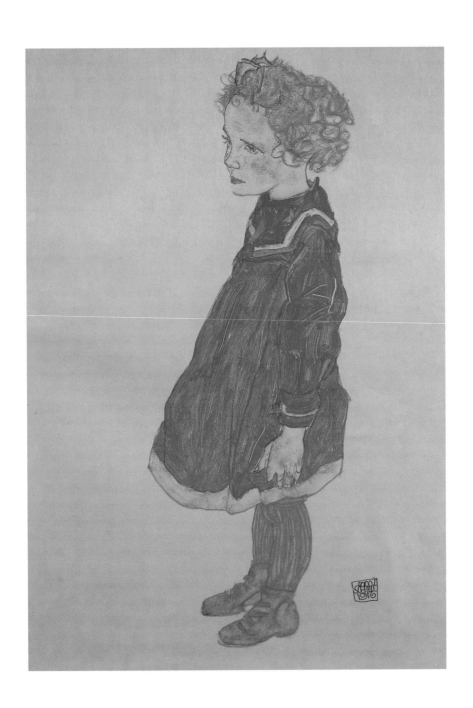

Little Girl with Blond Hair in Red Dress. 1916.
Gouache and pencil. Signed and dated, lower right. 46 × 30.8 cm. Kallir D. 1818.
Private collection, courtesy of Galerie St. Etienne, New York.

Couple Embracing (Egon and Edith Schiele). 1916.
Crayon. Signed and dated, lower right. 40.9 × 51.7 cm.
Kallir D. 1858. Santa Barbara Museum of Art, Santa Barbara;
Gift of the Ala Story Collection.

367

Female Semi-Nude, Reclining with Legs Spread (Edith Schiele). 1916.
Gouache, watercolor, and pencil. Signed and dated (as vertical),
upper left. 30.9 × 44.4 cm. Kallir D. 1833. Leopold Museum, Vienna.

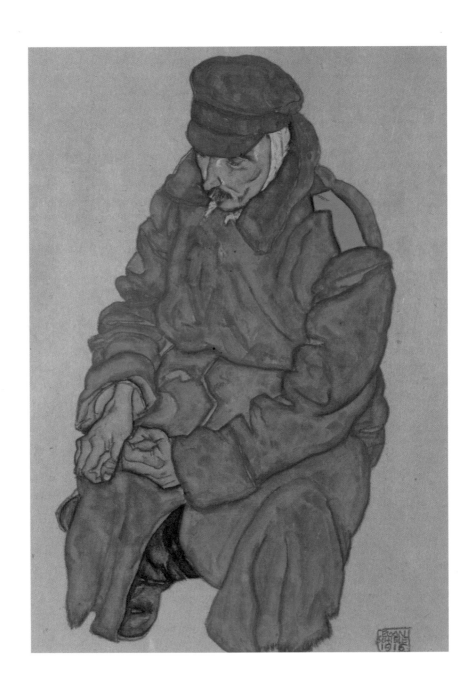

Russian Soldier. 1916.
Watercolor and pencil. Signed and dated,
lower right. 39.4 × 27.3 cm. Kallir D. 1840.
Private collection.

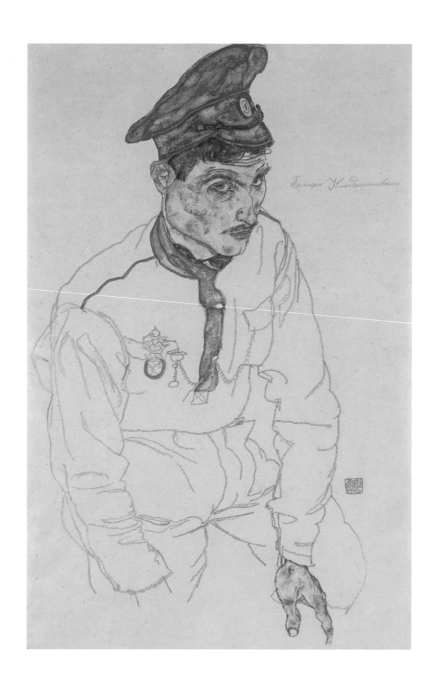

Russian Prisoner of War (Grigori Kladjishuili). 1916.
Gouache and pencil. Signed and dated, lower right. 48.3 × 30.8 cm. Signed (in Russian)
by the subject, upper right. Kallir D. 1839. The Art Institute of Chicago, Chicago;
Gift of Dr. Eugene Solow and family in memory of Gloria Brackstone Solow.

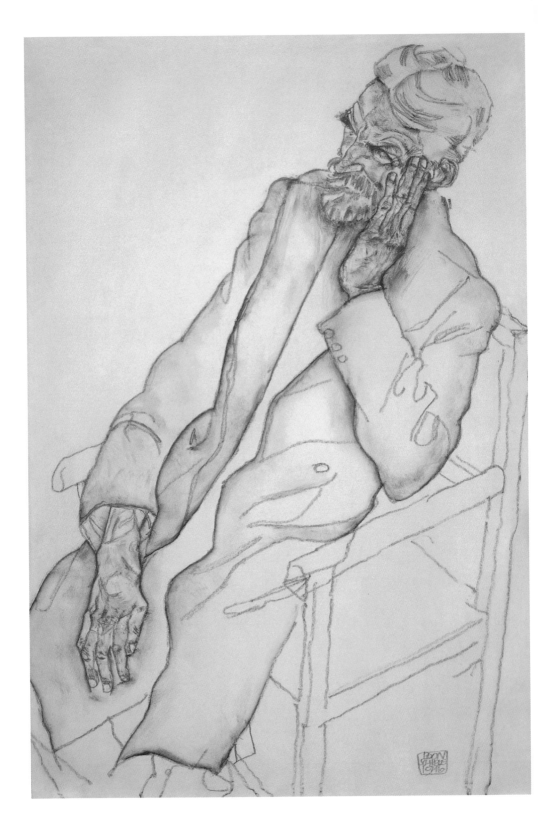

Portrait of Johann Harms. 1916.

Gouache, watercolor, and pencil. Signed and dated, lower right. 48.2 × 36.4 cm.

Kallir D. 1844. Private collection, New York.

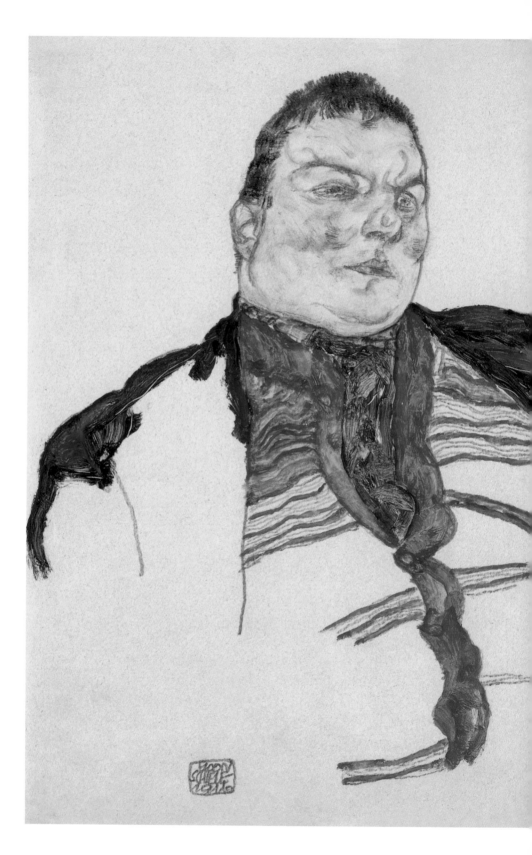

Portrait of a Fat Man. 1916.
Gouache and pencil. Signed and dated,
lower left. 32.5 × 29.5 cm. Kallir D. 1847.
Kunsthaus Zug, Kamm Collection, Zug.

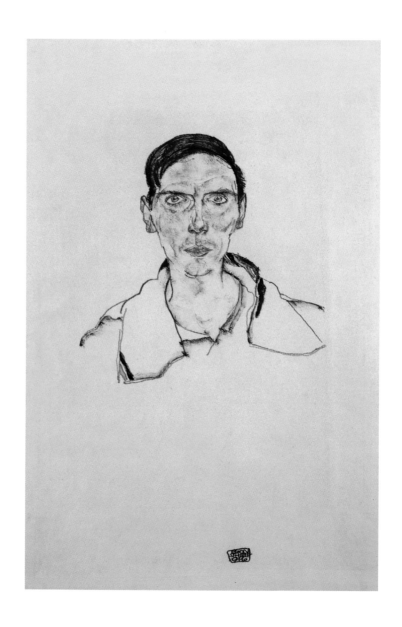

Above: *Portrait of a Bachelor, Front View.* 1916.
Gouache, crayon, and pencil. Signed and dated,
lower center. 46 × 29 cm. Kallir D. 1848.
Haags Gemeentemuseum voor Moderne Kunst, The Hague.
Opposite: *Portrait of a Man (Dr. Ofromowicz).* 1916.
Charcoal. Signed and dated, lower center. 45.9 × 39.8 cm.
Kallir D. 1853. Moravská Galerie, Brno.

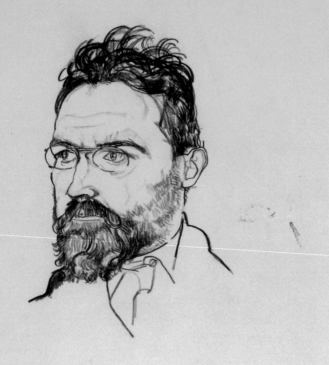

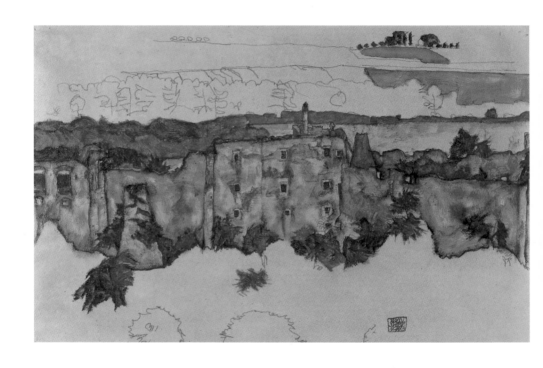

Above: *Landscape (The Weitenegg Ruins)*. 1916.
Gouache and pencil. Signed and dated, lower right. 29.5 × 46 cm.
Kallir D. 1864. Private collection.
Opposite: *Sunflower*. 1916.
Gouache and black crayon. Signed and dated, lower right. 46 × 29.2 cm.
Kallir D. 1868. Private collection, New York.

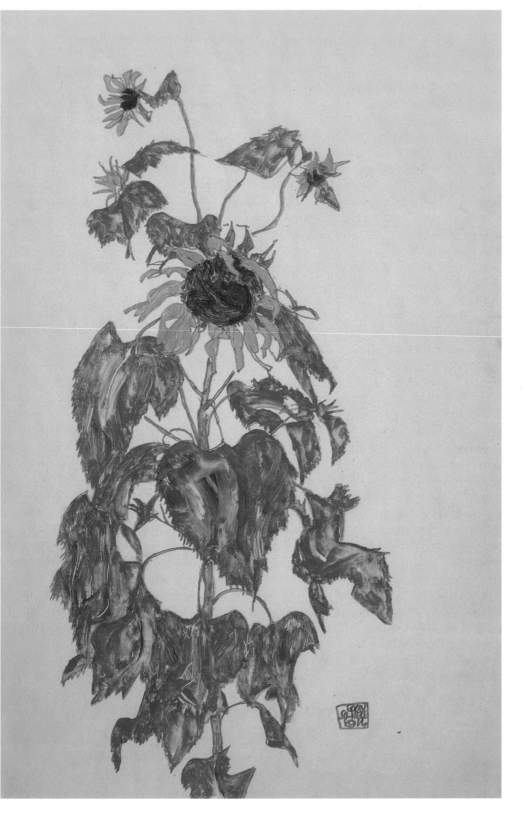

Self-Portrait. 1916.
Pencil. Signed and dated, lower right. 36 × 23cm.
Kallir D. 1854a. Private collection, courtesy of Richard Nagy,
Dover Street Gallery, London.

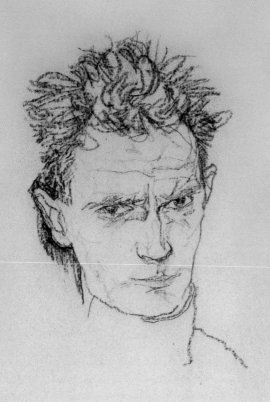

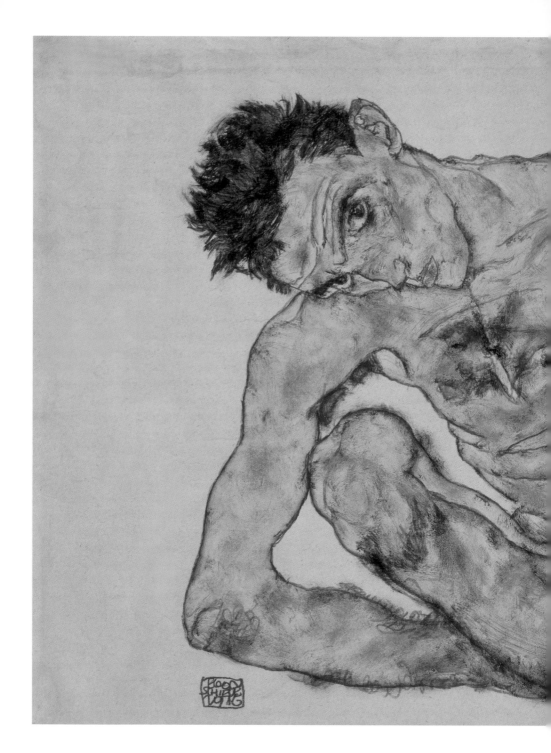

Nude Self-Portrait, Squatting. 1916.
Watercolor and pencil. Signed and dated, lower left. 29.5 × 45.8 cm.
Kallir D. 1855. Graphische Sammlung Albertina, Vienna.

1917

'I want to start anew,' Schiele wrote his brother-in-law, Anton Peschka, shortly after returning to Vienna in January 1917. 'It seems to me that until now I have just been preparing the tools.' In the next months, the artist made substantial strides toward his goal, achieving a theretofore unknown degree of professional stability. Although his finances had naturally suffered considerable slippage during the Mühling hiatus, Schiele was able to reestablish and expand his art-world contacts with surprising rapidity. By midyear, his career was perking along very nicely, and the artist could at long last afford to emulate the creative life-style of his mentor Gustav Klimt. A harem of models graced Schiele's studio, fostering the production of a grand new series of allegorical canvases. In stark contrast to the prior year, 1917 was one of the artist's most productive periods.

Schiele's sharp increase in productivity must at least in part be attributed to a newly energetic attitude, for military duties continued to demand a significant amount of his time. At the Imperial and Royal Military Supply Depot, Schiele was required to apply his talents to such mundane items as signs and (as in Mühling) the account book. Nevertheless, his colleague Karl Grünwald and their commanding officer Hans Rosé both endeavored to support the artist's creative proclivities. Again Schiele entertained the staff by drawing portraits and even produced a few demure 'pinups' of an actress, Marga Boerner, whom Rosé fancied (page 397). However, Rosé's happiest idea was the compilation of an illustrated documentation of all the supply depots in the empire. To that end, Schiele and Grünwald made a two-week excursion to the Tirol in June 1917. Schiele brought back not only a series of exquisitely detailed drawings of army offices (page 436), but a number of studies of the Tirolean landscape and farmhouses (pages 434 and 435). Much of the Austrian territory visited during this trip would be ceded to Italy after the war.

Austria-Hungary in 1917 had little inkling of the hardships of military defeat that awaited the failing empire. Instead, the war-weary Viennese art world looked forward optimistically to a coming era of peace. While Schiele did have to contend with drastically higher costs of living, war-induced inflation had not yet reached catastrophic levels (as it would in the early 1920s). Schiele soon found he could raise the prices of his pictures accordingly, and inflation encouraged a desire for tangible property that actually proved beneficial to the art market. In early summer, the bookdealer Richard Lanyi published the first portfolio of Schiele reproductions. It sold out quickly, and an ancillary selection of Schiele postcards introduced his work to an even broader audience. The artist began to receive fan mail and unsolicited inquiries from collectors, editors, and writers. Exhibition activities picked up apace, inspired in part by official attempts to use art for propaganda purposes. In the spring of 1917, the Army Museum asked Schiele to help organize a 'War Exhibition,' portions of which were subsequently sent abroad to counter the prevalent image of Germanic barbarism. Schiele also showed at the Munich Secession, where his work rekindled the interest of Hans Goltz, who declared that he was ready to resume representation of the artist after the war.

Ever since the founding of the Neukunstgruppe in 1909, Schiele's strong opinions and genuine concern for his colleagues had made him a natural leader. His ambitions, which had been derailed in part by the artist's protracted periods of absence from Vienna, now once again came to the fore. Thinking ahead to the end of the war, Schiele announced his intention to establish a new venture—the Kunsthalle. This was to be 'a spiritual gathering place [designed] to offer poets, painters, sculptors, architects, and musicians the opportunity to interact with a public that, like them, is prepared to battle the ever advancing tides of cultural disintegration.' Schiele's longstanding displeasure with the native cultural scene acquired an almost patriotic slant. He had suddenly become the man who would save Austria from its endemic philistinism. 'We want to emerge from the stagnation and joyfully witness the effect of the energies that our land is capable of generating,' Schiele announced. 'We want the flight of talent to cease, and we want all whom Austria has brought forth to be allowed to work for the honor of Austria.'

Perhaps inspired by Schiele's friendship with the writer Leopold Liegler, the Kunsthalle's ideology reflected not only the artist's personal aversion to commercial art dealing, but the more pervasive anti-capitalistic stance that would guide Austria in its postwar transition from monarchism to socialism (and would later fuel the anti-Semitic fires of Nazism). Schiele surely sympathized with Liegler's diatribes against 'speculative' art dealers and his glorification of 'patrician' collectors as an enlightened breed united with artists through 'their most personal identification with the artist's creation and the most noble interest in the artist's fate and development.' Thus

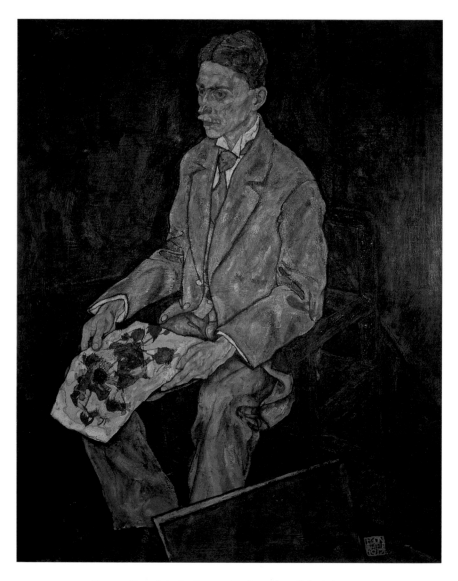

Fig. 27: Egon Schiele. *Portrait of Dr. Franz Martin Haberditzl*. 1917.
Oil on canvas. Signed and dated, lower right. 140 × 109 cm. Kallir P. 309.
Private collection.

private patronage, a practical necessity at the turn of the twentieth century, became a moral imperative. 'Art is something more than a matter of bourgeois luxury,' Schiele wrote in the Kunsthalle manifesto. 'We know that the coming era of political peace will bring with it the great confrontation between the materialistic tendencies of our civilization and those remnants of the noble culture that the commercial age has yet left us.'

A corollary to Austria's system of private patronage was the need for artists to take an entrepreneurial approach to marketing and promoting their own work. Thus the Kunsthalle, like the Vienna Secession and the Wiener Werkstätte before it, was to be run by and for artists. 'The Kunsthalle is its own dealer and publisher,' Schiele proclaimed. 'That is the most important thing.' The artist easily solicited support from a wide array of cultural luminaries, including Klimt, Josef Hoffmann, and the composer Arnold Schoenberg. However, getting financial backing was another matter. When Schiele asked Guido Arnot to donate exhibition space, the dealer was understandably reluctant, since the artist made it clear that all long-term economic benefits must accrue to the Kunsthalle. It was hard to be dependent on the good graces of the very species of 'corrupt middleman' one so strenuously wanted to avoid. By the summer of 1917, Schiele was forced to give up on the Kunsthalle. 'Our plans failed mainly on account of Vienna's reactionary tendencies,' he glumly reported. 'For the moment I consider this territory hopeless, and I have for now lost the desire to teach these people to see.'

The system of private patronage, which had once served Klimt's generation relatively well, was slowly succumbing to modern economic realities. Nevertheless, Schiele was not comfortable with any other form of support. Thus portraits, the genre most dependent on direct contact between artist and patron, came to constitute roughly one third of the oils he produced during the last two years of his life. In 1917, Schiele secured a prestigious commission from Franz Martin Haberditzl, Director of the Austrian National Gallery (figure 27). (The following year, Haberditzl acquired the artist's 1918 portrait of his wife Edith for the museum; figure 30.) Schiele also solicited sitters from the ranks of his erstwhile Kunsthalle collaborators, among them Schoenberg (page 394). For those who could not afford an oil, the artist was glad to provide drawings. His standard practice was to produce three likenesses, one of them colored, and offer the client his or her choice for a set fee. For these studies, he favored a three-quarter view, presented head-on or at a slight angle (pages 394–398, 400, and 402). Special attention was regularly given to the hands and face, which Schiele had always considered the most expressive parts of the human body. As previously, it is often possible to intuit the artist's personal feelings toward the sitter from his portraits. Most are remarkably sensitive to nuances of emotion and personality. A few—like the portraits of Schiele's army comrades—are comparatively lackluster.

During the last years of his life, the pace of Schiele's artistic development slowed markedly. The stylistic shifts that occurred between 1917 and the artist's death in October 1918 are almost imperceptible, and they evidence none of the volatility that characterizes his work through mid 1915. The realistic style perfected by Schiele in the latter part of that year truly comes into its own in the far larger and more varied oeuvre of 1917. Soft pencil gives way to black crayon, which yields heavier, more even lines that are less prone to fluctuations in density and strength. The artist's contours now hew exclusively to the requirements of representational accuracy, with little latitude for expressive deviation. His coloring style remains essentially unchanged from the approach developed in 1914: short bold dabs are applied over a dry, thin underglaze, and opaque solids (stockings or hair) set off luminous drapery and flesh. Overall, Schiele's palette is more subdued and naturalistic than ever before. He was less concerned with color than with volume and shape, and increasingly he was driven to explore his subjects through drawing alone.

Schiele's return to Vienna made it possible for him to resume regular contact with his family, members of which figure noticeably among his subjects from here on. His nephew Anton, Jr. was now a toddler, and in 1917 the artist began studies (page 393) for his oil portrait, executed the following year. Not only Edith, but her sister Adele (pages 402 and 403) are also recurrent models. In fact, the similarity between the sisters' appearances sometimes makes it hard to distinguish the two, especially as Schiele was not always accurate in his replication of telling details. Adele had dark hair, while Edith was blond, but either might be given reddish tresses by the artist. Stylization of facial features further complicates identification (pages 407 and 409–411). Several drawings as well as a studio photograph confirm that Adele, unlike Edith, was not shy about posing in her undergarments (pages 404–405). Whether, as Adele claimed decades later, she also usurped her sister's place in the artist's bed is a matter of conjecture; jealousy on the part of the older and still unmarried sibling could easily account for the assertion. Regardless, the artist's focus on his wife diminished in 1917, and her efforts to prevent him from using other models fell by the wayside as soon as the couple was back in the city.

The number of nudes drawn by Schiele in 1917 easily exceeds the total output of some earlier, less fruitful years. Due to the relative paucity of nudes produced in 1915 and 1916, the impact of the artist's more naturalistic style on this branch of his oeuvre is first fully visible in 1917. However, whereas realism facilitated the insightful *precision* of Schiele's portraits, it accentuated the *remoteness* of his nudes. Realism, after all, was the style used by artists through the ages to defuse the erotic volatility of the female nude. Classical aesthetic values such as symmetry, harmony, and clarity of form have traditionally been employed to transform the human body into an artistic object,

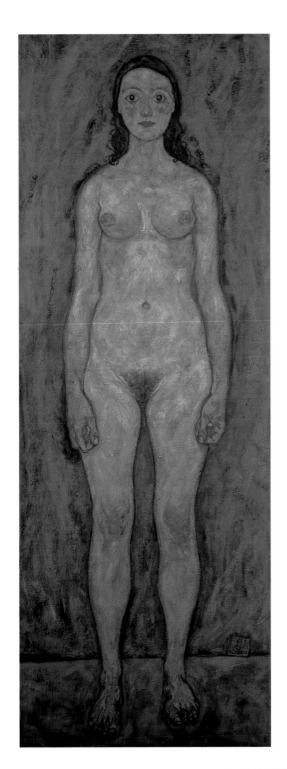

Fig. 28:
Egon Schiele. *Girl (The Virgin)*. 1917.
Oil on canvas. Signed and dated,
lower right. 180.2 × 65 cm.
Kallir P. 305. Private collection.

while single-point perspective has served to secure the female subject before the gaze of the (presumably male) viewer by providing and defining a separate space for each. Greater representational accuracy, the return of three-dimensional volume, and the gradual replacement of a garish palette with more subdued colors, all took Schiele's late nudes back toward the classical ideal.

Elements of the old Schiele—erratic cropping and spatial dislocation—remain in the 1917 and 1918 nudes, but these devices are reduced in both frequency and intensity. In tandem with his more traditional approach to volume and perspective, the artist's continuing practice of signing drawings of recumbent figures as verticals (pages 412, 413, 419, and 428–430) now becomes another way to reposition the nude in a distant realm, where she is presented like a butterfly pinned to the sheet. The models are accurately rendered and at times even recognizable in the 1917–18 drawings, but they are not especially engaged or engaging. Recalling the 'puppets' of 1914–15, the women's faces occasionally have a glazed, vacant appearance (pages 416–417, 430, 432, and 433); often the eyes are closed or averted (pages 412–414, 419–421, 428–429, and 431). The models splay their legs, fondle one another, or masturbate with the aloofness of professional performers. Schiele—and by extension the viewer—are no longer participants in a process of sexual exploration, but merely voyeurs. It is not a coincidence that nudes from Schiele's late period have for years been much sought after by collectors. These women are exquisite objects of delectation.

More in line with conventional erotica than his prior work, Schiele's 1917–18 nudes were nevertheless far less intimately connected to the artist's own sexual feelings. This development, like the artist's interest in realism, dates back to 1913. In his numerous preparatory studies for *Conversion* and *Encounter*, the nude for the first time became subordinate to Schiele's projected compositional designs. His immediate reaction to the naked flesh, his presumed arousal, were less important than the subject's function in realizing an allegorical vision. As the interrelationship between his nude studies and his allegorical canvases deepened in the ensuing years, Schiele's personal responses to his models grew harder and harder to detect. Ironically, as she became more realistic, the nude actually became less real: she was an allegorical 'everywoman,' a cipherlike icon who could be plugged interchangeably into almost any composition. The female nudes in Schiele's 1917 and 1918 paintings have the familiar doll-like stare (figure 28) and are so alike in overall appearance that it is difficult to tell whether one or several women served as models. This similarity of appearance (like the short tunics worn by the 1913 models) serves to unify many of Schiele's late paintings. Rather than trying to produce a single monumental work (as he had in 1913), he was now thinking in terms of a suite of smaller canvases that might function as a single entity. Begun toward the end of 1917, this last allegorical cycle would occupy the artist for the remainder of his life.

Schiele's continued interest in allegory, like his persistent dependence on private patronage, indicates the extent to which he remained firmly within the tradition established by Klimt and his forerunners. The Kunsthalle was essentially an attempt to replicate and sustain the prewar creative environment. Despite his acute sensitivity to human realities, Schiele failed to recognize just how radically the political and economic situation had changed. The Austro-Hungarian Empire would collapse in 1918, and with it would go all the peculiar circumstances that had made possible the artist's adolescent dreams as well as his adult expectations. The now legendary cultural wealth of turn-of-the-century Vienna was a luxury that the rump nation of Austria, stripped of its former imperial territories, could not afford. Economic and political disarray and, eventually, absorption into Hitler's German Reich followed. Schiele's burgeoning career, so much a product of his times, would come to a close with the turn-of-the-century era that spawned it.

Seated Boy Holding Apple (Anton Peschka, Jr.). 1917.
Gouache, watercolor, and black crayon. Signed and dated, lower right.
41.5 × 27.5 cm [sight]. Kallir D. 1884. Private collection.

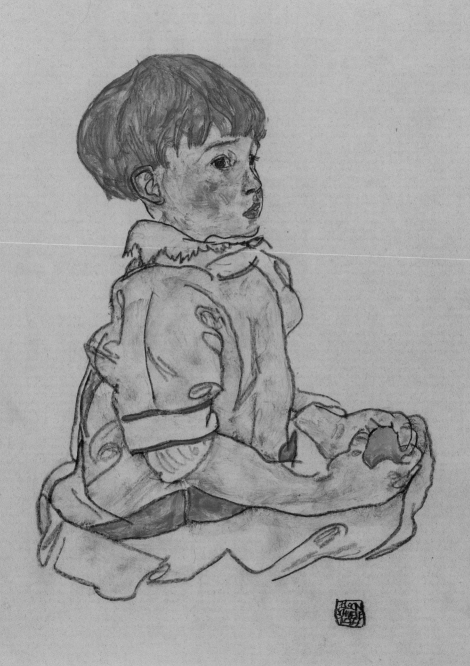

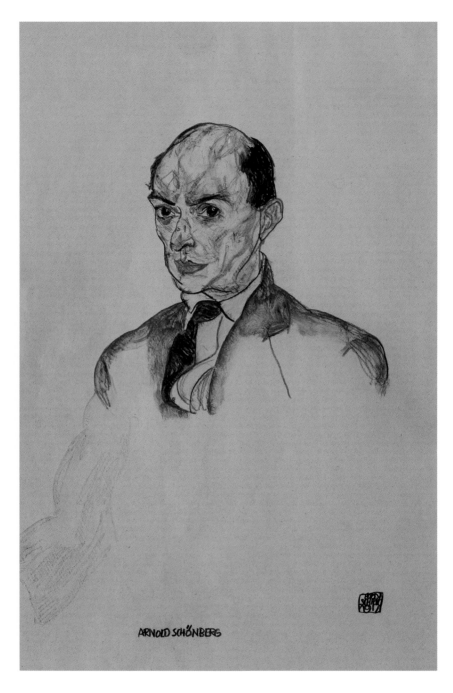

Portrait of Arnold Schönberg. 1917.
Gouache, watercolor, and black crayon. Signed and dated, lower right.
Inscribed 'Arnold Schönberg', lower center. 40.5 × 27 cm.
Kallir D. 2088. The Earl and Countess of Harewood.

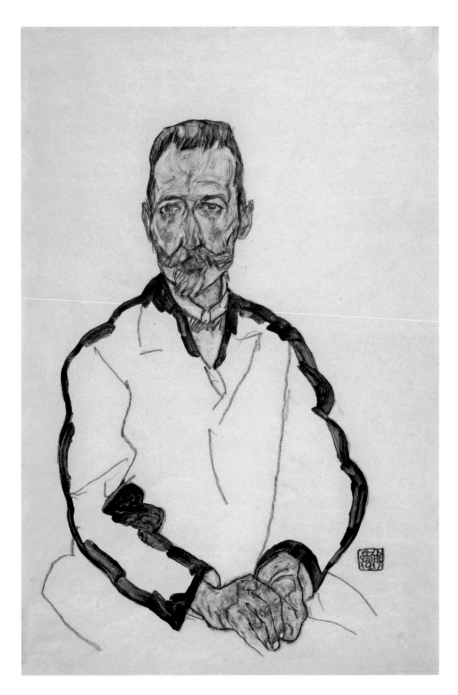

Chief Inspector Benesch. 1917.
Gouache, watercolor, and black crayon. Signed and dated,
lower right. 45.7 × 29.3 cm. Kallir D. 2098.
E. W. Kornfeld Collection, Bern.

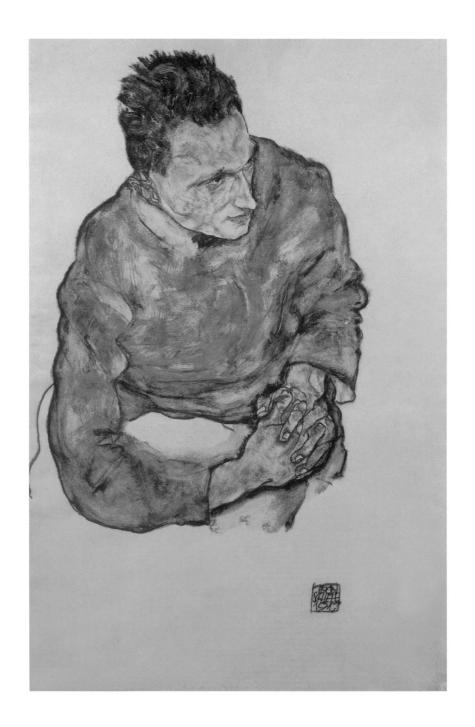

Portrait of Karl Grünwald with Clasped Hands. 1917.
Gouache, watercolor, and black crayon. Signed and dated, lower right.
44.5 × 27.9 cm. Kallir D. 2070a. Private collection.

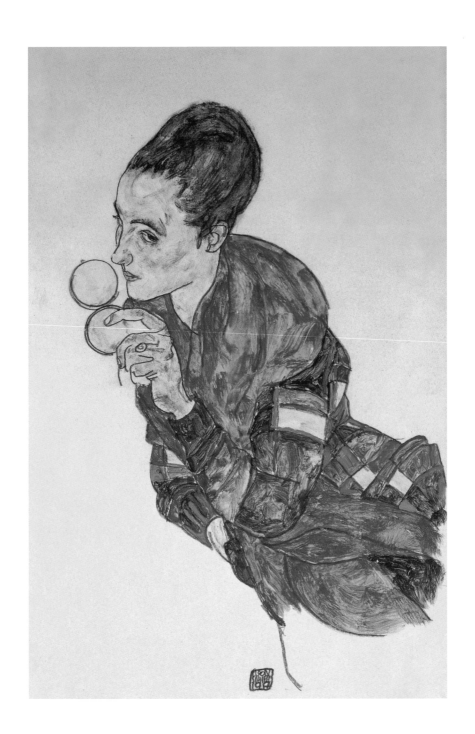

Portrait of the Actress Marga Boerner with Compact. 1917.
Gouache and black crayon. Signed and dated, lower center.
48.2 × 30.5 cm. Kallir D. 1902.

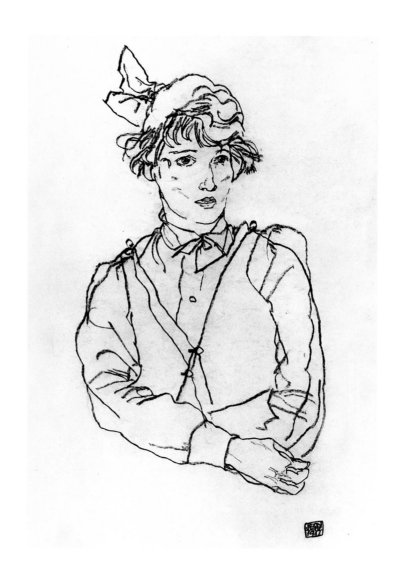

Above: *Portrait of a Lady*. 1917.
Black crayon. Signed and dated, lower right. 44.1 × 28.5 cm. Kallir D. 1889.
Szépmüvészeti Múzeum, Budapest.
Opposite: *Nude Girl with Fur-Trimmed Coat*. 1917.
Black crayon. Signed and dated, lower right.
44.2 × 28.6 cm. Kallir D. 1934a.

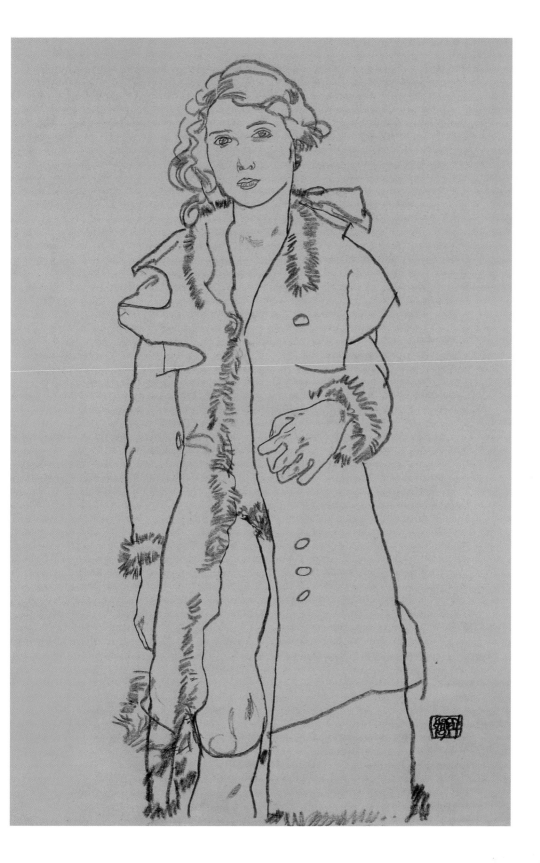

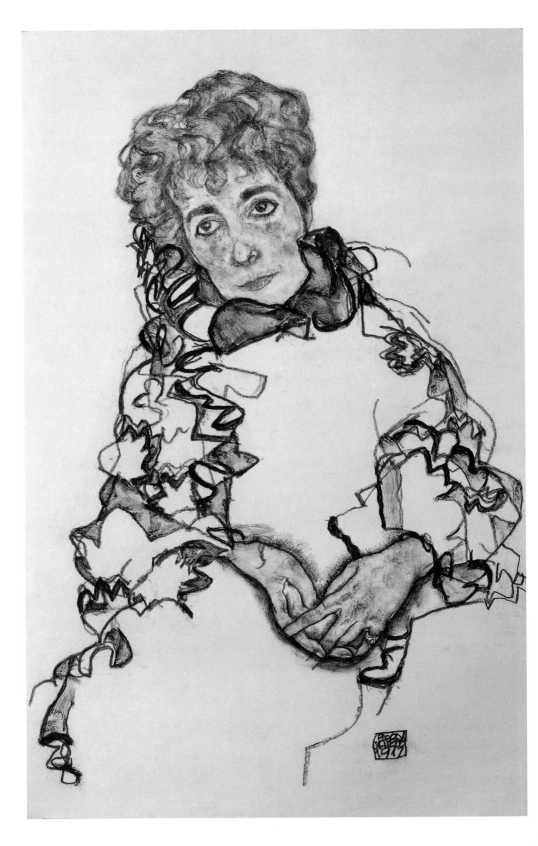

Serena Lederer. 1917.
Gouache and charcoal. Signed and dated, lower right. 46.2 × 29.6 cm.
Kallir D. 1886. Private collection.

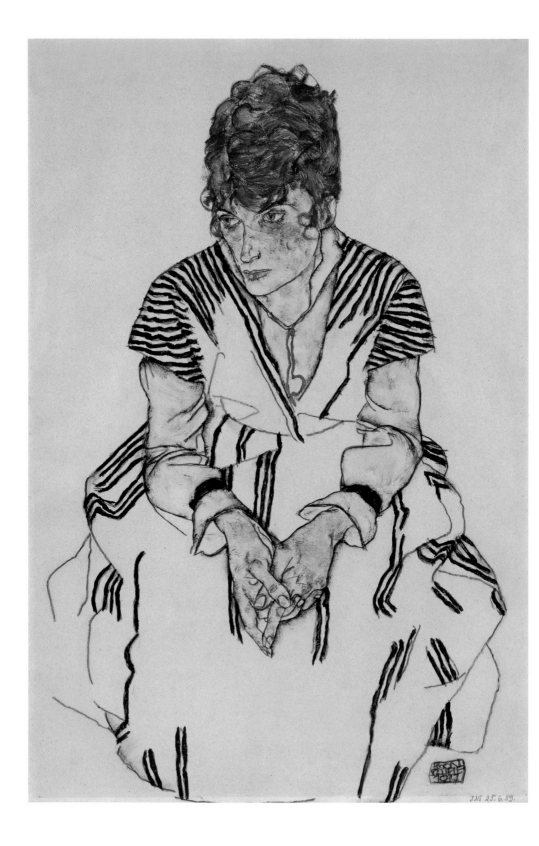

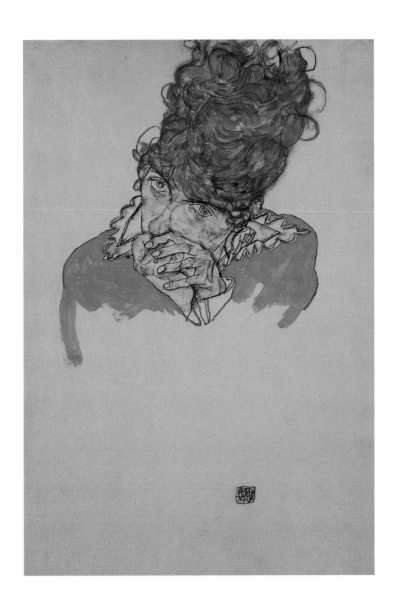

Above: *Portrait of the Artist's Sister-in-Law, Covering Mouth with Hands*. 1917.
Gouache and black crayon. Signed and dated, lower center.
43 × 28 cm. Kallir D. 1912. Private collection.
Opposite: *The Artist's Sister-in-Law in Striped Dress, Seated*. 1917.
Gouache, watercolor, and pencil. Signed and dated, lower right. 43.8 × 28.5 cm.
Kallir D. 1911. Graphische Sammlung Albertina, Vienna.

Reclining Woman in Green Stockings. 1917.
Gouache and black crayon. Signed and dated, lower right. 29.4 × 46 cm. Kallir D. 1995.
Private collection, courtesy of Galerie St. Etienne, New York.

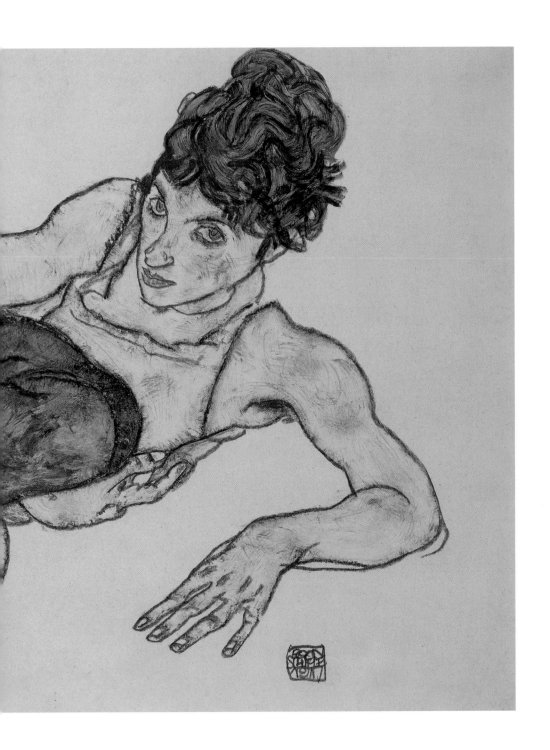

Crouching Nude Girl with Cheek Resting on Right Knee. 1917.
Gouache and black crayon. Signed and dated, lower right. 45.7 × 29.7 cm.
Kallir D. 1978. Private collection.

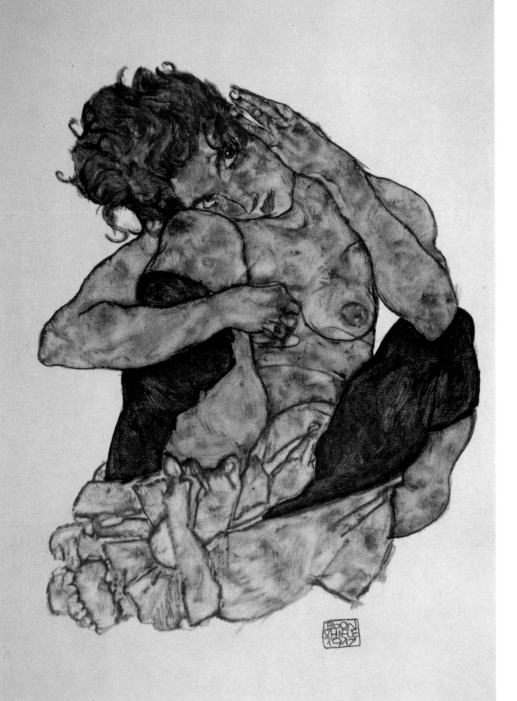

Seated Woman with Bent Knee. 1917.
Gouache, watercolor, and black crayon. Signed and dated, lower right. 46 × 30.5 cm.
Kallir D. 1979. Národní Galerie, Prague.

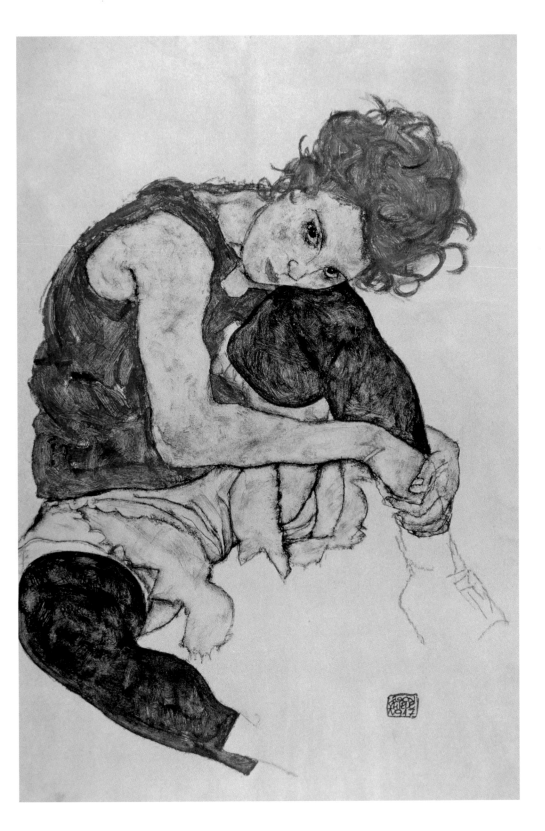

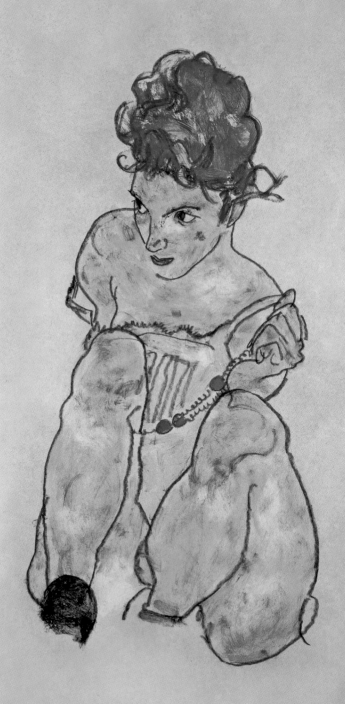

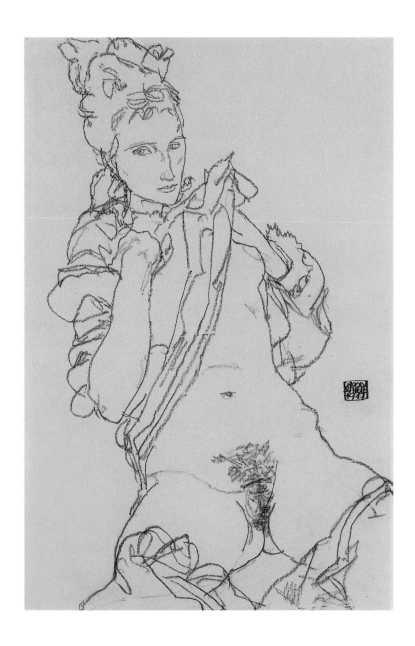

Above: *Female Nude*. 1917.
Black crayon. Signed and dated, center right. 45.9 × 29.6 cm.
Kallir D. 1980. Národní Galerie, Prague.
Opposite: *Seated Girl in Slip*. 1917.
Gouache, watercolor, and black crayon. Signed and dated, lower right.
45.7 × 29.5 cm. Kallir D. 1977. Private collection.

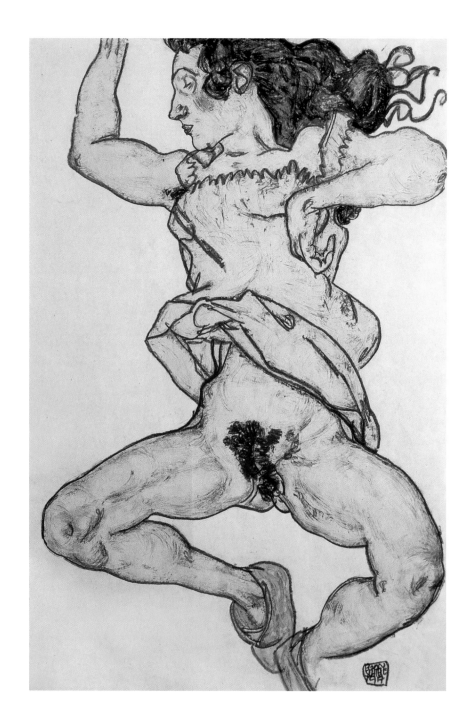

Reclining Woman with Green Slippers. 1917.
Gouache, watercolor, and black crayon. Signed and dated, lower right.
45.9 × 29.8 cm. Kallir D. 1925. Private collection.

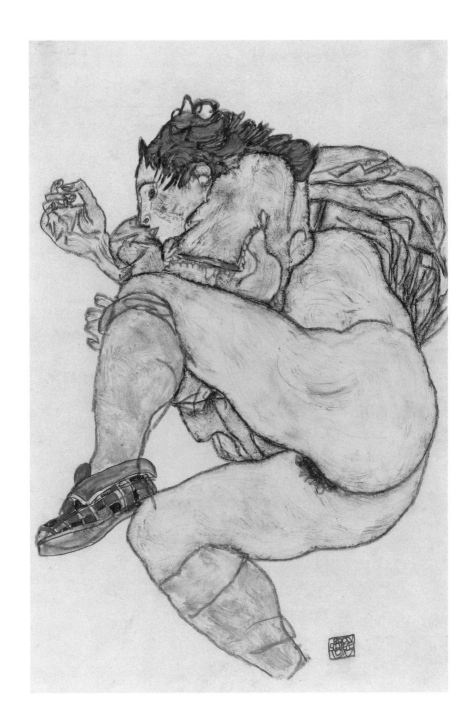

Nude with Checkered Slipper. 1917.
Gouache, watercolor, and pencil. Signed and dated, lower right. 45.9 × 29 cm.
Kallir D. 1928. Kunsthaus Zug, Kamm Collection, Zug.

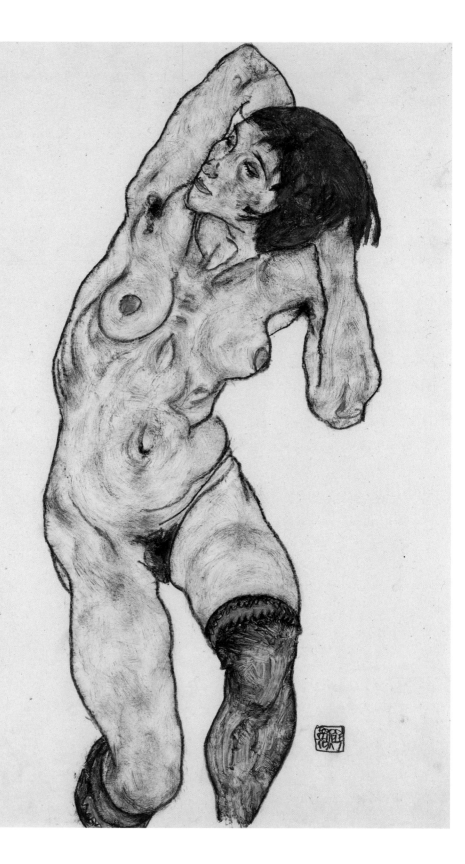

Female Nude with Black Stockings. 1917.
Gouache and black crayon. Signed and dated, lower right. 46 × 29.6 cm. Kallir D. 1931.
The Metropolitan Museum of Art, New York; Bequest of Scofield Thayer, 1982.

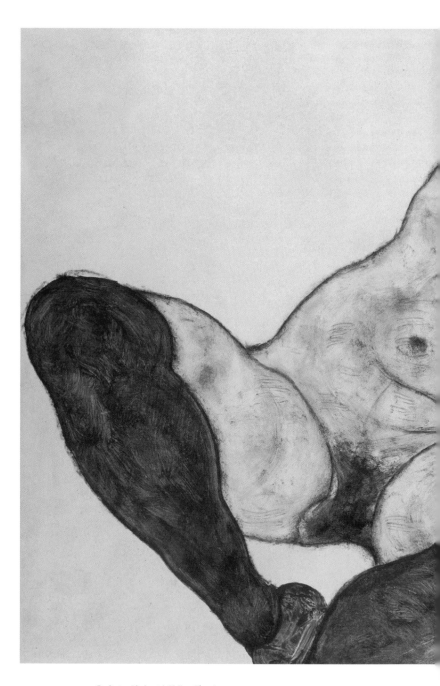

Reclining Nude with Yellow Towel. 1917.
Gouache and black crayon. Signed and dated,
lower right. 29 × 45.7 cm. Kallir D. 1948. Private collection,
courtesy of Richard Nagy, Dover Street Gallery, London.

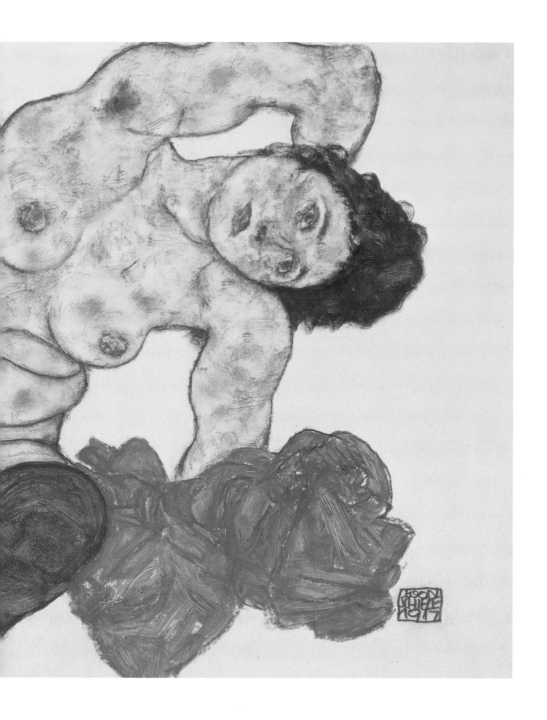

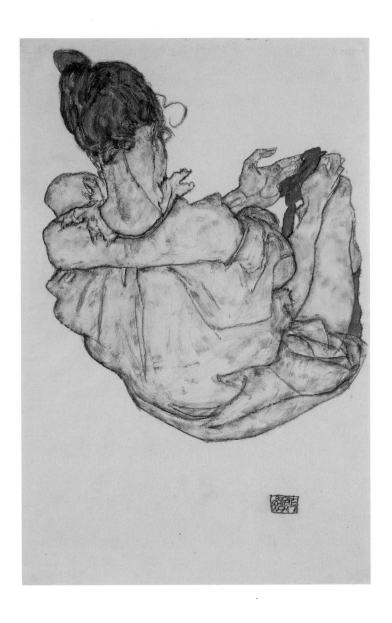

Above: *Seated Woman, Back View*. 1917.
Gouache and black crayon. Signed and dated, lower right.
46.1 × 29.4 cm. Kallir D. 1943. Graphische Sammlung der
Eidgenössischen Technischen Hochschule, Zurich.
Opposite: *Squatting Girl*. 1917.
Gouache and black crayon. Signed and dated, lower right. 46 × 28.8 cm.
Kallir D. 1941. Staatliche Graphische Sammlung, Munich.

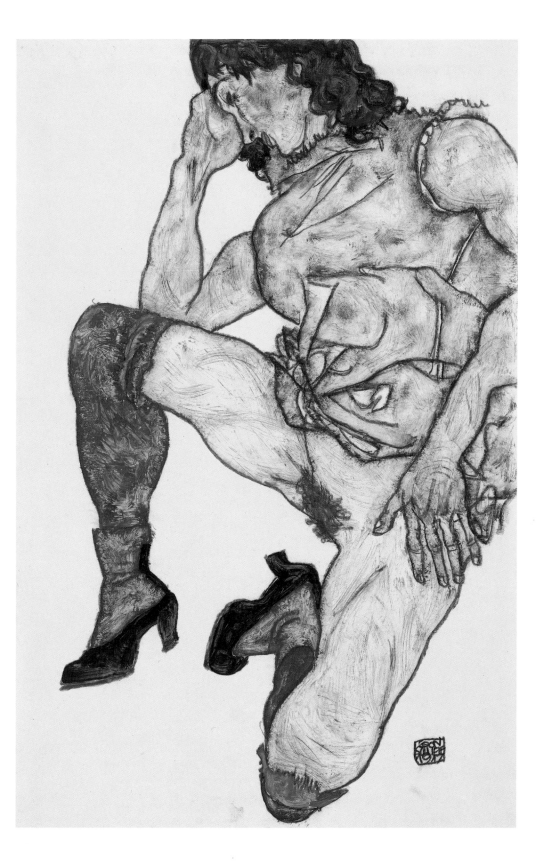

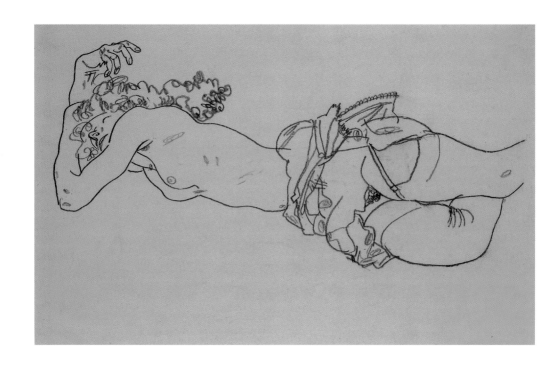

Above: *Reclining Female Nude*. 1917.
Black crayon. 29.7 × 45.6 cm. Kallir D. 1962.
Neue Galerie am Landesmuseum Joanneum, Graz.
Opposite: *Kneeling Semi-Nude*. 1917.
Gouache and pencil. Signed and dated, lower left. 45 × 28 cm. Kallir D. 1953.
Serge Sabarsky Collection, New York, courtesy of Neue Galerie, New York.

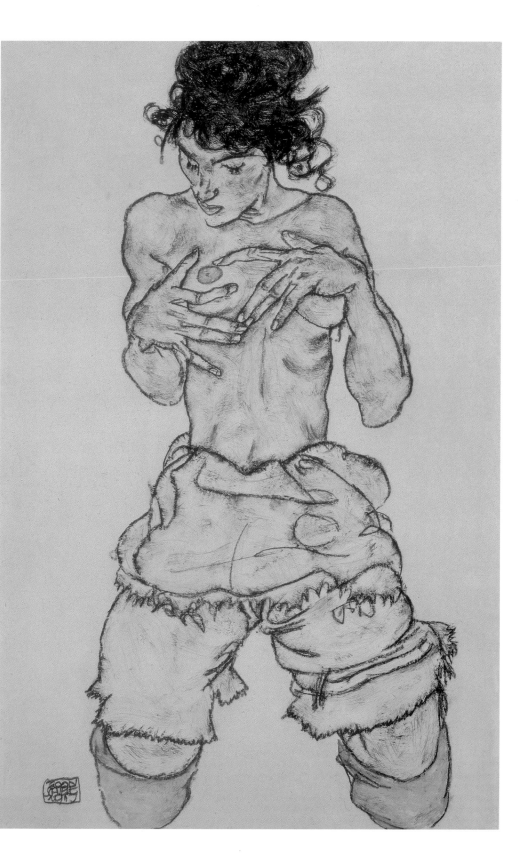

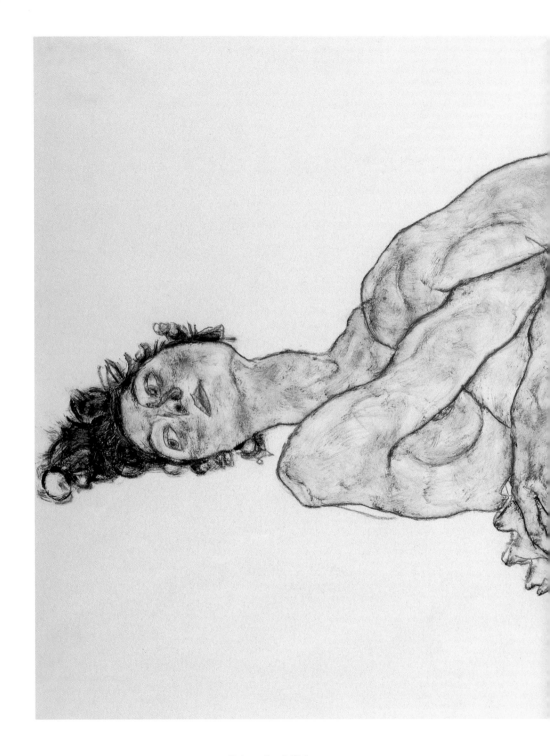

Reclining Female Nude. 1917.
Gouache, watercolor, and charcoal. Signed and dated,
lower right. 29.7 × 46.3 cm. Kallir D. 1945. Moravská Galerie, Brno.

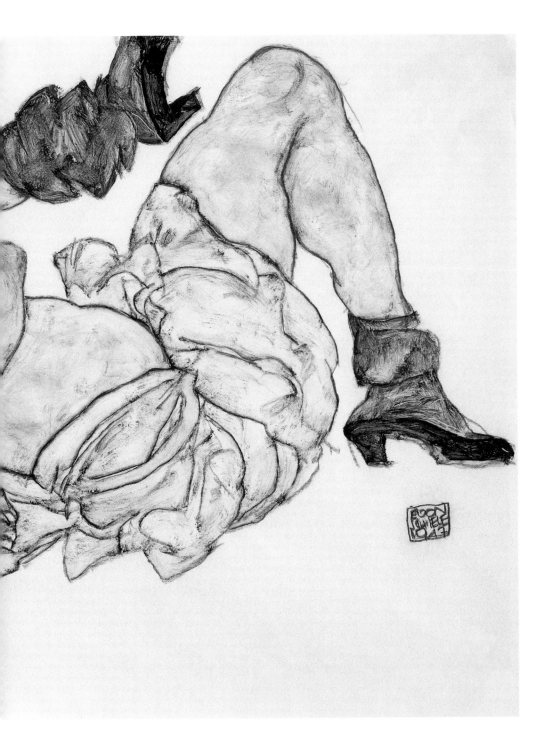

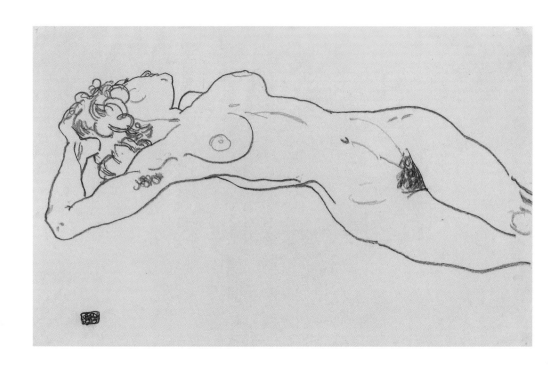

Above: *Reclining Female Nude*. 1917.
Black crayon. Signed and dated, lower left. 29.7 × 46.3 cm. Kallir D. 1963.
Staatliche Graphische Sammlung, Munich.
Opposite: *Female Nude, Back View*. 1917.
Gouache and black crayon. Signed and dated, lower right. 46 × 29.5 cm.
Kallir D. 1966. Staatliche Graphische Sammlung, Munich.

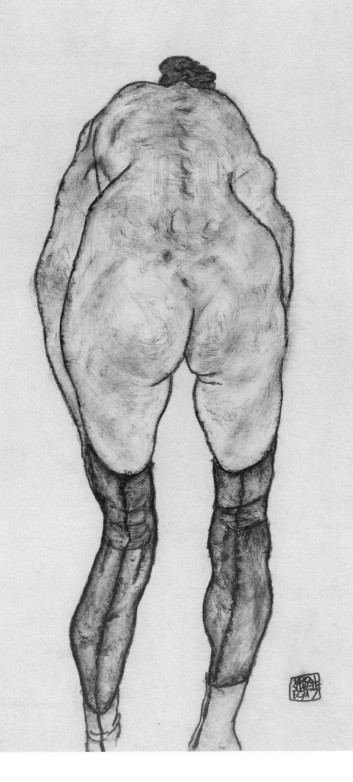

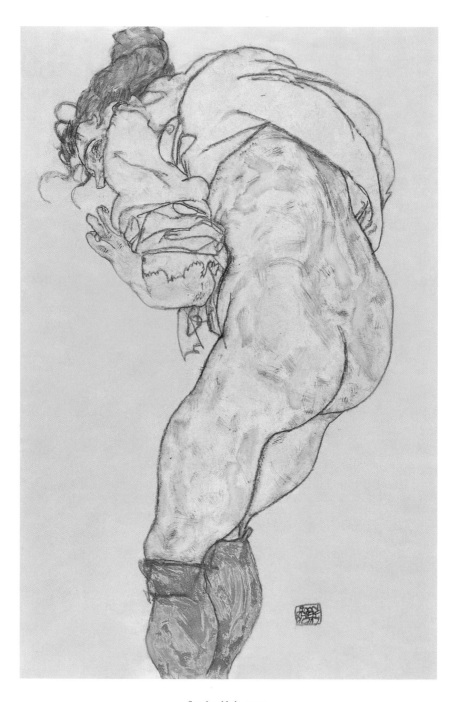

Standing Nude. 1917.
Gouache and black crayon. Signed and dated, lower right. 45.6 × 29.5 cm. Kallir D. 1969.
The Israel Museum, Jerusalem; Gift from Robert J. Mayer, New York, 1967.

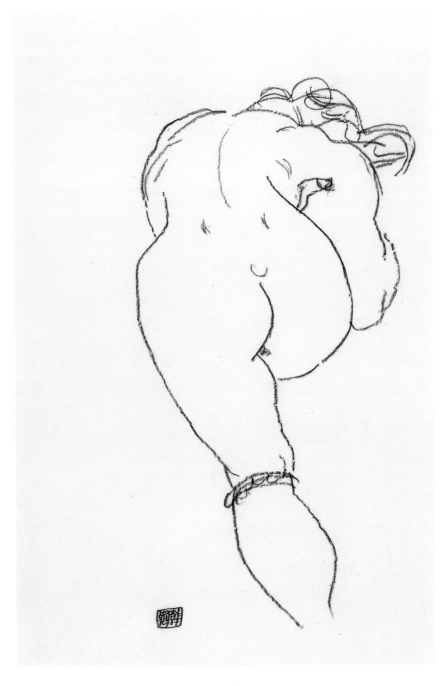

Female Nude, Back View. 1917.
Black crayon. Signed and dated, lower left. 46.1 × 29.6 cm.
Kallir D. 1970. Werner Coninx-Stiftung, Zurich.

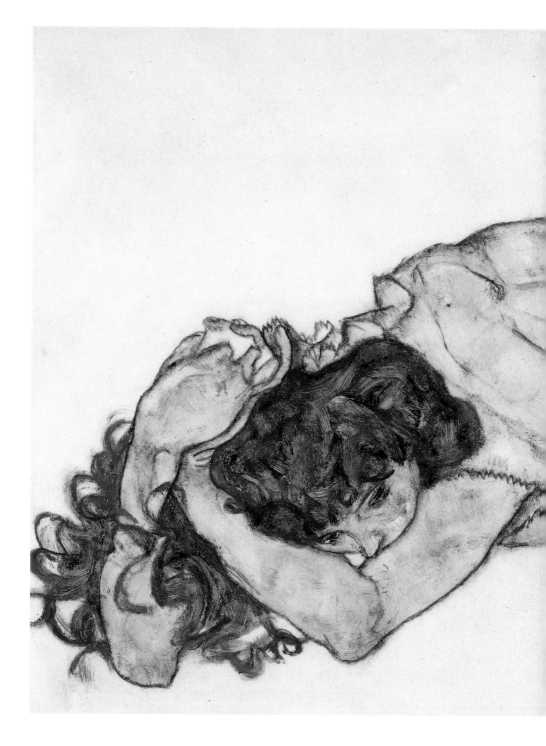

Semi-Nude Girl with Red Hair. 1917.
Gouache and black crayon. Signed and dated (as vertical), lower right. 28.7 × 44.3 cm.
Kallir D. 1952. Leopold Museum, Vienna.

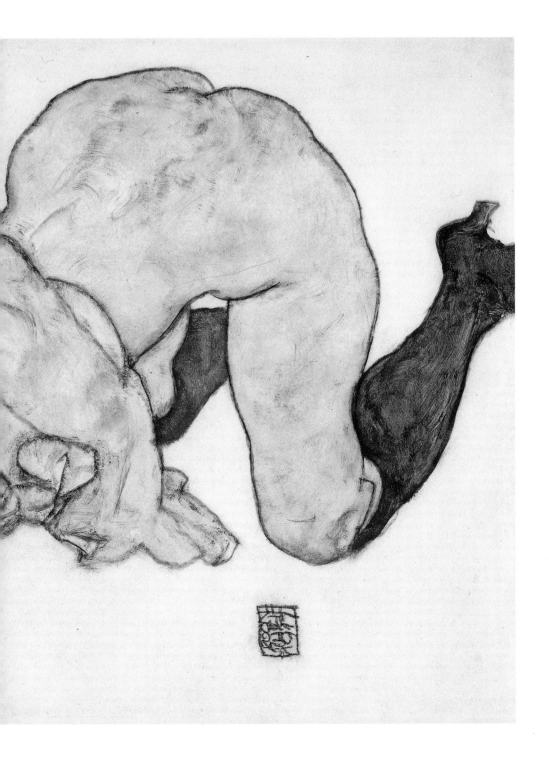

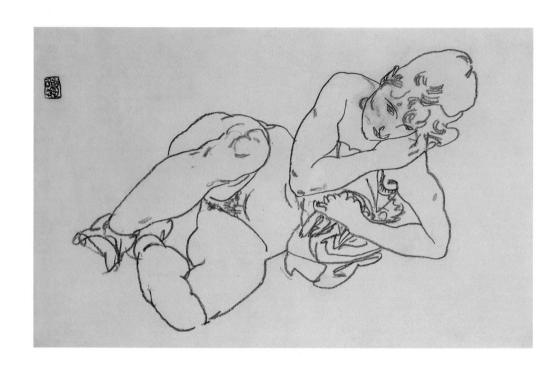

Above: *Nude*. 1917.
Black crayon. Signed and dated (as vertical), upper left.
27.5 × 43.3 cm. Kallir D. 2004. Tel Aviv Museum, Tel Aviv;
Gift of Mr. and Mrs. Serge Sabarsky, New York.
Opposite: *Kneeling Female Nude*. 1917.
Black crayon. Signed and dated, center right.
46.3 × 29.8 cm. Kallir D. 2015.
Staatliche Graphische Sammlung, Munich.

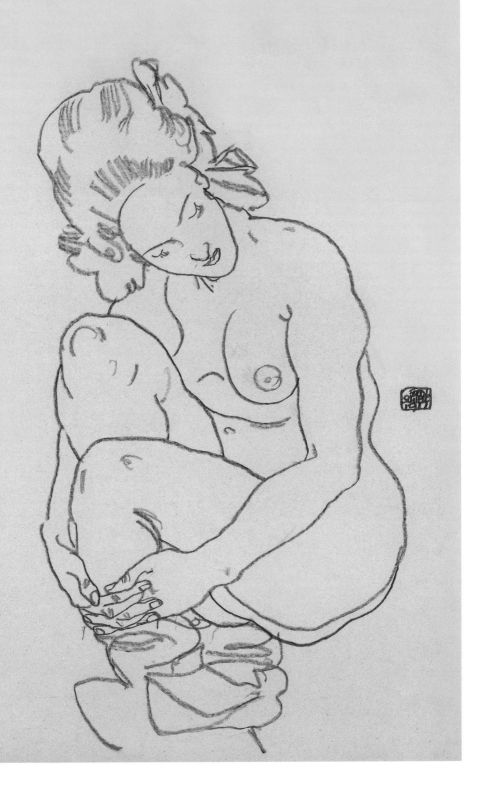

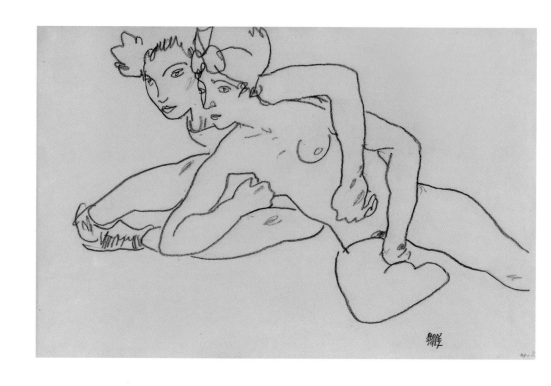

Two Nudes (Two Girls). 1917.
Black crayon. Signed and dated, lower right. 29.8 × 45.1 cm. Kallir D. 2023.
Private collection, courtesy of Galerie St. Etienne, New York.

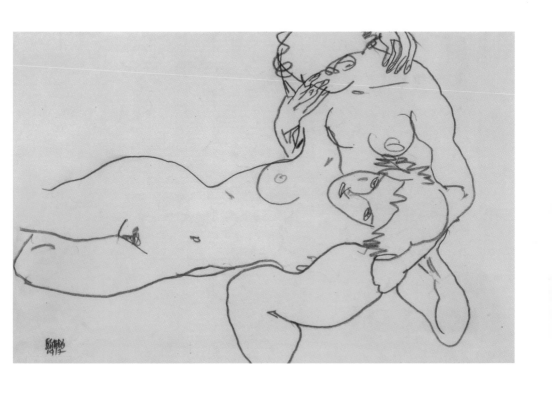

Two Female Nudes. 1917.
Black crayon. Signed and dated, lower left.
29.5 × 46 cm. Kallir D. 2026a.

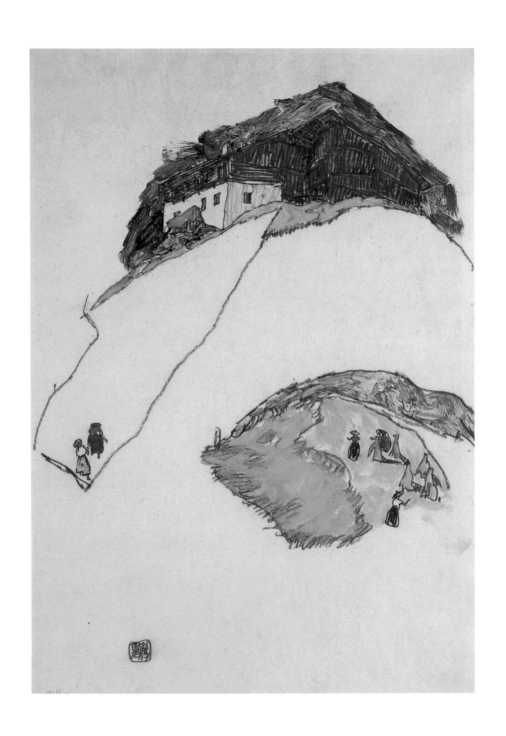

Farmhouse. 1917.
Gouache and charcoal. Signed and dated, lower left.
42 × 29 cm. Kallir D. 2140.

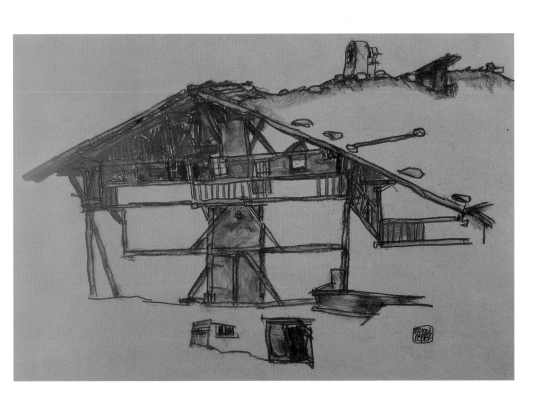

Tirolean Farmhouse. 1917.

Gouache and black crayon. Signed and dated, lower right.

28.3 × 44.3 cm. Kallir D. 2138. Private collection.

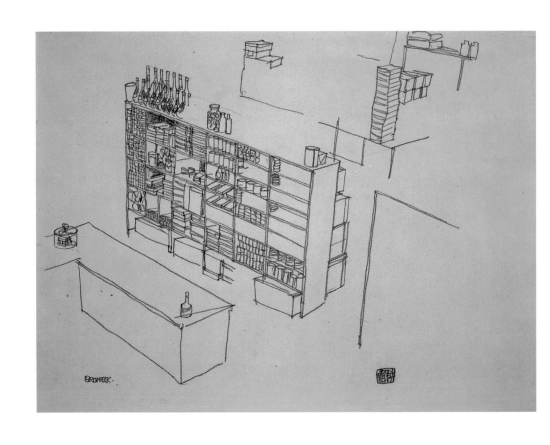

Supply Depot, Brunico Branch: View into the Sales Shop. 1917.
Black crayon. Signed and dated, lower right.
Inscribed 'Bruneck', lower left. 29.5 × 46.2 cm. Kallir D. 2155.
Private collection, courtesy of Richard Nagy, Dover Street Gallery, London.

Old Gabled House in Krumau, Seen from the Schlossberg. 1917.
Gouache, watercolor, and black crayon. Signed and dated,
lower right. 46.1 × 29.9 cm. Kallir D. 2133.
E. W. Kornfeld Collection, Bern.

1918

The last year of Schiele's life got off to an auspicious start that was, nevertheless, laced with harbingers of imminent doom. Following a near sell-out exhibition at the Vienna Secession in early 1918, Schiele was widely recognized as the preeminent Austrian artist of his day. That position, however, had only just recently been vacated by Gustav Klimt, who died in February of complications following a stroke. Over the course of the year, Schiele's career continued to expand impressively, all the while that the Austro-Hungarian Empire plummeted headlong toward its military and political demise.

When, in October 1917, the Secession solicited Schiele's membership, he was initially ambivalent, perhaps because Klimt had broken with that group of artists back in 1905. However, the invitation came with an offer too good to turn down: Schiele was asked to take charge of organizing the Secession's forty-ninth exhibition, to be held the following March. For the preceding year, the artist had wanted to gather all his artist friends for a group portrait. Now that painting (never fully realized) morphed into the poster for the Secession show (figure 29). Schiele placed himself conspic-uously at the head of a table around which his friends were seated; at the foot was an empty chair for the recently deceased Klimt. Although this was a group exhibition, Schiele was given (or gave himself) the central room, large enough to display nineteen oils and twenty-nine works on paper. After most of these were spoken for by collectors, a sort of 'waiting list' developed for the artist's future work. Reviews were almost uniformly favorable.

With the 1918 Secession exhibition, Schiele's leadership ambitions were finally realized. If some of his colleagues complained that he had stolen the show, they none-theless seemed willing to submit to his guidance in planning such events. Even Anton Faistauer, a rival since the early Neukunstgruppe days, conceded that he had absolute faith in Schiele's 'honesty in things that concern our common welfare.' One can well

Fig. 29: Egon Schiele. *49th Secession Exhibition Poster*. 1918.
Lithograph in black, red-brown, and ochre. 63.5 × 48 cm. Kallir G. 15.
Courtesy of Galerie St. Etienne, New York.

Fig. 30: Egon Schiele. *Portrait of the Artist's Wife, Seated.* 1918.
Oil on canvas. Signed and dated, lower left. 139.5 × 109.2 cm. Kallir P. 316.
Österreichische Galerie, Vienna.

imagine that exhibition coordination was an aspect of Schiele's success that few of his colleagues begrudged him, for in 1918 the artist spent an inordinate amount of time chasing down foreign contacts and lining up bookings. Perhaps as a result of these activities, Schiele finally succeeded, in April 1918, in having himself transferred to the Army Museum, where his duties seem to have consisted principally of arranging shows. The paperwork attendant to his new position obliged him to hire a secretary.

Schiele's success entailed more than curatorial activities, of course. The trickle of unsolicited inquiries that had begun in 1917 now swelled to a flood. He was asked to do lithographs, magazine illustrations, and even theater sets. By October 1918, he had received fourteen new portrait commissions. Schiele's increase in income was such that, for the first time, he could actually afford to collect other artists' work. And in July, he was able to rent a larger studio on the Wattmanngasse, which he had been coveting for the past year. So flush was he that he retained his apartment on the Hietzinger Hauptstrasse, where he proposed to open an art school.

There were many reasons for Schiele's sudden good fortune. In large part, it was the product of his protracted period of apprenticeship: the fruit born of many seeds planted during the preceding eight years. Then, too, the waning war stimulated an increased appreciation for all kinds of art. As Schiele wrote to his brother-in-law, 'People are unbelievably interested in new art. Exhibitions—be they of conventional or new art—have never before been this crowded.' Art had become a 'collectible,' a commodity whose appeal was heightened by wartime inflation. Schiele was also witnessing the first stages of the relaxed moral climate that would bring the avant-garde respectability throughout postwar Europe. And, last but not least, the artist's style was in itself no longer as shocking as it had been several years earlier. The humanism of Schiele's late portraits and the refined naturalism of his nudes were far more accessible than had been his jarring allegories and frenetic watercolors.

Always a speedy worker, Schiele had finally found the perfect line. In 1917 and 1918, he was usually able to capture his subject with a single, virtually unbroken sweep of his crayon (pages 466–474 and 477). In his works on paper, he became more and more focused on the qualities of drawing as such, and therefore relatively few of his 1918 studies are colored. Instead, he was increasingly interested in sculpting volume, embellishing interior details with curious little loops (pages 450–454, and 469), or, in the very last months of his life, using soft charcoal to shade the figure in an almost academic fashion (pages 479, 480–481, 483, and 485). Schiele had no need, as formerly, to redraw or embellish faulty contours, though he did on occasion make mistakes in draftsmanship (pages 433, 468, 475, and 478). These mistakes should not be ascribed to sloppiness, but rather to pace. The artist's extraordinary velocity, like that of a master racecar driver, occasionally caused him to veer off course.

Usually, however, he was in complete control, and in these drawings Schiele achieved an unprecedented degree of accuracy.

Few artists in history have managed to express the spirit of their subjects with such economy of means. In his nudes, Schiele strove for purity of form; in his portraits, for purity of being. With the precision of stop-action photography, Schiele could catch a moving body, or the flicker of emotion—a quivering lip, a furrowed brow—as it passed fleetingly across a sitter's face. In this, he ranks alongside such artists as Hans Holbein as one of the greatest draftsmen of all times. Because Schiele plumbed the very souls of his subjects, his drawings remain as fresh and vital today as they were when made. There is a timelessness to Schiele's best work that speaks to the unchanging essence of humanity across time and space.

Though Schiele's spiritual essentialism applies to all branches of his oeuvre, it is manifested differently in his portraits than in his nudes, because the artist saw these two subjects as intrinsically distinct. Whereas in 1910 Schiele had projected his own reactions onto all his subjects, since his imprisonment in 1912 he'd become acutely sensitive to his sitters' independent personalities. And whereas in 1910 it had been easier for him to identify with male subjects, since his marriage he had become a particularly keen observer of women. All his commissioned 1917 and 1918 oils depict men, but if one excludes the studies for these paintings, females outnumber males in the portrait drawings. Some of these may have been studies for oils that would have been executed had the artist lived longer. While Schiele's paintings of men can be perfunctory, suggesting a task done more for money than for love, the women in the drawings are invariably alert, vibrant human beings with a palpable presence (pages 461, 463, and 464). Just as Schiele once boldly chronicled the power of female sexuality, he now acknowledged female identity in a manner that was, for its day, hardly less radical.

This transformation is epitomized by Schiele's 1918 oil portrait of his wife Edith (figure 30), which contrasts sharply with its 1915 predecessor (figure 25). In the earlier painting, Edith's brightly striped dress overshadowed her personality; in the later one, by contrast, an extremely subdued palette focuses attention on the sitter's face. (A brightly checkered skirt, it is said, was painted out by the artist at the request of Franz Martin Haberditzl when he acquired the painting for his museum.) The 1918 Edith is clearly not a happy woman, but in her pensive sadness, she is infinitely more *real* than the 1915 Edith doll. The 1918 painting is also a vastly different sort of female portrait than the bejeweled icons that had always been Klimt's stock in trade. Klimt,

Fig. 31: Gustav Klimt. *Judith I*. 1901.
Oil on canvas. Signed, lower left. 84 × 42 cm. Novotny/Dobai 113.
Österreichische Galerie, Vienna.

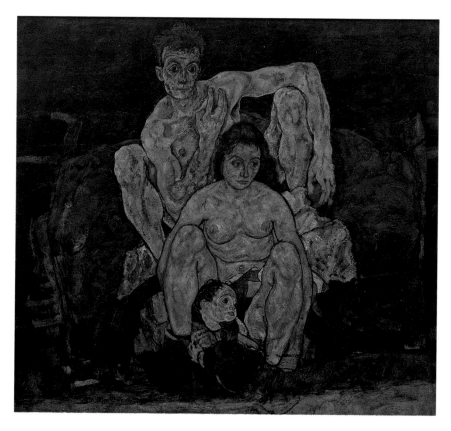

Fig. 32: Egon Schiele. *The Family (Squatting Couple)*. 1918.
Oil on canvas. 152.5 × 162.5 cm. Kallir P. 326.
Österreichische Galerie, Vienna.

following a prevalent turn-of-the century pattern, invested his seductive nudes (figure 31) with far more vitality than his society portraits. An extension of the double standard, this viewpoint presented women as either Madonnas (admirable but untouchable) or whores (sexy and human, but morally tainted). Schiele's 1915 female couples (pages 335–337) had expressed a similar dichotomy, but by 1917–18, he had reversed the paradigm. It was now his female portraits that were fully alive, and the nudes that had been removed to an airless aesthetic realm.

The apotheosis of the nude as iconic 'everywoman' was reached in Schiele's final allegories. Starting with the 1917 painting *Girl* (figure 28), this figure becomes a regular presence in his canvases. A vocabulary of stock poses—squatting, standing, reclining, floating—is rehearsed extensively in preliminary drawings (pages 404–405, 407, 410, 412, 416–417, 420, 424, 471, 474, and 480–481) and then replicated in

the deceptively simple compositions of the 1917–18 oils. Most often, the backgrounds of these paintings are articulated only by a network of overlapping brushstrokes, and the titles (such as *Three Standing Women* or *Two Squatting Women*) reveal little about the artist's underlying intent. This body of works is very different from the costume dramas, involving cloaked monks and saints, enacted in Schiele's prior allegories. However, sketchbook notes indicate that the artist saw his late canvases as an allegorical cycle, which he hoped one day to install in a mausoleum. It is not known whether this mausoleum project involved a real commission or existed only hypothetically in his mind. Schiele sketched out an elaborate sequence of nested chambers devoted respectively to the themes of 'earthly existence,' 'death,' and 'eternal life.' The late nudes were probably intended for the mausoleum's outermost chamber, signifying 'earthly existence.'

Because the mausoleum cycle was never completed, one can only imagine the potential impact of the projected installation. The blank stares and nudity, repeated across multiple canvases, would have underscored the figures' inherent isolation and vulnerability. It is a bleak view indeed of 'earthly existence': we are born alone, and we remain essentially alone throughout our lives, despite our sporadic engagement with other human beings. This belief finds its most poignant expression in the painting *Squatting Couple* (figure 32), considered by many to be Schiele's masterpiece. Because of its popular title—*The Family* (so dubbed after the artist's death)—and because the 'father' in the composition is a self-portrait, this image has often been ascribed a sentimental, personal meaning by Schiele's biographers. It would be more accurate, however, to interpret the painting in the light of the artist's other late allegorical nudes, and earlier, related compositions, such as the 1913 *Holy Family* (page 231) or the 1915 *Death and Maiden* (figure 23). As in the latter painting, the couple here alludes to an endless cycle of death and life. The child does not possess the redemptive power of the infant in *Holy Family*, but it at least offers the hope of a future generation. *Squatting Couple*, nonetheless, is as pessimistic in its view of the human condition as the other 1917–18 nudes. There is no substantive physical contact among the three figures, nor any sense that they are even aware of one another.

Schiele's use of his own image in some of the 1918 allegories is a continuation of his habitual practice since 1910, as well as a departure from it. Schiele had always been his own most convenient model, and the full-length mirror in which he posed was one of his most important studio props. However, the artist no longer employed self-portraiture to explore his feelings or to try on different identities. In fact, after his marriage in 1915, Schiele's production of self-portraits diminished markedly. In 1917–18, his self-portrait drawings and watercolors often have the same programmatic relationship to the allegorical canvases as do the female nudes (pages 450–451). The artist is primarily concerned with working out various possible poses. Nonetheless,

despite a palpable increase in detachment, the self-portraits are noticeably more animated than the majority of the late nudes. Whereas the women often appear stunned or somnolent, Schiele's expression is quizzical and watchful. This dichotomy is carried over into the oils: the women are mere symbols, but Schiele is a person. In the *Squatting Couple*, his is the shamanistic presence that gives life to the whole. As the artist, he is still the master of his self-created universe.

Given the previously close interrelationship among Schiele's personal experiences, his allegorical cosmology, and his artwork, it is surprisingly difficult to establish any concrete connections between the artist's 1918 oeuvre and his private life. *Squatting Couple* was rechristened *The Family* at least in part because Edith, in April 1918, discovered that she was pregnant, and later scholars assumed the artist must have been aware of this fact when he conceived the composition. However, *Squatting Couple* was probably completed before the March Secession exhibition, where it was exhibited. Schiele, once so devoted to the themes of procreation, birth, and childhood, revealed little reaction to his own impending paternity in his art. As a respectable married man, he was now sometimes actually paid to draw children (page 462). And in 1917–18, he hired a professional woman-and-child modeling team (pages 477–479). His formal portraits of children are as insightful as his adult portraits, the child nudes as beautifully impersonal as the grown nudes. Between these two poles, however, there is no place for Schiele himself to surface. As foretold in the blind self-portraits of 1914–15, the artist has indeed on some level lost touch with his inner self.

Also notable by her relative absence in the 1918 oeuvre is Schiele's wife, naked or clothed, pregnant or otherwise. Having completed the studies for the 1918 oil portrait the prior year, the artist seldom drew Edith. In all likelihood, he was unfaithful to her, if not with her sister Adele, then with other women. Edith and Egon, who at first—for better or worse—had endured his military ordeal together, now occupied two separate worlds: hers, in the custom of the time, exclusively domestic; his, professional. Edith's penultimate diary entry, written on 16 April 1918, reflects the state of enduring loneliness that she had come to accept as her fate:

> *Today when I lack nothing physically, I am again and again psychologically alone. E[gon] certainly loves me in his own way, but he does not want to share the least thought with me. He makes me stand aside and will not let me take part in the inception and growth of any idea. Would it be better for me if I had a child? I would then possess a part of him with which I would be allowed to concern myself. This thought of a child has not left me since I have become aware of being pushed aside.*

In Schiele's defense, it must be said that he was not lacking in solicitude for his pregnant wife. He made sure she was protected from the worst privations of war-ravaged

Vienna, and in the summer of 1918, sent her to a Hungarian sanitarium. However, that autumn conditions in Vienna deteriorated beyond his control. The cold snap came early, and it was almost impossible to get enough coal. The artist's new Wattmanngasse studio was damp, the windows leaked, and wartime rent control prevented the landlord from making necessary repairs. Black marketeers ruled the grocery trade, and even then, the simplest foodstuffs were virtually unobtainable. Under these desperate conditions, the so-called Spanish flu easily reached epidemic proportions. Eventually, the disease would claim more people worldwide than World War I.

In late October 1918, despite Schiele's precautions, Edith contracted the deadly virus. She suffered with the flu for a little over a week. On the evening of 27 October, the artist sketched his wife's fever-ravaged face for the last time (page 485). Too short of breath to speak easily, she scrawled a trembling farewell message on a scrap of paper: 'I love you eternally and love you more and more infinitely and immeasurably.' At eight the next morning, she was dead. The following day, Schiele, himself already ill, wrote a last note to his sister Gerti: 'Edith Schiele no more.'

Anton Peschka found his brother-in-law shivering in the cold studio and arranged to have him moved to Edith's family's apartment, where Frau Harms ministered to the dying artist's needs. Peschka, one of the last to see Schiele in a lucid state, tried to comfort him by telling him that peace was at hand. 'Now the war is over', Schiele sighed, 'and I must go.' That same evening, as the artist, sedated by his doctor, wandered between sleep and consciousness, Egon's mother and his sister Melanie came for a last visit. They did not stay long. At 1 a.m. on 31 October—All Saints' Eve—Egon Schiele died.

While Schiele's death—like that of any twenty-eight-year-old—must be considered profoundly tragic, his life and his oeuvre have an unusually organic completeness. His is the quintessential coming-of-age story, more commonly told in first novels than in the visual arts. Whereas older painters may wistfully look back on their youths, Schiele was one of the few who had the technical virtuosity to express those experiences as they were happening. His watercolors and drawings, executed so rapidly and spontaneously, have a diaristic quality. In these works, we watch Schiele literally grow up, almost day by day. It is somehow fitting that an artist so indelibly marked by youth should die just as he at last reached adulthood.

Much of the uniqueness of Schiele's achievement derives from the fact that he recorded experiences of identity formation and sexual discovery that older artists tend to repress—and he too, of course, gradually learned to repress them. Yet by sacrificing some subjective intensity of feeling in his later work, the artist gained a more compassionate, empathic understanding of his subjects and of the world at large. Where

he might have gone with this, had he lived, is naturally impossible to guess. Nevertheless, in terms of pure technical mastery, Schiele reached the height of his powers in 1917–18. Linear perfection and painterly grace were balanced harmoniously in his late drawings and paintings. Objective precision and philosophical profundity, the personal and the universal, the naturalistic and the spiritual, coexist organically in the artist's last works.

This desire to reconcile opposites—to be, in his own words, 'all things at once'—lay at the heart of Schiele's lifelong mission. Hovering between the nineteenth century and the twentieth, between Gustav Klimt's allegorical symbolism and a more bluntly expressive modernism, he sought answers to the most basic questions of human existence: what does it mean to live, to love, to suffer, and to die? Today, we tend to see these questions as unanswerable, and so it is that the very act of asking—the adolescent quest—has become central to our appreciation of Schiele's legacy. We generally prefer his watercolors and drawings, which pose the questions, to the allegories that purport to answer them. However, in the larger sense, Schiele's legacy must be understood within the context of the era in which it was created, the artist's quest acknowledged as successful, his mission fulfilled.

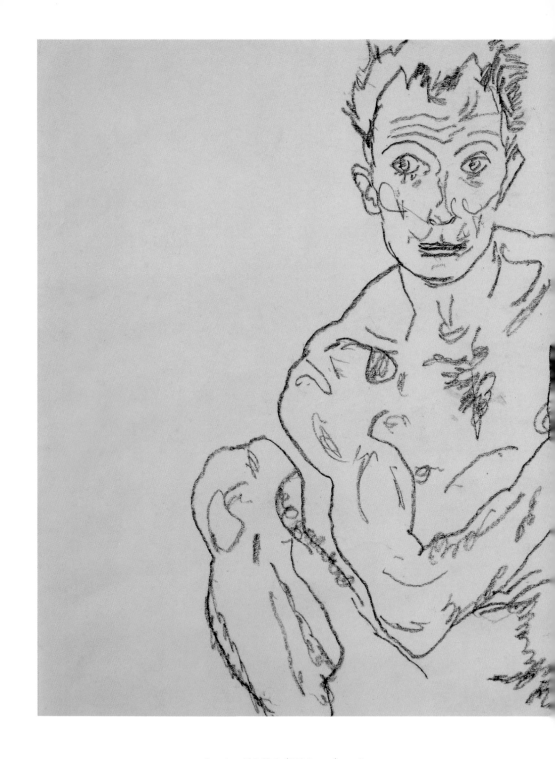

Crouching Male Nude (Self-Portrait). 1918.
Black crayon. Signed and dated, lower right. 30.1 × 47.1 cm. Kallir D. 2480.
Graphische Sammlung Albertina, Vienna.

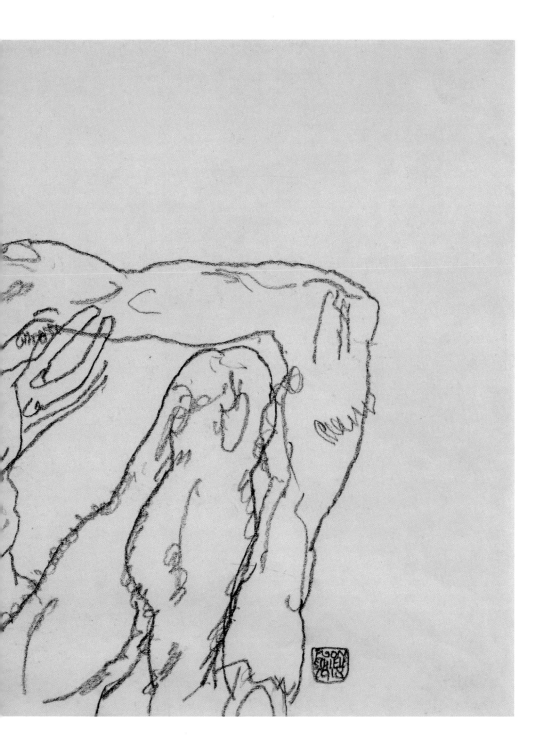

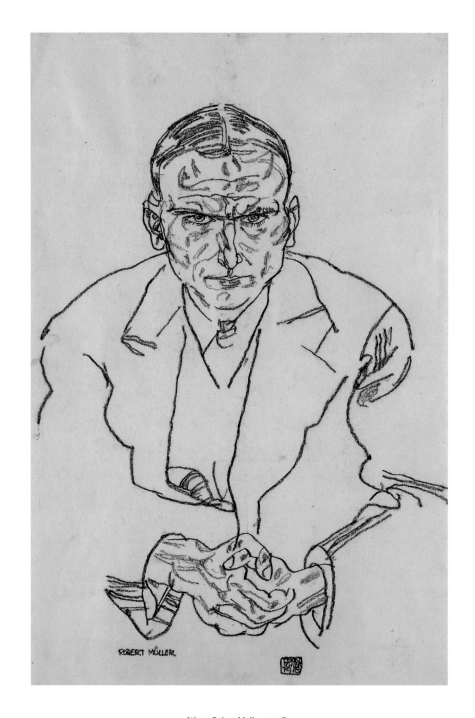

Writer Robert Müller. 1918.
Black crayon. Signed and dated, lower right. Inscribed 'Robert Müller',
lower left. 47.5 × 29.5 cm. Kallir D. 2435.
Historisches Museum der Stadt Wien, Vienna.

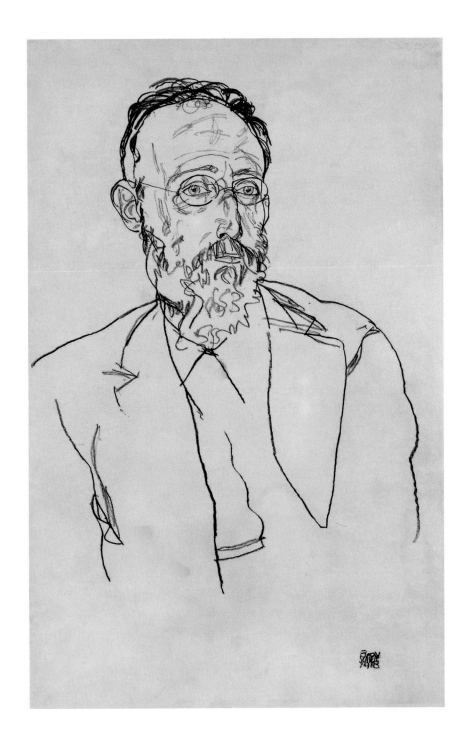

The Philosopher Heinrich Gomperz. 1918.
Black crayon. Signed and dated, lower right. 46.7 × 28.8 cm. Kallir D. 2463.
Historisches Museum der Stadt Wien, Vienna.

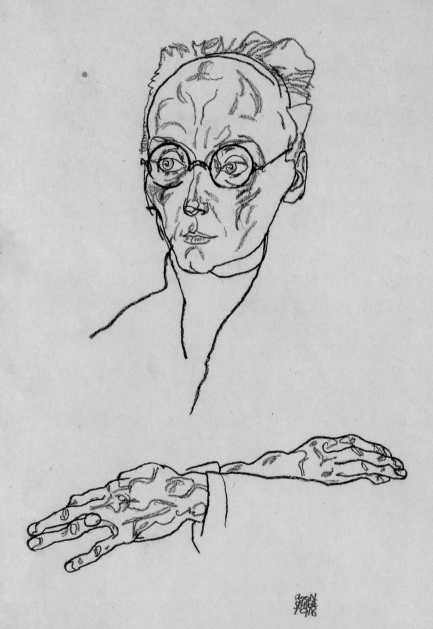

FRANZ BLEI

Portrait Sketch of Franz Blei with Arms Crossed. 1918.
Black crayon. Signed and dated, lower right. Inscribed 'Franz Blei',
lower left. 47.2 × 30.2 cm. Kallir D. 2461.
Historisches Museum der Stadt Wien, Vienna.

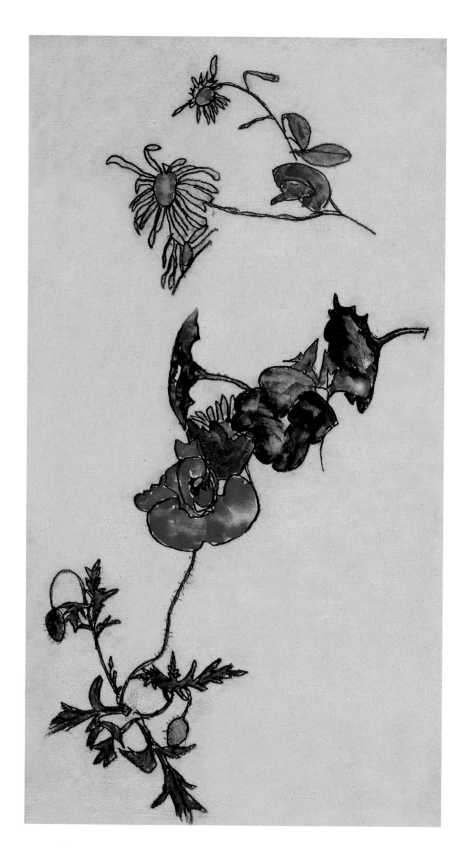

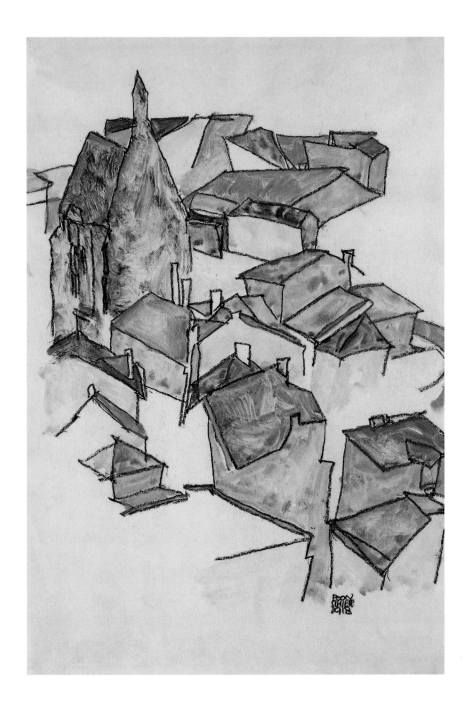

Above: *Spitalskirche Mödling, with Neighboring Houses*. 1918.
Gouache and black crayon. Signed and dated, lower right. 45.8 × 29.6 cm. Kallir D. 2493.
William Hayes Ackland Memorial Art Center, Burton Emmett Collection, Chapel Hill.
Opposite: *Daisies, Bindweed, and Poppy*. 1918. Watercolor and pencil. 42 × 27 cm.
Kallir D. 2490. Oberösterreichisches Landesmuseum, Linz.

Ceramics (Peasant Jugs). 1918.
Gouache, watercolor, and pencil. Signed and dated, lower left.
Inscribed '30.VIII' and 'O.W.', lower left. 43.2 × 29.2 cm. Kallir D. 2496.
Private collection, courtesy of Galerie St. Etienne, New York.

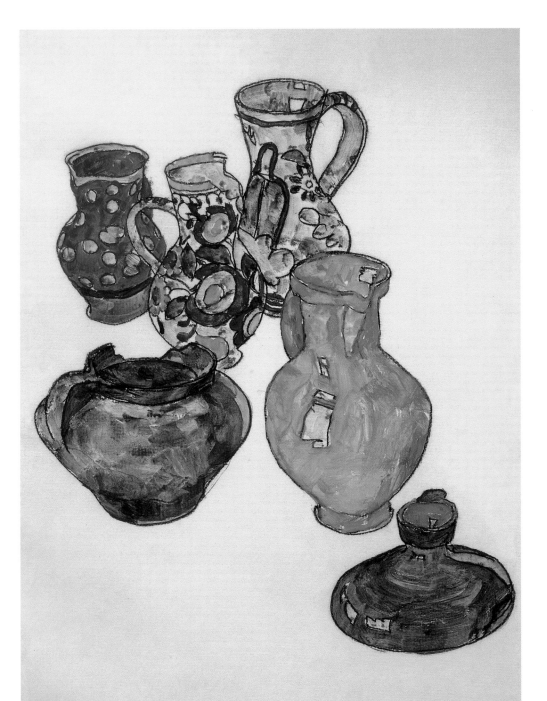

Portrait of the Artist Silvia Koller. 1918.
Gouache, watercolor, and black crayon. Signed and dated, lower left.
Inscribed '31.VIII.' and 'O.W.', lower left. 46 × 30 cm. Kallir D. 2224.
Private collection.

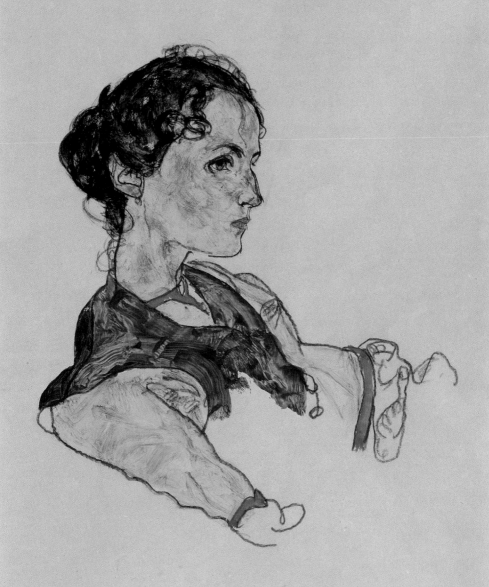

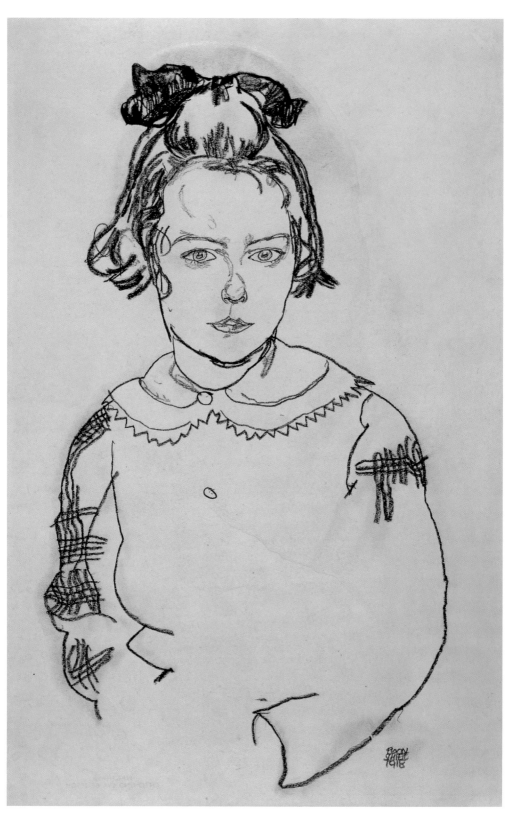

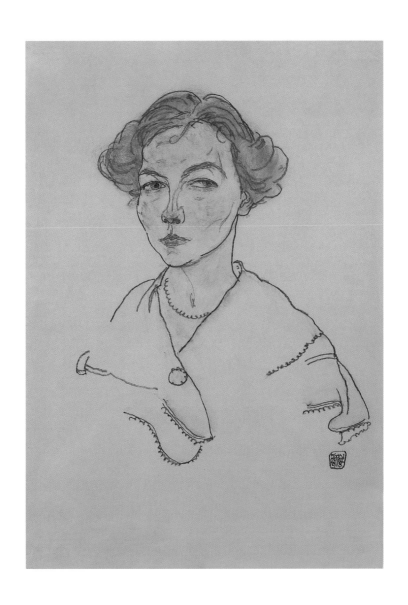

Above: *Portrait of a Woman (Lilly Steiner)*. 1918.
Watercolor and black crayon. Signed and dated, lower right.
44.1 × 28.9 cm. Kallir D. 2210. Private collection.
Opposite: *Portrait of Maria Steiner, Half-Figure*. 1918.
Black crayon. Signed and dated, lower right. 46.2 × 29.6 cm.
Kallir D. 2179. Graphische Sammlung Albertina, Vienna.

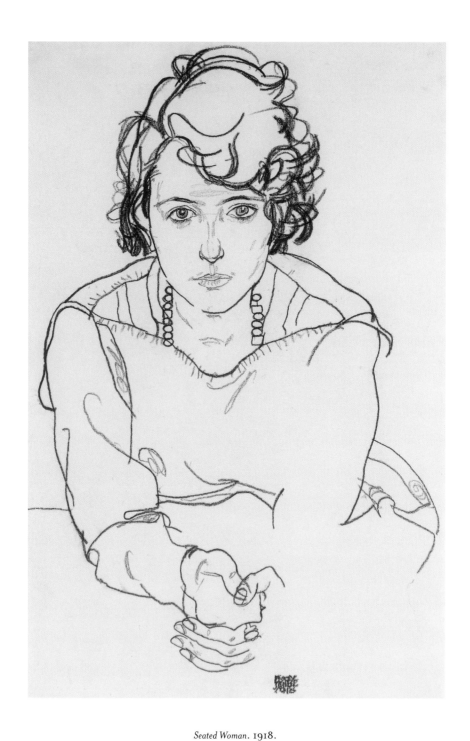

Seated Woman. 1918.
Black crayon. Signed and dated, lower center. 47.5 × 30 cm. Kallir D. 2222.
William Hayes Ackland Memorial Art Center, Burton Emmett Collection, Chapel Hill.

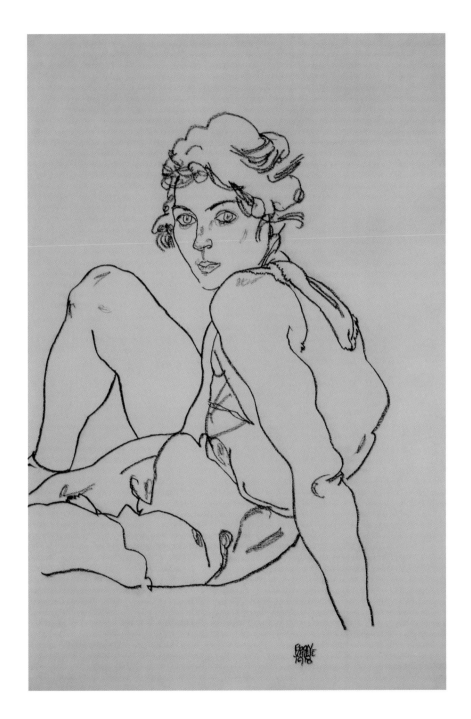

Seated Semi-Nude. 1918.

Black crayon. Signed and dated, lower right.

45.7 × 29.5 cm. Kallir D. 2340. Private collection.

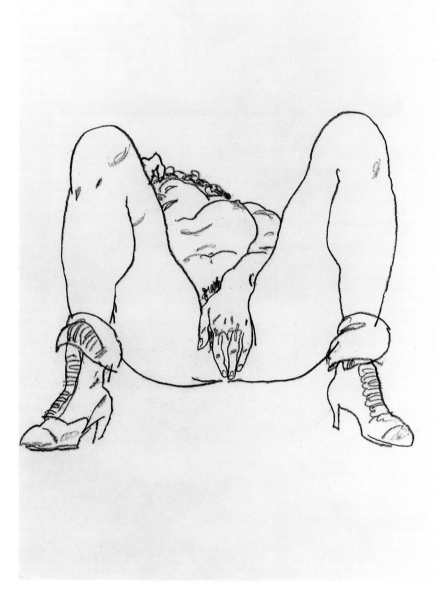

Autoerotic Nude with Boots. 1918.
Charcoal. 46.4 × 29.7 cm. Kallir D. 2239.
The Metropolitan Museum of Art, New York; Bequest of Scofield Thayer, 1982.

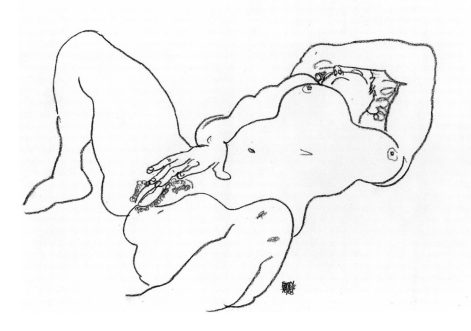

Autoerotic Female Nude, Reclining. 1918.

Black crayon. Signed and dated, lower center. 29.7 x 46.2 cm. Kallir D. 2241.

The Metropolitan Museum of Art, New York; Bequest of Scofield Thayer, 1982.

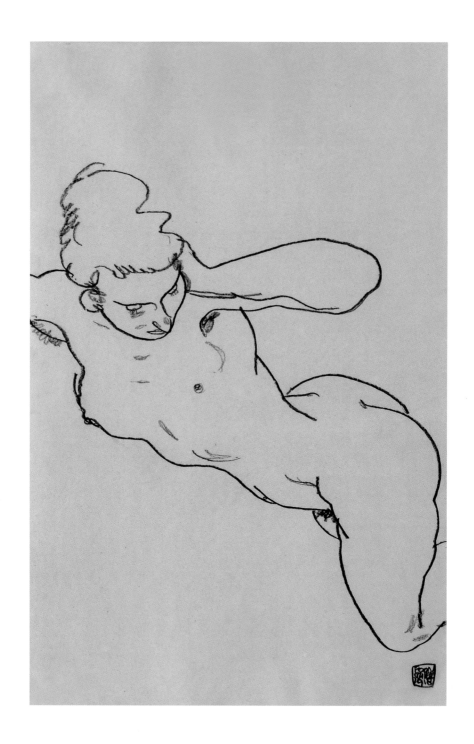

Nude Bending Forward. 1918.
Black crayon. Signed and dated, lower right. 46.3 × 29.5 cm. Kallir D. 2376.
The Earl and Countess of Harewood.

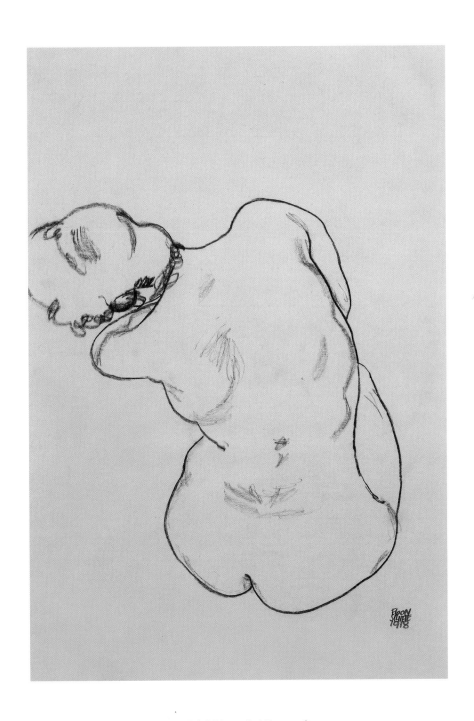

Seated Nude Woman, Back View. 1918.

Black crayon. Signed and dated, lower right. 45.3 × 29.4 cm. Kallir D. 2382.

Tel Aviv Museum, Tel Aviv; Gift of Leonard Lauder.

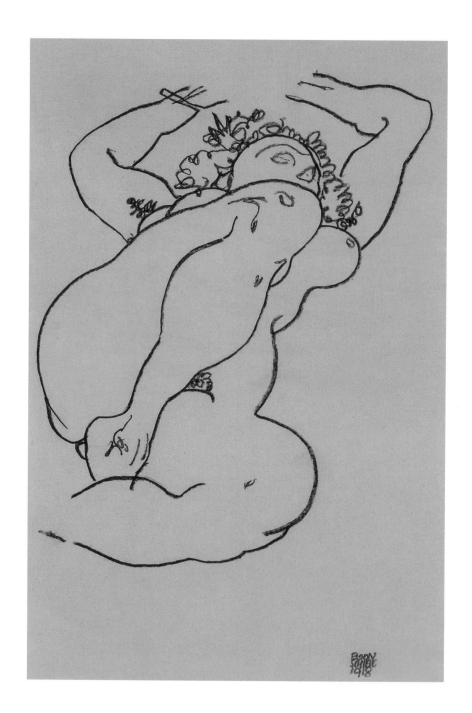

Nude Girl. 1918.
Black crayon. Signed and dated, lower right. 32.4 × 21.1 cm. Kallir D. 2255.
Kupferstichkabinett, Öffentliche Kunstsammlung, Basel.

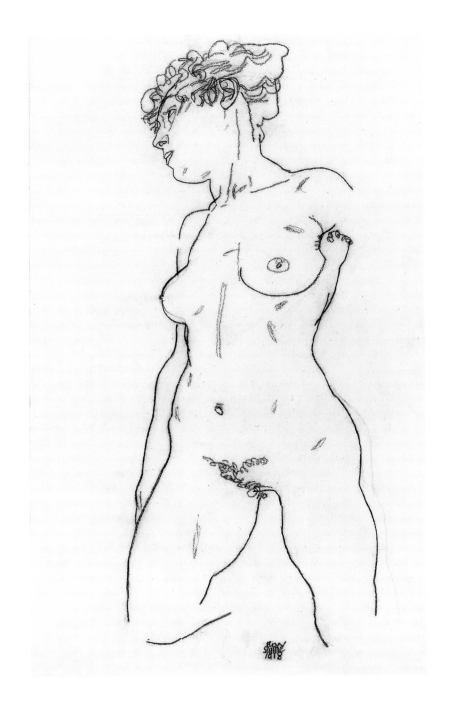

Female Nude, Kneeling. 1918.
Black crayon. Signed and dated, lower center. 49.6 × 29.8 cm. Kallir D. 2306.
Kupferstichkabinett, Staatliche Kunstsammlungen, Dresden.

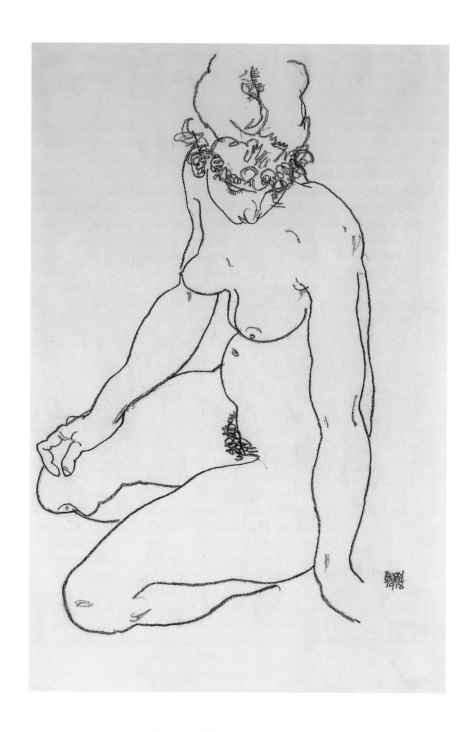

Kneeling Female Nude, Turning to Right. 1918.
Black crayon. Signed and dated, lower right. 44.5 × 29.5 cm. Kallir D. 2315.
Haags Gemeentemuseum voor Moderne Kunst, The Hague.

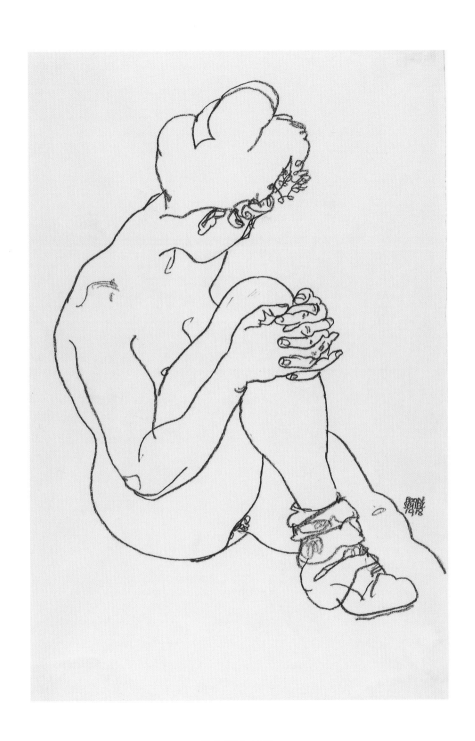

Seated Nude. 1918.
Black crayon. Signed and dated, lower right. 39 × 27.5 cm. Kallir D. 2316.
The Israel Museum, Jerusalem; Gift of Robert J. Mayer, New York.

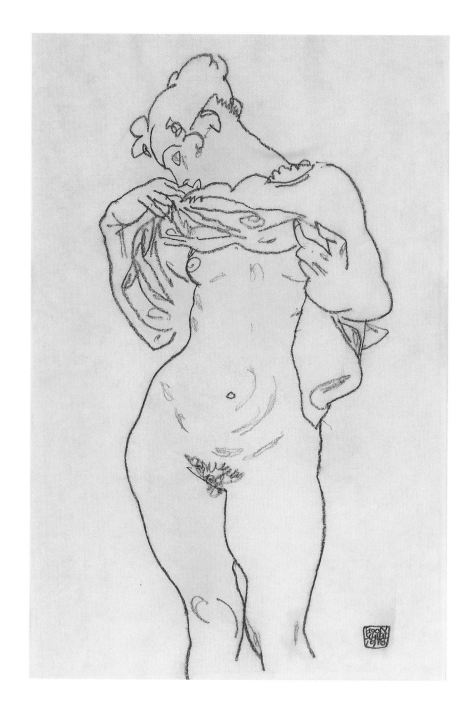

Standing Female Nude. 1918.
Charcoal. Signed and dated, lower right. 47.1 x 29.9 cm. Kallir D. 2366.
Kupferstichkabinett, Akademie der Bildenden Künste, Vienna.

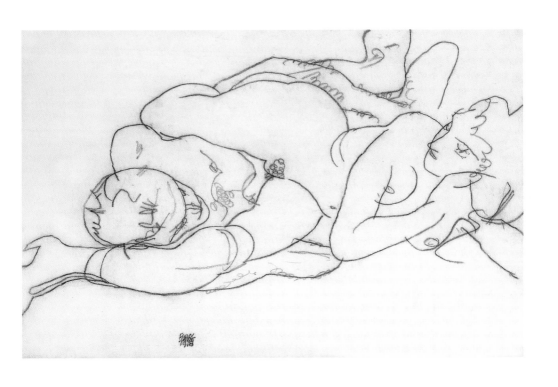

Two Reclining Figures (Lovers). 1918.
Pencil. Signed and dated, lower left. 33 × 48.9 cm. Kallir D. 2485.
The Earl and Countess of Harewood.

Mother and Child. 1917.
Black crayon. Signed and dated, lower center. 46.4 × 29.5 cm. Kallir D. 2185.
Private collection, courtesy of Galerie St. Etienne, New York.

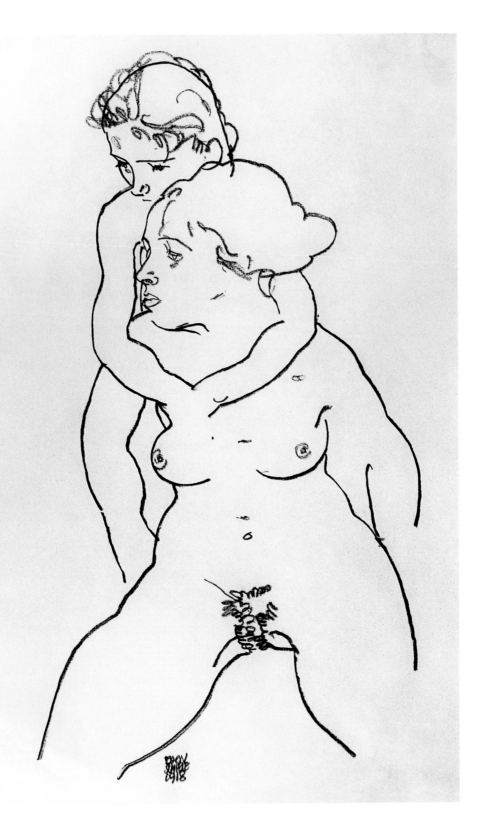

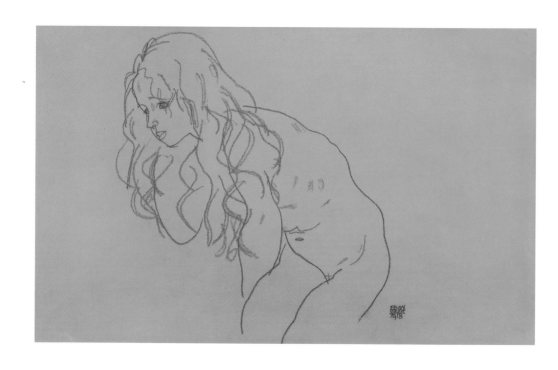

Nude Girl Leaning Forward to the Left. 1918.
Black crayon. Signed and dated, lower right. 29.2 × 41.3 cm.
Kallir D. 2193. Private collection.

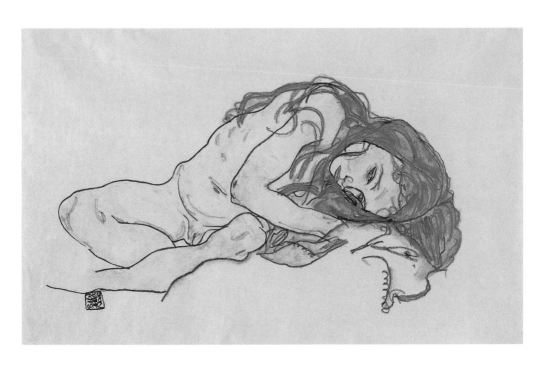

Nude Girl with Lowered Head. 1918.
Gouache, watercolor, and black crayon. Signed and dated (as vertical),
lower left. 29.7 × 46.2 cm. Kallir D. 2204.
Leopold Museum, Vienna.

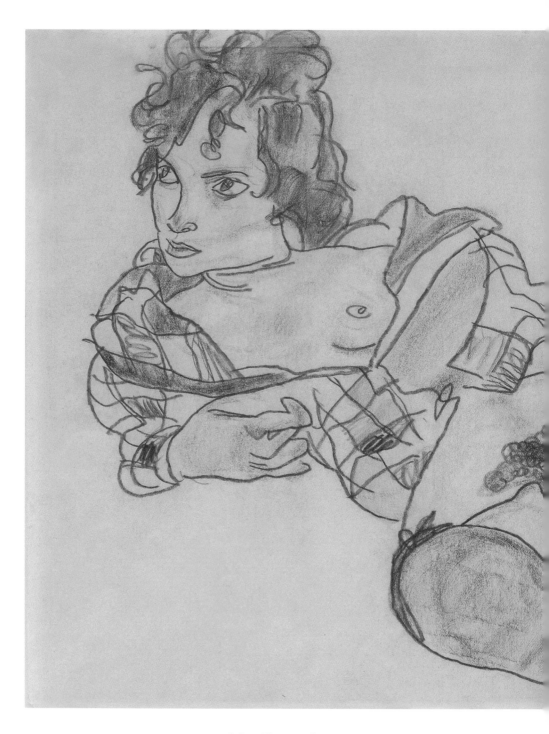

Reclining Woman. 1918.
Charcoal. Signed and dated, lower right. 29.5 × 46.4 cm. Kallir D. 2427.
Private collection, courtesy of Galerie St. Etienne, New York.

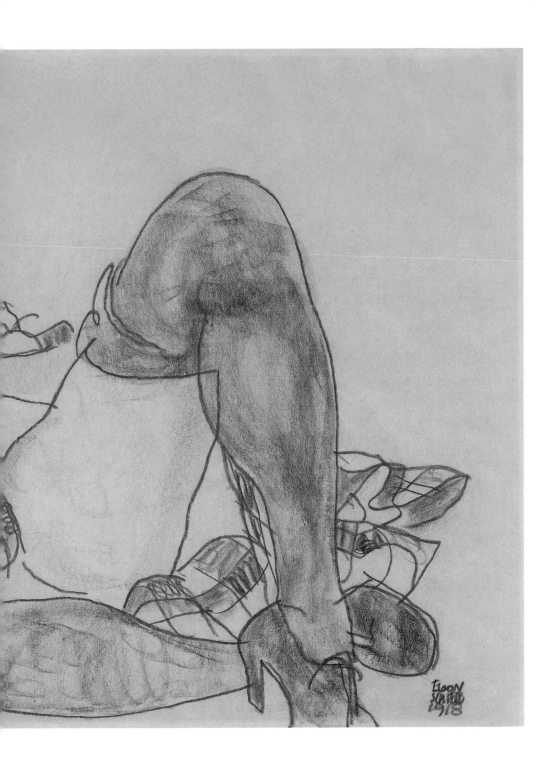

The Artist's Mother (Marie Schiele). 1918.
Black crayon. Signed and dated, lower right. 43 × 26.6 cm. Kallir D. 2230.
Graphische Sammlung Albertina, Vienna.

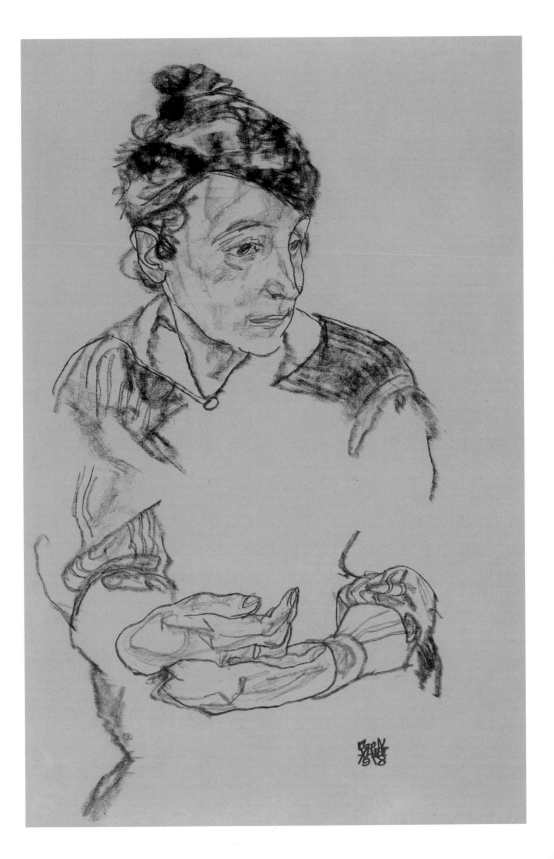

Edith Schiele. 1918.
Black crayon. Signed, lower left. Inscribed 'gez.27.X.abds', and
dated '28.Oktober 1918', lower left. 44 × 29.7 cm. Kallir D. 2233.
Leopold Museum, Vienna.

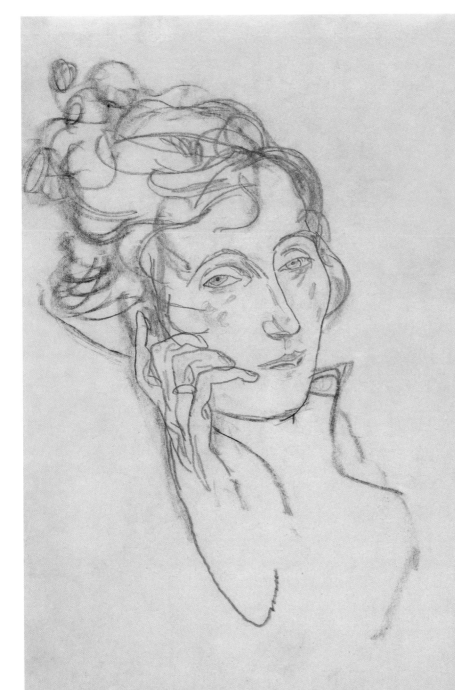

Photography credits

Authors biographies

Acknowledgments

Photography © Christie's Images: Pages 89, 90, 91, 172, 311, 351, 410, and 461. Photography © Sotheby's: Pages 16, 18–19, 46, 56, 92, 102, 117, 152, 153, 170, 182, 234, 243, 260–261, 270, 315, and 397. Photography © 1987 Metropolitan Museum of Art, New York: Pages 148 (Accession Number 1984.433.312), 167 (1984.433.298), 168 (1984.433.309), 179 (1984.433.311), 296 (1984.433.313), 301 (1984.433.305), 318–319 (1984.433.303), 414 (1984.433.316), 466 (1984.433.314), and 467 (1984.433.310). Photography © 2002 President and Fellows of Harvard College (Harvard University Art Museum): Page 235 (1964.0170.0000). Photography © Graphische Sammlung Albertina: Pages 30 (38.721), 36 (30.753), 39 (1110), 53 (29.981), 60 (30.538), 62 (30.771), 66 (31.391), 67 (31.392), 82 (32.438), 86 (30.772), 115 (30.395), 116 (31.247), 121 (23.599), 123 (30.996), 127 (31.153), 131 (30.892), 135 (26.276), 151 (33.357), 164 (31.249), 206 (31.032), 207 (31.160), 209 (31.161), 210 (31.028), 246 (31.149), 247 (31.150), 269 (39.929), 289 (31.105), 314 (31.157), 320–321 (31.158), 382–383 (31.262), 402 (25.659), 450–451 (31.345), 462 (37.099), and 483 (23.527). Photography © Historisches Museum der Stadt Wien: Pages 59 (115.155), 61 (75.404), 77 (78.951), 174 (115.169), 199 (115.159), 200 (115.149), 202 (115.160), 295 (115.168), 452 (102.821), 453 (102.021), and 454 (102.007). Photography © Niederösterreichisches Landesmuseum, St. Pölten: Pages 20 (1908), 22–23 (1907), 24–25 top (1911a), 24–25 middle (1911b), 24–25 bottom (1911c), 26–27 (1911g), 28–29 (1910b), 34 (1901), 38 (1900), 50 (1917a), and 51 (1905). Santa Barbara Museum of Art, Santa Barbara (Scott McClaine): pages 366–367. Photography © Museum of Fine Arts, Boston: page 340 (65.1322). Photography © The Art Institute of Chicago, Chicago: page 371 (1966.172).

Citations following an artwork's dimensions refer to entries in the artist's catalogue raisonné:

Jane Kallir, *Egon Schiele: The Complete Works—Including a Biography and a Catalogue Raisonné.*
New York: Harry N. Abrams and London: Thames & Hudson, 1990; Expanded
Edition 1998.

Fritz Novotny and Johannes Dobai, *Gustav Klimt, with a Catalogue Raisonné of His Paintings.*
New York: Harry N. Abrams and London: Thames & Hudson, 1968.
Translated from the German by Karen Olga Philippson.

Johann Winkler and Katharina Erling, *Oskar Kokoschka: Die Gemälde, 1906–1929.*
Salzburg: Galerie Welz, 1995.

JANE KALLIR is the author of numerous volumes on Schiele and other topics in early twentieth-century Austrian art. Among her many books are: *Austria's Expressionism* (Rizzoli, 1981); *Egon Schiele* (Abrams, 1994), and the seminal *Egon Schiele: The Complete Works—Including a Biography and a Catalogue Raisonné* (Abrams, 1990; expanded edition 1998). The co-director of New York's Galerie St. Etienne, Kallir has curated exhibitions of Schiele's work throughout the world, at such major venues as the National Gallery of Art in Washington, D.C., the Historisches Museum der Stadt Wien, the San Diego Museum of Art, and the Indianapolis Museum of Art. In 2001–2002, she organized "Gustav Klimt—Oskar Kokoschka—Egon Schiele" for the Museo del Vittoriano in Rome and the Revotella Museum in Trieste. Kallir lectures widely, at such institutions as New York's Museum of Modern Art, the Smithsonian Institution, the Baltimore Museum of Art, the National Gallery of Art, and many others.

IVAN VARTANIAN is the founder of Goliga Books, a Tokyo-based independent publishing house and book packager specializing in books on drawing, graphic arts, and photography. He is the author of *Andy Warhol: Drawings and Illustrations of the 1950s* (2000); *Now Loading . . .: The Aesthetics of Web Graphics* (2001); and *TypoGraphics* (2003).

When I wrote the 1990 Schiele catalogue raisonné, the text was of necessity divided into two sections. A lengthy biographical essay was followed by a detailed analysis of Schiele's year-to-year development, which accompanied the catalogue of his oeuvre. Although that catalogue was chronological in its overall organization, the individual years were subdivided according to subject matter in order to make the sequence more intelligible to audiences not previously familiar with the nuances of Schiele's stylistic development during each twelve-month period.

Since completing the catalogue raisonné, I have always yearned to combine the story of Schiele's life and his development into a single narrative, and to trace the latter more precisely in an illustrated publication. I would like to thank Ivan Vartanian for giving me the opportunity to do so, and also for his elegant layout. Particularly in the early years of Schiele's mature career (from 1910 until 1915), his development proceeded rapidly through many stylistic phases. To see these phases laid out precisely for the first time, as they are herein, is a real treat for me, and I hope it will prove likewise for the readers of this book.

Many others have contributed to the creation of this publication, first and foremost Hildegard Bachert, my partner at the Galerie St. Etienne. As always, she was tireless and scrupulous in her editorial assistance and proofreading, often working under extreme time pressure. Ariana Markoe undertook the exhausting task of coordinating much of the pictorial matter, compiling endless lists, typing captions, locating images, and then cheerfully doing it all over as the content of the book changed. Diana Stoll was a superb text-editor, tweaking my text gently to make it more readable. Although I did not have personal contact with many of the behind-the-scenes contributors to this project (who are cited in the Editor's Acknowledgments), I would like to thank them as well.

Editor's Acknowledgments

The editor would like to extend his humble thanks to the following individuals, with-
out whose gracious support and collaboration the preparation and completion of this
book would not have been possible. I'd like to thank Jane Kallir for her brilliance,
collaboration, and rich enthusiasm for Egon Schiele's work and for the creation of
this publication. Richard Avedon for his kind permission to reproduce the passage that
appears as the book's foreword; Diana C. Stoll for her deft and sensitive text-editing;
my tireless assistant Kyoko Wada; Hildegard Bachert and Ariana Markoe of the Galerie
St. Etienne, New York; Syûzo Hayashi of Lim Lam Design, Tokyo, for help with the
book's design; Jamie Camplin, Alison Slienger, Charlotte Troy, Catherine Hardy,
and Nicola Lewis of Thames & Hudson Ltd., London; Yutaka Yano, Yuhuko Takano,
and Kazuhide Miyamoto of Shinchosha Ltd., Tokyo; Dr. Christian Brandstätter,
Elisabeth Hölzl, and Dr. Brigitte Hilzensauer. Gary Cosimini of Adobe Systems, Inc;
Frankie Lee of Everbest Printing, Ltd.; and Ocean Reprographics, Inc.

Numerous institutions and private collection have been gracious in allowing
artworks in their holdings to be reproduced in this publication. I'd like to thank, in
particular, the following individuals whose assistance facilitated the unearthing and
assembly of materials for this publication: Monika Knofler of the Akademie der
Bildenden Künste Wien, Vienna; Richard Nagy and Caroline Schmidt of the Dover
Street Gallery, London; Leslie Graham of the Allen Memorial Museum of Art,
Oberlin; Christina Schwill of the Staatsgemäldesammlungen, Munich; Stefan Ståhle
of the Moderna Museet, Stockholm. Christopher Atkins and Debra Lakind of the
Museum of Fine Arts, Boston. Charlotte Grant of Christie's New York; Maaike
Westerveld of the Gemeentemuseum, Netherlands; E. W. Kornfeld; Bianca Slowik
of the Germanisches Nationalmuseum, Nüremberg; Alexandra Barcal of the
Graphische Sammlung der Eigenössischen Technischen Hochschule, Zurich; Jane
George of the Harewood Trust; Ziva Haller of the Israel Museum; Elsbeth Gerber of
the Kirchnermuseum, Davos; Joanna Ling and Sue Daly of Sotheby's, New York;
Janis Staggs-Flinchum of the Neue Galerie, New York; Sandra Tretter of the
Leopold Museum, Vienna; DeAnn Dankowski of The Minneapolis Institute of Arts,
Minneapolis; Dr. Gudrun Danzer of the Neue Galerie am Landesmuseum Joanneum,
Graz; Dr. Elisabeth Nowak-Thaller of the Neue Galerie der Stadt Linz, Linz; Helmut
Ehgartner and Flora Königsberger of the Niederösterreichische Landesmuseum, St.
Pölten; Franziska Heuss of the Offentliche Kunstsammlung, Basel; Gonda Zsuzsa of

the Szépmüvészeti Múzeum, Budapest; Cynthia Gavranic of the Coninx Museum, Bern; Renata Antoniou of the Graphische Sammlung Albertina, Vienna; Susanne Vierthaler of Artothek, Germany; Helmut Selzer of the Historisches Museum der Stadt Wien, Vienna; Kathy Ann Taylor of the Indiana University Art Museum, Bloomington; Priska Brändli, Erika Hofstetter, and Susanne Rüegger of the Kunsthaus Zug, Zug; Vera Silvani of Scala Archives, Italy; Alena Martycakova of the Moravian Gallery, Brno; Dr. Eva Neumannoveá of the Národní Galerie, Prague; Angelika Katzlberger of the Rupertinum, Museum Moderner Kunst, Salzburg; Brian Eyler of the Santa Barbara Museum of Art, Santa Barbara; Eugenia Alonso of the Museo Thyssen-Bornemisza, Lugano.

Throughout the last several years, the following friends have provided invaluable support, encouragement, and advice and I'd like to extend my thanks to them for their kindness: Merry Angel, Benjamin Budde, Debbie Bibo and Riccardo Bozzi, Wendy and Tom Byrne, Eric A. Clauson, Melissa Harris, Valerie Koehn, Rico Komanoya, Lesley Ann Martin, Kenji Miyazaki, Yumi Shimano and Julian Stevens. And, finally, I'd like to give a special thanks to my friend and mentor, the late Michael E. Hoffman.

Egon Schiele: Drawings and Watercolors was created and produced by
IVAN VARTANIAN / GOLIGA BOOKS, TOKYO.

Text Editor
DIANA C. STOLL

Editorial Assistant
KYOKO WADA

Book Design
IVAN VARTANIAN

Jacket Design
SHALOM SCHOTTEN / Thames & Hudson

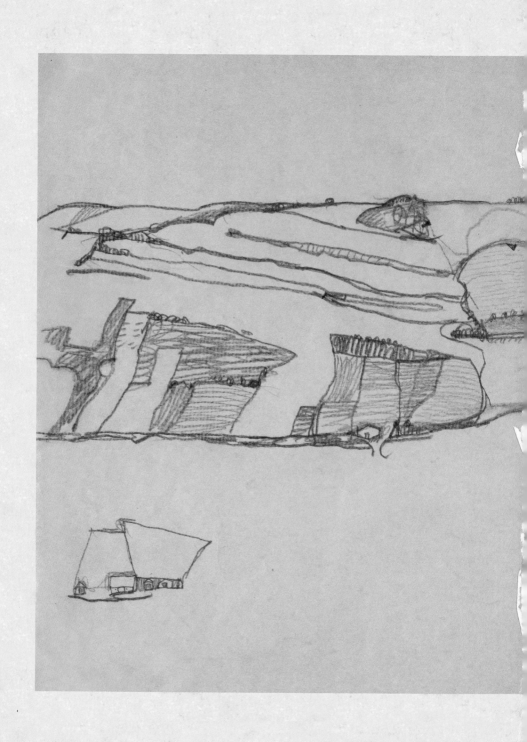